Surfaces

Surfaces

A HISTORY

Joseph A. Amato

UNIVERSITY OF CALIFORNIA PRESS
BERKELEY LOS ANGELES LONDON

Frontispiece: "Surely Joy," by Abigail Rorer, inspired by Henry David Thoreau's poem of that name. Reproduced with the permission of Abigail Rorer, Petersham, Massachusetts.

University of California Press, one of the most distinguished university presses in the United States, enriches lives around the world by advancing scholarship in the humanities, social sciences, and natural sciences. Its activities are supported by the UC Press Foundation and by philanthropic contributions from individuals and institutions. For more information, visit www.ucpress.edu.

University of California Press
Berkeley and Los Angeles, California

University of California Press, Ltd.
London, England

© 2013 by The Regents of the University of California

Library of Congress Cataloging-in-Publication Data
Amato, Joseph Anthony.
 Surfaces : a history / Joseph A. Amato.
 p. cm.
 Includes bibliographical references.
 ISBN 978-0-520-27277-4 (cloth : alk. paper)
 1. Environmental psychology. 2. Perception. 3. Science—
Philosophy. I. Title.
 BF353.A43 2013
 155.9'1—dc23 2012042651

Manufactured in the United States of America

22 21 20 19 18 17 16 15 14 13
10 9 8 7 6 5 4 3 2 1

In keeping with a commitment to support environmentally responsible and sustainable printing practices, UC Press has printed this book on Rolland Enviro100, a 100% post-consumer fiber paper that is FSC certified, deinked, processed chlorine-free, and manufactured with renewable biogas energy. It is acid-free and EcoLogo certified.

Cover: Illustrations © istockphoto.com.

To Cathy, comfort and spirit of my days

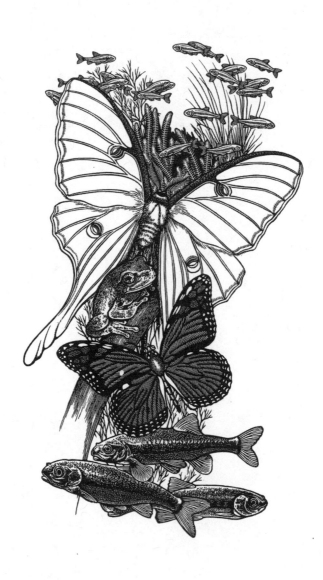

Surely joy
is the condition of life.

Think of the young fry
that leap in ponds,

the myriads of insects
ushered into being
of a summer's evening,

the incessant note of the hyla
with which the
woods ring in the spring,

the nonchalance of the butterfly carrying
accident and change painted
in a thousand hues upon his wings,

or the brook minnow stemming stoutly
the current, the lustre of whose
scales worn bright
by the attrition, is reflected
upon the bank.

HENRY DAVID THOREAU, "Surely Joy"

CONTENTS

ILLUSTRATIONS

PREFACE

IN THIS BOOK, I EXPLORE OUR RELATION TO SURFACES in order to carry out a historical, philosophical, and anthropological meditation on humans as self-reflecting, self-defining, and self-making creatures. Having written an impressionistic and, I hope, evocative history of microsurfaces in *Dust: A History of the Small and Invisible* and a history of macrosurfaces in *On Foot: A History of Walking,* I took a jump: why not write a history of surfaces in general?[1]

. . .

Surfaces cradle and nurture our bodies and awaken and define the minds that perceive them. Surfaces direct energy, generate motives, and become ends in themselves. Surfaces shape space; they measure change and reveal movements and motions. They declare in patterns things near, around, and afar. They signal what is, what is leaving and vanishing, and what might be coming. They stretch before us in fields of woven beauty, coherence, and logic, or offer jumbles and thickets that bar order and entrance. They give rise to elemental pairings such as up and down, front and back, around and across, without and within, hot and cold, tight and loose, thick and thin, full and vacant, transparent and opaque, heavy and light, sinking and buoyant. As blatant and blaring as trumpets and as startling as a fresh bank of forsythia in early spring, surfaces declare places and conjure expectations.

Surfaces may be great and bold walls that over time are scored by lines and cracks and splotched with green moss. Surfaces also can be gates and windows. Skins cover interiors, too. Baby skin sets the spirits of the old dancing. Feeling a face, a blind woman reads the lifetime of the person standing before

her. A first bulging pimple sets a child with little knowledge of anatomy to pondering the chemistry of his inside. Unconsciously, we forever move back and forth between inner and outer layers. We conjure substances, hear signals, conjugate being, or are filled with unspecified foreboding.

Surfaces, to suggest a general kind of dialectic (though nothing as systematic as Hegel's or Marx's), are the topic of this work. They establish the contexts, configurations, and juxtapositions of thing and flesh, nature and society, and they nurture life and awaken the mind. Humans forever and constantly move in and out of the world's surfaces, traveling between things and objects, the other and the self. Outsides point toward and come to identify insides.

Surfaces arouse and guide animals and human alike. As the fanning movement of a bird's colorful tail feathers attracts potential mates, so a single glimpse of Beatrice's face won Dante's lifelong devotion and spurred his poetic creations of great refinement. More prosaically, people speak about a subject as being as plain as the nose on their face. They read fate in the lines on their palms, talk about laughing on the outside and crying on the inside, and circle an ear with an index finger to describe the loss of one's inner and outer bearing. Surfaces provide immediate signals, and yet they take on metaphoric meaning. The German word *Blatt*—and, similarly, the Russian word пucm̄ [пuct]—indicates a page, blade, or leaf, but is also used to describe a plate, a lamina, or a newspaper. The French word *taille,* a cut or trim of page, also has come to mean an edge, to hew, or the slim figure of *une personne bien taillée.* Our word *trim* can be used in descriptions of shaping hedges or heads of hair, and we also trim messy budgets and sloppy sails.

Indeed, we construct worlds out of ideas of interrelations, out of the realities of surfaces, spaces, and things. In what has been for me a long-time favorite, the 1958 French classic *The Poetics of Space,* twentieth-century French philosopher Gaston Bachelard offers an ontological perspective on the space and surfaces of inner worlds.[2] A whole cosmos is equated with the interiority of such homey things as the inside of a drawer, chest, cabinet, or other container. The historian of objects and inventions Henry Petroski makes even the modest Band-Aid worthy of consideration, given its outer, water-resistant surface and its inner, absorbent surface. Toggling between exteriors and interiors, outsides and insides, a contemporary surgeon cuts through and folds back three layers of skin on the way to an internal target, and then must pass through another five to eleven layers of tissue in order to reach the inside of an organ. In parallel movements, using the tip of a pencil,

a sheet of paper, and a keen and leading line, artists design, decorate, and express interior and exterior worlds and even suggest, as Leonardo da Vinci proved with pen and charcoal, that "drawing is thinking," to use the title of a 2008 book by popular New York designer Milton Glaser.[3]

Moving in approximately the same direction in this work, I go from outer to inner layers of life and thought. In the introductory chapters, I affirm that humans, in our life and as animals, can be understood as a set of surfaces living among other, greater, and more varied sets of surfaces. With special attention to skin and hands, I examine our evolution and development as a consequence of our interactions with both natural and made surfaces. In the following chapters, I take up cities and civilizations as both the result of and laboratories for the making and refinement of surfaces, and I consider how surfaces, through our drawing, writing, sculpture, weaving, pottery, and metallurgy, have become material and symbolic means of self-making and self-definition.

In accord with a phenomenological approach, I suggest that surfaces are transformed from sensations and perceptions into concepts, images, symbols, and language. Surfaces furnish our primary encounters with the outer and the inner layers of things—their cover, epidermis, membrane, bark, rind, hide, and skin. They also present us with our first experiences of the primary disposition of objects, bodies, and life out there, beyond us. In other terms, humans, ourselves a body of surfaces, meet and interact with a world dressed in surfaces. Surfaces are the wardrobe of being. They present the world as animate and inanimate, as parts and wholes, as singularities and particularities, and also as faces and Gestalts of selves, others, animals, objects, places, situations, and whole horizons. On the largest scale, surfaces form and are organized into, to draw upon Clive Gamble's *Origins and Revolutions,* a series of *scapes:* bodyscapes, soundscapes, mindscapes, taskscapes, landscapes, and sensescapes.[4]

Surfaces are not only our first terms of recognition and cognition, but are also workshops for human bodies and actions, social groups and organizations. Our primordial and abiding work requires breaking, grooving, perforating, dividing, shaping, leveling, weaving, joining, and fashioning surfaces. Since (and, to a degree, even prior to) the rise of cities and the subsequent appearance of civilizations, humans have been involved in the systematic and aesthetic creation of spaces, structures, objects, and surfaces. With the emergence of industrial society, originating in western Europe, modern mankind has enveloped itself, body and mind, thought and action, in made

surfaces—built environments, engineered landscapes, organized cities, designed goods and spaces, and segmented and structured time. Particularly in the past century or so, we have lived, innovated, designed, controlled, and administered surfaces, and as a result, we individually and collectively have known, judged, imagined, planned, and designed ourselves.

So, in conclusion, even though my exposition of surfaces is structured as a historical narrative, my explanations and elaborations border on philosophical investigations, inspired by metaphorical invocations and shaped by advancing reflections on human positions and pathways in being and meaning. Within the inner workshop of this book on intellectual architecture, surfaces proved an engrossing project. From the moment I conceived of this work until its completion, surfaces monopolized my attention. They took hold of my senses. I found myself tracing sensations—sights, sounds, touch, feel, and smells—back to their sources in surfaces. Surfaces became reasons to chat with local university geologists, psychologists, and biologists, my dentist, the town architect and gunsmith, and others whose occupations deal with surfaces. Although surfaces didn't take me to the beauty parlor or the chiropractor, they were explicit grounds for my inquisitive expeditions to the local scrap-iron dealer, body repair shop, and machine shop and my inventory of the local hardware center, ever rich in newly designed screws and bins of nuts and bolts, in addition to shovels, saws, knives, files, scrapers, and other bladed instruments. I was particularly fascinated by new materials and products: superglues, sealants, polishes, cleaning products of all sorts, and smart glass, a self-tinting product that automatically operates like chemical shades and blinds.

Noticing and reflecting on surfaces regularly punctuated my days even when I was away from writing and my sullen computer screen, lively keyboard, and sticky mouse. I thought twice about surfaces when negotiating the windblown fairways and fast greens of the nearby nine-hole public riverside golf course, when hiking the river bottom upstream in the state park, and when rowing my small Norwegian bay boat through the choppy waters of our shallow lakes. Whether they were new tennis shoes, freshly paved roads, grocery bags, my oldest daughter's ceramic portraits, or even my hardworking wife, Cathy's, flower garden and my budding raspberry patch, things expanded my conceptions of surfaces. Leaves, wings, fins, and scales—worn, still, or in motion; part of a context; a convergence and fusion; or signaling contrast and juxtaposition—both seized and subtly lured my attention. Covers, sheets, skins, eyes, tires, tracks, layers,

laminations, and interfaces—surfaces seen and thought about—made me, if only for a moment, a biologist, a chemist, a civil engineer, a forge-and-lathe man, a joiner, a wheelmaker, a manufacturer, a designer, a packager, and an artist. Nevertheless, the mortar that joined sets of surfaces into this book was composed of read and written words.

One surface that escaped becoming a topic—and having a chapter of its own—was the human face itself. It was too rich in calories for the diet of this work, for the face is the great interface between the self and the body, the self and others, and the interior and exterior worlds. Helen's face never itself pushed off a boat, but it did launch a thousand ships. Her face—her eyes, lips, brow, nose, fair skin, and alluring smile—put more wind in sails than any ballast could stabilize. Though I speak of the surfaces of things and objects, signals and images, as revelations and epiphanies, I never let the light fully shine on the human face, for in the words of Thomas Campion's sonnet "Cherry-Ripe":

> There is a garden in her face,
> Where roses and white lilies blow.[5]

As I recognized through a recent reading on the human face in Roger Scruton's *The Face of God,* an effort to write a history of this great revealer and concealer would lead from its first depictions in art to the most recently manufactured makeup to plastic surgery.[6] Perhaps humanity builds the world into the faces it perceives and imagines, fears and loves, and yet stares at without resolution.

In any case, it was not my aim to write a book about faces and all other possible surfaces. Beyond satisfying my own wish to offer a poetic sketch or universal history of surfaces, I simply intended to evoke for lay readers— along with reflective historians, anthropologists, scientists, and artists—a recognition of how much humans, ever embodied and earthly, belong to surfaces, and to acknowledge how much humans, through our conditions, experiences, and knowledge, are the parent and the child of the surfaces we encounter, know, work, and make. And, in conclusion, I feel compelled to caution that the surfaces that give and reveal so much can also wall us into prisons.

The Surface Is Where the Action Is

> Our senses evolved as sublime intelligence-gathering operations
> minutely attentive to every scent, rustle, and shadow in a land-
> scape. Keen senses bring us intense pleasure and at the same time
> vital information.
>
> JUDITH THURMAN, PREFACE TO MILTON GLASER,
> *Drawing Is Thinking*

SURFACES INCLUDE THE SCORED FACES of my old and worn golf irons,
the overlapping boards of my handmade rowboat, the high, wind-catching
side of my keelless aluminum canoe, and the bending tips of the fly rods I
inherited from my father-in-law. Surfaces evoke images, hold memories, and
occasion stories. They are the worn peasant shoes that philosopher Heidegger
found, on reflection, to be rich with meaning; they are the pair of scuffed
shoes I wore to work at a Chrysler missile plant, which infuriated a fellow
worker who thought my apparent disinterest in caring for my shoes was a
display of superiority by indifference.

Surfaces are infinite in number and form. They are distinct in themselves,
but we often perceive them in their contexts and juxtapositions. Moving
from small to big and big to small, gathering and pulling apart, they
multiply as a person's eyes toggle and he moves farther and closer to
them. Surfaces attach to and, conversely, point away from what is imme-
diate to them. Bountiful in presence, they give manifest testimony to
myriad things and the plethora of life, as suggested by the frontispiece of
this work, which depicts an epiphany of life. Perceived by the senses as
identical to their material existence in the world, surfaces, as a first and
primary face of being, serve as signals, are made into images, and then become
symbols, metaphors, and icons through which we transact connections and
understanding.

Surfaces evade easy definition. They raise classic questions of episte-
mology and aesthetics. They require thinkers to ask themselves what they
perceive, how they sense and classify surfaces, and how they transform

surfaces (individually and in combination with other surfaces) into ideas and images. Furthermore, surfaces, as perceived, experienced, envisioned, and represented by images or words, lead thinkers to the question of how surfaces capture thinkers, and how thinkers capture surfaces. Along other lines, thinkers ask about how the world is encountered by body and mind, how humans order the world with images, and how images form conscious and subconscious meanings out of which arise cultural and social understanding.

Although I do not engage these questions at length or systematically, I leave my responses to them embedded at various points in this unfolding narrative and offer a few preliminary ideas about surfaces that might serve as a primer, or light calisthenics, for the course ahead. For definitions, I turn momentarily to the work of James J. Gibson (1904–79), American psychologist and realist, whose *Ecological Approach to Visual Perception* introductorily asks: "Why, in the triad of medium, substance, and surfaces, are surfaces so important?" He replies, considering particularly how surfaces define layout and the interaction of things with light: "The surface is where the action is."[1] Refusing to make surfaces merely the sum of interpretations of them, he issues what could be considered—at least I would embrace it as such—an anthropologist's or historian's manifesto challenging the reduction of surfaces to abstractions and quantitative measures. Reminding one of early-twentieth-century French philosopher Henri Bergson, he resists defining the outer world and surfaces as an homogeneous set of calculable geometric spaces, lines, points, and fixed moments of time that describe both the organization of the world and the optics of perception. At odds with the scientific tradition, which is commonly identified as starting with Descartes and extending to Newton and beyond (see my short history in chapter 5), Gibson declares that human perception and vision are rooted in man himself as an ambulant and ambient being. Circling and seeing, Gibson's perceiver moves in the medium of air, below a sky, and across the horizontal band of a landscape. His perspectives are continuous, multiple, and varied. The landscape and objects presented are illuminated, shaded, crammed with beaming, reflective, and reclusive faces that absorb, emit, transmit, and radiate light. This ambulating creature examines, perceives, pays attention, and, I would add, intermittently uses all his senses, not just his eyes, to observe, verify, take heed, and respond as he goes. He does not follow set lines, look through a consistent or determining frame, or walk in a fixed protocol; he does not step, snap, and shoot what he

perceives. To the contrary, he operates in diverse modes and uses many forms of engagement. Drawn from a plethora of surfaces, his harvest of faces, covers, shells, wrappings, and laminates includes countless shapes and objects, contexts and compositions, and fine- and coarse-grained substances. He sees singular and multitudinous objects, myriad spaces of diverse contours, permanence and change, and substances of all types—solids, gases, liquids, meshes, and nets, to name only a few.

Gibson identifies three categories in the visual world. First are substances. Next is the sum of objects and diversified mediums, which could be water, soil, or air (or, beyond his elaboration, skin, blood, food, tools, wrappers, and so on). Third, there are surfaces, which, for Gibson, are the most expressive, immediate, and interactive faces of the world beyond ourselves. Additionally, surfaces have distinct shapes; belong to large areas or landscapes; are illuminated or in the shade; and have distinct reflective qualities, which constitute their colors. Thus, for Gibson, a realist, human perceptions and visions do not arise out of—or have their origin in—interpretations, emotions, ideas, memory, or traditions (as much facile modern and contemporary aesthetic and social theory contends), but instead belong to the structure and being of what is seen, and are embedded in our mechanisms and mechanics of seeing it.[2]

Gibson's ecological definition of perception can be augmented. First, in addition to sight, other human senses—hearing, smell, and especially touch—identify, authenticate, and enhance what is perceived, experienced, and taken and named as surfaces. Second, the perception of surfaces (as singular or collective, unified or juxtaposed) is contingent on whether they are being perceived for the first time or in light of previous associations, experiences, and established images and modes of perception. Although I agree with Gibson that memory is not the source of (or even need accompany) perception, surfaces do call forth previous experiences, which implies learning. (As a young physiologist, William James insisted that learning occurs quickly, almost instantaneously, in early encounters.) Learning, or call it instinctual assimilation, derives from the engagement and interaction of body and surfaces.

Third, surfaces are incorporated into experience, learning, and education. Surfaces, which become the object of observation, are taken in by eye, mind, and hand; they are explored and entered into—their inner space, compositions, linings, ligaments, tubes, organs, and so forth. In this way, surfaces are classified as objects and noted as similar or different in

their type, location, use, need, association, and so on. Known visually, tactilely, and with sensual immediacy, surfaces are distinguished and classified. Hence perception, vision, and recognition are compounded with images, names, definitions, and complex experiences. (This opens the door to a paradox frequently debated in aesthetic, religious, and philosophical discourse: people look without seeing. Phrased differently, seeing is not recognizing, and recognizing is not perceiving.) The failure to see the nose on one's face, to cite the vernacular expression for being blind to what one sees, is a problem in perception of all familiar surfaces—the face of common things, objects, persons, and landscapes. It has resonance for members of our advanced, engineered, and organized society, in which all is made to have a smooth, repetitive, dependable, and thus unnoticed place and function.

The increasing and radical dominance of made—that is, engineered, designed, and organized—surfaces establishes the narrative and underpinning chronology of this work. In turn, my preference for narrative removes this book from a static study of philosophy, aesthetics, and psychology and gives it over to history to outline the stunning growth of human knowledge, design, and creation of material, social, and intellectual surfaces. I begin my narrative with the story of man as a set of surfaces living amid a world of surfaces in biological and evolutionary time. After focusing on the profound transformations of mind, action, and society in relation to surfaces in Paleolithic, Neolithic, and Classical times, I focus principally on Europe and western culture, which with the Industrial Revolution became beyond comparison the world's most radical and profound synthesizer and artificer of macro- and microsurfaces and the source of the contemporary world's dramatic, revolutionary fashioning of natural, made, thought, and designed surfaces.

The proof that the contemporary person is a creature largely of human making is found today in almost every surface seen, touched, conceived of, and designed. Made, invented, controlled, and administered surfaces define whole environments and shape lives. They form images and minds, establish symbols and metaphors, and elicit dreams. Unlike his predecessor of a century ago, the inhabitant of a contemporary city lives among macro- and microsurfaces that are systematically built, scientifically and aesthetically designed, industrially manufactured, and commercially distributed across the world. Invented, controlled, and regulated as the cover of objects and the face of structures and environments, surfaces are

at the service of society's pleasure and efficiency. Two-dimensional when serving as inner and outer walls, and three-dimensional when serving as ceilings and floors, surfaces form homes and buildings, towns, cities, and the countryside.[3] Friendly to the needs of the individual body and responsive to group life, modern surfaces are strong, flexible, safe, sanitary, smooth, bright, colorful, and even diaphanous. By contemporary design, they are cheap and efficient to make and either resistant to and conductive of water, oils, and electricity. Made in millions of shapes for endless contexts and functions, surfaces grid, cover, laminate, wrap, and enclose the exterior and interior spaces of manufactured things and legislated and administered lives.

From a historical perspective, the narrative of surfaces involves their propagation in number, use, and economic, synthetic, and specialized forms as covers and linings of the instruments, objects, structures, and landscapes of the world. The rough and broken roadways once traveled by even kings and aristocracy, which sinuously and erratically worked their way across the countryside, now have become the bountiful, flat, even, and paved highways of car-owning nations. The cultivated gardens of the elite few are now echoed in the lawns and public parks of the people. Common building materials now include not just brick, stone, wood, and masonry, but steel, rubber, glass, plastic, and recycled materials, joined and coated by synthetic paints, sealants, caulking, and glues. Tools and machines of advanced and economic design now work, organize, contour, and control the face of made environments. Interior walls, ceilings, floors, and surface tops are well lit and smooth, pleasing the eye and serving the hand. Everywhere and on everything, edges are rounded off and rough surfaces are leveled, smoothed, and polished. Materials don't snap, shatter, splinter, degrade, or rot as predictably as they did in the past. Roads and walkways have been made smooth, wide, and straight for easy and fast travel.

As society shapes the exterior surfaces of the world at large with legions of architects, gardeners, civil engineers, and inspectors, so it treats, cares, beautifies, and covers human bodies. Armies of doctors and exercise instructors take up failing bodies, while plastic surgeons and cosmetologists take up sagging faces and rejuvenate paling, blemished, and wrinkled skin. Clothes, mass produced and composed of an expanding number of synthetic materials, are warm, waterproof, cleanable, and pleasurably colorful and styled. They put a respectful cover on contemporary citizens, who must be dressed and taught manners and comportment for all occasions.

Open offices, with portable or even transparent walls, now have surfaces shaped and colored to confer congeniality, are well lit, and have efficient desks, rolling and, at least ideally, ergonomic chairs, and discrete and task-specific technology. Tools and machines—from glue and scissors to pens and paper to computers and printers—efficiently design, fill, and duplicate words, images, and numbers on lined and gridded sheets and screens. Packaging, ever so streamlined for strength and lightness, further illustrates how the appearance and functionality of surfaces constitute an element of efficient production and commerce.

As evidenced by its open and shining buildings, plazas, and public places, contemporary democratic and industrial society—the subject of chapter 7—is heir to both a revolution in creating fresh surfaces and a profound cleanup.[4] This cleanup, the Herculean task of purging the Augean stables created by the growth and expansion of humanity, was carried out essentially in the past 150 years as science, technology, earth-moving and water-channeling civil engineering, public health agencies, and governments took control of water and land; removed wastes; swept away dust, dirt, and other nuisances; and regulated the movement, behavior, and discharges of human bodies and ever-expanding industries.

With immense supplies of water and innovative machines, modern industrial society created a giant administrative and technological broom. Its purpose was to sweep clean city surfaces of the perennial dirt its enlarging and industrially engaged populations created. Modernity's war for cleanliness, as well as for production and efficiency, was waged in factories, in homes, and on the streets, as well as on the skin, faces, and clothes of a new breed of citizen. Cleanliness promised a bright, safe, healthy, and abundant world. All surfaces would shine as a beacon of this new world.

Cleaning regimes made great advances coincident with the advent of industrialized lighting.[5] Light brought concealed surfaces and figures to the fore. It spotlit hidden enemies in previously dark and indistinguishable places. Night's shadowy underworld was increasingly vanquished and banished to alleys, lanes, and the unlit countryside and farmyard. Meanwhile, the modernizing world caught glimpses of itself and its inhabitants in the multiplying and alluring faces of illuminated glass storefronts. Footlights accented bright wardrobes, while intense electric lights in hospital rooms eliminated the necessity of lugging patients to naturally lit galleries for surgeries, and lightbulbs dangled over the smooth wood floors of dance halls late into the evening. More individuals strode out of the crowded wings of

historical obscurity into the footlights of the contemporary stage. Clean, bright, and colorfully dressed, the democratic many, like new lords and ladies of contemporary times, pressed forward to participate in the drama of their times.

Parading, marching, and above all strolling, national populations put themselves on display. Soldiers paraded in uniform under brilliant banners; cheerful and well-heeled citizens wore colorful clothing. At the beach, women started to show more skin, bobbing along the shores. And if full nudity was still reserved for and relished only in dimly lit bedrooms, on the canvases of bold avant-garde art, idealized nudes cropped up abundantly across the pictorial landscape. In that world, Venus sat incarnate in the white flesh of Manet's nude picnicker or, like Renoir's busty bathing pink lady, waded into fresh waters.

Glass windows and showcases made a lush splash of shine up and down the avenues. Like manifestoes, they declared the availability and selection of goods and products within. Stylish young women twirled umbrellas, and dapper, flirting young men trolled the streets. While nations began to assemble their uniformed and decorated recruits and fill the atmosphere with signs and slogans, a newfound glamour protested its independence in a living display of fashionably decorated surfaces formalized with proper but dashing gestures.

Avenues were straightened and widened for crowd control and traffic flow, and areas were zoned and rezoned, while buildings grew taller and metro and train lines cut multiplying straight lines above, below, and beyond the city. Out of this new grid of space and time, still taller steel, concrete, and glass structures arose. These and other great structures—bridges, canals, tunnels, ports, zoos, and railroad stations—redefined cityscapes, and vertical surfaces intersected with horizontal skylines. The hour's project, which both declared and monumentalized itself—most distinctly through the rich and diverse faces of world fairs and expositions—was the creation of a new body and face for collective mankind.

Light and air broke into dark cellars. At the same time, medicine unblushingly produced new scopes and bent germ-resistant stainless-steel instruments to deeply probe human orifices. Reform and therapy sought to chase away hidden membranes of psychological darkness. Everywhere space and life was slated for transfiguration by the transformation of society's surfaces. Women were brightly wrapped in new fabrics, and objects for sale were neatly and symmetrically displayed in ordered piles, on shelves, and in transparent

cases and cabinets, with owners and workers standing neatly nearby. Steel alloys (fashioned with chromium, manganese, tungsten, and titanium) glistened in fine tooling and ever-finer and turning gears.

The era's surfaces did not form a still life, however. Machines and crowds moved, life in its flashing surfaces. The spins, turns, and falls of the era's amusement parts mimicked a world breaking out of old, slow, and staid ways. Startling new invented, synthetic, mixed, fused, and kaleidoscopic surfaces appeared in shifting combinations and altering patterns, and they frenetically danced the fine line—presented in the clicking rolls of early motion pictures and so meticulously exploited by Charlie Chaplin—between efficient production and chaotic commotion. With newly woven patterns, fresh textures, keen lines, and wild juxtapositions between the old and the new, the small and the big, the slow and the fast—and the horse and the car—modernity insisted on metamorphosis. Natural and traditional surfaces testified to the imminent eclipse of the past. As one set of outer coverings of things (tools, weavings, containers, environments, and landscapes) voiced nostalgia for handicraft, another, and contradicting, set of surfaces declared an ongoing future revision: The surfaces of the city would change in a morphing, rising swell that would quicken and sweep across countryside and nation, transforming and baptizing everything anew.

Movement was experienced everywhere. It was, in itself, the surface of changing times. Revolutionary inventions such as automobiles, bicycles, motorcycles, powerboats, and airplanes propelled life at new paces and rhythms. Elevators and escalators serving high-rise buildings brought vertical motion to horizontally spreading cities. Telegraph, telephone, and power lines transmitted energy and communication invisibly and at previously undreamt-of speeds. Hung from poles, buried in the ground, or strung along the bottom of the sea, these lines—which seemed to be magic conduits—formed grids and networks of transmissions and communications. Meanwhile, like a commanding avatar, clocks were hung in stations, courthouses, factories, and classrooms, dictating the pace of manufacturing, business, education, and public administration. A tick-tock enshrined all objects and compelled confessions of when production kept to a prescribed pace, moved faster, or fell behind. All perceptions were becoming temporal.

Things were zooming out from under eternity's broad and fixed grid. In 1909, Futurist F. T. Marinetti, who glorified engines and especially motorcycles, those wonderful fusions of car and bike, frame and motor, carriage and power, made accelerating speed and aggression his manifesto. Futurism

was grounded in the promotion of a complete renewal of human sensibility brought about by the great discoveries of science in changing times. The telegraph, the telephone, the phonograph, the train, the bicycle, the automobile, the ocean liner, the dirigible, the airplane, the cinema, and the great newspapers (syntheses of the newly kaleidoscopic cosmos)—each had a different and decisive influence on minds.[6]

Just as movie projectors flickered a progression of scenes onto a screen, visual artists sought to transform lines, colors, and images into energy, motion, and ideas. They too conjured invisible dimensions of being. They submerged thing and mind below sight and touch and other bodily sensations. Matter, which to the end of the nineteenth century had held so firm and certain for materialists, was vaporized. Turn-of-the-century entertainment featuring the unseen included demonstrations of electricity, hypnosis, psychoanalysis, and more. Then, too, there was physics. Master mystery maker, it performed the impossible stunt of dividing even the invisible and even etymologically indivisible atom (in Greek, *a tomein,* "that which can't be cut") into tiny parts and set them moving in seas of attractions and repulsions and traveling at hyperspeeds through vast interior spaces as particles and waves of convertible mass, energy, and light.

With new theories and innovative technologies, scientists turned their scrutinizing gazes inward, as we will see in chapter 8. Making surface perceptions seem not just by definition but in truth "superficial perceptions," physicists sought to visualize and envision what could not be directly seen or touched. No mean magicians themselves, chemists, in conjunction with industry, began to describe, manipulate, and even make new materials by understanding and controlling combinations of atoms (molecules) and their reactions, and their work proceeded at accelerating rates throughout the twentieth century.

Physics, chemistry, and their associated sciences and technologies declared the existence of whole defining orders and factories, all below the faculties of human sight and touch, that could be explored and utilized. Pulling rabbit after rabbit out of their hats, the new sciences produced new technologies that enabled industry and medicine to establish beachheads for a full-scale invasion into unexplored lands of body and matter, cell and atom. They would let no surface, no skin, no membrane go unexamined or unpeeled. Seeking what had been invisible and untouchable since the beginning of time, science put the world under the microscope and within the reach of hand, tool, and machine. And if science did not explicitly invalidate immediate

sensory perceptions, and the concepts and understanding derived from them, it did qualify any claim on the foundational truth of what was immediately apparent to eye and hand. Just as religion and philosophy once—and, for that matter, still do—dispute immediate perceptions and the ideas based on them as superficial and false, contemporary science, with all its power to predict and make things, judges surface observations and consequent knowledge as shallow because it lacks contact with the invisible, interior, and efficacious laws of things.

In simpler terms, science and technology brought forth verifiable truths from subsurface theories. Beginning its interior expeditions through the skin into the human body with x-rays, technology ventured on with the penetrating powers of angiograms, magnetic resonance imaging, and CT scans, which now send back images from the deepest spaces of the human body. Exterior surfaces, which once concealed the inner continents of bodies, became transparent doors that swing open to our enhanced peering eyes and probing hands as surgeons inspect and repair the interiors and exteriors of spinal columns, hearts and other organs, tissues, nerves, and cells. Stem cell research now promises that we can someday literally grow replacement parts for skin, organs, and cells of every sort. Genome mapping, gene design, and nanotechnology mount ever more penetrating expeditions into the body's invisible depths. The surface and foundation of the universe have become porous, diaphanous, touchable, and alterable in their depth. And doctors, among the first explorers of the inner depths, have learned to read sheets and screens of invisible organs and processes, deciphering what until recently have been largely unexplored realms.

Yet envisioning inward surfaces still relies upon visualizing exterior surfaces. In reviewing a book on Leonardo, possessor of the greatest natural eye and most adroit hand, Ariane Banke writes of the primacy of visualization, "However sophisticated our techniques for probing the unknown—x-ray, sonar, electron microscopy, ultrasound, computer modeling—we are constrained by our inability to visualize [except] in three dimensions, with light and shade, relief and color. As we attempt to 'see' the unseeable—the arrangement of atoms in space, for instance—we still have to resort to those visual devices that have become integral to our purchase on the world."[7]

Science and technology, however, did more than peer inward and publish its results to enhance the function of earthly eyes and to guide earthly hands. Starting in the 1920s, thanks to synthetic chemistry's creations from coal tar and petrochemicals, a long string of polymers came to compose the surfaces,

walls, and capsules of our lives. Plastics, beginning with Lucite, vinyl, and Bakelite, proved the synthetic powers of chemistry by resurfacing our goods, tools, and even machines, and their invention began what from any historical perspective is seen as a great revolution: the creation of new materials for the sake of surfaces.

With multiple desirable properties, including transparency and pliability, plastics metamorphosed the world of things as they are used, touched, and seen. As the polymer nylon, created in 1938, drew attention to a woman's shapely and clean-shaven legs, so the same material, in the form of parachutes, enabled the descent of airmen and paratroopers back to earth during World War II. In a different form and for a different end, nylon's younger cousin Velcro, patented in 1955, kept people and things under tighter wraps with its fresh array of hooks and loops. Teflon, with an opposite assignment, lined pots and pans so that food didn't stick to them. Polymers, which produced joining superglues and adhesives, made possible many of the substances that compose the light, strong materials that characterize contemporary industries. Current research in biomacromolecules, for example, is looking for a new polymer in spider silk proteins. Herein, it is conjectured, might be found materials for engineering membranes of slow-release medicine capsules, lightweight waterproof fabrics, biologically friendly plastics for surgery, and strong and flexible components for aircraft manufacture and space capsules, all sought by industries producing sturdy, light, malleable, and smooth wrappers for hulls, wings, and other structures.

We find ourselves repeatedly marveling at such ordinary and attractively shaped things. We praise such creations as light and extra-strong snowblowers, paints that don't chip, wood as durable and smooth as stone, and the omnipresent screens filled with images and words that are cropping up across the globe. Before us, instantaneously, is the face of the sun, a suppression of a people, a soothingly voiced president—all to be seen on the universal screen. We find ourselves in a cocoon of made surfaces. The face of nature seems banished from our days—it is an illusion of the present, a hunger for the past, or a set of images serving commerce, tourism, and political parties centered on preserving the environment.

Our world, so to speak, has become superficial. It is composed of made, invented, and artificial surfaces. They form our walls, our house of mirrors—or simply our artificial, fabricated, composite, specialized, integrated, controlled, and manipulated environments. They establish mind and body, home and work, street and landscape; they offer exterior signs and

identities of self and other; they become signs and symbols for what we are and what is around us. They represent, decorate, and advertise who and what we are and what we want and would have ourselves be. We have become, to materialize this idea, our flooring, walls, ceilings, windows—the face of the materials of which they are made—and also the streets and lawns we look out on. And we conform our words and actions to them—to, for example, the Formica and knotty pine, the plastics and aluminum we produce, shape, and live among. We increasingly grow accustomed to living in and thinking of ourselves in environments of our extensive making, constant invention, and profound transformation. We have organized and compartmentalized spaces and surfaces to fit our activities and ideals. And in this way, we weave ourselves, mind and body, into the surfaces with which we surround ourselves. No wonder that our languages conflate the artificial and the superficial. And from the broadest perspective, it can be said that contemporary national, commercial, and industrial society has empowered us as never before to design things and build environments and lives, and thus has entered us, on an unprecedented scale, into self-making and self-defining.

Surfaces—as always, but especially now—enwrap humans. They house us in ongoing systems of constant revision and sought perfection. Surfaces become the object of total art and perpetual design. They reorient being—all of which is perceived, conceived, represented, and selected. Askew from and even in defiance of tradition, synthetic and innovative surfaces offer new symbols and metaphors. To borrow Gibson's division, they put humans before various substances and surfaces; offer fresh and different mediums; and present humans with new points of interaction. This produces altered perceptions, mutates orders and contexts, and transforms senses and meanings. Surfaces place individuals before invented faces, enwrap us in altered grids and contexts, and offer innovative machines, tools, and materials. With perception, conceptions, and learning altered, alternative properties are assigned to being; people swear—on and by the very surfaces of things—our belief that the world is the sum of things made and displayed today.

Surfaces become fresh windows for seeing and unprecedented tools for making want and wish real. In this world, restless and relentlessly agile hands and eyes increasingly are equipped to transform all. Torn from tradition and nature, surfaces become ways to alter human life and mind.

. . .

Of course, this analytic historical approach to surfaces cannot escape a nest of perplexing questions. It cannot finally resolve differences between natural and made surfaces and our perceptions and conceptions of them. Nevertheless, this approach, which joins narration, explanation, and speculation, draws a tight bead on human relations to surfaces—and the dialectics between made surfaces and surfaces that define their makers.

From the longest perspective of deep history, reaching back to human origins, I offer a dramatic narrative of humans as self-defining and self-making creatures. In chapter 1, I start with humans as a unity of diverse and heterogeneous surfaces (skin, eyes, ears, noses, hair, hands, and so on) evolving amid myriad natural surfaces. The second chapter initiates a historical treatment of the interplay of body, mind, and world. With no intention to imply either a deterministic and materialistic causality or a unidirectional and inevitable progression, it conceives of the development of hands and tools as means to not only explore and manipulate the world, but also to form and unleash the extraordinary human brain, which integrates, directs, and organizes actions; transmits skills and knowledge; utilizes symbols; and envisions alternative worlds. This development proceeded dialectically with the formation of social groups, the emergence of communal representations of meaning, and the creation of language. All of these developments both resulted from and caused greater use, control, and symbolization of macro- and microsurfaces.

In chapter 3, I show how, starting with the Neolithic Age (twelve thousand to ten thousand years ago), advanced crafts and skills, which supplied knowledge of and allowed for the creation of surfaces, transformed humans into makers of their environments and definers of their societies and themselves. Early civilizations, beginning approximately fifty-five hundred years ago, multiplied and concentrated human societies, radically magnifying their ability to shape the landscape, build its structures, make objects, and create tools and containers. Through pottery, metallurgy, weaving, and other crafts, civilizations fashioned, with remarkable precision and aesthetics, the substance and surfaces of made objects and goods. At the same time, administrative and royal cities transformed the landscape with megaliths (such as monumental temples, pyramids, and mortuary structures) and such massive undertakings as roads, canals, ports, and walls, which, like skin itself, wall us off and contain us and yet also open us to take in the surrounding world. This radically expanded dominance revealed humanity as not only a major geographic and ecological agent, but also a willful and self-defining being.

In chapter 4, I begin with analytical reflections on the human urge to represent and decorate surfaces. I examine human expression across ten thousand years, dwelling particularly on how humans enwrap themselves in meaning through and with things. Across a deep and long history, humans have conflated their lives and meanings with vessels, homes, and cities. They decorate and beautify surfaces to express their place in community and society and define their lives. In the concluding sections of the chapter, I examine measurement and writing, which, as seen in the early civilizations of the Near and Far East and China, reveal how surfaces are a primary way to know and represent the world. Stylus and stone, and later pen and paper, furnished humans with a means to identify, establish, record, and retain what concretely—in number, size, distinct properties, and characteristics—is in and collected from the world. Writing provides symbolic, analogical, and metaphoric ways to represent, enumerate, and even beautify invisible orders, hidden elements, and transcendent powers and realms.

In my exploration of medieval technology, I reflect on the informing spirit of representation and decorations as concentrated in and on the façades of medieval cathedrals. These cathedrals displayed the whole spectrum of a civilization's skill in working with wood, stone, metal, ceramics, glass, and fabric. Using symmetry, proportionality, design, and symbol, their builders shaped structures to provide an accounting of creation, sacred history, and New Testament hope. In some fourteenth- and fifteenth-century churches, clocks, driven by gears whose principles also drove watermills and windmills, illustrated the movement of hours, days, months, and years.

In chapter 5, I begin exclusively to follow western civilization. A partial justification for this focus is the fact that by the eighteenth century, Europe had become the paramount, though not the first or sole, explorer of the world and the creator of diverse surfaces. Juxtaposing art and science, as embodied in the craft of Leonardo and the thought of Descartes, I continue a discussion of surfaces in terms of measurement, art, and geometric and symbolic expression. Medieval architects, who had built their cathedrals with advancing craft techniques, rudimentary geometry, and a tacit belief in the correspondence of form, perfection, and creation, turned stone, wood, and glass into monumental, symbolic, and light-filled structures. Yet Italian Renaissance builders and artists, who continued to craft similar surfaces with the skills and tools inherited from their medieval predecessors, rendered the world anew. Using light, shading, and perspective, they produced naturalistic representations of skin and cloth, erected buildings, and organized landscapes to classical

and human measure. In the case of drawing and painting, they utilized grids of proportionality, and shaped objects out of corresponding and alternate, congruous and incongruous, compatible and incompatible, parallel and oblique, symmetric and asymmetric, and highlighted and flattened polarities. Siding with the truth of the eye and hand and the mechanics of optics and perspectives over and against radiating presence, symbolics of color and form, and dialectics of ideas and theologies, Renaissance and early modern artists, quintessentially Leonardo, anticipated the observational, empirical, and experimental qualities later proposed by natural scientists, geologists, botanists, anatomists, and inventors.

At the same time, one major wing of modern science, as represented and furthered by the seventeenth-century mathematician and philosopher Descartes, flew away from the sensuous and tactile surfaces of world, things, and society. It made its truth the abstract and rational graph and formula. It charted space, as well as forces, energies, and time, with the geometric rubric of abstract points, lines, shapes, and single frames of perception. Contradicting a concept of truth derived from ambulant and ambient humans, this "new" truth rested on calculable numbers and verifiable mathematical formulas. Another wing of modern science peered outward and upward to the heavens to observe and calculate their movement. These scientists began to calculate the laws of such elusive and ethereal realities as gravity, light, and perception itself. And a smaller band of scientists, starting with Galileo, turned the reflective faces of their telescopes downward and inward. Piercing porous epidermises and the shells of things, they looked at smaller unseen things and the swarm of hidden life. Through the lens of the first microscope, Robert Hooke (1635–1703) peered with awe at sheets of cells of cork, the stinging apparatus of nettles, and the compound eye of a fly.[8] Indeed, there were all sorts of things *within* things—and being itself was surfaces on surfaces, layers upon layers, up and down the line.

As much as mathematicians and scientists sought to view and know the inner and outer faces and workings of nature, so sixteenth-, seventeenth-, and eighteenth-century artists, the subject of chapter 6, indulged the eyes' and hands' organization, making, and beautifying of the world and celebrated wealth and means. In the Golden Baroque era, humans erected palaces, ordered gardens, dug reflecting ponds, established carriageways, and constructed urban avenues, and they built exquisite stairways in the golden interiors of their churches, palaces, and residences. Mirrors, clothes, and etiquette all reflected this newly ornate world, in which decorated surfaces

paid homage to royal and aristocratic orders and ideologies. Amid organized spaces, the courtly person was in gestation the public person who lived by the exterior gaze and the glamour of styles.

As we have already detailed, middle-class urban society then took its bow. As we will see in chapters 7 and 8, it wore the face of spreading prosperity. With industry and commerce creating dust and din and a new order of things and peoples, fresh constellations of social and material surfaces shone forth on city streets, where water washed and cleaned, streetlights glowed, store windows beamed, and the public, increasingly cleaned up and made orderly, if not royal and princely, paraded in colorful mass-made clothing, almost all wearing shoes. The nineteenth century undertook, out of necessity and through planning, a profound remaking of urban environment. Iron, steel, reinforced concrete, and glass pushed buildings upward in the cities. Multiplying mines, expanding agriculture, and spreading transportation and communication technologies made the West, and humanity at large, a new geologic agent and an artificer of the earth.

The twentieth-century western world, the focus of chapter 8, carried out the mandate to remake society and the face of the earth. Technology, industry, and design took up the command to make the world as smooth, flat, light, and translucent as possible. Science and technology transformed the goal to tailor nature and create new surfaces for maximum efficiency and comfort. With bold leaps into the atom and cell, physics, chemistry, and medicine sought to make the small, invisible, and elemental malleable, manipulable, and even mechanically visible.

In the conclusion, I consider the dimensions and implications of encapsulated contemporary life. I ask about the consequences of humans having turned themselves into the surfaces they make and design. I reflect on humanity as a consequence of its own achievement, and on the prospects for a being who is now detached from nature in body, thought, and imagination; and who, by habit, intellect, and presumption, lives and thinks by made surfaces and invented symbols. I affirm that contemporary humanity threatens to finally sever its ties to nature, tradition, and transcendence, and I ask whether humanity can fly free of the labyrinths of its own making.

We Are Surfaces and Surfaces Are Us

The body is our general medium for having a world.

MAURICE MERLEAU-PONTY, *Phenomenology of Perception*

So boundaries—so the physical structures that constituted them, membranes, skins—were crucial. First, they held the animal's substance in, and the rest of the world out. Second, by virtue of being located at the animal's surface, they formed a frontier: the frontier at which the outside world impacted the animal, and across which exchanges of matter and energy and information could take place.

NICHOLAS HUMPHREY, *The History of the Mind*

SURFACES ARE NATURE'S INSTRUCTORS. Circles, arcs, and angles, lines and grids, crystals and jumbles, they reflect light and cast shadows; reveal movement and aging; indicate size, shape, form, slope, and color; and create texture. They bloom afresh, age continually, and die. They fly up and dive in, breaking the surfaces of water, land, and sky. They signal edibility, danger, and chances for reproduction. They indicate pain and pleasure, friend and foe, dead and alive, and whole ranges of similarities, contrasts, and polarities. The face of things individual and collective, they reach deep into our brains. They prompt reactions, spawn images, and evoke emotions and moods. Although, in dark and wintry Minnesota, I commonly hear about depression caused by the absence of sunlight, one local doctor speculates that a winter without a solid coat of snow exposes people to a blandly colored landscape of yellows, browns, and grays, causing cases of depression.

Surfaces, as we will see in the next two chapters and across this book, do still more. They declare what is light and shadowy, near and far, what is at hand and imminent and what is remote in space and time. Beyond the forms and patterns they present, they offer the most immediate classifications and also the first clues to what is within things. To early, traditional, and even modern humanity, they testify to the whole and the greatness of creation

and creator. To most secular contemporary people, the face of things testifies to the bountiful work of the human mind and invention. In nature, we all perceive the line, the grid, the curve, the spiral, the pattern, the texture, the gloss, and the importance of the color of things—and most of us, like a gullible Polonius, can be tempted to espy in passing clouds whatever Hamlet alternately and mockingly proposes we see.

Rocks and minerals testify to the presence of crusts and layers, basalts and granites. Collections of shells and crystals (such as the George III collections in the British Museum) evince a nature responsive to light and rich in sizes, shapes, curves, whorls, colors, and patterns. Fossils, which speak of life past, represent a range of creatures, from those with small exoskeletons (insects, turtles, and mollusks) to those with large endoskeletons (mammals). They are rich in meaning for paleontologists and archaeologists, who read them as chapters and turning points in life's oldest book.[1]

Seeds, too, whose mysteries lie wrapped within, sprout as testimonies to fertile soil and nature's elaborate forms and generous, even joyous, flowering varieties. The small carob seed, once mistakenly thought to be consistent in weight, was once used to measure gold (thus the word *karat*). Hitchhiking burrs still catch rides as best they can on the passing fabric of clothing and animal hides. Twirling maple-seed propellers, ever the delight of children, ride gentle winds. Coconuts cross thousands of miles of ocean to land on new shores. Feathers, leaves, flowers, and hides of all sizes, shapes, colors, and textures are like tongues speaking many revelations, a Pentecost for human beings' perceptions and conceptions. Like sapient bees, humans build the honeycomb of learning from what they gather, accumulate, and store.

Surfaces present us with and come as part of wholes, configurations, and contexts. They form and belong to the composition, the borders, and the tightness, knit, and bind of things and objects. They blurt out and craftily conceal similarities and differences. Surfaces make contrasts, juxtapositions, and dualities. They establish dimensions, lend spatial and linear form, and have tops and bottoms and ends and edges. They move, change, and progress through states of development. By the lights of my handmade phenomenological approach, surfaces define our location, condition, situation, and position, among other things.[2] Surfaces—in the form of tops, covers, shells, sheaths, barks, rinds, and other coverings and exteriors—delineate individual objects and represent whole environments, horizons, and seasons. As coverings and epidermises—homogeneous and heterogeneous, permeable and impermeable, permanent and transient—surfaces constitute an

immediate and tangible geography of the world and a prima facie index of all its different things.

Surfaces are the boundaries of both natural and human environments. They are both the great fact and the mirror of nature, being, and what we humans make and who we are. Surfaces provoke our first sensations, evoke our initial reactions, and become the stuff of our comparisons, analogies, images, and representations. Surfaces permit instantaneous, if sometimes only rough and provisional, classifications. They allow us to identify, to name, and, from a very early age, to associate actions with actors, and movements with sources and consequences. All this, learned from surfaces, has no end of importance for memory, judgment, and will.

Surfaces are the points of connection and interactions among body, things, and world. Surfaces, as I quoted Gibson saying in the introduction, are where the action is. They send us sounds and smells; offer touch and feel; direct and shape perceptions; elicit attention; excite expectations; and stimulate urges. Arousing our curiosity and even our concentrated stare, they lure our probing hands. At the same time, surfaces both reveal and veil things. They make the obvious, prima facie present impeachable, and make a judgment evident. At the same time, surfaces declare what is within: its accessibility, its taboos and prohibitions. Surfaces can be rife with multiple signals to our attention and conflicting messages about their purpose. Things and people with differing faces both express ambiguity and dangerously entice us.

Humans, with varying skills and widely varying success, spend a lifetime reading surfaces. First are the sucking lips of the infant and the nipple of the breastfeeding mother. Later infants progress to faces: the lips, eyes, complexion, smell, and voices of those who feed and cuddle them. The human face, followed by human gestures, composes a rudimentary text, and lessons learned from it provide people with a vital social compass for a lifetime. Individuals read the world and their place in it in the faces of others, which can display threat, friendliness, anger, uncertainty, weariness, misery, and so much more. Long before humans had language, they made sounds and showed faces that communicated shared circumstances, situations, plans, and dependence. The eyes, when not made opaque by disability, read with incalculable velocity the slope of a nose, the set of another's eyes, the point of toes, or the flow of an opulent dress down and along the turn of a staircase. The most gracious members of royal courts were often the most superficial of creatures; they could read status, but not the heart, and thus made vanity the antithetical surface of wise, true, and sincere inner depths.

Surely, humans conduct lives in and by surfaces. They encounter them bodily—with the step and shuffle of their feet, the extension of arms, grasp of hands, the grip and rub of fingers, the scratch of nails, and, to supplement a long list, the purse and lick of lips, the flick of a tasting tongue, and the cutting and grinding of teeth. Individuals perceive, conceive, create, imagine, and act through the medium of surfaces.[3] Surfaces continually deliver materials to the mind. Transmitted as images along the way—via the nerve corridors and stations of the body—surfaces come into intelligence, imagination, and judgment, and memory for identification, enhancement, refinement, and synthesis into thought. And insofar as they are transformed by the craft of thinking, things recognized, identified, named, represented, and made into symbols become units of reflection and memory. Facts, hypotheses, conjectures, wishes, dreams, and hopes further interpret the surfaces of the world.

It would be a profound error to believe that appearances always deceive—*fronti nulla fides!*—or that every window is a trompe l'oeil. Perhaps the contrary is closer to the truth, for by survival, reflex, learning, habit, craft, and skill, people trust, if not universally, the information given to them by the single and multiple faces and bodies of others and the myriad facades and outer covers of the natural world. If these sources do not reveal the full truth or complexity of things, in all likelihood they still offer valuables clues and leads. Eye and hand first encounter and finally represent and design their findings. So much human experience, learning, and art begins and ends on the surface. The hunter reads tracks and broken brush; the farmer picks up, rubs, strains, and drains his soil; and cooks and craftsmen begin and complete their tasks by appraising, measuring, and touching the surfaces they work. The sailor observes the waves and wind, just as the doctor examines the patient's posture and complexion, and the counselor watches the movement of eyes and hands to diagnose the workings of a mind. A geologist is trained to read contours, beds of rock, types of erosion, and individual rocks to discern the internal conditions, forces, and processes that define topographies and reveal deep inner histories. Indeed, surfaces are the chalkboard of first learning, the mind's developing sketch of the covers of objects. They teach with the speed of light, the glance of an eye, and the thrust of a hand. They instructed organisms billions of years before the recent appearance of humans, two or so million years ago, and before anything resembling the one-hundred-thousand-year-old *Homo sapiens* brain—with its capacity for symbolization and metaphorization and its ability to analogize, connect, imagine, suppose, conjecture, and even

believe in what can't be seen or touched in present time and location—had developed.

Humans' first knowledge of things, objects, contexts, and conditions can emerge as singular points of light, color, and motion, or can be cast up (as in the work of wind and water and time itself) as mixed jumbles and juxtapositions suggesting no immediate forms or orders of perception. Surfaces, whether they provide garbled or clear epiphanies, evoke, to use Aristotle's phrase, *koine aesthesis* (common sensation) "as the awareness of external objects through the coming of together of special sensations (sight, hearing, touch, taste and smell), that is perception of *'things'* and their varying states and modes. This common sensation is what enables humans to perceive 'movement, rest, number, shape and size, such being not special to any one sense but common to all.'"[4] Additional philosophical enhancement suggests that surfaces render both concrete images and abstract symbols. They provide sources for concepts, metaphors, and predictions of what lies before, within, and in the past and times to come. Needless to say, surfaces trigger past associations of multiple types and learning. They also call up stereotypes and occasion instant parody, coarse satire, and even subtle irony by the contrast of big and little, strong and weak, cause and effect, and all that the keen eye deciphers that is asymmetrical, disproportionate, or incommensurate. Humans take delight in finding complex shells on a beach and, in their advance stages of sorting things out, puzzling over optical illusions, as Wittgenstein did, deciding how a single now-famous sketch could be seen as a duck or as a rabbit.[5]

The human mind finds no analogue to itself in other animals. The mind is stunning not only because of the amount of world it brings into itself, but also because of the diverse and complex processes it integrates into its thought, knowledge, judgment, and vision.[6] The mind is amazing in its capacity to turn things into speculative coinage and leap with metaphor and analogy between realms of the real and the imagined. It turns surfaces themselves into images of and thoughts about its transactions with the world, and its wishes beyond the world.

SENSATIONS AND SENSES

The outer world comes to us through sensations and senses. And—admittedly simplifying immensely complex orders and interrelations of

perception and conception—sensations are joined and fused to past experience and present intentions. Surfaces and the things they stand for are, by comparison of like and unlike, fashioned into images and ideas. Sensations have and are given the dress of things, objects, and landscapes. Often embedded in pleasures and pains, they are conducted through the gates of expectation, caution, fear, wish, despair, and hope. Once formed into images and representations, surfaces become keys and corridors of perception, signaling immediate reactions, eliciting habitual responses, exciting associations, and awakening and establishing memory. All this explains, so to speak, why in *these* clothes in *that* room I become *that* person.

Sensations come through our skin, eyes, nose, mouth, and ears. With millions of sensory receptors dedicated to registering what's happening on the body's surface, skin signals information from and reaction to both our interior and exterior worlds.[7] The vast majority of skin receptors are devoted to recording pain from the surface of the skin, as well as from the respiratory, circulatory, and nervous systems.[8] The scraping of an arm, the itch of a hand, the prick of finger, or a sudden gasp for air alerts an individual to imminent danger. The stomp of a foot tells the walker about the solidity of a surface, just as a jostle from a familiar hip reminds one of a lifetime of walking together.

So sensations, which accompany the presentations of surfaces, things, and means, vitalize attention and establish perception. In turn, instantly transformed or developed into images, surfaces awake and engage minds, making experiences. The *fakir* makes an audience cringe by putting pins through himself at will. He may have retrained his mind so that he does not associate memories of pain with piercing the skin, but the more common lot of humanity are not so trained—we cannot launder a certain shirt or see a color without memory. One need not be an aesthete, learned in the arts of Proust's *In Search of Lost Time,* to know that a set of surfaces can form doorways into youthful days or make us nervous about tomorrow's events.

The body anchors us in being. We superficially identify ourselves by the face we see in our mirror. Thinning hair and a bristly beard turning whiter with the years signal mortality. Far more disconcerting are bouts of dizziness that rob surfaces around us of their solidity. The self-monitoring vestibular system orients us to our position and movement in space, and disruption of its function causes such dizziness.[9] Composed of two distinct organs—the semicircular ear canal and the otolith in the inner ear—the vestibular system enables the subtle balance of a skater on ice and a gymnast on a beam, as well

as the more modest but necessary acts of standing and going up and down stairs.[10]

Our ability to move nearly instantaneously, in any given context, depends on an ability to navigate among surfaces, to assign them dimensions, direction, and movement, and to attribute real and possible causes and effects.

HANDS AND EYES

The eye and the hand best allow us to explore, know, and make the world. The full formation of both depended on bipedalism.[11] Freeing hands for use and development and lifting eyes and face from the ground, bipedalism put humans in fuller micro- and macrocosmic contact with the faces of the world. Working in tandem, eye and hand created a different creature who forever toggles between the tactile and immediate surfaces of touch and the vision of distant and abstract landscapes.

Hands, to consider these instruments of touch, grip, and grasp first, are the body's inspectors and verifiers of surfaces. They confirm that the world is real. They conduct private talks within self and body with the scratch of a scalp, a pick at the ears or nose, a pull on an arthritic finger joint, or a rubbing of the feet. With gestures, hands express things, conditions, and situations. Fingers and nails assess temperature, hardness, dimensions, and texture. They also register vibration, pressure, and granularity. Gripping with their opposable thumb and fingers, hands take hold of things, determine their size, shape, and weight, and find their point of balance. Hands match, test, break apart, and join surfaces to surfaces, things to things. In simple terms, hands make humans *dexterous*—which in Latin and Old French meant "right-handed" and "skillful." In a larger sense, such terms deem us handy users of tools and ultimately members of the crafty and inventive race of Daedalus, whom we will meet in chapter 3.

As will be elaborated on in chapter 2, evolution provided a rotating arm, bendable elbow, fully flexing fingers, and opposable thumbs, which gives humans both power and a precision grip.[12] Hands, profoundly supplemented by tools, whose use enhanced our brains, led humans—though not mechanically or predictably—in increments and leaps to enter into and think their way through the world. Surfaces were the stones and rocks by which they crossed the intertwining rivers of being and meaning. They were also our

hands' primary laboratories and the elemental workshops of our analytic, synthetic, aesthetic, and fashioning minds.

The touch of the hand shapes human culture. Diane Ackerman suggests in her *Natural History of the Senses* that touch picks out, makes special, and even heals.[13] And touch, which we designate as the essence of a reaching being, can also soil, violate, and profane. The command *Noli me tangere* is richly translated into the vernacular as "Don't touch!" "Hands off!" or "Keep your slimy paws to yourself, buddy!" Touch also encompasses the grace of the dancer's extending hand, and we speak of a fact as being true enough to touch.

Yet the world belongs to the eye as much as it does to the hand. The eye connects us to the world that we first encounter and represent as surfaces. We follow the flight of a dragonfly, pick up the path of a hockey puck flying at speeds reaching a hundred miles an hour, and distinguish the brushstroke of a Manet from that of a Monet. Visual function occupies a large part of our cerebral cortex, with millions of nerve cells dedicated to vision—which generates a constantly rotating, richly detailed kaleidoscope of patterns, shapes, colors, brightness, and movement.[14]

Vision thrives on surfaces. They are light's nectar. Like flies buzzing toward flowers, eyes need—and drink in—surfaces. Surfaces fill eyes, permitting them to distinguish foreground from background, to recognize objects in contexts and in movement, and to detect changes in light. Responding to light, the eye—prehistorically older than the brain itself[15]—continually scans, creating images at the rate of thirty per minute and stitching them together as if they were one.[16]

In *Man and the Landscape*, Paul Shephard takes us a step further into the composite world of perceptions, which scramble surfaces and sensations and images of them.[17] He argues that, in fact, many perceptions are based on incompatible and opposing images. Contending that animal binocularity arose from the needs of predation and jumping, he extrapolates that the human eye (significantly similar to a monkey's) resulted from our primate ancestors' early life in the crowns of trees in tropical forests, where they jumped and grasped as they went from limb to limb. Shephard argues (not in opposition to Gibson's position, as delineated in the introduction) that observing and predatory eyes, when awake, are never at rest. They constantly focus and refocus on various images as the head changes position and the eyes redirect their glance. This river of different and juxtaposed subliminal double images may account for, Shepherd provocatively suggests, "our

FIGURE 1. Ants, worms, and here a common housefly, which walks with sticky feet on screens, walls, and ceilings and has only two wings that beat extraordinarily rapidly—each animal, like every member of the animal kingdom, has evolved and integrated to master a disparate set of surfaces of earth, water, and air. Drawing, Abigail Rorer, 1990.

widespread philosophical tendency to see the world dichotomously as infinite antinomies."[18]

Insofar as a dog joins us in a hunt—he "points" to a bird, flushes it from cover, and retrieves it as taught—we can surmise that man and animal are joined across the same bands of sensations and recognizable surfaces. Only perceivable planes and axes spare the ambient animal, with its roving eyes, confusions and chaos. The human eye in particular, Shephard suggests, tends to follow flat lines and vertical lines, and this tendency contributes to our rectilinear sense of the world: "We experience," Shephard writes, "a kinesthetic relation between the sense of motion and the visual field, oblique lines giving a sense of motion as the eye moves swiftly along them in search for symmetry of verticals or horizontals on which to rest."[19]

TELLING POINTS

Sight delivers sensations to us from perceived surfaces. Moving from thing to context and back, I toggle from surface to surface, from objects to horizons. Moving from near to far, vertical to horizontal, light to dark and back, my mind perceives and conceives. I recognize and make the connection among what my eyes see, what my brain thinks, and what my hands touch, and back

and forth all three perceptions go. Yet perceptions, recognitions, and representations are often independent and lost to one another, as is evidenced by the difference between perception and art, images, and words.

Images gather attention, awake memory, become symbols, initiate thought, and join systems of symbols and meaning disconnected from their origin, context, and juxtaposition in sensual surfaces. I cannot look out a back window without seeing, observing, and thinking. Out there exists a plurality of things. I make and classify them as individuals, wholes, even Gestalts and ideational units, and of course they awaken memories. So many surfaces come as images that expand with the moods they feed. A northbound trip out of Rome through a cypress-filled landscape reminds me of our family cemetery in Sicily. We embroider new surfaces with the means, ways, and conventions of perception; we shape, color, fuse, and layer it with our images, connections, associations, and representations.

When miniaturized—in the form of images, symbols, and ideas— surfaces become the currency of the conscious mind, especially when they are minted into words and icons, and when they become part of our discussion of aesthetics and what we define as the beautiful.[20] We arrange, mix, cut, pattern, and order them. Surfaces multiply when we divide, congregate, and substitute them for what was freshly perceived and seen, as when a society shapes a countryside to its use and taste. Long before a select few surfaces are converted to theory, they serve bodily interaction and understanding. If every surface is, at least hypothetically, composed of infinite microsurfaces, how does one calculate their sum? They are all the faces of nature, with grains of sand composing a whole beach of differences. Also, in addition to appearances, there are constructed concepts and the phantasmagorias of imagination—and on this basis, cannot we speak of infinities of surfaces? Among worlds of surfaces and things beyond enumeration, our thirsty telescopes and lapping microscopes image what our eyes cannot directly see or our hands ever touch.

Because time, I suggest, multiplies the faces of all material being, surfaces—to cite a point central to Aristotle's reflections—exist in states of change. The inanimate and the soulless are changed by external forces and accidents; inanimate things such as a tree, though without locomotion, are always growing and maturing, while the animate, with diverse systems of locomotion, move at will. No landscape goes unruffled by the seasons.

As the face and composite of things, surfaces such as crumbling rock, shedding skin, or rising seas register change. A single seacoast forces us to speak of fractals to measure its mutant line. Each grain of sand reveals with

its microcosmic faces a long migration from eroded inland mountains and veins of quartz (and other polymorphs of silicon dioxide) down to eroding rivers to the beach and a descent towards the floor of the continental shelf.[21]

Minute and majestic, great and small, organic and inorganic, crystalline and amorphous, metamorphic, sedimentary, and conglomerate, natural and synthetic are among the elemental classifications of surfaces and things. The pattern on the underside of the eastern painted turtle's shell, the colors of a totem pole, and the lines on an aging face suggest that there is a wealth of form and meaning in both nature's works and human design. Of his walks in the country, G.K. Chesterton writes in his 1903 biography of Robert Browning: "To the man who sees the marvelousness of all things, the surface of life is fully as strange and magical as its interior."

SIMILAR BUT NOT THE SAME

Humans, like other animals, survive by immediately perceiving difference. Speed is efficient and necessary—even for us, who reflect, built, refine, and organize societies. To ignore, overlook, reject, select, and concentrate on certain things are requisites of successful projects. Nevertheless, beyond the immediate, automatic signals and learned reactions negotiated by our interaction with surfaces, we must also consider surfaces as representation. Before we assemble evidence or engage in logic, we must distinguish between likeness and difference, between this and that, these and those, then, now, and next, and ultimately the possible and the impossible.

Like a blink, glance, or glimpse, our wit (a mixture of learning and intuition) moves with speed as it recognizes singularity and likeness. Deliberate judgments must accomplish this recognition, as they classify and categorize situations past, present, and future. Involved initially in all judgments are determinations of similarities and differences. We must first distinguish among individuals and sets. Also, differentiation between like and unlike rests on such surface qualities as homogeneity, equality, proportionality, and commensurability, as well as on our first impressions of symmetry, harmony, and complementariness. Prima facie characteristics such as line, size, weight, shape, and color, among other factors, accompany our ongoing assessment of things and lead us from image to icon.[22]

By focusing on a characteristic or two, such as quantity and ratio, we can produce distinct perspectives on things, and when we formulate these

perspectives into consistent judgments, we can in turn make our assessments and judgments a matter of will and project. By measuring, matching materials, and consistent technique, we erect a home in which we dwell and where we make metaphors to explain our place in being. More abstractly, we imagine structures in terms of intersecting planes ordered by numbers, proportions, and ratios. In this way, we realize scale models—and, at some point, measures, shapes, and proportions themselves became the sciences of mathematics, especially geometry and algebra, which are so efficacious for abstract understanding, engineering, and design.

Analogies and metaphors, which, like numbers and calculations, are drawn and abstracted from surfaces, belong to the tool chest of poets and religious thinkers. They allow the mind to move from thing to thing, order to order, realm to realm. The boldest creators leap, though not always flawlessly, from the world of surfaces to metaphysical intuitions—from prima facie things to *universal* truths—and even with the Psalms carry on a prayerful conversation with God.[23]

Philosophers of the Platonic and Aristotelian persuasions ultimately turned thoughts drawn from the shapes and forms of surfaces into the two founding assumptions of their thought. First, the symmetry and pattern bountifully displayed in nature—especially in the case of shells, scales, minerals, leaves, pine cones, and parts of the animal and the bilateral human body—suggest that form accounts for the structure of being. Second, the human mind, or more precisely the intellect, is a form that mutates itself to participate in and know all the other material forms in existence. These two assumptions, in combination with the Old and New Testaments' assumption that Creation mirrors its Creator, allowed medieval thinkers of this philosophical bent to analogize their way across the depths and heights of being. They followed first appearances (as if they were sparks of the divine) upward from names, forms, and ideas to their author, the former of form and the Creator of the Great Hierarchy of Being, which caused and encompassed all being and radiated from its sublime and everlasting self downward to the transitory, the dissipating, the formlessly inchoate.[24]

On whatever basis we classify being, we cannot dispense with elemental distinctions. On the contrary, classification stimulates recognition of difference. Indeed, scientific taxonomies, which seek to catalogue parts and wholes, thrive on difference, oddity, exception, divergence, mutation, peculiarity, and singularity. If we are to identify and order the natural and human worlds, things must be differentiated into classes and sets—and these classifications

merit at least a prima facie validity. We cannot say that only select differences truly matter. As the neo-Kantian Ernst Cassirer points out, we cannot declare numbers to be more real than colors.[25] From grain of sand to leaf to human face, the phenomenal world is shot through with plurality, heterogeneity, variety, and singularity. Thoughts of the world, as I argue elsewhere, are perceived and understood across a band of contrasts, polarities, differences, oppositions, dualities, antinomies, and contradictions, whether the particular subject is nature, society, or even thought itself.[26]

Phenomenal and conceptual worlds mirror the tension between similarity and difference. On this basis, architectural theorist Christopher Alexander criticizes schools of contemporary architecture that state the art of building must include the integration of identical and thus modular units. In his *Timeless Way of Building,* he writes, "Nature is full of almost similar units (waves, raindrops, blades of grass)—but though the units of one kind are all alike in their broad structure, no two are ever alike."[27] "At each scale," from wave to drop of water, "there are global invariants and detailed variations. In such a system there is endless variety; and yet at the same time there is endless sameness."[28]

JUXTAPOSITIONS

We encounter the world as a matter of juxtapositions. They are found in a landscape, a rock, a weave, and even a carefully examined pebble. Looming and receding, big and small, near and far, curved and straight, protruding and recessive, plain and intricate, smooth and rough, light and dark, moving and still, growing and dying, surfaces—the face of the world we know first and best—all contain juxtapositions. We (like a snake's flickering tongue as it gathers and analyzes scents) divide our accumulating data about the world along such axes as order and chaos, or single and complex objects. At the same time, cultures have their own ways of recognizing and dividing objects—and even classifying those that do not fit into their rubrics as taboos.[29]

We cannot conceive of things without reference to juxtaposition. Surfaces are still or in movement. They reflect the patterned and odd fall of things. Accidents, collisions, and collapses conform to or dispute our theories of cause and effect. Changing surfaces keep us standing alert, attentive to the world. They present us with incongruities. They bring forth fresh juxtapositions. They provoke our curiosity, observation, and deliberation.

The face and events of nature make us, despite ourselves, detectives who forever watch, suspect, surmise, and conjecture. A day that begins with ordinary and predictable successions of surfaces (to offer the common form of a mystery) resolves itself by nightfall into a labyrinth of false clues, wrong turns, continuing ambiguities, and misunderstood things.

Surfaces net the mind in juxtapositions. They arrive as sensations, take form in images, and call for action. Their arrival is greeted by emotion and can feed and ignite passions and memories, mixing our present sensations and reflections with those of earlier places and times and desired things. They are announced in both the joyous and the solemn halls of the mind. As I suggest in chapter 2, in a discussion of the hand and tools, we place things next to each other, we locate them in a context, and we classify them by likeness and difference. Positions declare relations. The Latin root of *pose* (derived from Latin *ponere,* meaning "to put, place, set forth") implies that we measure, grasp, and judge things by their *position,* dis*position,* and juxta*position.* Related words, such as *depose, compose, decompose, repose, impose, oppose, transpose, juxtapose, suppose, propose, postulate,* and *posit* suggest that we describe and know the world in terms of things' positions.

Likewise, we define the condition and value of a thing, person, or occasion in terms of its *state, stature, standing,* and other words derived from the Greek and Latin root *sta.* Similarly, the Greek word *thema,* rooted in the literal sense of what has been laid or placed down, planted, buried, deposited, or made a prize, came to carry with it the sense of "assumed," "contended," "proposed," or made into the theme of a conversation, text, politics, or life. *Thema,* so material and concrete in its origins, speaks for the abstract process, the making, ordering, and organization of ideas. Rhetorical language likewise turns on joining, conflating, separating, and above all juxtaposing one thing to another, such as the irony of a man who began working in surgery but ended in taxidermy, or the sublimity of Shakespeare's vacillating Hamlet speaking of the time being out of joint.[30]

THE INS AND OUTS OF THINGS

Surfaces, in all their variety, define margins, set down borders, establish grids, and form interfaces. But surfaces also have openings and entrances, cracks, caves, and crevices. They abound with holes, doors, portals, entries, and windows, forming two or more realms of being. They materialize the

great juxtaposition between inside and outside. They also symbolize a passage in being and meaning. Medea, Greece's great female antagonist, "comes out of the house, to which her female role confined her, [and] delivers the most assertive feminist manifesto in ancient literature." Transgressing the bounds of household *(oikos)* and public *(polis)*, she kills her children; her husband, Jason's, lover, Glauce; and Glauce's father, King Creon of Corinth.[31]

The juxtaposition between inside and out—interior and exterior, within and without—is inexhaustible. The inside is all that is out of reach, veiled from view, hidden up an opponent's sleeve, or beyond the grasp of our mind. Even though we acknowledge the fact that insides can be empty and vacant of meaning, that there are Potemkin villages, that pretty faces can be a fool's mirror, nevertheless, in the words of Arthur Miller's *Death of a Salesman,* "you can't eat the orange and throw away the peel—a man is not a piece of fruit." Finally, we believe things have interior substances of worth, power, and even surprise. Earth and water are puzzled over in terms of what looms below their surface—in the magical inner cauldrons of volcanoes, rock exists as seas of fire.

Every living creature has its orifices and living insides: what is below the skin and in the womb vouch for mysterious processes and unknown powers. Life seeks dark, warm, secure, and inner places. Life beds down before arising. Trees, plants, and seeds are rooted in dark soil before they spring forth and flower. Yellow forsythia announces spring at the back of a rusted trailer court. A bright mushroom breaks the ground, and a cautious eye reads its shape and colors to discern poisonous powers therein. We reach down into an animal's burrow, filled with trepidation of all we imagine could be within. Packages and gifts excite expectations, delight, and surprise, for we must unwrap them. We cut through the layers of the lower intestine to discover agonizing cancers; we touch a piano key or hear the deep clink of a metal pot and are delighted by the jump of fresh sound from their interiors. Even opening a door is dramatic. What lies within? Who might come out? We remove tops and lids with suspense, too. Herein lies our fascination with the jack-in-the-box, an early mechanical creation that still makes children jump with joy and sets adults to thinking about how all things escaped from Pandora's box, except hope.[32]

Like the opening and closing hand, surfaces conjure being. They appear and vanish. In such a magical world, we forever postulate that an outside has an inside, possibly a heart or a living spirit. Such an assumption comes with having a body, itself a matter of inside and outside. Porous, permeable

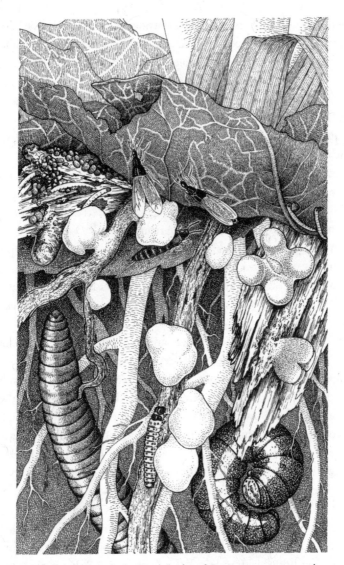

FIGURE 2. "Beneath the Earth," Abigail Rorer, 1997, suggests that the underworld is alive with interactions. Particles of differing size cohere and coalesce, water runs along and through beds of materials, and things decompose. Within the soil, animals crawl, claw, burrow, and seasonally reside.

and impermeable, and multilayered skin respires, disposes of wastes, heals itself, dies, and replaces itself in new sheets. At the same time, the skin and hair protect the body's interior against outside heat, pressures, elements, and poisons, while the body itself, through special organs and orifices, draws in air, water, light, nutrients, and sensations and clues. Our lives turn on an axis of living both within and without. With the body ever in question, our blood, heart, brain, lungs, penis, uterus, liver, bowels, and other visible or hidden organs have mystified us and proven fertile sources of myth and ritual across the ages.[33]

There are endless analogies to draw between earth and body, nature and human handiwork, cracks in clay sediment and lines peeking from below the makeup on a face. One speaks commonly and facilely of the skin of the earth, as if the planet, too, were a great animal that breathes in and out, respiring, transpiring, and aspiring. Saint Paul finds an analogy between the seen and unseen when in Hebrews 11:3 he writes, "So what is seen is made by things that are not visible." And the most speculative of human puzzlers, across cultures and ages, have puzzled over God, the Creator of all puzzles, who let there be light and breathed life into man.

In the realm of made objects—as we will examine in the next chapters on tools, language, and crafts—we note differences, find similarities, and draw analogies between inside and outside.[34] This fundamental division and juxtaposition determine the discovery, invention, representation, building, and comprehension of things; made things spring from these processes. Walls, so important to early civilizations and a focus of chapter 3, once guarded cities—their springs, fertile soils, places of divination, treasures, and fruits of crafts. In ancient architecture, abundant walled corridors belowground led to special chambers and inner vaults, which contained valuable and/or sacred goods and sarcophagi, the latter providing temporary stony skins for those who planned long afterlife voyages. The walls of temples formed cabinets, chests, and crypts for the sacred, while other walls, mounds, fences, screens, and curtains established external and internal boundaries between the wild and tame, legal and clandestine, protected and exposed.

Crypts (the word is from the Greek *kryptein,* meaning "to hide") keep things and secrets concealed behind, below, and within. The assumption that the most powerful knowledge is required to extract what hides deepest explains swaths of magic and alchemy and those who confuse struggle and effort with the truth. Relying on the dual notion that what shines brightest

in full light has the greatest glory and that what is most valuable is secretly kept, jewelers since ancient times have produced miniature gemmed jewelry containing secret compartments. No jeweler of the precious, the hidden, and the revealed went as far as the nineteenth-century esteemed Russian master Peter Carl Fabergé, whose firm created the fabulous imperial Easter eggs. One of the most extraordinary of its creations was an egg supposedly given by Tsar Alexander III to his wife, Empress Maria Feodorovna, in 1885 on their twentieth anniversary: Covered by white enamel, the gold egg—the very symbol of nature's actualizing miraculous potency—opened up, revealing a hollow golden yolk. The yolk itself had a golden hen inside it, which in turn had inside it a tiny crown with a ruby pendant hanging inside, all of it reminiscent of *matryoshka* nesting dolls.[35] The essence, the precious center of things, though often tarnished by chicken-or-egg arguments, lies within; it is the embryo, seed, fruit, egg, crystal, and heart that exists at the living core. And with it comes the metaphor that tomorrow is the yolk of today, from which bitter times and events may hatch: The Russian Revolution nationalized the Fabergé brothers' company and drove the whole family to the West in fear for their lives.

In the magical world of folklore, even ordinary things can hold and birth extraordinary powers. The crooked way proves straight; the ugly, the most beautiful; and the clumsy, graceful. The beautiful red apple poisons; a single kiss turns an ugly toad into a prince; the ring that proves royal lineage comes pursed on the lips of a fish; and a single pea under a mattress steals the princess's sleep. And then there are the three humble beans that produce the magic stalk that Jack climbs to the kingdom of the giant, where Jack escapes death and steals the chicken that laid golden eggs.

Analogies and metaphors just don't connect orders, but leap over whole realms of being. Classical Greeks took appearances to be mere *phanos*—phantoms, illusions, stray images—and called truth *aletheia*: that which is disclosed, unconcealed, no longer veiled. Plato turned eyes and minds away from the changing and uncertain world and sought truth, the good, beauty, and justice in their eternal forms. In the Old Testament, prophets speak of the truths hidden in the embrace of God and time, and the Christ of the New Testament, in the prophetic tradition, declares, "Fear them not therefore: for there is nothing covered that shall not be revealed; hid, that shall not be known. What I tell you in darkness, that speak ye in light; and what ye hear in the ear, that preach ye upon the housetops."[36]

Culture turns surfaces into the coin of the realm. The poet incises the face of things; he turns the sparkle of an eye, the subtle turn of a tongue, and the pallid color of a complexion—into meanings. Artists, whose purpose, according to Horace, is "to inform and delight," hang out images like wash on a windblown line.[37] Writers weave events into their parodies, satires, comedies, ironies, and tragedies. In Greek and Shakespearean tragedies, singular flaws bring down the most elevated kings.

Visual contrasts substitute (especially in the world of photography and television) for explanations. Images and symbols, which are often consolidated into icons, represent truths in themselves. They reduce surface appearances to thought. Juxtaposition offers content and can be both more comprehensive and more subtle than logic. Writers call things to life by naming and putting things side by side. This is illustrated by the opening paragraph of Italo Calvino's first novel, *The Path to the Spiders' Nest:*

> To reach the depths of the alley, the sun's rays have to plunge down vertically, grazing the cold walls which are kept apart by stone arches spanning the strip of deep blue sky.
> Down they plunge, the sun's rays, past windows dotted at random over the walls, and plants of basil and oregano in cooking pots on the sills, and underwear hung out to dry; right down they go until they reach the cobbled, stepped alleyway with its gutter in the middle for the mules' urine.[38]

Poets find energy in what stands before them outwardly and confronts them inwardly.

> Along the edge of the golden corn field
> Struts a big black crow.
> He leaves tracks in the melting snow.
> Undaunted by my approach
> And the flinty shine of my shotgun
> He stands certain, black and brazen.
> Cawing, cawing, cawing,
> Declaring with all his blackness:
> There comes a season,
> When you will take coughing steps
> Towards death
> Across a solitary winter of your own.[39]

There are contrasts of surfaces other than those made by words. Geometry measures the world by what is even and uneven, equal and unequal, proportionate and disproportionate. Greeks did their first work in the field with a straightedge (a key to line and angle) and a compass (a string and a stick). Combining these tools, they measured the earth and created an architecture based on symmetry and perspective. The Greek root *kri* carries with it the literal sense of "straight" and "notch" (words describing the elementary tools used to measure the surfaces around us), and derived from it are such measuring words as *discrimination, criterion, criticism,* and *hypocrisy.* In Sophocles' play *Antigone,* King Creon of Thebes (not the same as the king killed by Medea) errs grievously against the order of things when he harshly punishes his prospective daughter-in-law Antigone, whose name comes from *anti,* meaning "against" or "opposed to," and *gon,* "corner," "bend," or "angle." Creon buries her alive for having buried her brother Polyneices against his royal command. Creon's punishment for having twice violated the law of man and god could not be worse: Antigone, trapped in a cave, hangs herself, and his son Haemon, betrothed to Antigone, commits suicide on top of her. Creon's wife, upon finding this out, also commits suicide. So the just balance between things must be maintained.

Cultures have a major function in classifying, valuing, and regulating society and whole landscapes into juxtaposing grids. As there are uplands and lowlands, marshlands and mountains, woods and prairies, so there are sacred and profane places. Cultures draw mythical, magical, religious, and profane divisions—and scholar Thorleif Boman finds a stunning contrast between "Greeks, who find beauty in the plastic and consequently in the tranquil, moderate, and harmonious expression of the intellectual" and the Hebrews, whose aesthetics of "beauty begins in the sensuous," which resonates with material objects and the symbols of the work of the creator.[40]

As I hope I have shown (and will take up further in the following chapter), the body itself draws us into a landscape of things and relations. With its skin, senses, and limbs, the body forms an engulfing network of relations and activities. In radical contradiction to rationalists, who demarcate truth from sensations, senses, body, and action, we are what we encounter and do, and we are the means and results of what we ourselves experience. In sum, we are embodied and embedded—and here I borrow from Clive Gamble's *Origins and Revolution*—a collection of bodily actions: a hand pressed against a cheek, a finger on the back of hand, an elbow pushing against someone else's ribs.[41] The hand, to take only one example, by habit and learning

forms attachments, establishes dependencies, creates tools, and establishes rudimentary knowledge, which with metaphors and symbols blossoms into trees and forests of connections and meanings.

The story of human development requires a long and rich narrative. Its beginnings and first phases belong to evolution and early human history. And as I tell this story, the tale moves from surfaces to interiors and back again to made environments and built things. Linking exteriors and interiors, it constitutes an enduring and ongoing discourse between world, body, and mind.

The Grip and Grasp of Things

The body is man's first and most natural instrument.

MARCEL MAUSS, "Body Techniques"

THE EYE CANNOT BUT CHOOSE TO SEE; the hand—to echo Wordsworth's verse—cannot but choose to touch and grip. The hand digs into what the eye uncovers. By touching surfaces—however humble and close by—by taking hold of them, twisting, and breaking into them, we identify things, compose worlds, and make a mind, which, over the course of ages, reaches as matter of habit into existence and grasps its things and symbols as our own. Shape, color, and size define both the places we call home and the distant ports toward which we hope to sail. Surfaces are also the handles of memory, which we grasp in order to comprehend, and the wells of metaphors, from which we draw in order to represent.

In this chapter, I venture close to a conceptual tar pit, a stew of subjects, theories, and generalizations—there are great gaps of evidence here, and ignorance abounds.[1] I seek, nevertheless, to thread my way through evolution and prehistory by following a simple narrative. Over eons, humans have shaped their genetic inheritance through their own activity and purposeful adaptation as they made themselves and lives.[2] We have extended our ever-active hands, reaching arms, and touching fingers in order to know and make our world. First with tools of wood and other natural substances, and then with stone tools (the first of which, found in Africa, date to approximately 2.5 million years ago), bipedal hominins, toggling between exteriors and interiors, began to shape the micro- and macrosurfaces of their environment, and in so doing, they altered their brains, transformed their intelligence, and ultimately presumed to design, make, value, and simply talk about the world and its order and meaning.

My explanatory narrative, cast as suggestive evocation rather than consistent argument, first examines the formation of human skin and then

proceeds to the development of the hand, which establishes our tactile and kinetic experience with the outer and inner world of things, and influences the development of brain, mind, community, and culture. The chapter concludes, *in arguendo,* with the idea that toolmaking underpins our ability to physically and mentally manipulate the world, both in fact and as an assemblage of symbols and possibilities. Man as both a self-making and a self-defining creature is taken up in the next chapter, which explores civilizations' unprecedented control of micro- and macrosurfaces and abstract language.

The assumptions of the history of consciousness are not odds at with evolutionist and humanist Julian Huxley's proposition that humans are evolution turned in upon itself. Nor do they contradict Jesuit paleontologist Teilhard de Chardin's *Phenomenon of Man,* in which he conceives of humans as collaborators in creation and beings in an unfolding cosmos en route toward what he postulates as an omega point, a complex and conscious state of being and divine convergence.[3] And, as I discovered in the course of reading for this chapter, my intuitions about evolution of mind converge with British evolutionary psychologist Nicholas Humphrey's. In *A History of Mind,* Humphrey conceives of the mind and its functions as a historically generated multiplicity.[4] At the center of its diversity, Humphrey locates a division between the part of the world that is sensed and touched and the part that is perceived and conceived. For him, this division runs parallel to the dichotomy we draw between the rational Enlightenment and the emotional Romantic era, or between Freud's reality and pleasure principles.[5] Attributing humans' awakening consciousness to polarized phenomena arising both without and within, Humphrey suggests that the past million-year history of the human mind has been about "two existing sets of facts: on the one hand the existing phenomena of subjective experience and on the other the existing phenomena of the material world."[6] And without referencing the interplay of exterior and interior surfaces, Humphrey sees all animals as evolving between outside realities and interior responses. Conceiving of every animal as "a spatially bound package," Humphrey remarks that covering surfaces assure the integrity of an individual life: "So boundaries—so the physical structures that constituted them, membranes, skins—were crucial. First they held the animal's substance in, and the rest of the world out. Second, by virtue of being located at the animal's surface, they formed a frontier: the frontier at which the outside world impacted the animal, and across which exchanges of matter and energy and information could take place."[7]

From the selective interaction of inner and outer worlds—with the former accounting for sensations and the latter, perceptions—Humphrey initiates his history of human consciousness. Consciousness began four billion years ago, when life may have arisen out of pools struck by lightning, the first stimulus. Evolving as mutating and adapting, life eventually produced the most complex and interior of all creatures, *Homo sapiens*. This new creature and developing cocreator partakes of the world with its *skin-covered* body, its *touching* hand, and its mind full of realms unknown and ever unknowable to all other animals. Uniquely mixing understanding, imagination, values, emotions, and wishes, *Homo sapiens sapiens*—our species, the sole surviving hominin, including all modern races (or, more elegantly, Aristotle's form that participates in other forms)—lives in part submerged in the complex depth of its own subjectivity.

BY THE SKIN OF OUR BEING

Skin, the most visible aspect of the human phenotype, defines us. It puts us in fleshy dress. Buffering; resistant to sun, heat, and cold; and plastic and self-replacing, its condition marks our age, race, wear, and injuries.[8] The outer face of our incarnation, skin sports burns, wounds, scars, blemishes, tumors, warts, infections, and other irregularities that function as life's tattoos, testifying to our particular condition and fate. While biologically the boundary, mediator, transmitter, monitor, and regulator of the interior and exterior worlds, skin—science's much-studied integument—is also culture's much-read book, in which those free of calluses and with fair skin (indicating a life spent out of the sun, or *in* the sun, depending on the era) express their privilege, and those with tattoos and scarification express their cosmic ties, tribal identities, and allegiance to contemporary gangs.

In the declarative first sentence of the one-paragraph foreword to *Skin, Surface, Substance, and Design*, Paul Warwick Thompson, past director of the Cooper-Hewitt National Design Museum of the Smithsonian Institution, writes of skin aesthetics: "Skin, the complex membrane that holds the body together, also embraces the full spectrum of design from product to architecture, fashion and media."[9] The domain of skin melds with that of tattoos, jewelry, body piercing, and clothing; and our experience and use of skin shapes our conception of other coverings and hulls and their plasticity, softness, and multifunctionality. In her introduction

to *Skin, Surface, Substance, and Design*, the editor and Cooper-Hewitt contemporary design curator Ellen Lupton describes skin in "the new design of organics":

> Skin is a multilayered, multipurpose organ that shifts from thick to thin, tight to loose, lubricated to dry, across the landscape of the body. Skin, a knowledge-gathering device, responds to heat and cold, pleasure and pain. It lacks definitive boundaries, flowing continuously from the exposed surfaces of the body to internal cavities. It is both living and dead, a self-repairing, self-replacing material whose exterior is senseless and inert while its inner layers are flush with nerves, glands, and capillaries. Contemporary designers approach the surfaces of products and buildings as similarly complex, ambiguous forms. Manufactured skins are richly responsive substances that modulate the meaning, function, and dimension of things.[10]

Like those of bones and organs, skin's story includes a long evolution. And like every membranous cover of organ and tissue, skin is composed of layers, which, called epithelia in the plural, form the outer surface of an animal's body and the inner surface of organs that connect to the body's orifices. When joined to the history of the mouth, lips, and tongue; the insides of the nose and ears; and the palms of the hands and the soles of the feet, the story of skin serves as a gate into the library of human creation.[11]

Life exists in movement and reaction. It moves—through phototaxis—at the first touch of light. On the surface, life primordially and primarily reacts with motility to signals, stimuli, and impulses. Nerve cells, which unify organisms' actions, tend to grow in the direction of stimulation, in a process called neurobiotaxis. Life is alive to what's going on in the world.

The most powerful reactions occur at the margins, the boundaries, where lives meet the outer world. Thus, the integument that registers exterior stimuli also seals the animal against change. Especially in more complex animals—whose exteriors are covered by combined layers of epidermis and dermis—the integument functions analogously to the walls and gates of a frontier city: it selectively seals, guards, and defends what is within, while permitting the entrance of nutrition and information and the expulsion of internal wastes and poisons.

The epidermis is attracted to and repelled by differing chemicals, fluctuating pressures, the intensity of light, and other stimuli. Alive to external threat, membranes house defensive systems, as is illustrated by the antimicrobial rind of the pomegranate; the sharp, thorny, and bitter outer shells of many insects; and the detachable sharp, hooked quills of the porcupine,

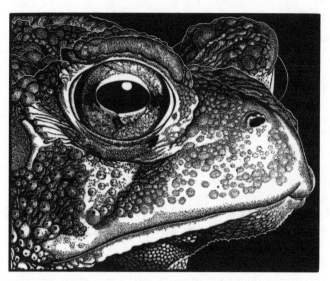

FIGURE 3. "Bufo the First," relief engraving, Abigail Rorer, 2005, had its inspiration in an excerpt from Henry David Thoreau's May 1, 1857, journal entry, in which he celebrated *Bufo americanus*'s resounding call of life to a new season. *Bufo,* the double-chinned toad, inflates its throat, but this tailless species is also noted for its protruding eyes, its permeable and subtly camouflaged skin, and its extralong and sticky tongue that can unroll to catch and gulp down an insect before Jack can jump over a candlestick.

which disable any curious and sniffing young dog such as my boyhood Canadian collie, Spikes.

Light spurs on earthy, watery, and airy life. Light, especially through photosynthesis, accounts for both what grows and what is stored in plants. The sun doles out day and night and measures the cycle of the changing seasons of life. God's first declaration of being in the Bible is "Let there be light"—and a local poet who reads natural science speaks of the sun captaining the goose's winging migration, which is fueled by the ancient treasury of the sun's stored energy and carbon reserves. Because the sun, the greatest exterior catalyst, drives life's processes, entire species are classified as phototropic, phototactic, or heliotropic.

To start with the most elemental families of life, bacteria are phototropic, using light to turn inanimate material into food. Some bacteria, additionally, are motile. With their cilia and flagella, they move, not just responding to the outward stimuli of light and other objects, but kinesthetically

adjusting and reorienting their bodies' position in space.[12] Identifying life and its development with growth and voluntary movement, as Aristotle did, contemporary theories of neurobiotaxis affirm that individual nerve cells, which inhabit the outer membranes of organisms, tend to grow and develop in the direction of stimuli. The first neurons and synapses, which take in and relay outer signals, appeared in cnidarians—that is, hydra, sea anemones, and jellyfish, which themselves appeared around 600 million years ago. Next in this geologic parade of early life came (as best we know) a wormlike ancestor in the Cambrian period, 550 to 600 million years ago. In contrast to the relatively unstructured nervous system of radiata (jellyfish), this particular worm had the unified nervous system of a bilaterian.[13] Forming the vast majority of animals, bilaterians (as their name indicates) are bifurcated (both inside and out) into approximately identical right and left sides. The integration of the bilaterian animal depends on the neurological centralization afforded by a coordinating cord with segmental enlargements and a brain at its front, suggesting that, as animals feel and sense the world, they react to it.

With the emergence of complex bilaterian organisms, equipped with a spinal cord, a brain, and a sight-producing retina and optic nerve, living entities began to receive and coordinate exterior and interior information and produce unified reactions throughout the animal. These organisms learned to react instinctively and habitually to external stimuli and internal signals and sensations.[14] At the level of mammals and humans, the bilaterian body plan is coordinated by a complete nervous system. The spinal cord contains a series of segmental ganglia, each giving rise to motor and sensory nerves that innervate a portion of the body's surface and underlying musculature. On the limbs, the layout of the innervation pattern is complex, but on the trunk, it is merely a series of narrow bands. The top three ganglia segments belong to the brain, giving rise to the forebrain, midbrain, and hindbrain.

MEMBRANES: SKIN, FEATHERS, AND OTHER COVERS

Integrated into interior and peripheral nervous systems, skin—pliant, plastic, and rubbery—shapes itself inwardly to organs, muscles, and the skeletal structure. Responsive, adaptable, and capable of growth, it serves the vital functions of ingestion, respiration, reproduction, and excretion.

The evolution of skin lies in the folds of the first animal membranes. It advanced from the simple epidermis of the first sea creatures to fish,

amphibians, feathered birds, and finally the scaly and soft hides of tetrapods, vertebrates with four limbs. Jablonski tells the natural history of skin:

> Scientists believe that the earliest multicellular organisms, which lived in the sea, consisted of single types of cells. The surface of the cells that faced the open water often supported a thickened membrane as well as small tail- or whip-like structures that allowed organisms to move around to a limited extent. When such organisms began to get larger and became more solidly filled with cells, several very important things happened. Because the cells on the outside could not absorb enough nutrition and oxygen through their membranes to support the needs of the entire organism, a new structure (a mouth of a sort) evolved to permit food and oxygen to get in.[15]

The outer membrane of life later developed to serve more complex animals. It housed different tissues with specialized functions. These were integrated and coordinated by sensory and nerve cells. Early invertebrates established outer protective shells for defensive purposes. In the form of increased layers and thickened walls, they sealed themselves tightly away from damaging chemicals and disease-causing microorganisms. The skin of vertebrates allowed the maintenance of a constant inner environment despite the passage of various substances, including salts, water, and oxygen, through its surface.[16]

From the first, invertebrates put their skin in the service of their survival. The skin of the cuttlefish, the adroit cousin of the brainy squid and octopus, is mutable in color and size and reveals when it is in love, on the attack, retreating, or camouflaged and hiding. The cuttlefish shows an exceptional capacity—beyond that of its smart cephalopod cousins—to work through mazes. Its ability to learn from and adapt to its environment rests on its ability to read and relay clues and solutions from skin to brain and back again, making it from head to foot (to play on the Greek root of the word) a true cephalopod.

Another function of an animal's outer surface is locomotion, its capacity to move through its environment. The backboned fish is a coordinated set of mucous-covered scales designed for swimming. Its moveable plate of scales, combined with fins, makes for quick, smooth, and diverse movements in the water. Once ashore, the first tetrapods (namely amphibians) required a whole new covering, as well as a transformed interior. They had to shed gills and let their skins take over the gills' function of regulating ions and water. Along with lungs to absorb oxygen and kidneys to establish the proper salt balance came a new, protective, and more complex epidermis for

amphibians, as well as for reptiles, birds, and mammals. The exterior of the new epidermis was defined by the chemical keratin, a tough, fibrous protein. Keratin aided land creatures in two main ways. First, it toughened skin against abrasion (so powerfully experienced by reptiles such as snakes and crocodiles) and formed a barrier against water. Second, it enabled the development of discrete coverings and appendages. Crocodiles developed ossified bony structures; turtles, shells (a composite of spine, dermis, and epidermis); and snakes (paradoxically a limbless tetrapod), versatile scales that served their sinuous gripping movements and constrictive holds, and yet were pliable on the inside for swallowing and digesting prey whole.[17] Mammals received an all-purpose covering of skin—a protective, malleable, and warming wrap of hide and hair that also enabled them to fully embrace their young.

Feathers, which enable flight, are considered by the naturalist, aeronautical engineer, and poet to be the most remarkable microsurface in evolutionary history. Stiff, light, long, contoured, short, and fluffy, feathers of many forms and uses cover the bird's body. They too are composed of keratin. Hooked and barbed together, feathers dress each bird in marvelous utilitarian plumage. Dead when fully grown and lacking nerves, feathers are nevertheless joined to muscle and the nervous system at their follicles, serving birds in romance and other flights.[18] Renewing the bird's cover annually or biannually, molting (shedding and replacing the feathers) is carried out symmetrically and at staggered periods so as not to interrupt flight. Aside from providing an outer wall against the intrusive and bruising world and its cold, light, heat, and rain, feathers allow the bird to nurture its bald, flightless chicks in a soft, warm, and dry environment. Feathers also provide attractive colors and patterned fans to lure mates. They constitute all-important camouflage for hunting and protection, especially for small birds that feed and nest close to the ground. Feathers, which also improve hearing and can be used to transport drink to young, allow some birds to not only float, but also to swim, dive, and hunt in watery environments.

In flight, feathers, which show remarkable variation in shape, size, and length, grant the bird lift and directional movement and allow it to accelerate, glide, hover, and, thanks to their instant collapsibility, dive and descend for attack—making raptors imperially menacing. With their circling flight, keen eyes, incredible plunges, and striking and holding talons, raptors exert dominion over flat and open fields. With their near-silent flight, thanks to specialized feathers, owls hunt field, brush, and woods day and night, while

other raptors (such as eagles and osprey) fish the flat surface of lakes and beaches and the face of rising and falling ocean surf.[19]

Leaving behind high-sky fliers for trudging earthlings, three properties distinguish the skin of Old World anthropoid primates. They share with their mammal predecessors hairiness, the ability to produce sweat, and melanin to block ultraviolet rays.[20] These traits (which misleadingly make chimpanzees seem closer to gorillas than they are to humans)[21] suggest that humans increasingly belonged by virtue of our skin to our environment. As scales, feathers, hair, and hides distinguish whole classes of animals, so skin is the defining human cover. Skin localizes and generalizes touch. Utilizing the whole body as an antenna, skin brings the tactile world to us. Recording and expressing stimuli and perception, skin senses what is moving, vibrating, solid, taut, hard, heavy, soft, smooth, sharp, and rough. As varied as the differing touches of palm, finger, nails, hand, cheeks, lips, and breast, skin brings us a rich world of objects and bodies—all surfaces themselves—to be declared, explored, and, in the spirit of that fleshy pantheist Whitman, celebrated.

The fruits of touch come to us across the full register of sensations, emotions, and ideas. They ignite and inform our perceptions, conceptions, and representations. Aside from conducting primary and elemental functions of life, skin announces humans to the world. Through a blush, standing hair, shiver, goose pimples, panting, and sweat, skin confesses our physical, emotional, moral, and other inner states. About blushing, perhaps the most revealing of all epidermal signs, Byron declares, "So sweet the blush of bashfulness," while Keats writes in a letter, "There is a blush for won't, and a blush for shan't. / And a blush for having done it."[22]

With a wealth of meanings that language cannot penetrate but only artfully explore, touch occurs where a breastfeeding mother and child meet, where all we take to be gentleness, love, and beauty are joined in grace. As outlined in chapters 4 and 5, artists and poets depict the sublime and cruel theaters of life with reference to touch. All this reveals as false the old adage that beauty is only skin deep! In so many matters, humans straddle both the ins and the outs of things.

THE WORK OF HANDS

Human skin (like that of other mammals, primates, and hominoids) has knitted, shaped, and formed itself over eons into our principal organs. Skin

formed the exterior and interior of our lips, and it formed the outside and part of the inside of our nose and ears. Certainly, we must look to skin for the genesis of our senses—our hands themselves grew as appendages to skin in conjunction with the formation of our muscular and skeletal structure. With skin covering both our thick palms and our sensitive fingertips, and keratin forming our protective, cutting, and penetrating fingernails, hands put us in touch with the inside and outside of things. With their cushioning and protecting skin, hands grip and grasp; with their probing fingers, hands can roll and touch what eyes cannot see, and they can pull, separate, and pick apart things. Thus skin ideally equips human hands to take up the world, both literally and figuratively.

Hands are the first and distinct instruments of the committed body, and form the condition and means for humans to exist. Or, in the words of Merleau-Ponty, "Our body is our general medium for having a world. Sometimes it is restricted to actions necessary for the conservation of life, and accordingly it posits around us a biological world; at other times, elaborating on these primary actions and moving from their literal to figurative means, it manifests through them a core of new significance."[23] In other terms, hands pick and probe, peel and penetrate, swish and squash, pick up, hold, and put things into the mouth. They commit to the outside and inside of things. They weave humans into being, and with gestures and lines they describe and situate humans in real and symbolic places.

Hands not only are elemental in defining the body's bilateral symmetry; they allow people to enter the world and orient them once there. They form a compass of twos. They divide things into left and right, up and down, arms and hands, legs and feet. Hands supply indications and expression before tongues have learned the discipline of speech. Hands respond to things without and impulse from within. They are spontaneous and wild, deliberative and precise. They make and define a person as an interactive set of surfaces existing in a world of inert and responding surfaces. In union with other senses, hands offer preliminary and yet vital measures of close and far, high and low, within and beyond, attractive and repulsive. They define the polarities of tactile experience. They validate the existence and substance of things. Hands deliver us to the world, and the world to us.

Hands constitute, to modify a Heideggerian formulation, a distinguishing means—a praxis—for entering into and comprehending being.[24] From their first touch, hands lead us to and from the surface of things (including our own skin and bodies) and allow us entrance into objects. Aside from being

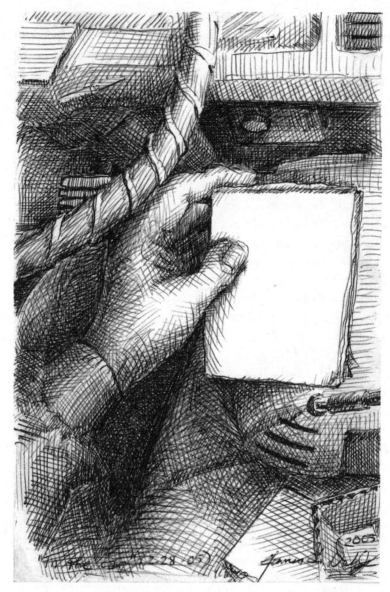

FIGURE 4. "Hand and a Steering Wheel," James Dahl, 2005. Singularly or in combinations, hands fit us to the world and fit the world to us. They are the instruments by which artists—and the rest of us, too—identify and form surfaces, seek their fortunes, and, in the case of this world (which walks little), steer themselves to their destinations.

a means to identify and explore the world, hands are the principal agency by which we participate, manipulate, alter, and incorporate the outer world into ourselves. Not only are their touching, gripping, and grasping of surfaces and things indispensable to experience, learning, and memory, but their work shapes the collective and evolutionary activity and work of the species. And the hands shape the brain itself as an organ and an instrument for making acute differentiations and the longest leaps from limb to limb of being.

Hands join, enter into, and take measure of the world. As readers of Leonardo's *Notebooks* or, to choose another example, early-nineteenth-century English anatomist Charles Bell's *The Hand: Its Mechanism and Vital Endowments, as Evincing Design* (1833) know, the marriage of eye and hand has made man a designer, thinker, and creator. The composer's hands attune the orchestra to the subtlest wishes of his anticipating ear; the hand, in coordination with the eye, comprehends the finest movement of a microscope. At points, the tactile trumps the visual as hands touch what the eyes cannot see. When the eyes cannot focus, hands keep us in touch with the world—and working hands constitute an experience that no other sense creates.

The roots of knowledge go with the mastery of the hands—I think of my grandmother Amato busily preparing food, and recognize that her patting and kneading hands were alive to food in a way mine would never be. Each person's unique touch, grip, and grasp, singularly and in tandem, define his experience, memory, skill, knowledge, and culture. Moving back and forth between surfaces and subsurfaces, hands are our primary instruments for learning about the ins and outs of things. By touching, gripping, scratching, and rolling between the fingers, hands grasp the outer and inner sides of things. They reveal to the senses and mind what did not immediately stand forth. Hands guide us in the dark. They teach the finest size and texture and the subtlest movement, tension, and elasticity of things.

Hands teach by probing and by feeling what bodies are and what they are made of. Before (and in addition to) mirrors, they confirmed the unseen head, face, neck, back, legs, and feet—and explored the insides of orifices. In multifold ways, they establish what is the human place: as a set of parts and surfaces among a world composed of infinitely more parts and surfaces.[25] Hands are surfaces themselves. They reveal a lifetime of certain kinds of work, and across ages, palmists, practicing chiromancy, have read fates and fortunes on the lines of palms. As Charles Bell writes and illustrates in his 1806 *Anatomy of Expression,* just as the face reveals moods and states, so the

extension, placement, and tension of the fingers, palms, wrists, and arms tell the world who is before it.[26] Hands, by their movement, wrinkle, poise, and gesture, express both a moment and a lifetime.

Hands play the leading role in making humans active among the surfaces of the world.[27] Working singularly and in combination, hands are multioperational. With sensitive fingers and opposable thumbs, they have developed a fine and discerning touch, along with an acute picking ability and great holding and twisting power. Because they are attached to long arms (extending about half the length of the body), they can reach much of the world that is aside, above, and below them. Like agile cranes, arms lift, extend, and rotate. Just below the hand is the four-directional, pliable wrist. Beyond the forearm is the extending and rotating elbow, and further multiplying the movement and directionality of the arm is the 360-degree rotating shoulder. In combination with the rotating neck and bending and rotating waist, bending knee, and pliable ankle, these features enable humans to readily enter the world around us. As the world encompasses us, so we compass it—ready to point and extend our reaching hands.

Hands enable biological survival and social activity. They are essential tools in hunting and gathering. They kill, embrace, and communicate. They wave and signal; they play loud drums and subtle snares. Even everyday language testifies to the hand as the lord of surfaces and objects. The words *tactile* and *tact* have their roots in the Latin word *tangere* (to touch). Manual (hand) work has been performed throughout the ages; the dexterous ("right-handed" in Latin, as noted earlier) person is ingenious, artful, and adept. Even the sly and sticky-fingered always have had a role to play in human affairs.

Hands made humans agents of self-making. And their evolution and full use can be understood only as a consequence of bipedalism.[28] Scholars speculate that bipedalism permitted hominins to make fuller use of their breath and vocal cords, which gave them a more powerful voice—a megaphone, so speak, perched on an upright and rotating head. Now that hominins were on foot—out of the trees and on the savannahs—their hands were free to develop. They could pick up, hold, and carry things. With a swiveling head that enabled them to see the horizon, strong legs that could move at up to three miles an hour on flat terrain for days at a time, and scanning eyes and scavenging hands, humans spread themselves out across the face of the earth. Their legs and hands underwrote hominin migrations across Africa and on to Asia and Europe, transforming the owners of these appendages into explorers, searchers, and ever more successful gatherers and hunters.

In *The Hand,* neurologist Frank Wilson, synthesizing the work of many scientists and anthropologists, postulates the coevolution of brain and hand, suggesting that the brain's development followed that of the hand and, later, human toolmaking. *Homo erectus,* an extinct African species that lived around 1.5 million years ago, remodeled the hand and thereby opened the door to augment movement and increased manual activity, reordering brain circuitry.[29] In the last hundred thousand to fifty thousand years, the hands of *Homo sapiens* have continued to reorganize the brain. An interdependent ability to manipulate and conceive of the world—inside and out—has formed a new brain, a new consciousness and self. Although the concept is a contested one, in the past ten thousand years, hands have enabled *Homo sapiens* to establish dominion over the world.[30]

Homo sapiens' symbolic capacity can be seen in our ability to convert our activities in the outside world into objects of the mind. Juxtapositions between a plural world and a multivalent mind—and the difference between made and to-be-made—suggest distinctions between what was, is, will, or might be. By turning language into a vast system of such juxtapositions, *Homo sapiens* allowed our consciousnesses to grasp alternative realities. With increasing visual acuity, tactile ability, and manual knowledge of what is, the mind remade reality in terms of interests, meaning, values, symbols, and plans. In this way—hand leapfrogging mind, and mind leapfrogging hand—earlier hominins became *Homo sapiens,* who ourselves have jumped over consciousness and action to possibility, hypothesis, conjecture, fear, wish, and hope. On the basis of imagined conditions and proposed states of being, humans have come to know ourselves, define nature, and carry on relations with superior entities and deities, which operate beyond what can be seen on the surface and deeper than any known and explored interiors.

In *How the Mind Works,* psychologist and linguist Steven Pinker conjectures, "Hands are the levers of influence on the world.... Precision hands and precision intelligence co-evolved in the human lineage, and the fossil records shows the hand led the way."[31] Hands, with their advancing control and diversifying use of tools and instruments, were increasingly able to represent the world with drawn lines and made figures. Toolmaking profoundly increased human manipulation and use of micro- and macrosurfaces and birthed *Homo sapiens,* a creature who incorporated the world into its being, mind, wishes, life, and, ultimately, civilizations.

Without providing a chronology of stages or creating a distinct or mediating species between *Homo erectus* and *Homo sapiens,* it makes sense to speak of *Homo habilis,* or "handy man."[32] In an altogether unique way, and to a degree unprecedented in the entire animal kingdom, human hands took to tools, and tools were selected and developed to fit the use and habits of hands. With opposable thumbs, working in unison with strong and sensitive fingers, hominins utilized and made tools. They altered in almost every way the protohuman perspective on things. As microsurfaces, tools (composed of diverse materials, of varying forms, and serving multiple purposes) became microinstruments for exploring and controlling macrosurfaces. Tools allowed early hominins to examine and explore the outsides and insides of plants and animals. They permitted early man to hunt large mammals, and they allowed our ancestors to carry fire from site to site.

Indeed, some believe that fire, preserved and carried from place to place, was among early humans' first tools, if not the premier tool that made other tools. (Some anthropologists controversially credit fire's capture and use to *Homo erectus,* which, as noted earlier, lived from 1.8 to 1.3 million years ago; others, with more evidence, date fire's use to four hundred thousand years ago.) Defining home more than other things, fire afforded protection and warmth. It furnished a place to gather, sleep, and eat. It was crucial for curing and drying meat for storage and later eating. Fire, the most metamorphic of tools, refashioned surfaces and transformed the insides of things. It was used to shape and harden wood into carbonized tips, to hollow out wood for containers and boat hulls, and to split rocks. Boiling water and defrosting meat, it also produced useful fire sticks, embers, coals, ashes, and dust. The heart of primitive campsites and the hearth of ancient dwellings, fire stole light from the dark. By firelight, eyes and hands could work on tools and imagine tomorrow's tasks. Once human groups learned how to start, rather than carry, fire, they could establish provisional campsites for hunters and migrants. In turn, fire purposely turned loose on environments defined macrosurfaces, controlling wild-fire, clearing wood and brush, and stimulating the growth of berry bushes and fresh grasses, which were used, at least on the North American plains, to lure grazing bison.

Tools and toolmaking, no doubt supplemented in multiple ways by fire and the new campsites it enabled, extended humans' manipulation and

use of the world of surfaces.[33] Tools refined the primary distinctions of light and heavy, thick and thin, hard and soft, smooth and rough, permeable and impermeable, tight and loose, weak and strong, taut and slack. They increased our capacity to turn specific materials and whole spaces into desirable shapes and formations. And with tools came metatools, tools that made other tools. I suggest that tools—which broke, cut, filed, sawed, and bored into surfaces—not only further extended our exterior and interior reach, but more sharply delineated in our mind the outside and inside of things and our tactile knowledge of what we can and cannot obtain, and altered the boundary between the natural and the made. This distinction consolidated an analogical and dialectical way of thinking between surface and interior, out and in, here and there, now and then, and even the primary modality between the possible and the impossible.

Tools further engaged an interactive body with the world before it. Indeed, modern thinkers (often of materialist persuasion) assume the work of hand and tools transformed not just the world, but man himself. Particularly inspired by the fact and promise of the Industrial Revolution, they identified *Homo sapiens* as *Homo faber* (man the maker). Karl Marx, a radical Hegelian, was not alone in doing so.[34] In an early poem he praised Prometheus, who stole fire from the other gods and gave it to man. A cosmic rebel, Prometheus became godfather to the human family, the tribe who used fire and initiated technology.

Humanity exploited the earth's energies and materials to change the world and itself, taking some control of its own evolution. Rather than being only a vast and beautiful story of genetics and embryonic development, the human story also became a saga of hands and tools, design and craft. The species assembled itself in order to remake and transform the world into a semblance of itself.

Humans everywhere started our work with the most common and humble materials. With mud, dust, and even urine and fecal waste, humans healed and decorated ourselves. From plants, we made shelters, clothes, bindings, and medicines. Animal and human body parts, particularly bones, furnished whole tool chests that in turn were used to make, alter, and decorate humans and our worlds. (At the arrival of Europeans in North America, Plains Indians were known to turn skins into glues; tendons and muscles into cords and ropes; organs and hides into sacks, containers, clothing, and bedding; and hard and flexible bone into struts and ribbing for boats, as well as weapons, knives, scrapers, and needles that shaped, with

decorative quills and beads, hides into the impermeable exteriors and insulating interiors of coats, hats, mittens, and footwear.)

Wood, so commonly available but, unless carbonized or scorched, lost to the ages and thus undocumented by scholars, was more versatile in its use than was bone—and it could be worked with hand, stone, bone, shell, and other, harder woods. From wood of all shapes and sizes, from barks, boughs, and trunks, humans made objects and tools that differed in purpose, thickness, length, strength, smoothness, pliability, rigidity, weight, and delicacy. And the special fruit of seashores—shells of diverse sizes and forms—though more brittle and less workable than wood and bone, nevertheless were made into elemental hand tools such as knives, punches, pincers, drills, containers, and hair combs and became, singularly and joined like beads, the finest jewelry.

Stone tools, which furnish lasting evidence for anthropological and archaeological theories, have been the star of toolmaking study, especially in the form of the multipurpose biface hand axe. Made by hand from chips and chunks of highly crystalline rocks—quartz, agate, chert, flint, obsidian, and fine-grained lava—stone tools were instruments for both rough and fine work on the surfaces and the interiors of things. They served as axes, adzes, and sledgehammers to cut, smash, and pound; they served as sharp knives and scrapers to cut flesh, clean hides, and shape bone and wood; and they served as deadly weapon tips, boring drills, and needles. At the same time, they furnished balls for milling lasting ledgers and faces for recording and for making a variety of containers.

By extending the ability of the eye, the hand, the senses, and the body as a whole to utilize things, tools advanced humans' perceptions and conceptions. They increased the human capacity to turn materials into desirable shapes and forms and make metatools, tools for making tools, and incrementally led humans toward changing the face of the earth and defining our place and power among things.[35]

The chicken-and-egg questions of hand or brain, tools or conscious thinking, as the driver of human development may hinge upon unobtainable evidence that would be millions of years older than the stone tools and fossils of protohumans and other erect bipedal primates we have found to date. Indeed, the question of tool use may turn not just on known made stone tools, but on unaltered objects that were found, sought after, and utilized. Likewise, they may pivot upon tools that used materials other than stone, and on uses of tools other than those suggested by the early stone tools found so far.

In accord with the interplay among hand, tool, brain, and the exterior and interior of things, I conjecture that a nucleus of hominin tools might be identified: ones that were used to care for bodies. Tools that were readily at hand—sticks, grasses, and leaves—could be used for cleaning; grooming; removing dead skin, prickers, ticks, and other irregularities; scratching; and probing sources of pain and irritation. Perhaps marking a radical disjuncture between human and animal, at some point humans (individually and collectively) began to confront (to probe, examine, and treat) rather than retreat from our pain, as animals commonly do. In addition to the use of soaking, mud baths, emetics, laxatives, licking, and massages, humans turned to tools to heal ourselves. Leaves patched wounds; tourniquets stopped bleeding; rope and pegs were used to reset limbs; and various styles of canes and crutches supported walking. We used tools to penetrate our own skins and bodies into order to treat growths, wounds, infections, pains, and aches. With wood picks to probe teeth and skin and straight, curved, and pliable sticks to explore the body's orifices, we anticipated dentistry and surgery. Doubtless, humans learned our own inner anatomy from injuries and wounds; from experiencing, witnessing, or assisting in childbirth; from the butchering of animals; from the removal of teeth, bone, and skulls for various reasons; and even from cannibalism. (Evidence of trepanning from the Neolithic evokes one moment in the long trip humans took toward treating internal ailments and surgery—the Greek roots of the latter word mean "handwork," from *kheir*, "hand," and *ergon*, "work.")[36]

THE WALKING STICK: AMONG THE MOST VERSATILE TOOLS OF ALL

Many tools, other than heavy stone ones made of relatively scarce materials, may be conjectured to have aided the migration of bipedal man and his ancestor *Homo erectus,* who left Africa for the rest of the world a million and half years ago, fanning out to the Near East, Europe, and Asia, going as far as China and Java. We can hypothesize that they had early tools and instruments—though these were not part of a generalized or shared technology—associated with starting and carrying fire, establishing campsites, preparing and transporting food, and carrying bedding and containers. Early hunting might have utilized grass and twig snares, bone and wood weapons, and blunt

instruments for dressing animals. Both travel and hunting could well have involved whistle- and drumlike instruments.

Yet perhaps no instrument in the entire repertoire of early man was more available, and necessary, than the walking staff. At least I—a walker, hiker, and writer on walking—would argue that it constituted *Homo erectus*'s first tool for moving across the surfaces of the earth. Made of wood, the walking staff was of diverse sizes and shapes. In the form of staff, cane, crutch, crook, baton, or measuring rod, it had varied purposes. Readily available in wooded landscapes, it could be broken and cut off trees to size or found as needed in piles of fallen brush and along rivers. It also could be easily fashioned for smoothness, length, sharpness of point, and handle shape by stone, knife, and fire. Its forms and uses (like those of other tools and technologies) reveal a variety of human needs and the ingenuity and traditions of its users.[37]

Additionally, shaped by need, tradition, and imagination, the walking stick joined in its user's search for food. As an extended arm, it reached high nests and hives; as a pry bar, it overturned rocks and logs in search of grubs and insects; as a digging tool and a type of plough, it worked the soil; and in the form of a rod, it drilled for water and served as a center pole for tents and as scaffolding for suspending and dressing the catch.

A versatile tool, the multipurpose walking stick was the companion of migratory cultures, the symbol of the journeyman and the shepherd. It was a tool for crossing the rough, uneven, and dangerous faces of the earth.[38] Extending the reach, strength, and balance of arms and legs and aiding the weak, infirm, and encumbered, the walking staff helped its bearer to cope with surfaces of all sorts—to balance on steep and windy slopes, to step between irregular rocks and debris, to move along ledges, and to bridge crevices, as well as to work one's way through marshland, follow meandering banks, and ford streams and rivers. Additionally, it probed uncertain surfaces, parted vegetation and brush, and proved handy for killing snakes and lizards. It offered a strong defense against wild dogs and intimidating robbers. It evolved into the fighting stick, possibly the sword, and the sharp-edged, sharp-tipped cudgel, which some know best as the large knobbed and strap-held Irish shillelagh.[39]

In the form of the balanced and sharp-pointed throwing spear, the walking staff became the foremost weapon of Paleolithic hunting. By some accounts, it turned our early ancestors into *Homo necans* (the killer ape). With a fire-carbonized tip and, later, an attached stone point, the spear hurled our predatory instinct at the world and embedded organized killing

into collective ways and individual minds. It made stalking, encirclement, slaughtering, butchering, feasts, and all else that goes with group hunting easier. Some theorize that the spear led humans (creatures who face their own pain and death) courageously, though not guiltlessly or without ceremony, to confront, kill, and eat great fellow mammals, which in many ways—by head, legs, death, and spirit—were considered to be *living creatures* like ourselves.[40]

The walking staff accompanied man across landscapes of every sort. With this versatile stick, we improvised new ways and secured our role as the world's farthest-migrating species. The stick's importance was acknowledged by kings and leaders. The decorated staff—as is still witnessed in contemporary West Africa and many other places—identifies the power of a group and its leader, and is called the "talking stick," since it pronounces the authority of the speaker and affords a means to emphasize his words. And in the past it took on celebrated form as the magical staff of Moses and the rod of Aaron; the pharaoh's ruling, guiding, and healing scepter; and the medieval bishop's crosier, which symbolically brought the errant into the fold.

THE BIFACE

Not the walking staff but the biface stone tool plays the paramount role in the anthropologist's reconstruction of man's tools and their influence on development. By current accounts, it emerged in East Africa about 2.6 million years ago years ago and traveled, paying part of the fare, with the first migrations of *Homo erectus* out of Africa. The biface punctuates hominin history from the Upper Paleolithic to a hundred thousand years ago and the appearance of Neanderthals and Cro-Magnons.[41]

The biface—a two-sided, multipurpose stone tool—extended the hands' reach out into and their control of the world. Of many shapes and forms (knife, adze, projectile point), the biface—made by crude or refined lithic reduction—is considered to be one of mankind's oldest instruments for shaping surfaces, making objects, and fashioning tools out of other materials.[42] Stone technology attested to hominins' differentiation from animals and our expanding migration over the earth's surface.[43]

Proto-stone tools, which cannot be dated, sequenced, or even assigned to particular hominin groups, carried out elemental work such as hammering, grinding, scraping, shredding, boring, and drilling into surfaces and

immediate subsurfaces. They were not necessarily made, but could be found in ordinary places—at the base of open seams, in mountain streams and rivers, and glacial washes. They could also be roughly made by simply throwing one rock against another. Doubtless, these proto-stone tools, whether found or coarsely made, called intelligence into play. They both expressed wants and needs and, through learning and habit, satisfied them.

Anthropological literature identifies the making of bifaces as the primary source of the development of the human frontal brain. Bifacial lithic technology required, it is contended, consistent and precise methods, established patterns, existing craft traditions, and social cooperation. Biface toolmaking necessitated the procurement of materials, the establishment of worksites, traditions and apprenticeships to pass on skills, and social planning and support. Stone toolmaking called for a knapper's hand and eye in order to chip the right stone in the right way, and it could flourish only where tradition was passed on and social cooperation was constant. Manufacturing required a certain geographic permanence insofar as supplies of flint, quartz, chert, and even obsidian depended on available quarries, trade routes, and places where stoneworkers could practice their craft.

The bifacial hand axe is commonly considered the Swiss Army knife of paleoantiquity. Suggesting how much early technology and strategies relied on mixed and interdependent uses of wood and stone, hand axes proved equally ideal for cutting, stripping, and debarking plants and trees and for turning their outer surfaces and inner marrow into rope, clothing, baskets, and covers. With a handle and a notched and grooved head, the hand axe took on new powers as a powerful adze for flattening soil, breaking soft rock, pounding in pegs, and pulverizing ice, and as a tool for chopping down trees, notching logs for tying, bridging, and climbing, and hollowing out trunks to make carrying vessels and boats.

TOOLMAKING THROUGH THE AGES

Metatoolmaking—making tools that make tools—irreversibly ensured that humans would be *artificial* creatures, skillfully shaped by our hands, tools, and designing mind. Even without access to recent studies of animal tool use, historian George Basalla insightfully wrote: "Humans have a different relationship with the natural world than do animals. Nature simply and directly sustains animal life. For humans nature serves as a source of

material and forces that can be utilized in pursuit of what they choose to call for the moment their well-being."[44]

Extending human control over the exteriors and interiors of things, tools widened human powers. They strengthened the hand's grasp of things and the mind's grasp of meaning. Tools made humans creatures of action (praxis), technique (skills), and comprehension. In this spirit of engagement and transformation of being, Karl Marx was convinced of the transformative and freeing powers of contemporary industry. In its application he espied a new relation between man and nature and the creation of a new humanity in the service of itself. Herein lay principal sources for a humanistic anthropology based on viewing evolution and history as a path to selfhood and human independence.[45]

Twentieth-century anthropologists such as Stanley Ambrose also root their narratives in toolmaking.[46] They attribute the genesis of the human brain—its circuitry and functioning—and the conscious mind to toolmaking. One young American anthropologist, Dietrich Stout, opens a rich and seminal approach when he connects the use of hands and tools and the growth and formation of the brain, and, more problematically, the development of symbols and the emergence of syntactical language and complex social development.[47] Associating rudimentary stone toolmaking with the earliest humans of two and half million years ago, he ties complex stone toolmaking to group hunting, differentiated social life, and the ability to classify and transmit the world, present and past, through language and symbolic representation. So with the intuitional sparks from knapping flying through human society, the human mind is conjectured to have moved from working the surface of stone to human self-making.

This construction of the human hand and action invited a materialist narrative: biology and environment formed hands; hands shaped nature, and they made brains. Starting in the 1930s, European archaeologist and philologist Gordon Childe, a specialist in European history, offered such a narrative with his articulation of the Neolithic revolution of approximately twelve thousand years ago. Of Marxist inspiration, Childe identified a underlying material causality. Agriculture for him was paramount. It increased food supply, which boosted populations and concentrated settlements. Settlements afforded free time, which permitted the refinement of specialized activities such as pottery, weaving, metallurgy, and advanced toolmaking.[48] In turn, centralized control, ecological dominance, and geographic hegemony emerged from advanced settlements and cities. All this was accompanied

and witnessed by imposing megaliths, multiplying walls, and the buildings of roads, canals, ports, temples, and gardens. From this perspective, hand and action preceded society, thought, and symbols; material making accounted for thought and imagination. In search of workers and goods, cities mustered conquering armies and outfitted ships to pillage and commandeer materials and peoples from other lands. Civilizations ultimately advanced to control nature, materials, techniques, and surrounding villages and peoples.

Yet this now seems only a partial and simplified view of a complex story. The Neolithic narrative requires a more multifaceted story, one focused on diverse cultures, discrete historical coincidences and convergences, and particular jumps and leaps; and one that must explain a mind occupied with expanding dreams and imperializing visions of human destiny and meaning.[49] Even if we agree that the Neolithic marks the beginning of the first large-scale and systematic human manipulations of nature, this extraordinary metamorphosis has yet to be fully explained. A successful explanation must reconcile and sequence altered climates and altered ecologies, and increased population and spreading settlements, with exhaustive hunting and the beginning of agriculture.

Beyond this, to explain the birth of city and civilization, there is need to construct a dramatic narrative of man as "king of civilization." Before all interpreters of early history stands a creature who, in the poetic words of historian Jacques Cauvin, had become a conscious "master and possessor" of all living orders. He multiplied the species he domesticated while decimating those that remained *sauvage* (wild). Drawing energy from inert matter itself, he overturned whole landscapes and began the transformation of the planet that continues today. This portrait, Cauvin concludes in the opening paragraph of his *Naissance des divinités* (Birth of the Gods), is disquietingly our own as well as that of early man.[50]

However recent the archaeological and ecological evidence of irrepressible human planetary dominance and social organization, humans were long in preparation for this singular and self-assumed mission. Their preparation involved acquiring skills from hunting and gathering, and their project could not have advanced without social skills learned through living together in large communities. But the formation of the new "lordly" mind also was accompanied by the symbols, myths, and religions of the hundred thousand years preceding the Neolithic. Such a suggestion is supported by the earliest Neanderthal burials; by evidence of the arrival of *Homo sapiens* in Europe about forty thousand years ago; by cave paintings; and by the much more

recent beginnings of language and the abstract and symbolic ways that humans connect the world with words.

From our deepest and oldest inheritances, humans, communally and culturally, have assumed our separation from and superiority to animals (to take up a favorite theme of Cauvin). We presumed, ages before cities and civilizations, a special attachment and relation to gods and spirits, and we called for transformations of life and nature. On this count, as hunter and gatherer, as migrant and settled cave dweller, humans (with variations by place and group) had begun through wish, metaphor, symbol, myth, and ritual to frame and hence to entitle ourselves and our imagining minds as the first earth dwellers. We had found in the deepening interiors of our own minds the means and modalities to take the world into the self, and to refashion the world with conceptions, dreams, and prayers. In this way, our mind became a laboratory in which surfaces and objects were miniaturized, internalized, and made into thoughts about real and imagined beings. Place and time did not contain this wondering and reaching mind, which took the world apart and put it together with symbols, language, art, religion, and what might be called conscious and attentive thought.

Walls and Homes

THE INS AND OUTS OF LIFE

Civilization: instead of an explosion of power, there was rather an *implosion*. The many diverse elements of the community hitherto scattered over a great valley system and occasionally into regions far beyond, were mobilized and packed together under pressure behind the massive walls of the city. Even the gigantic forces of nature were brought under conscious human direction: tens of thousands of men moved into action as one machine under centralized command, building irrigation ditches, canals, urban mounds, ziggurats, temples, palaces, pyramids, on a scale hitherto inconceivable.

LEWIS MUMFORD, *The City in History*

> O my country, I can see the walls
> And arches and columns and statues
> And lonely towers of our ancestors
> But I don't see glory.

GIACOMO LEOPARDI, "To Italy"

HUMANS, LIKE OTHER ANIMALS, live among and by surfaces. These skins and shells, covers, crusts and crystals of animate and inanimate, natural and built world, have no single or simple classification. They do not lend themselves to the uniformities of a periodic table; they are not always predictable or definite; they do not always have the certitude of forms or the conviction of common grids, certain lines, and identifiable colors. As single and discrete or as a profusion, burst, and riot of appearance, they are seen, touched, smelled, and drawn. They are the given, encountered, experienced, and speculated upon. They are built and turned into images and icons. Also, both singularly and collectively, in harmony and juxtaposition, they constitute the wrappings of inner worlds. Although they may be revelations of processes under way (such as peeling bark) or things to come (such as the wind-bent heads of trees), surfaces more

commonly are doorkeepers of places and things. At first glance, touch, and thought, they reveal with clarion clarity or obfuscate and hide what lies within—the inner stuff and interior layers and linings. But surfaces are more than façades of predictable inner worlds. They are a font of cues and evidence. They invite attention and raise curiosity. They evoke a promise of tactile and intellectual passageways to unexpected realms and concealed worlds. They are veritable passageways into human evolution and self-making. They reveal the connections and associations with which humans built their material environments and the inner dwellings of their minds. Indeed, surfaces express our complex and multilayered human body, and a history of surfaces, built up over the past few million years, reveals the substance and motives of our minds and cultures.

In their embrace and dance with surfaces, humans are a species that leapt from nature's endowment to historical development. With great variation across cultures and over immense periods of time, humans defined themselves in terms of surfaces perceived, conceived, made, controlled, and assigned meanings. This chapter, which covers prehistory, early history, and the beginnings of man's wide-reaching control over the earth's micro- and macrosurfaces, considers human development through the use of new materials, establishment of crafts, identification with a plethora of made objects, and the built worlds and intellectual lives that came with the rise of walled cities, established commerce, and eventually hegemonic civilization. It suggests links and themes that unify the past twelve or so thousand years of human history.

From the sedentary life afforded by settlement arose the wider and systematic utilization of technologies and the crafts of pottery, weaving, and metallurgy.[1] Amid domesticated and even irrigated fields, abundant villages and the concentrated populations of Near Eastern cities built megastructures such as walls, burial vaults, ziggurats, and pyramids. Similarly large structures followed later elsewhere in the Far East, in Europe, and in the Americas.

With the first courts and cities of the Near East and Egypt, humans can be seen to have emerged as builders of their own environments and as shapers of the world's ecology.[2] By 1000 B.C. in Sumeria, Egypt, China, northern India, and the eastern Mediterranean, especially in Greek settlements, another significant stage of human mastery over the surfaces of made objects and goods emerged, which formed social bonds and, as we will see in following chapters, constituted the means and ways by which

the world was experienced, valued, and transmitted. With an incremental and additive effect, the manufacture of goods, which began as a trickle of decorative elements marking personal status and serving as symbolic objects, became streams that turned into "rivers of stuff that mark Neolithic, Bronze Age and Iron Age societies—some of it displayed on bodies, some of it packed into households and other architectural forms whose history [on a larger scale] parallels that of goods."[3]

As improved and bountiful goods, tools, and containers allowed humans to shape, gather, and retain things, so written languages, measuring systems, cosmologies, and complex symbolic systems allowed humans to net abstract concepts and intellectually manipulate material worlds. In various cultural modes, civilizations began to speculate systematically on nature, the elements, the gods, and mankind's own place and fate in the greater order of things. As I argued in the preceding chapter, this advance rested on and went hand in hand with increased comprehension, manipulation, and symbolization of surfaces.

The Neolithic revolution, whose direct heir is the transformative contemporary world, consisted of a set of advances in knowledge and in control of micro- and macrosurfaces. Without establishing direct or dominant causal links, the revolution, based on long-acquired skills, involved the use of fire to open grasslands and clear forests; establishing drainage to dry out wetlands; and damming and channeling to utilize water for irrigation, cleaning, travel, and transportation.[4] With tillage, seeding, plowing, and irrigation, agriculture itself shaped fertile river valleys into arable monocultural fields and altered the face, soil, and appearance of human settlement. In Southwest Asia and the Near East, barley, wheat, and lentils were established as principal crops. They evicted most other competing plants as weeds, revealingly called in French *mauvaises herbes*, "bad grasses." Crops had the real and metaphorical effect of differentiating landscapes into partitioned and specialized fields, while defining adjacent lands as gardens, orchards, grazing land, and hunting, fishing, and scavenging grounds. In turn, a regular and abundant supply of food and expanding fields gave villagers the means to increase animal domestication and assure the dominance of selected animals over large portions of the landscape. Domestication, which so defines the face of the countryside, cut paths to and from local and upland grazing areas, encircled fields and villages with walls and fencing, and dotted the landscape with feeding stations, wells, watering holes, and manure piles. Besides determining diets, seasonal rituals, and a sense of humans' place in the order of things, animals

defined humans' work and status and yielded clothing and other goods and artifacts made from bone, gut, and hide.

Crops and animals, by themselves and in the shared relations of field work, food processing, and rural labor, shaped landscapes and economic geographies. From nine thousand to four thousand years ago, barley, wheat, lentils, and domesticated goats, sheep, cattle, pigs, donkeys, camels, and horses appeared in Southwest Asia. Showing the power of crops alone to differentiate the natural and human surfaces of place and region, in the period from nine thousand to sixty-three hundred years ago, rice appeared in southern China, while northern China began to grow millet and soybeans. Around eleven thousand to nine thousand years ago, first in Southeast Asia and then in China, the domesticated pig, which in so many ways shaped human diet and influenced our senses, language, and metaphors, showed up. It was followed a thousand years later by the influential chicken and, considerably later, by the water buffalo, used for plowing.[5]

Agriculture accompanied and advanced in conjunction with accumulating, interlocking, and transformative skills, crafts, and technologies across whole regions. Agriculture introduced human hands and minds to the mysteries and uses of the rich worlds of soils, plant growth, and animal reproduction. It taught its practitioners the rudiments of water control, the use of fertilizer, and the basic skills of planting, harvesting, and butchery, as well as the economics of input and output.

At the same time, inhabitants of settled homes in the Near East scooped the earth for clay and mud to build walls and make containers. They perfected the use of fire, required by metallurgy, pottery, ceramics, and glassmaking, each of which required moving from exterior surfaces to interior substance and back again. Dependent on digging and shaping tools, dried mud supplied bricks, while potterymaking—with its incising tools and later brushes and paint—supplied containers and decorative objects. Made of special clays and fluxes, ceramics, which required additional heating, were smooth, hard, water-resistant, lasting, and colorful surfaces.

Metallurgy, which began with the decorative metals gold and copper, ultimately produced the utilitarian bronze. Bronze, a mixture of copper and far smaller amounts of other elements such as tin, appeared in the Near East and Egypt around 3000 B.C. We assign the name of the omnipresent alloy to the period that began about a thousand years thereafter. Multipurpose bronze was followed by multiuse iron, and today we say the Iron Age started around 1000 B.C. These two most utilitarian metals provided improved tools

for cutting, drilling, joining, fastening wood and stone, and mounting sharp and strong heads and tips on weapons and plows.

With more tools, containers, and goods, whose production was situated on fixed sites and settlements and among extended kinships, humans—in great numbers and with a correspondingly great use of energy and tools—encapsulated themselves in built environments composed of relatively consistent and predictable surfaces.[6] In cities, humans entered a world dramatically of their own making, order, and representation. Cities, which were established as regional economic and military bases, distributed food supplies, organized work projects, formulated and crystallized social hierarchies, and became centralized "chiefdoms."[7] They subordinated the realms outside their walls, which served as shells and skins of this new human collectivity. They sought craftsmen and slaves to extend their transformative powers in the world, and they pursued goods to affirm the order of their own bodies and minds. Urbanites created waterways and trails for armies and commerce. They divined the heavens; they established calendars and sacred rituals in service of fertility and sovereignty's indisputable dominions; and they promulgated laws and codes to assure order, harmony, and justice. With geometry and primitive calculations, city-dwellers measured the size of lands, allotted goods, and even issued money, titles, and receipts. They established armies and appointed administrators and tax collectors; they initiated and maintained vital public works such as walls, dams, irrigation projects, and roads; and they promoted trade far afield while their craftsmen and slaves enabled them to accumulate useful and decorative worldly goods.[8] So humans, in their cities, built, measured, regulated, and homogenized the surfaces of things amid which they knew the world and themselves.

In an elemental way, this marked a revolution in the interplay of body and environment and of hand and mind. Humans—I echo Giambattista Vico's *verum factum*—could now establish their work and thought not only on what they had done, but on what they were doing and intended to do. They had, in effect, placed and built themselves into an intramural world composed of the surfaces, spaces, and things they had made. And this, in some special way, delivered them to a new order that they understood and were responsible for by virtue of being its creators, maintainers, and perpetrators. At the same time, this entitled them to transform the constructed world, in whole and in part, into the symbols and metaphors, the representation and decoration, of their own being and meaning. The built world of shaped nature, made things, and design objects not only contained their bodies, but also both

FIGURE 5. As shown by this sketch of ruins ("Roads, Walls, and Homes," James Dahl, July 2012), stone once formed many of the structures and surfaces of a place. These structures divided, defined, and centered a society, and enwrapped and directed its inhabitants' lives, activities, and imaginations.

expressed and shaped them and their minds. Settlements were worldviews constituted in matter.[9] Lending support to the concept of such a revolution, Trevor Watkins, professor of pre–Near Eastern history, who takes a cognitive approach to understanding, contends that amid these first built architectural frames and settled communities, humans established social orders and sovereignty, consolidated crafts and skills, and formed "symbolic orders of meaning."[10]

The walled house became a primary encapsulator of life and the microcosm of permanent settlement and inhabitation. The center of centers, it put a shell around the most intimate kinship, that of a family living on common land, and it physically defined the stranger as one who did not enter that shell. Home was not just a special space for living; it became the lens through which one saw the world—or, as Gaston Bachelard remarks in his *Poetics of Space,* "Our house is our corner of the world. As has often been said, it is our first universe, a real cosmos in every sense of the word."[11] In *The Domestication of Europe,* archaeologist Ian Hodder sees *domus* as hearth and home, not merely as a metaphor for change in the early Holocene (which

began twelve thousand years ago and continues today), but as a literal vessel and a means to establish a different order of life, just as domiciles did in the Near East and Europe.[12] With its measure of permanence and its physical door, the house, as structure and home, and as a place, enriched and filtered humans' sense of inside and outside, inward and outward, intimate and alien.

Encapsulated in a home and then in a city, humans used these sedentary built environments as their biological platforms for life, as a well of metaphors for thinking, and as a way, to borrow a phrase from Colin Renfrew, to appropriate the cosmos.[13] "In many domesticated societies," as Peter Wilson writes in *The Domestication of the Human Species,* "the house is appropriated to mediate and synthesize the natural symbols of both the body and the landscape."[14] Sitting in a house establishes a corporeal abode and a meditative connection between humans and the surfaces of the world. After being on a regime of seasonal moves and prolonged journeys, which may have been initiated by the two-million-year trek out of Africa initiated by *Homo erectus,* humans now found themselves in settled communities. There, thanks to a relatively certain food supply, they could plant themselves in somewhat fixed places and domesticate themselves beyond simple tribal kinship to complex and abstract social orders dependent on hierarchies of power and status. In settlements established over long periods of time, they could build structures and develop, specialize in, and perfect crafts. At the same time that they took control of the physical landscape and social environment, they shaped and designed their tools and containers. Correspondingly, their outward control of building and things stood in dialectic relation to their inner mastery over language and thought.

THE INS AND OUTS OF THINGS

For approximately ten thousand years, relatively autonomous cities defined their own lives, politics, and, in measure, cultures. This held true up until approximately the past three hundred or so years, when the new, systematic firepower of western, centralized states' cannons began to level city walls. Walls had been the skin, the epidermis, of antiquity; perhaps more than any other structure, they convinced humanity that they could build the face, establish the outer container, and probe the foundations of things. Whether they were mere trenchlines and heaped-up mounds or great edifices of earth, wood, and stone, societies' walls declared, as much as humanity could, their

permanence in being. Within walls, humans built other enduring structures, anchored borders and lands, secured themselves, stored their harvests, protected their livestock, practiced crafts, exchanged and treasured goods, and established continuity in their rituals and symbols.

Wherever agriculture and sedentary life developed, there were tools and other objects to be stored and worked on. Agricultural success required saving seed (at a rate of about one grain saved for every four or five harvested) and maintaining breeding stock. Domestication linked cultivation and preservation, and as historian Lewis Mumford writes of Neolithic settlement in *The City in History:* "The domestication of plants and animals, the domestication of man, and the material landscape all went hand and hand."[15] And with domestication came civilized life, wearing an outer face stating that it was tamed, regulated, regimented, and hierarchical—that it was made not by the commands and whims of nature, but by the will and design of humans.

The first agricultural villages took a form different than the hunter's camp. They were shaped by the work of women's hands and in the models of their bodies. The first gardens and compost piles, the making of decorative and utilitarian vessels of diverse sizes and shapes, and spinning and weaving belonged principally to women. Mumford again pertinently writes, "House and village, eventually the town itself, are the woman writ large." Parenthetically, he notes, "In Egyptian hieroglyphics, house and town may stand as symbols for woman."[16] The world of reproduction and nurturance belongs to enfolding and incorporating vessels and containers. With smooth inner and outer surfaces, this world also belonged to curved and decorated containers, be they made of gut, clay, or cloth, that held, stored, and transported grain, food, and water. Also, decorated boxes, sarcophagi, bags, sacks, and purses carried the remains of the dead, other valued goods, and ultimately written texts.[17] Aside from gut and hide and leaf and tree bark, the first medium used to wrap things—and to put, so to speak, the earth in the earth—was plastic, malleable clay. It could be rolled out, shaped by hand, and fired, which, as artifacts testify, first occurred as early as twenty-five thousand years ago. With the potter's lathe (wheel)—of widely contested origin and date, from Mesopotamia to southeast Europe, Egypt, or China, and anywhere from 8000 to 3000 B.C.—circular vessels crafted of coiled clay could be contoured into regular and smooth (inside and out) vases and vessels to hold, measure, dispense, and store the world. The caressing and intelligent hand turned out utilitarian and prestige-giving jugs, pots, and large amphorae. Ceramics, which required special mixtures of

materials and high temperatures, produced strong, impermeable, colorful, and long-lasting vessels as well as religious and decorative objects, including jewelry and toys. By 1500 B.C. in Egypt, Mesopotamia, and Phoenicia, primitive glass technology, too, offered abundant colorful, lasting, luminous, and translucent surfaces.[18]

Echoing Mumford's notion that—emerging prior to the potter's wheel, the war chariot, or the plow—containers of many forms already had a long career, Clive Gamble judges the Neolithic as a period of the ascendance of containers over tools. He considers them—be they boxes, purses, sacks, pots, urns, or cups—to be the material proxies of the body, and as having developed out of one of two interactions between the body and the world. The first relation was that of human limbs—legs, arms, hands—and their extensions in the form of tools. In this modality, early humans conceived of the world as exterior things to strike, hit, break, chip, split, and bore into. In the reverse direction, as humans gained increased control of their environments, they took the things and materials of the world in hand and compounded them from small to big in a "container revolution" that started twenty thousand years ago. Although this shift was neither absolute nor irreversible, we can see, by a count of artifacts (from the oldest stone tools, dating to around 2.5 million years ago, to the appearance of writing in Mesopotamia five thousand years ago), that there was a decrease in the number of instruments such as knives, spears, walking sticks, pestles, plows, and axes and a corresponding increase in the number of containers and capsules, a multiplication of bowls, pits, houses, stables, barns, caves, pots, baskets, quivers, clothes, shoes, and cradles.[19]

Gamble classifies this "drift . . . from instruments to containers as the dominant mode of invention" as a move away from reductive technologies and toward additive technologies.[20] And I extrapolate from this movement a shift of human activity and intelligence from the outside, the exterior surface of things, to the inside. In effect, this shift from hand axes to pots and pans marked a new stage in fitting the world into our hands and mind. To linger for a moment on the philosophical side, Gamble writes, "Mind extends through the interface of body into matter," and self becomes a composite, hybrid, and plurality of material, social, and cultural networks formed out of the interactions of body, mind, self, other, and the provisional assemblages and arrangements (or *bricolage,* to use a term Gamble borrows from Lévi-Strauss) of objects in made and built environments.[21]

Much of this implies that, in these agricultural settlements and protocities, humans collectively turned their hands, tools, eyes, intelligence,

and social organization away from the outside (from what was happening) to the inside (the development and gestation of things). At this juncture, humans focused on interior substances and processes: stomach and womb; planting seeds and roots; the flow and protuberances of spring; mixing clays; digging wells, mining, and fishing the depths. Their crafts and inventions were increasingly predicated on harvesting nature and fostering and imitating its wealth. Increasingly, the city became a hive and its honey the work of craftspeople, women, and speculators. And much like the bees that Egyptians and Cretans were among the first to keep, Near Eastern and Mediterranean people shuttled in and out of stone walls to gather the golden essence of things they desired.[22] The inside and outside of things further demarcated the human mind and creation.

THE GLEAM OF BRONZE

Soft copper, which was originally found on the ground's surface, was molded into objects by 5000 B.C., but two thousand years passed before bronze—which had separate origins in the Near East and China—commonly turned up in the artifacts of Crete and other eastern Mediterranean islands. (And yet another two thousand years passed before iron entered into large-scale circulation.) Bronze was the gold of this new era. The Bronze Age, signaling the wide use of prestigious bronze by all who could attain it, began in the middle of the second millennium B.C. and lasted a thousand years, until the beginning of the Iron Age. A gift of metallurgy, bronze formed both the face and the substance of tools, decorative goods, and other objects. Useful for many building tasks, it proved crucial in the construction of megaliths. As a medium for decoration, it displayed the techniques of craftsmanship, the prosperity of elites, and the prominence of warriors. Bronze characterized a resurgent Crete and reflected the emergent power of Mycenae. With new tools, tastes, and weapons, the most prestigious Greek cities entered into full participation with Mediterranean life, as modeled on Egypt and the Near East.[23]

The unfolding bronze revolution (as witnessed in China, the Far East, the Near East, Europe, and elsewhere) attested to humans' ability to put the metamorphic power of fire to work. For bronze, in fact, to become more than a decorative material, new skills and crafts had to converge. Beyond an organized social structure that allowed for production, enterprise, and

commerce and a set of geological skills integral to prospecting and mining, bronze metallurgy relied on a mastery of the arts of smelting, pouring, and cooling.[24] An alloy composed principally of copper, plus from less than 5 up to 20 percent tin, bronze requires furnaces with bellows capable of attaining temperatures of at least 1,100 degrees Centigrade. Additionally, other technical processes, all dependent on observing and manipulating surfaces, were used to work bronze, such as hammering it into plates that were riveted together to make utensils and statues; casting with wax over a core of clay or plaster to produce large-scale sculpture; and fashioning relief decoration with *repoussé* work and incised ornaments, especially mirrors.[25]

Lighter and stronger than gold, brass, born of furnaces' and forges' transformative magic, shimmered as the era's wonder material. Malleable, strong, smooth, not brittle, lasting though corrodible (turning pink or salmon and, once corroded, lime green or even brown), bronze's many properties invited a wide range of uses. Aside from its alluring aesthetic quality of smoothness, bronze made sharp and strong edges, the cutting teeth of file and saw, and pointed and probing surgical tools. It made long, flat swords with keen blades. It furnished stonemasons with strong chisels and heavy-headed mallets; it supplied carpenters with hammers, nails, and drills. Hammered into long, flat, thin bands, it proved architecturally significant for high-tensile wrapping and the joining of stone and wood columns. At the microlevel, bronze facilitated an age of making and commerce when it was used to make measuring tools such as styluses, calipers, weights, and scales. It underwrote communication and exchange in the form of currency and seals. Aside from furnishing high-class cookware and vases, bronze was made into pleasing jewelry and trinkets—rings, bracelets, and the like—and helped equip early Egyptian, Near Eastern, and Greek surgeons with cutting, probing, and separating instruments.

Beyond this, once annealed, it was ductile. Finely hammered and pounded thin, it proved to be an excellent outer cover to wood and leather, and as such its most prestigious use was in fine shields, helmets, swords, and spear points, of which Homer so amply and diversely sung. And it found a singularly important use in early-fifth-century Athenian naval strategy. Molded in sand and wax, bronze encased the ramming prows of Themistocles's two hundred triremes—which were aimed against any future invasion from the East.

Bronze supported and expressed the military hegemonies, the pursuit of prestige, and the conspicuous consumption of the increasingly

cosmopolitan and prosperous peoples of the eastern Mediterranean. It glorified the warring elite of the Hellenes, who, by Homer's accounts of the Trojan War, were so numerous that he "could never tally, never name / not even if I had ten tongues and mouths / a tireless voice and the heart inside me bronze."[26] Homer had Old Priam, set on retrieving his son Hector's body, declare: "And if it is my fate to die by the beaked ships / of Achaeans armed in bronze, then die I shall."[27]

Though comparatively late to enter the Bronze Age proper, people on the Greek mainland and islands—never rich in copper or tin, their own veins of silver and gold still buried deep below the surface, and their closest source of ore in northwestern Europe—learned to value bronze, as they could trade for it and use it in place of stone, flint, and obsidian for dagger blades, axes, fishhooks, nails, and any number of woodworking tools.[28] It is hard to think of the Minoans or Mycenaeans without recalling Agamemnon's golden funeral mask or their bronze spear points, helmets, breastplates, shields, and swords. Homer sent the Achaeans to Troy "in gleaming bronze." And he had Achilles's mother, the goddess Thetis, equip her son with a divinely fashioned, decorative, cosmological, partially bronze shield made by the god Hephaestus, one that declared his position among men and one whose multiple layers foiled Aeneas's deep-seeking spear:

> Famous gifts of the gods do not break lightly. . . .
> So now not even seasoned Aeneas' heavy shaft
> Could smash Achilles' shield:
> The gold blocked it, forged in the god's gift.
> It did bore through two plies but three were left
> Since the crippled Smith had made it five plies thick
> With two of bronze on the outside, inside two of tin,
> Between them one of gold where the ashen spear held fast.[29]

REACHING SAILS AND ROLLING WHEELS

Other vessels besides the beaked ships of the Aegeans took ancient peoples on great journeys, both on the seas and in their dreams. Wind-flying and water-floating surfaces, ships carried soldier and looter, colonist and trader to and from distant lands. Deep in the past, boats float at the outer rim of our historical horizons. They move in the protoforms of hide- and bark-covered dinghies, fire-hollowed dugouts, and papyrus rafts. It is

hypothesized that sixty to forty thousand years ago, people used rafts of some sort to cross a hundred or so miles of open water to settle in Australia; and that sailing in outriggers and catamarans accounted for the very early dispersal of Austronesian and Polynesian languages to Madagascar and throughout the Pacific and Southwest Asia, thanks to the favorable and biannually reversing winds of the Indian Ocean, the Indonesian archipelago, and the China Sea.[30]

The seagoing sailing ship, which dates in the Aegean from approximately 2000 B.C., was a triumph of the intersection of natural and human-made surfaces.[31] A volume on the philosophy of shipbuilding is correctly introduced by the statement that sailing ships were "the most complex construction of any society until just before the Industrial Revolution."[32] A floating container, the ship was a mobile home, a transporter of humans and goods, a military barracks, and a portable fort. It was invented via an accumulation of skills and crafts, tools and techniques that made it possible for humans to navigate and negotiate the face of seas and winds.[33]

Oars of diverse form and shape were designed from simple paddles into the rows and banks of oars that characterized antiquity's bireme and trireme ships. Complementing and supplementing sails, oars remained indispensable for moving a becalmed ship, entering and exiting ports, and approaching uneven shorelines, as well as for boarding, attacking, and ramming—piercing the membranes of other ships—as Themistocles immortalized via his large, bronze-tipped Athenian navy's destruction of the Persian fleet in the Battle of Salamis in 480 B.C.[34] Sails, anything but mere sheets of cloth, were designed to catch and hold the winds, as well as to evade them and outlast the weathering of climate and seasons. Whether wide and low or slender and lofty, sails had to be strengthened, shaped, and fitted for mounting to masts, booms, spars, flooring, and gunwales. Forming heads and bodies well above hulls and decks, sails—singularly and in conjunction with the enclosing keel and steering tiller—had to be operable: they had to be opened and spread full, trimmed, furled, and held close and tight by the sailors' arts of roping, knotting, and rigging. A complex assemblage of water-cutting edges and taut airborne sheets, sailing ships needed efficient speed, direction, and course.

Seamanship requires a complex of skills and arts, involving mastery of the face of water and wind, the edges of bow and rudder, and the catch of bow and sail.[35] Assembling a seaworthy ship tested an age's and place's carpentry. Carpenters had to join the planking of a ship—whether by sewing, clinker method, lapping assemblage, or mortise-and-tenon joints (or another sort

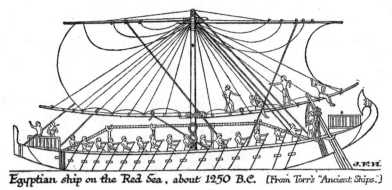

Egyptian ship on the Red Sea, about 1250 B.C. [From Torr's "Ancient Ships."]

FIGURE 6. "An Egyptian Ship on the Red Sea, about 1250 B.C.," published in 1920. Its sails and roping, oars and rudder, planking and caulking testify to the boat as perhaps the first truly great joining of surfaces and the instrument of the first far-reaching expeditions.

of tongue-and-slot method). Sealing and caulking the ship's outer skin to guarantee that it was waterproof required knowledge of tars, resins, and other sealants—or, as some now suspect was used by the Egyptians, the first great sailors of antiquity, a combination of wax and linens.[36] Many other crafts and skills underwrote shipbuilding and sailing.

In the second millennium B.C., the Egyptians, Cretans, and Greeks took their full plunge into the Mediterranean. Ships extended the reach of maritime cities and empires. As single vessels or in a fleet, ships made efficient and artful use of the winds. They moved across the changing face of the waters for the sake of fishing, war, colonization, communication, and hauling materials, worldly goods, slaves, and specialists. Despite the fickle gods of sea and wind, ships made seascapes an object of human will and dreams.

Wheels did not roll on land as smoothly as ships moved across deep seas. Wheels, which are dated to a million and half years ago (and are so often mistakenly joined in origin to humans' use of fire), did not serve vehicles until approximately five thousand years ago, in the Near East. Like pottery, gold, bronze, and copper, they were used first for decorative and prestige-marking ends. Wheeled carts ceremonially transported royalty to appointed stations and delivered the dead to their final resting places. Miniaturized, such carts served as royal gifts and toys. And in the form of ornate chariots, they chauffeured aristocratic warriors to staged battlegrounds. Rustic carts carried out ho-hum local chores of lugging goods from field to village and back.

The limited role (and roll) of wheels between the time of Isaiah and the time of early Christ is heard in Matthew's John the Baptist's cry in the

wilderness: "Prepare the way of the Lord, make his paths straight. Every valley shall be filled and every mountain and hill shall be made low, and the crooked shall be made straight and rough ways made smooth. All flesh shall see the salvation of God."[37]

Stretches of long, flat, dry, solid, level, and consistent surfaces were scarce. Road construction and maintenance took great legions of men and systematic command. Everywhere roads were thwarted—by wetlands, rivers, deserts, hills, forests, and steep and rocky mountains. Inevitably, such barriers gave way to narrow, sinuous, and broken paths. On long trips, humans on foot and animals hauling in teams proved more dependable than wheeled vehicles.[38] Until recently, the great majority of merchants, soldiers, messengers, and travelers who could not find their way onto boats placed their bets on themselves rather than on wheeled vehicles. Wheels, in fact, did not find accommodating surfaces on the earth (of course with limited exceptions in Rome, China, and a few other locales) until the past two hundred years, when in developed nations, as we will see in chapter 7, earth-moving machines, civil engineers, dynamite, asphalt, concrete, and iron produced bridges and long, flat roads. And the train, the first engine to master continents, ran on its own steel tracks.[39]

WALLS

Cities have had demarcating walls since the earliest urban areas arose more than seven thousand years ago. Stone walls and roads formed and held the history of cities and civilizations. Relying on lines, curves, and circles, rectangles and sharp angles, walls, like no other human-built surface, constitute a human delineation of space. Made of various materials and with diverse techniques, the walls of each city were its face over centuries. They were scored by the powers of the lashing and abrading wind, the growth of mold, the prying of frost and ice, and the seismographic movements of the earth. Battering assaults and sieges and the singeing and cracking powers of fire destroyed walls, but most destructive of all was the intermittent plunder of old walls for the sake of erecting new walls to accommodate growing populations and craft industries.

The walls of early Near East settlements encircled only a couple of acres and tens of families. Greater walls became the shields and masks of full-blown cities containing hundreds of acres and tens of thousands of citizens.

The encircling walls at Mycenae, the richest town in Greece at the end of the second millennium B.C., enclosed a mere twelve acres, making it, in the opinion of Mumford, little more than "an armed citadel" when compared with such cities as Karkemish on the Euphrates in Syria, which covered 240 acres, and Ur, the early home of Abraham, with its canals, harbors, and temples, which occupied 220 acres.[40]

Walls were the shields and the prominence of cities. Defining interior and exterior like the shell of an egg, walls protected necessary and enshrined treasures. From behind walls kings ruled; on their ramparts priests augured and divined and kept tabs on heavenly and earthly movements. Walls encircled wells and springs and defended ports and the confluences of rivers. They also surrounded "umbilical" centers where great pacts between men and gods were sealed and reconfirmed by sacrifices and blood covenants, such as those made in the Aztec pyramids of Mexico.[41]

Walls presented an array of surfaces. They performed multiple functions, both utilitarian and aesthetic. They varied in height, thickness, and length. Their texture was dependent upon natural topographic features; their inhabitants' design and technology; locally available materials, such as wood, rock, mud, clay; and cut and laid stone and brick. Diverse forms of masonry characterized the rock walls of Greece, each stamping a distinct imprint on human experience and imagination.[42] Although walls eventually also become megalithic wonders in the forms of pyramids, ziggurats, temples, and hanging gardens, walls collectively had humble origins.[43] These included the trenching and mounding of earth around early agricultural settlements, and structures made from the first mud heated in kilns. Perhaps even prior to serving as defensive structures in the Near East, walls formed storehouses, stockades, and the outer surface of dwellings. Walls on upland environments (notably evidenced by the Incan Machu Picchu) not only terraced the earth, but also furnished platforms for stairs between ascending levels.

City walls, though vulnerable and, from a geologic perspective, ultimately temporal and frail, stood on the human landscape as foundational and monumental. They seemed to be the enduring face of their ages and the measure of memory. They represented social permanence and read as the longest page in the book of history. Walls, the largest, flattest, and most definitive surfaces of built architecture, formed the shell and cover of the human hive and egg. Yet they wrapped life in a familiar theater and an imploding drama. Sporting events and mortal duels were staged in their

shadows, and walls—none as much as Jerusalem's Wailing Wall—provoked vows and tears and the recitation of one's ancestry. Florence's walls, rebuilt six times, testify to the dramatic growth, in the High Middle Ages and Renaissance, of its community, as well to the growth of other Italian cities and to the birth of modern Europe as a land of cities.

Even a short list of ancient walls (the Anastasian Wall in Turkey, Hadrian's Wall in England, the walls of Ávila in Spain, and the much-reconstructed and disputed nine walls of Troy) reveals the telling power of the surface of stone. Jericho, founded eleven thousand years ago and considered the first walled city of the Near East, had walls that grew in height and thickness over the course of twenty successive settlements.[44] The Great Wall of China cumulatively spans more than five thousand miles of uneven topography and was two thousand years in building and rebuilding.

Architectural historian O. Siren writes of China's walls:

Walls, walls, and yet again walls form the framework of every Chinese city.... There is no such thing as a city without a wall. It may be just as inconceivable as a house without a roof.... There is hardly a village of any age or size in northern China, which has not at least a mud wall, or remnants of a wall around its huts and stables. No matter how poor and inconspicuous the palace, however miserable the mud houses, however useless the ruined temples, however dirty and ditch-like the sunken roads, the walls are still there, and as a rule kept in better condition than any other construction.[45]

The father of Greek history, Herodotus (ca. 484–ca. 425 B.C.), gives a stunning description of the walls and ports of Babylon. Walls 76 feet in width and 304 feet in height—paralleled by a wide and full moat—encompassed a singularly immense city with a perimeter of approximately 55 miles. The walls were made of clay bricks and reeds, and the ramparts were so wide that two four-horse chariots could ride abreast. In Herodotus's words, "Around the wall they installed 100 gates all of bronze, including the pillars and lintels."[46]

The very walls of Rome, as revealed by nineteenth-century archaeological excavations, tell the long history of the expanding city, whose civil engineering and building talents were unsurpassed in the construction of roads, bridges, aqueducts, and domed structures, often in brick with arches, the Pantheon foremost among them. In his classic *The Primitive Fortifications of the City of Rome,* historian John Henry Parker identifies at the city's heart its first eighth-century B.C. walls.[47]

Rome's walls, according to historian Numa Denis Fustel de Coulanges, rested on foundations other than those created by a feat of engineering. Beyond being a technical accomplishment and social undertaking, the walls constituted a collective religious and cosmological act. They enclosed the city in one hallowed boundary that encircled with a single ring home, sacred soil, and the dead. "Every city," he writes, "was as a sacred enclosure . . . every city was a sanctuary . . . every city might be called holy."[48]

As we'll discuss in the next chapter, on decoration and representations, Fustel de Coulanges also points out how elemental the marking out of sacred space was across cultures. Greeks, he comments, relied on the Oracle of Delphi; the Samnites, on inscribing the trail of the sacred wolf or the green woodpecker; and Latins, instructed by the Etruscans, on the auguring flight of birds. The day that the walls' foundation was begun was, for the Romans, a cosmological moment. Inscribing boundaries required early Romans to jump through a fire of purification. They then had to dig a small circular trench, and into it they threw a clod of earth that they had brought with them from their homeland. It contained the remains of the ancestral dead, and by this metaphorical act the hole, the *mundus,* transubstantiated the new land into a fatherland and joined the living to the dead and the fatherland. And at the very spot where Rome's foundations began, legend has it, Romulus set up an altar, a holy fire, and established a sacred hearth for the city. And around that hearth Romulus traced, with a copper plow drawn by a white cow and white bull, a furrow, the soil of which could be thrown only inward, and which no one dared transgress but at the cost of his life. At points along the furrow, gate sites were designated. On the furrow, or slightly inside in it, sacred walls were erected. The walls, thus constituting a special face of the world, were seen, understood, and acted on as a layer connecting people, heaven, and earth, the living and the dead, and the present and the past. And walls forever declared who the rich, powerful, and commanding of a place and region were.

In some analogical way, we can conjecture that ancient peoples built their lives and minds into walls. Literally joining people's material artifacts to their sense of the sacrosanct, city walls functioned as bonds of religion that etymologically tied *(re-litigare)* people together. Walls visibly defined a sacred boundary, encapsulating a society and geography into a cosmos, which people experienced, named, and came to know by a mere glance.

Walls staked out a landscape, a place, a people, and a time. Walls, foundational in human building, anchored places at the edge of a sea or the top

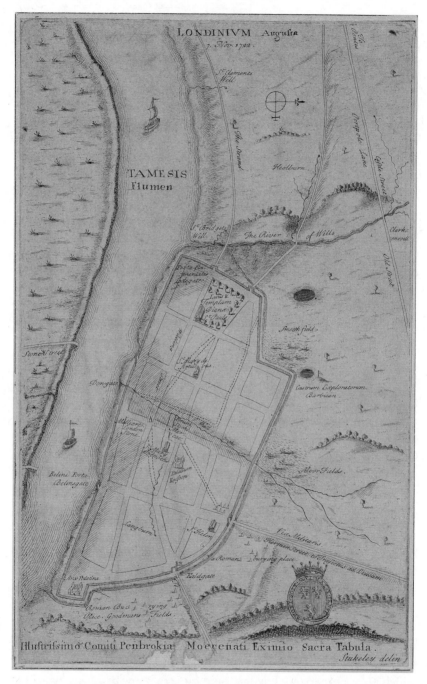

FIGURE 7. "Londinium Augusta," a classic map showing the intersection of the walls on a Roman city and river banks executed for William Stukeley, for his *Itinerarium curiosum* (London: Printed for the author, 1724; 2nd ed., 1766). From *Dictionnaire encyclopédique Trousett* (Paris: Girard & Boitte, 1886–91).

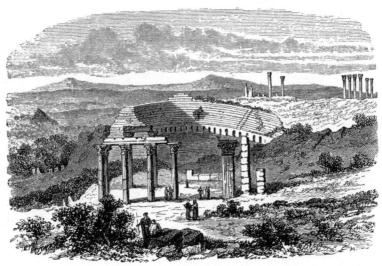

Le petit théâtre à Gerasa.

FIGURE 8. Jerash, the city of a thousand columns, which lies in the northwestern highlands of Jordan, was a spectacular Greco-Roman provincial capital. Rock quarried and hauled in from many places was used to build blocks, columns, capitals, and paving stones; each structure testified, prima facie, to the city's power to gather, build, and command. From *Le Magasin pittoresque,* Paris, 1837.

of a hill or mountain. And seen from another angle, walls danced in the light of day. Their faces were ever afresh with meaning. They were dynamic structures, alight with movement. Long and reticulating, like great snakes, walls flowed out in sinuous curves across the countryside, down to seas, or in pursuit of the banks of meandering rivers.

Perhaps a biological analogy proves more economical. Walls were the epidermis of a city—the living and respiring skin of an organism, breathing in and out.[49] They kept out toxic invaders—the diseased, poor, foreign, and alien. Gates and doors formed the pores and orifices of cities. Walls monitored transactions with the surrounding world, both emitting and admitting vital things.

Walls cannot be thought of without considering exteriors and interiors, which are ever locked in discourse between surfaces and thing, outside and inside. So our mind swings on the hinge of Frost's line in his commonly cited poem "Mending Wall" that asks whether "we are walling in or walling out." With its doors, gates, and ports, the wall's nature as both inside and outside becomes axiomatic. Walls, although explicit, also signal deep implicit

springs, hidden cisterns, vaulted treasures, and secret crypts—what must be sequestered and hidden from eye and hand.

As if to prove that outsides have insides, myth has fashioned the complex walls of Knossos's palace, on Crete, into a labyrinth.[50] The labyrinth held the horrible Minotaur, half bull and half man, the fruit of the unnatural coupling of King Minos's wife, Pasiphaë, with a bull, and it was built at King Minos's command by that master Athenian craftsman Daedalus, whose copulation device had facilitated Pasiphaë's sin. Later Daedalus himself, with his son, Icarus, escaped imprisonment in either a tower or the labyrinth itself (depending on the source) by Minos because of their aid to the Athenian hero Perseus or another wrong. Daedalus engineered their escape, fashioning wings from feathers and wax. Foolishly, Icarus flew too close to the bright and burning face of the sun. His wings came unglued; down he plunged into the deep, dark, and waiting sea.

BEYOND THE WALLS

The world beyond the sight of city walls was not domesticated. It was wild and unpredictable, forever threatening. Against the dangers of nature the superhuman Gilgamesh built the walls of Uruk after the Flood. Beyond the walls of Mesopotamia and Greece, alien peoples, forces, and gods roamed. Enraged seas and rocky coasts tore apart fragile ships and sent them to the depths. The oceans carried armies and pestilence to one's own shores. Unpredictable things occurred beyond careful regulation and tending and prophecy's telling. Tomorrow overthrew today, and fate encircled intentions and corralled freedom. People scanned the face of everything—humans, animals, and landscapes—to divine fortunes. Abundant local temples, and even whole islands, were devoted to prophecy, riddles, and cures—and in their search, the Greeks were not alone. Everywhere altars were set up to appease gods and powers of all origins and ilk—earth and sky; male and female; mixtures of divine, animal, and human. Humans needed protectors, patrons, and warrantors. The face of things was porous with apparitions, and time was saturated with tragedy. Ex-votos were amply used to secure wishes and to express thankfulness. Blessings and curses shaped speech, and being danced in "the crooked slant of light," to borrow from Emily Dickinson.

In comparison to the people and settlements of early Neolithic and protohistorical civilizations, treated earlier here, the Greeks and their

contemporary civilizations had tamed the surfaces of the world within the shadows of their walls. On an unprecedented scale, they had bent the world to their eyes, hands, needs, pleasure, reasoning, will, and aesthetics. No doubt heirs to the ingenious Egyptians, aesthetic Cretans, and other Mediterranean societies, the Greeks had learned to build a flourishing life between earth and seas, mountains and small valleys, mainlands, islands, and colonies. They based their very wealth on movement and commerce, exchanging goods, crafts, and ideas at home and abroad. At the same time, the Greeks were comparatively open to the world and to change. With city-states reaching from Asia Minor across the eastern Mediterranean to Sicily and beyond, the Greeks, among themselves and with alien empires, conducted complex policies that secured trade, organized alliances, secured peace, and prepared and concluded wars. At home, starting after the heroic Homeric periods and as early as the seventh century B.C., the Greeks sought a more complex balance and equilibrium. Through multifold constitutional experiments, of which Aristotle and his students collected more than 153, the Greeks grappled for a political order that transcended kinship and kingship.[51] For these reasons—inherent in their geography, commerce, and independent politics—the Greeks were disposed to take hold of the world and prove themselves inventive and resourceful in language, measurement, geometry, the arts, philosophy, and speculation.

By the time of Herodotus, the Greeks had a full tool chest for building their individual lives and their *poleis* (city-states) as their own—and, as no other people and culture had done, they had established a large literature and a full public discourse for stating, valuing, and debating their personal and communal accomplishments and intentions.[52] Techniques underpinned their life. Farmers mastered their landscapes, plants, and animals, while craftsmen made objects, created tools, utilized lifting and moving machines, and erected structures and homes. Indeed, the Greeks, who were great thinkers, also became truly skilled makers. Their highest attributes, to use two Greek words, were *tekne,* which combined notions of art, craft, and skill, and *praxis,* which signified doing and practice.[53] Craftsmanship demanded not just an understanding of materials and the tools with which materials are fashioned, but, when generalized across a society, it produced a genuine pride in the process of production itself. As taming surfaces provided a doorway to understanding and exploiting interiors, so Greek craftsmen, by their skill and product, analogously created a mind trusting of its own eyes and hands, figuring, shaping, and producing. Or to quote from Sophocles's *Antigone,*

"With cunning beyond belief, / In subtle invention of art, / He goes his way now to evil, now to good."[54]

In 454 B.C., Pericles, according to Plutarch's account, confessed the dependence of Athens on its craftspeople when he announced his intention to move the treasury from sacred Delos to the impregnable sanctuary of the Acropolis in Athens and to put its craftspeople on state salary for its construction:

> For building we shall need stone, bronze, ivory, gold, ebony, and cypress wood, and to fashion them, carpenters, masons, dyers, goldsmiths, ivory carvers, painters, and sculptors. Our shipwrights and seamen will work to bring the materials we need from overseas and our wagoners will find employment hauling materials we need from the hinterland. Every auxiliary craft will be stimulated, from metallurgy to cobbling, and every trade will be organized under a chief, becoming part and parcel of the services of the state. In a word, all the different needs will be carefully planned and catered for and prosperity will spread to every citizen of whatever age and trade.[55]

Even a hundred or more years before the age of Pericles, in the fifth century B.C., the Greeks understood themselves as a creation of the plethora of their own crafts and techniques. They grasped that their ability to shape things made them at home in the cosmos. The virtues of the crafts echoed in the poetic attributes of select gods. There were the gods Hephaestus and Athena and the ingenious craftsman Daedalus (born of Athenian royalty and tutored by Athena). Artifice itself was understood to rely on daemonic powers.[56] None of the crafting divinities, however, was equal to Hephaestus, whom the Romans knew as Vulcan. A limping, ugly, and inferior son of Hera (the daughter of Kronos and the wife and sister of Zeus), he had whole stables of inferior divinities assigned to the crafts of smithery and metallurgy. Hephaestus's powers extended to the binding and joining of surfaces, the making of objects, and the forging of nets, in which he ensnared his mother, Hera, and his cuckolding wife, Aphrodite, and her clandestine lovers. (Hephaestus even fashioned and gave life to animals, statues, and a walking tripod.) Local cults, temples, and popular tales elevated this lesser Olympian brother of Zeus to the father of fire, the master of the forge, and the shaper of gold, silver, and bronze. All of these metals he formed into Achilles's impenetrable layered shield, with its singular visage.[57]

Athena, divine patroness of Athens, alone or in combination with Hephaestus, was another divinity of crafts. She wore dazzling armor and was a practitioner and a source of war and its guiles. She was also a special protector over smiths, potters, and woodworkers, including woodcutters,

carpenters, and chariot- and shipbuilders. The mistress of harnessmakers and ship pilots, Athena, also known as "the working woman," was the jealous and unrivaled patroness of weavers, who, analogously to carpenters, turned threads into structures and assembled fabrics, webs, and nets. Inventor of the swing plow, Athena, who crushed men in wild and unrestrained war, also aided the dexterous crafts and knowing skills by which people built and feathered their nests in the world. She, too, sported, according to Homer, an indestructible, opulent, and intimidating shield of Hephaestus's great crafting.[58]

Craftiness also characterized human heroes. There was the Athenian founder Theseus, the monster-killing Mycenaean founder Perseus, and cunning Odysseus, but in dexterity, craft, and invention, none rival Daedalus. An Athenian descendant of Hephaestus and Athena, he improvised what others could only imagine. He built living statues and furnished carpenters and architects with the hatchet, the plumb line, the gimlet (a small hand tool for boring holes), and glue, whose history in joining surfaces is as long, deep, and sticky as glue itself is multiform and multiuse.

Homer's *Iliad* also testifies to the important place of crafts in early Greek society. Even at the time of Solon (and afterward), select craftspeople were free citizens who could even fill designated positions on the ruling councils as archons. Called *demiourgoi,* meaning "public workers," these independent specialists were different from the simple manual workers engaged in the mass manufacture of goods.[59] Though not members of the highest and most powerful classes, the diverse *demiourgoi* were never segregated, as in India, into a caste or classified and awarded certain status, as in China.[60] Craftspeople in Greece included not only blacksmiths, metalworkers, potters, weavers, and laundry workers, but also flutists, acrobats, and cooks, who were indispensable to public displays and celebrations. Additionally, there was an assemblage of intellectual workers, such as soothsayers, physicians, and bards.[61] The highest class of artisan directed the skills and work of others (such as goldsmiths and shipwrights) whose crafts were hidden in secret traditions and elevated by the inspirations of patron gods.[62]

Assuming that humans progress from familiarity to presumption to disregard, I hypothesize that at some point Greeks came to take for granted much of what they regularly encountered in their environments and the covers and surfaces of their things.[63] And in some proportionate degree, they correspondingly devalued craftspeople who made the common faces of their world. However, in early periods, Greeks would not have enjoyed an

abundance of made objects or experienced the skilled products of hand and tool. They would not have evolved beyond the newness and the implicit wonder of making things and building the world. They were generations away from demarcating (as rabbinical and intellectual cultures regularly do today) the works of hand and body from those of thought and writing. Surfaces still startled, hid surprises, had an indwelling spirit, and evoked speculation; products still scarce and necessary held attention and value. Embodied in the necessity of things, the majority of ancient Greeks did not live in the privileged world of philosophical and political discourses. Indifference to shaping the fertile skin of the countryside and assembling the structures and homes of port and *polis* awaited the surfeit of richer days, and the relegation of work to slaves, domestics, and women.[64]

Yet despite their eventual indifference, crafts still displayed power, beauty, and the status of their owners by their mere shape, size, and intricacy. Walls, doors, and temples, and the like testified to power and magnificence. Arts, with primal power, expressed a place's meaning. The highest activities of speech and thought themselves were understood as crafts and arts. The Greeks knew that they deciphered nature, outwitted their enemies, and yet still puzzled over the riddles and paradoxes of what their eyes saw, their hands did, and their minds unlocked. Greeks considered thinking, according to twentieth-century German philosopher Martin Heidegger, to be "a *tekne* and *poiesis,* a process of deliberation in the service of doing and making."[65] Aristotle, for instance, conceived of ethics as an applied set of rational, social, and emotional skills that joined such values as friendship, pleasure, virtue, honor, and wealth. Politics itself was idealized as the craft of governance and the art of legislation. Through it citizens fashioned the boundaries and substance of their free lives in the *polis.*[66] Not without conscious analogy to the skillful carpenter, Greek intelligence chose, cut, fashioned, and joined ideas to describe and explain the world.

Like other and older civilized peoples of the Near East, Egypt, and China, the Greeks measured things and reckoned the order of being. With ruler, square, compass, protractor, balance, measuring containers, and weights, they described, recorded, and apportioned the world by its outer surface dimensions and the weight of its substances. With diverse measures, they uniformly reduced things to their quantity, length, width, volume, and weight. For the most utilitarian reasons of exchange, trade, and commerce, they put interchangeable and calculable numbers on things. Greek geometers advanced their craft, freeing it from fluid senses and ephemeral

manifestations. Anticipating modern science's ability to calculate the world, they delineated the surfaces of earth into straight lines, squares, rectangles, circles, and triangles, polygons, and irregular shapes. Using angles, Greek astronomy charted the stars and the movement of the heavens. And without the aid of the calculus and physics that birthed modern science, which we will examine in chapter 5, the Greeks produced calibrated machines and conjured a world of force, motion, and levers. Archimedes of Syracuse championed the birth of science and the presumption of technology; across a long literature, he is reputed to have said, "Give me a place to stand and with a lever I will move the whole world."[67]

And though the Greeks did not finally move the world, they profoundly altered their own position and that of all their heirs in Europe, around the Mediterranean, and throughout the world. They constructed a world in which they saw, sought, and found the order and the laws of creation, as they forever moved back and forth between hand and mind, between the outside and the inside.

Decoration and Representation

We have become complex, multilayered, hybrid minds, carrying within ourselves, both as individuals and societies, the entire evolutionary heritage of the past few million years.

M. DONALD, IN CLIVE GAMBLE,
Origins and Revolutions

Les objets sont en dehors de l'âme, bien sûr; pourtant, ils sont aussi notre plomb dans la tête. (Surely objects are outside of the spirit; however, they are also the weighty substances of our thought.)

FRANCIS PONGE, IN CARL KNAPPETT,
Thinking through Material Culture

HERE I TURN BACK TO ADVANCE our chronological exposition. I do not argue only that we live by surfaces perceived and conceived, but that we participate in being and know ourselves through decorative and representative surfaces. I suggest, more tangibly, that we come to meet, construct, and imagine ourselves within the embracing walls of city and home, before and inside the temple, and at the very point that the stylus cuts clay.

I started work on this chapter with many questions, none of which I brought to an entirely satisfactory resolution. I asked what decoration is. I did not seek it in the aesthetics of the beautiful or the impulse to make and embellish. Rather, I sought decoration's roots in the perception and rendering of light, color, shape, proportion, symmetry, texture, pattern, context, and juxtapositions on surfaces. At the same time, I could not query decoration without interrogating its companion, representation, which conceptually inspires, guides, and shapes decoration in terms of traditional renderings and prevailing worldviews of the order of things. On the basis of this point of view, I drew an analogy: Though parented by the immediacy of eye and the skills of hand, decoration goes out into public wearing conventional identifying signs and even sporting a full symbolic face. On such outings (to extend this analogy for one more sentence), decoration

associates itself with the meaning of its companion, representation. The correspondence between decoration and representation has meanings beyond those discerned by the analytic eye, articulated by parsing language and elaborated by rational judgment. This creates a junction, a correspondence, and an indivisible union between myriad things as they exist and the plethora of human meanings. Surfaces fill sensations with every sort of declaration about things and their orders, and humans reciprocally place them in contexts, arrange them by similarities and differences, and transform them into signs, images, metaphors, and symbols. A single glance takes hold and frames its object. It recognizes clarity and ambiguity. It acknowledges singularities and juxtapositions; and in terms of shape, size, and color, it instantly categorizes likeness and differences. Motion itself signals much: what is approaching and receding, coming and going, converging and coinciding, dispersing, coming undone, and being destroyed. Instantaneously, the mind observes the assembling of a world of "epiphanies and revelations," to use a phrase I favor here; and, when the mind's attention and interest are won, it takes up what is configured, posited, juxtaposed, opposed, transposed, and—with greater interior and conceptual resonance—supposed and proposed. In this way, humans merge surfaces they perceive and conceive, decorate and represent, live and experience.[1]

Individuals and cultures meld together surfaces with both decoration and representation. Anthropologist Larry Zimmerman suggests this in the case of North American Indians. In his *American Indians,* he shows how they represented the earth, its animals, plants, and humans themselves with beads, clay, reeds, porcupine quills, leather, and feathers in their crafting of footwear, cradles, clothing, basketry, pottery, masks, and totems. Through geometric and abstract design, these crafts suggested the compass, which pointed and gave meaning to the dwellings of the gods, the seasons, and the origin and life of the Indian peoples.[2]

THE TONGUES OF SURFACES

Decoration, born of the languages of surfaces, covers surfaces with "tongues" that sing songs to human eyes, senses, hearts, and minds. Decoration forms the images, textures, and appearance of surfaces as they are perceived, grasped, and conveyed. Decorations reveal making and designing hands—the craft's tools, instruments, materials, means, and traditions of making. Decoration

wraps and slices surfaces into sheets of social meaning and provides food and bone for culture's gnawing.

Decoration uses marks, lines, colors, patterns, and illuminations to make surfaces that catch the eye, fit the hand, accompany the ear, satisfy the body, and strike the spirit. It turns materials into goods, tools, instruments, and entire landscapes. Rich in association, decoration is diverse in its origin, use, users, place, and myth. It can be spontaneous—produced by a mere whisk of the hand—or as tedious as a repetitive grid; it can be as elaborate as complex traditional designs composed of intricate lines, ornate curves, and interwoven symbolic systems. Decorations can depict the surface chop of water in a light breeze or conform to the subdued etiquette of a discreet court.

Decorations belong to the materials from which they arise—wood, stone, bone, or shell—and they wear the countenance of their materials' aging. The craftsman must understand the material that he works and sees. Its grain, elasticity, and shattering point; its response to heat, water, and light; and its disposition to fuse and mix or to remain separate—each characteristic, singularly and in combination, commands the hand and eye. Decorations also stem from our bilateral body and the movement of our five-fingered hands and scanning and adjusting eyes. The genesis of decoration is found, too, in the elemental nest of our consciousness, that weave of perceptions, figures, proportion, symmetry, color, and texture. Likewise, decoration belongs to both single and associated senses, to the mind of the craftsman, to the standards of his craft, and to the culture, rites, and ways of his society.

Surfaces travel and reveal with light, and humans superimpose on select surfaces the sum of things sensed, experienced, thought, learned, and imagined. Yet surfaces can become invisible through familiarity as well. Only startling new epiphanies and the most disciplined analytical (or simply keen and cunning) eye can direct our fresh attention to surfaces constantly perceived and free them from the wrinkles and folds of the mind—the snags and snares of abstractions; the imprints of repeating images and thoughts.

ARCHAEOLOGISTS, ANTHROPOLOGISTS, AND PHILOSOPHERS

My disposition toward phenomenology joins me to a handful of contemporary British anthropologists who are inspired by twentieth-century continental philosophers.[3] In fact, one of the anthropologists, Christopher

Tilley, articulates his phenomenological approach with explicit reference to Maurice Merleau-Ponty's concept of knowledge, which Tilley describes as the "intertwining of subject and object, things and persons, places and Being in the world."[4] In the spirit of James Gibson's ambulant and ambient perceiver, a concept discussed in the introduction, Tilley postulates the notion that the world is constructed around the body in motion. Humans know the world by walking and moving about in it.[5] "Perceptual meanings of place and landscape," he writes, "are constituted as gestalts, themes against horizons [foreground and background] to which the human body and external world both contribute."[6] Defining the body as a set of surfaces that interfaces with a world of objects and other surfaces, Tilley proposes that experience is formed around "a dialectical exchange between the structures of the engaged perceiver and the structures of that which is perceived."[7] Such an approach is in accord with a binary construction of world and thought developed around the polar dimensions of experience and such metaphorical dyads as close and far, open and hidden, visible and invisible, connected and disconnected, and so on.[8]

From this perspective, human experience hinges on a needful and meaning-giving body that moves in space and a mind that seeks, finds, interprets, and investigates surfaces as they appear and in terms of what they signal and represent. In less elaborate terms, self, body, society, and world exist reciprocally. Humans incorporate world into self and community, and as body, habits, images, decorations, and representations, they transpose individual and communal selves into the world. The individual and corporate human body speaks of selves and meanings to other animals, humans, and divine beings. Gestures, which can be expressive, confessional, communicative, or directive, display and reveal humans in action, will, and intention. Humans express and read one another by face and hand. A prolonged glance, curl of a lip, the flip of a tongue, a broken smile, the hearty toss of a head, an accented display of teeth, the raising and expansion of one's chest and shoulders—all convey intention and meaning via body talk. Gestures are, to speak analogously, humans' "displaying feathers." They are made still more emphatic by accompanying sounds.[9]

It can be argued that the body's movements and actions contour the mind, and that the mind maps the world. The body establishes "the elementary structures of embodied experience."[10] The body stamps and then represents experience with Tilley's aforementioned primordial dyads, such as "above and below or up/down; in front/behind; and to the right/to the left."[11] The somatic symmetry of twos, including our upright head and feet on

the ground, and our right and left arms, hands, feet, eyes, ears, and so on, demarcates the exterior world from ourselves, and it supplies elemental metaphors that are embedded in all languages, which, in the words of James Geary's *I Is an Other*, make "language fossil poetry."[12] *Up* is, for instance, metaphorically equivalent to being well-off, knowledgeable, and elated, whereas *down* means depressed, that which drags along the ground. With other polarities such as inside and outside, male and female, weak and strong, and walking straight and crooked, the body furnishes starting points for representation and decoration, instructing humans in how to draw and how to know what comes to eye and mind.

FIRST DECORATIONS

Humans, I conjecture, first decorated their own bodies, and in so doing distinguished themselves from the other animals. The body and its parts were literally at hand, there to mark, to smear, to bejewel, to clothe—to decorate. The body presented the self and the group with a set of immediate, inviting, informative, portable, and traveling surfaces. Skin provided sheets of varying contours and accessibility on which to put lines, curves, markings, colors, scratches, and even stitches; skin could be used to inform others, record places, celebrate events, and enter its owner as a participant in a ritual. Head, face, nose, lips, eyelids, hair, breasts, nipples, navel, and buttocks, as well as stomach, arms, legs, and feet—all afforded a medium for expression and decoration. Each region of the body could carry a declaration of self, membership, and totem.

Contemporary African tribes such as the Pende of the Congo—to suggest a tenuous analogy between people in the past and those in the present—drape, color, paint, and in other ways decorate themselves with mud, sticks, bones, feathers, pieces of metal, plants, sheaves, stalks, vines, branches, berries, burrs, fruit, and whatever else is vivid, shapely, colorful, and at hand.[13] With their ornamental and patterned painting of faces, legs, arms, and torsos, along with their strings of colored beads, florid stoles, bracelets, plated lips, scarified bodies, drooping and stretched earlobes, these people visually turn themselves into a full chorus of expressive surfaces. In dance, they become a field of motion, what I would describe as a riot of color, bodily movement, and tribal meanings.

Nomadic and many other tribal peoples decorate their bodies to place themselves in a world of objects and in a familiar world of kin. They use,

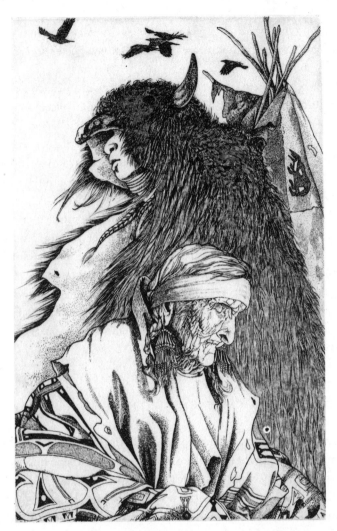

FIGURE 9. "Two North American Plains Indians," wood etching on paper, Abigail Rorer, *Three Coyote Tales,* 1989, shows that dress (not unlike food and ritual objects) reveals on its surface who, what, and where a people and an individual are, and it also evokes the worlds in which people define themselves by their beliefs, identities, and styles. Insofar as *advert* means to "call attention to," dress is advertisement.

as "skin," hide, bone, stone, ceramics, and weavings to define themselves as a gathered and designated (designed) people. With markings, colors, and coverings, they make themselves shrines to their animals, spirits, gods, and ancestors. Every article of clothing—from feathered headdresses to woven and beaded shoes made of hides—serves to express and represent themselves.

Every garland of flowers, each piece of jewelry (for ears, hair, lips, wrists, or neck), identifies and communicates through its vivid color and movement their place in being.

The mask, a particular kind of decoration, is used to enact a ceremony. With multifold purposes, it stands for a person, group, place, story, or the whole cosmos. The mask—whether painted and embellished or carved, incised, and inlaid—joins the dance, complements the ritual, and expresses the group. Like all forms of art, to borrow an idea from anthropologist Alfred Gell, masks are agencies of a distributed, shared meaning.[14] According to a contemporary Pende, "You can't just invent a [face] mask . . . you need a dance."[15] Masks are named after particular dancers.[16] For the Pende, the mask disguises its wearer and affords its maker and dancer acclaim, but for many peoples the mask also presents parts of the group to the world, for it mirrors and embodies a person, clan, motif, and story. The decorated mask fuses the moving body and celebrating group to myths of hunting, reproduction, and origins. It also can express gratitude, incantation, lamentation, and supplication, and it can voice multiple dimensions of remorse, penance, purification, joy, and ecstasy.

THE FACES OF THINGS

Anthropologists quarry, through conjecture, in the deep layers of human experience. They hypothesize, for instance, that an aesthetic impulse was at play in the symmetry of the hand axe (especially the carefully fashioned Late Paleolithic biface), an instrument that was in evidence 1.4 million years ago and which remained a key product of human technology until fifty thousand years ago.[17] Anthropologist Steven Mithen and evolutionary biologist Marek Kohn contend, with perhaps some bravado, that the production of the symmetrical and well-made hand axe advertised its maker as a being of high cognitive, behavioral, and physiological skills and, thus, as a desirable mate.[18]

I return to my favorite example, the walking stick, discussed in in chapter 2—it too emanated power and magnified gestures. It established the rank and status of its possessor. It carried with it a history validating the bond between stick and person. In an analogous way, objects can represent a self and group and evoke a place, time, and narrative of creation and possession. In this way, objects found and made form nets of connections and meanings—a plethora of ontologies, as I would state it. To borrow a concept

from social anthropologist Tim Ingold, humans draw lines between things and images and concepts of things.[19] With their profound metaphorical disposition, lines are seen to lead from thing to things—from parts to whole, materials to objects, uses to ends, and one realm to another. And so lines weave mats and nets of manifold meanings.

Representation arises out of primary and elemental connections, associations, and meanings. Decoration expresses, informs, refines, and embellishes meaning—indicating the place, source, author, owner, or association of things. Although both representation and decoration can be communicated by elaborate and detailed song and poetry (I think of the *Iliad*'s ornate and formalized descriptions), they operate first via the manifest meaning of surfaces. They stand forth on tools and instruments; they indicate makers, users, owners, functions, and purposes. Markings, colors, signs, pictures, symbols, and later ideas, numbers, and metaphors join things together loosely and tightly. They weave objects, places, people, actions, and situations into tapestries and patterns of associations, connections, and correspondences.

ORIGINS AND FIRST FORMS

As decoration and representation have advanced in human history, they have developed their capacity and habit to label, name, identify, and associate things. The collective process of naming proceeded hand in hand with an ability to denote and connote the relations among things. Decoration—an embellishing mixture of materials, lines, colors, signs, sounds, and words—designates things as belonging to orders of meaning.

Though lacking both definitional and chronological resolution of their origins and relations, decoration and representation surely were joined in symbolic intention when dead bodies were first colored in red ochre (which occurred in the Near East ninety thousand years ago, in Australia about forty thousand years ago, in Europe in the Upper Paleolithic, and subsequently elsewhere in the world).[20] Red is the color that most activates human physiology and the brain. It conveys warnings of poison, promises pleasure, signals sexual arousal, and displays anger. Furthermore, red has manifold associated connections with blood, wounds, death, and hearts. Decorating bodies in red ochre returned them to the womb of the earth, ready for a bright-red rebirth.

Beginning around a hundred thousand years ago, burial and campsites began to abound with tools and decorative and representative objects. The decorative power of red is vividly evidenced among these items by a recent archaeological discovery. It was made at Blombos, a rich archaeological site dating from eighty to seventy-five thousand years ago, and possibly considerably earlier, located in a limestone cave on the coast of South Africa's Southern Cape, which was a veritable workshop of skilled craftsmanship. There researchers have found beads made from *Nassarius* shells, bone tools, and two striking shalelike ochre crayons covered by crosshatched geometric designs that constitute, in the opinion of some archaeologists, the "oldest known artwork" and "the first record of abstract graphic activity by humans."[21]

The finding of cave paintings of Europe, in the first decades of the twentieth century, proved a singular event in the discovery of the aesthetic dimension's depth in human experience. Begun in the Upper Paleolithic, approximately thirty thousand years ago, cave paintings were made until the threshold of the Neolithic, about ten thousand years ago, when the well-known and advanced style of France's Lascaux and Spain's Altamira caves died out. These stunning pictorial surfaces vividly depicted wild horses, deer, bison, and other animals and included tracings of human hands in abstract patterns of line and color.[22] Drawn with charcoal tips and filled out using stick brushes with red and yellow ochre and other colors, these cave paintings, so manifestly aesthetic in their subtle and concise beauty, are hidden away on the walls and ceilings, the inner recesses and tight crannies, of caves. These drawings left little doubt that humans were, by the Upper Paleolithic, using decoration and representation to project themselves across reality using image and symbol. Combining hunter and hunted, ritual and reality, these naturalistic, decorative, and beautiful images demonstrate that decoration and representation are interconnected means to participate in being.

Like a honeysuckle vine, representation and decoration wrapped themselves around body, mind, things, and world. Scoring, drawing, coloring, and shaping surfaces proved a means to migrate out of oneself. To again quote Ingold: "We make lines in all endeavors," from sketching forms to outlining maps to tracing genealogies. Considering surfaces to be enhanced lines, Ingold writes: "Threads have a way of turning into traces, and vice-versa. Moreover, whenever threads turn into traces, surfaces are formed."[23] Life itself bends lines into curves, drawing the spiral of shells, the lobes of oak leaves, the stream-rolled boulder, the turns and twists of horns, the bends

of vines, and the contours of the human body. Lines and curves generate shapes and forms, which afford us elemental frames of meaning, aesthetics of decoration, pathways of meaning, and sources of metaphors.[24] Aside from being pleasing, natural, and familiar, do circles, squares, and grids evoke and frame the meaningful? The Hindu and Buddhist mandala is a square with four gates containing a circle and a center. The four points of the compass, designating the wind and seasons and spirits, structured the worldviews of many North American tribes, such as the Dakota and the Pawnee.

HOME: THE WINGS OF THINGS

The migrating pastoralists and early sedentary agriculturalists made, utilized, and read the diverse faces of given nature and transformed their landscapes. Multifarious faces and sets of surfaces stimulated, vitalized, and encapsulated mankind, increasingly making the environment in which people lived, experienced, and thought. Arguably, enhanced powers of domestication and the context of developing agriculture spurred the multiplication of female representations seen throughout the whole Near Eastern Neolithic. By the seventh millennium B.C., in the civilization of Çatalhöyük (see chapter 3), the woman and bull had come to represent the binary symbolic division of being into male and female. Woman and bull, prototheological subjects, were worthy of the keenest decorations. They, and their cohorts and retinues, abounded in Çatalhöyük on painted frescoes, in modeled relief sculptures, and in statues—and such figures were subsequently found across the Near East, as typified by Crete's royal and bestial genealogy of bull and queen, singularly condemned by the God of Israel.[25]

As humans settled in specific locations, built cities, shaped landscapes, and domesticated plants, animals, and themselves, they became by virtue of their macro- and microenvironments creatures of their own making and definition. The acts of decoration and representation were increasingly intertwined as humans further defined themselves in relation to what they made. Professor of geography and early history Clive Gamble, a critic of those who identify the advance of the human mind with individual manipulation of abstract symbolic language and the articulation of complex visual presentation, locates human cognitive development in a distributed and collectively formed mind. He traces the growth of human consciousness to societies that have formed environments and have mastered and built the worlds they inhabit.[26]

Gamble particularly focuses his analysis not on surfaces, objects, or tools, but on containers. As if to bend the surfaces of objects into curving and enclosing wrappers, Gamble interprets the forms, abundance, and dominance of containers as being the counterpart of tools that strike, cut into, and divide things; and he interprets them as offering a cue to human control and cognition. As enclosing vessels—clothing, drums, fenced yards, corralled fields, and storage barns—containers extended the engulfing human body's capacity to take in and utilize. Gamble contends that containers, in contrast to tools, became the dominant instrument of the past twenty thousand years of human history. Beyond their material use and variety, they afforded a principal intellectual and aesthetic frame in which the human mind could envision unifying and gathering things, and classify and generate ideas. Containers, in the language of this work, allowed humans to act in and conceive of the world as a matter of enclosing and enfolding surfaces, and collecting, taking in, storing, and utilizing things and ideas.

Walls, as previously discussed, embedded people in a place and incorporated them in a cosmos of their own making. Architecture and homes likewise proved to be containers in which humans, since pre-Neolithic times, have gathered things, families, and ways of living, and via which they have represented and decorated, with varying degrees of symbolic and mythic density, their place among things and in being. With feminine and embracing curves, containers, so indispensable to agriculture, storage, settlement, and domestication, extended the analogy of the human body in action and mind to the landscape.[27] As a rich source of metaphors, containers became types of social wrappers, like "systems of marriage and the reckoning of kinship in terms of generational boxes that enshrine rules of descent and recruitment."[28]

Containers netted the world of things. Starting ten to twelve thousand years ago, in Late Neolithic settlements and cities, concentrated groups of humans in the Near East incorporated themselves into the landscape they shaped and the settlements they made and organized. Walls, demarcating both cities and city governments, engulfed, defined, and organized lives. Structures declared orders and values. Crafts and their tools, language, writing, measuring, and currencies became agencies and metaphors for joining groups and minds. Representative and decorative objects furnished mental bridging for life, community, and being. As in the function of the rhetorical terms *metonymy, synecdoche,* and *metaphor,* embellished and connoted things on surfaces connected, joined, and crossed realms of things and meaning.

An alternative and more humble way to express this web of meanings is to consider the declarative and connective power of a pair of shoes. They belong to an individual. They carry a person from morning to night and through his days. They are often associated with a certain class and way of life. A great classifier, over ages, distinguishes those with shoes and those who are barefoot, those with tattered and torn rags for footwear and those who prance in sequined golden slippers. We ponder the Egyptian artisans' crafting decorative shoes made of stone and gold for the pharaoh and his court. In fact, shoes—or simply the hope for a comfortable and stylish pair of them—have inspired humans for eons. Similarly, homes, as discussed in chapter 3, which constitute a vessel for our lives, a ship going across the prairie or the seas of times, and a face turned toward guests, were our deepest, most common, and hence metaphorically rich dwelling places. An agency, as well as an entity by, in, and with which humans depend and live on this sensually entangling earth, home has been the center of our days and nights and the hearth of our emotions, thoughts, and hope. In *The Domestication of the Human Species,* Peter Wilson develops the notion that in home resides the idea of a permanent dwelling place.[29] The Neolithic seeded the earth with the great stone projects of tomb, shrine, mausoleum, and ultimately the temple—for as the animals have their nests and dens and humans their homes, so the dead, the mighty, and the gods must abide and dwell in lasting habitations. Home, which situates family and provides the heart of community, is a treasure of settlement.

Home—to *be* at home—centers families. Its space gathers and expresses its inhabitants' membership in an order of reproduction, work, and prayer. Therein families cherish their goods. Its walls, a set of enclosing surfaces, enwrap our physical, social, and emotional selves. A womb, room, and tomb, home is the repository of our being. In classic and popular literatures, home, which can be a cruel prison and even a torture chamber, beats like the heart of life. Like a magnet, home bends emotions and cognitive ideas to its idealized form and content. It constitutes a prism through which we experience and view the world, others, and ourselves. Its geometry proves to be a cognitive instrument.[30] First erected out of humble earth, the home grew up to become a metaphorical cosmological center of being. It was the designated center of human dwelling. As a new body and skin, it mediated human experience between nature and the made world. The home assembled a primary visual and interactive order of surfaces, spaces, substances, and things. It reordered our ecological relations to earth, water, air, and fire.[31] Borrowing

a notion from psychologist James Gibson's *The Ecological Approach to Visual Perception,* I argue that home served as a medium of perception.[32]

The cloak of social settlement, the home, a physically enclosing space, also became a primary place of memory and tradition *(un lieu de mémoire).* As a matter of surfaces, spaces, and walls, home underwent "progressive materialisations" that, conjectures art historian André Leroi-Gourhan, linked "physiology, invention, and art."[33] A protean metaphor, home now erects lines of loyalty, trust, and duty, all of which are essential to the structure and organization of the community at large. House and cosmos indeed form homologous structures. With its structure marking the four points of the compass, or cruciform, or composed of concentric circles and contrasting elements such as a central hearth and a heavenlike dome, the house, like the cosmos, shares in spatial delineation and organization of being. The house, which "symbolizes the human body and its processes," also stands for "the cosmos and its processes."[34] "The house," Wilson writes, "is itself a universe representing each and any universe."[35]

Homes—as characterized by the first ones unearthed in Near East—were thrown together from small and barren mud walls fastened together by sands, sticks, and grasses. Only later were they formed of bricks of hardened earth and whitewashed and their inner walls covered with plaster.[36] At some early point, they contained a door that opened to and closed against the world, a floor that was dry and level, a waterproof ceiling, and a hearth that held fires for heating, cooking, and (to borrow again from historian of antiquity Numa Denis Fustel de Coulanges's construction of the ancient city) joining the dwellers to the spirits of ancestors and to the household's protective gods.

In the eighth century B.C., the signature Greek temple sprang up. It transformed the human dwelling into the abode of the gods. It itself developed from a small, homelike structure, consisting of mud-brick walls, wooden columns, and a thatched roof, into the temple, which, inspired by sculpted Egyptian monuments, became an architectural model of organized human space.[37] In temples and palaces—voluminous, proportionate, and decorated stone structures—earthly gods, in concert with organized priesthoods who charted the seasons of the earth and the course of the heavens, declared their preeminence and dominance. Royalty and nobility (one can select examples from Sumer, Egypt, China, and Greece, and even the Baroque period in early modern Europe) displayed decorative and representative structures and objects whose imposing and embellished surfaces elevated their possessors before society and the gods.

A veritable explosion of decorated objects occurred within Neolithic settlements. Evidence is furnished by Jericho, whose origins date to 9000 B.C. Composed of ten layers—ancient cities built upon still more ancient ones—Jericho housed such first architectural achievements as walls, steps, and a tower. Already in its earliest times, the site was rich with figurines and pottery. Artifacts found here include ten skulls plastered and painted to represent personal features of the dead. They are taken to be the first example of portraiture in art history.

Such decoration coincided with multiplying networks of trade, the use of new materials, and the specialization of crafts. Anthropologist Alasdair Whittle suggests that the things of the Neolithic brought a cognitive revolution to Europe that reframed self and society. Accompanying new materials, especially copper and its alloys, and the inventions of the plow and the wheel, were social and intellectual transformations. Cultivation, herding, and advances in material culture produced not only fresh means to pursue perennial goals, but also seeded ideas that sprouted unprecedented conceptions and representations of things. "Neolithic people," Whittle suggests, may have become "more conscious of their separate place in the scheme of things. . . . [They] may have become more conscious of the possibility of failure. . . . With a new sense of beginnings, descent, and time came also sacred imperatives."[38]

Civilizations in the Near East, especially those of Mesopotamia and Egypt, created an order of interactions among societies. Reaching beyond established political boundaries, these interactions rested on the exchange of metals, scented oils, wood, colored stone objects, and other goods. Furthermore, as seen in early Crete and throughout the eastern Mediterranean, the societies borrowed styles of decoration and symbolic representation from one another.[39] Cities and civilizations increasingly wore a cosmopolitan face with a variety of embellished objects; they increasingly identified themselves with what they made, traded, and possessed. (Imagine China, for instance, without its terra-cotta army, temples of heaven, five-level pagodas, brass and bronze bells, organized gardens, jade, dashing calligraphy, and swirls of red and painted silks.) Objects, by their grandeur, intricacy, and uniqueness, gave prima facie testimony to a society's prominence and preeminence. Rather than being considered the fruits of civilization, decoration and representation must be understood as the drivers of crafts, technology, and commerce.

As noted in chapter 3, aside from its use in local carting, the wheel first rolled on toys and wagons that delivered illustrious warriors to fields of battle; copper found its earliest use in ornaments and decorations; and bronze advertised not only Homer's renowned Greeks and glorious Trojans, but, as we read in Samuel, topped off the overpowering Philistine Goliath's "six cubits and a span" with a bronze coat of mail and bronze helmet.[40] Archaeologist David Wengrow confirms that even in those areas where a tin-bronze alloy was adopted, "mechanical efficiency seems to have played little role in its initial uptake." Metals were used to make elaborate items for personal display, which, giving surfaces a glint and gleam, included a "dazzling variety of pins, rings, diadems, head-dresses, necklaces, and bracelets." Techniques of jewelry-making—granulation, stone setting, gilding, and chasing—that are still in wide use today were pioneered in the workshops of Mesopotamia.[41]

Materials flowed from backcountry to cities, and luxury objects were channeled from centers of production to seats of power. Decoration, like metal drawn by a magnet, was pulled to the highest level of significance, flowed in the direction of kings' residences and bodies. The representative of all earthly representatives, the king embodied the cosmos, mirrored the heavens, and was seen as the first and all-potent earthly mediator of humanity.[42]

ON DISPLAY

During the four millennia B.C., practitioners of pottery, architecture, and metallurgy discovered a new capacity to fashion materials and decorate objects. Ceramicists displayed new skills in locating, mixing, molding, and baking clay with other minerals ("the rich rot of rock," so to speak). Handled, wheel-shaped earth became common blocks, basic containers, colorful vessels, fertility figurines, and a thousand ornate faces of things. Metallurgists traveled deeper into the elements, mining productive veins of the earth and refining the art of utilizing fire. Dependent on discovering, quarrying, purifying, mixing, and heating ores and minerals, metallurgists produced both hard, sharp tools for working, cutting, and piercing hard wood, bone, and stone and malleable, bendable, and inciseable soft surfaces upon which intricate and elaborate decorations could be made. As in the case of pottery, metallurgy, flourishing during the three millennia B.C., produced a science and technology of material forms. Toggling between outer and inner surfaces

and substances, control of metals made whole societies feel themselves to be lords of the earth and masters of its inner secrets.[43]

With pottery and metallurgy, humans broke through the crust of the earth. And they magically turned base elements into beautiful things. Through these crafts, humans both took in the world through their eyes and hand and turned their lives over to the things they made. The blazing light of the forge's tongues of fire and the ringing peal of the anvil sounded the truth: humans now participated in higher orders of making.

The cities of antiquity dedicated ever more inhabitants to assembling, amassing, and protecting the fruits of artifice, and they trumpeted their dazzling array of creations. In addition to pottery and metalwork, they made cloth and ropes, mosaics and friezes, paintings and sculptures. Decorations and representation, tacit in human work from its beginnings, became ever more articulate. They acquired a state of increased consciousness and intention. Across the third and second millennia B.C., decoration, as practiced by specializing craftsmen, and representation, as formulated by priests and through symbols and myths, diverged. Both moved in the direction of autonomy. The craft object increasingly stood by and for itself; whereas, especially in the case of the God of the Old Testament, the deity professed was affirmed to be beyond embodiment and concrete representation. As cities and associated classes, cultures, and traditions developed in the millennia B.C., crafts and arts became more specialized and subsidized. Joined to larger trade networks, they had at their disposal more tools, materials, consumers, and forms to copy. Figurative and sculptural decoration was increasingly identified with the mastery of visual surfaces. At the same time, representation, thanks to the development of language and writing, sought meanings independent of the visual surface. It increasingly situated its meaning in the arts of rhetoric, logic, and storytelling. In the case of Greece, the *polis* focused rhetoric—the language of its statesmen and sophists. Grammar and syntax underwrote political, religious, cosmological, and philosophical discourse. In rhetoric's most advanced (dialectical) forms, it evacuated meaning from surface and elevated representation to the realm of the abstract and symbolic. In the disembodied world of Platonic forms, the true, the beautiful, and the good existed as one and were everlasting.

Language, free of visual, tactile, and sensually rooted images, is free of the sights and senses of the world, and it dispenses with visual analogies and metaphors that link here and there, now and then, and the seen and unseen. It plucks the wings of knowing insofar as it separates truth from

the surfaces of natural things and made objects. Disincarnate philosophy dispenses with the epiphanies of incarnate fare. It turns a stone ear to Keats's "Ode on a Grecian Urn," which would have the beauty of the urn satisfy the soul. Yet why not let the urn, or a gracious, shapely piece of jade from China, or another lovely artifact—say, an Egyptian spoon—satisfy us with its plain sight alone?[44]

STYLUS AND CLAY, TEMPLE AND AMPHITHEATER

Decoration and representation grew up as twins along the banks of expanding production and building: specialized crafts secured the independence and the near-autonomy of the arts, and systematic speculation detached meaning from sensual surfaces and objects and made symbolic and numeric representations on the surfaces of hides, clay, and paper.

Courts and cities exercised hegemonic powers and covetous dominion over local peoples, places, and cultures. Kings, priests, and cities, and their divines, prophets, and augurers, regulated transactions with celestial and cosmopolitan gods. With language itself now the prow of advancing conceptual thought, priests and learned scholars spelled out cosmic and transcendental meanings and suggested the order of things to higher powers. Through mathematics, literature, philosophy, and religion, civilizations (as evidenced by the Greeks, Egyptians, Chinese, and many others) made themselves translators and mediators with powers that seemed invisible, or at least not often seen, and without consistent images. While decoration informed and pleased, symbolic representation, in a widening divide, became the privileged (and even monopolized) domain of speculative minds and transmissible written words.

Civilizations, on this count, distributed and divided minds, with demarcating lines following (not with precision, of course!) class, language, and ultimately literacy. The division fell between the many, who (not with the supplement of the spoken word) read meaning on and in terms of the face of things, and the chosen few, who deciphered truth through abstract symbols and formulas, which were entered into and drawn from written texts. Along this zigzagging divide, decoration increasingly identified itself with what was outside, what people could see on the natural and made surfaces of things. Representation increasingly worked under the inspiration of religious, philosophical, and scientific systems. As decorations multiplied and concentrated

their tactile intricacy and visual embellishments, complex representations sought to unveil, penetrate, and even reach accord with hidden forces and orders. Pointing to the impenetrable boundary between the human and the divine, holy, and mysterious, God queries the intellectually exhausted Job, "Who then is he who can stand before me? . . . Who can open the doors of his face?"[45]

Advancing civilizations compounded the love of objects that could be seen and handled, hefted and set into action. They did not overturn counting benches, dispel local mysteries and rural cults, or quit auguring the face of things for concealed meanings. Nevertheless, these civilizations' specialization, free time, and survey of things near and far fostered speculation among a few, which meant that they would continually probe and systematically query whatever came before the court or the more open, democratic, interrogating, and combative *polis*. Truth went with words, which, in pursuit of the highest meaning, tracked far beyond the tangible, material, and visual and reached toward the invisible powers and sublime higher orders. Indeed, twentieth-century German philosopher Karl Jaspers labeled the period of 800 to 200 B.C. "the axial age," with reference to the full emergence of the distinguishing, philosophical, and comprehensive Indian, Chinese, Hebrew, and Greek universal worldviews.[46]

If this age were to be metaphorically housed in any one vessel, it, by western lights, would be the Greek temple. The commanding architectural structure of the Greeks, the temple served as the dwelling place of and the door to the gods and as the face of heaven.[47] Within its interior—the place of optimal decoration and highest symbolic representation—the all-important transactions between visible humans and invisible gods occurred. There gifts were given, sacrifices made, and gratitude expressed for divine protection, favors, rewards, and victories. There sacred pacts were drawn up and consecrated.

The temple was then the largest frame of human building, according to Ian Wilson. It crowned the cosmological and geometric unity of all Neolithic building. He contends that early literate philosophers of ancient Greece sought to put into words the surfaces, lines, and geometry of the Neolithic world. Their political theories had their origins in and translated temple architecture into words and ideas. "Aristotle's polis," he argues, "was not a system of living so much as a place of living that exercised control spatially."[48] The temple stood in harmony with the political thought of Plato and Aristotle: as Zeus ruled the household of heaven against the mischievousness of the gods and the yawning chaos of first times, so the thinking

political man had to bring order to his public dwelling, the *polis*. The surfaces and frame of their material building analogically accounted for their verbal construction of being.

It might be noted, however, as we try to establish the dichotomy of visual decoration and verbal representation, that in more than one Greek landscape—I think particularly of Segesta, in western Sicily, my family's place of origin—the amphitheater stood above the temple. This tempts me to conjecture that the Greeks elevated the acting-out of tragedy—the unpredictable and decimating course of human matters—above transactions of sacrifice and praise. In any case, the prominence of the amphitheater and the work of Aeschylus, Sophocles, and other playwrights of the fifth century B.C. suggest that images perceived by the eye can betray. And, in fact, words, spoken in all their modalities and taken in all ways and meanings, do not free humans from the greater course of justice. So the crafty tragedians narrate stories of shared fates we experience but cannot fully comprehend. Images and languages, however joined in decoration and representation, do not set us above time. Ultimately, they only enter us deeper into it.

Writing itself did not begin or develop in order for us to know and resolve our position in being. It origins are more of a process, which can be simplified as follows: Once pictures and signs that were drawn, marked, or incised on sand, mud, bark, leaf, cloth, or hide were reduced in complexity and standardized, as first occurred in the Near East, writing appeared. Once semantic and phonetic signs, a great feat in themselves, were affixed to glyphs (marks supplementing a text), written language was created.[49] The revolution of written language took place in the late fourth millennium B.C. in Sumerian society, which had already begun to encapsulate itself, body and mind, in clay. Between, within, and on the flat surfaces of clay, it centered its life. Sumerians housed themselves in structures of clay, grass, twigs, and heated bricks. By hand and with the first potter's wheels, they turned clay into the vessels that contained their food and valuables and were later transformed into their advanced ceramics. Out of clay, they also created figurines that served in rituals and furnished a type of currency. Beyond this, they recorded their inventories, transactions, and promises on clay. In "The Changing Face of Clay," anthropologist David Wengrow suggests that clay's evolving use resulted in its becoming the all-purpose material of Sumerian society.[50]

Cuneiform, writing in clay, was a Sumerian invention. One of the first two writing systems (the other is hieroglyphics), cuneiform writers impressed clay with standardized pictures using a stylus. A common ancient writing

tool that resembled a pencil and was tapered like a pillar, the stylus was used to mark clay sheets, pottery, and wax. Originating as a means of accounting, cuneiform evolved (with the addition of symbols and phonetics) into a written language that spread across the Mediterranean and was used for mundane tasks, such as recording prescriptions for pulverizing, mashing, and mixing materials, and for lofty matters, such as narrating heroic undertakings, victories, and kingships.[51] Surely cuneiform mixed decoration and representation in the service of multiple types of meaning.

Around 3300 B.C., at approximately the same time that the Sumerians invented cuneiform, Egypt gave birth to ceremonial hieroglyphic script (with its cursive variant, hieratic). The Greek etymology of *hieroglyphics,* meaning "sacred markings," offers one indication of its use. Though also initially used for accounting and then to convey royal and divine stories, it clung to its pictorial character, never evolving into the simplified, efficient, and thus transmissible written language that cuneiform became.[52] On this count, Chinese calligraphy resembles hieroglyphics. With its origins lying, controversially, anywhere from six thousand to four thousand years ago, Chinese calligraphy, a stylized form of writing, comprises an imposing number of characters, reaching into the thousands, that as sets of signs and symbols, singularly and in combination, produce words and phrases. Mixing painting and writing, and inseparably combining both decoration and representation, Chinese calligraphy remained throughout its vast history, until recent times, exclusive by virtue of its scholarly and aesthetic character.[53] Whereas in early times the Chinese had written on strips of wood and bamboo, they transformed calligraphy, the quintessential merger of painting and writing—some might say beauty and truth—by developing brushes and using silk, ink, and paper.[54] Aside from driving the exclusivity of many other Eastern written languages with calligraphy's fusion of the decorative and the representational, the Chinese influenced writing across the world with their invention of paper, India ink, and finally woodblock printing.

So written languages, a fusion of many crafts and artistic methods, produced informative, beautiful, and meaning-laden textual surfaces. Writing, working its magic on the picture-talking sheets before us, turned things into names, offered distinctions and definitions, and in some remarkable way consistently and permanently testified about distant things, people, and places. It did so in all modalities of time, possibility, and wish. It subjectively ventured to speak of imaginary acts and situations, and even gave accounts of the gods, their promises and their doings. Writing gave birth

to reading, a radically new means to perceive, conceive of, understand, and render being. With the regularized tip of the cuneiform engraver's stylus, the fine camel-hair brush of the calligrapher, the sharpened feather quill of the Europeans, and the standardized, incised, molded, and inked type blocks of Gutenberg's press, literate societies marched headfirst into books and erected libraries—those paper granaries of information, recollection, and speculation—as their most complex and cacophonous temples of meaning. Turning rags into paper and crafting words out of a succession of regularized dashes and ornate curves, cities and civilizations set down visible texts. And in this way, humanity came to embed itself in its scribble—to marry itself to what these epiphanic and wordy surfaces showed and said, and to make a household and a temple of the mind. And one cannot read the classics or the Old and New Testaments without marveling at the triumph of the written word as it is repeated, taught, preached, and believed over the world. Through the word, men and women see and grasp what is before them and give it meaning.

The Eye and Hand

THE MIND AND SCIENCE OF SURFACES

The sense which is nearest to the organ of perception functions most quickly; and this is the eye, the chief and leader of all others; of this only will we treat and leave the others in order not to be too long. . . . Experience tells us that the eye takes cognizance of ten different qualities of objects; namely: light and darkness—the first serves to reveal the other nine—the other serves to conceal them—colour and substance, form and position, distance and nearness, movement and rest.

LEONARDO DA VINCI, *The Notebooks*

I shall consider myself as having no hands, no eyes, no flesh, no blood, nor any senses, yet falsely believing myself to possess all these things.

RENÉ DESCARTES, *Meditations on First Philosophy,*
"Meditation I"

Surfaces furnish epiphanies of life. They provide an abundance of sensual perceptions and offer a multiplicity of worlds to the eye and hand. They trigger emotions and stimulate elemental intellectual curiosity. Surfaces, which present themselves in configurations and juxtapositions, define context for all things and announce things as rich in contrasts and contradictory meanings, furnishing a basis for comparisons, classifications, and associations. For the poet, particular surfaces, which are the face of both the one and the many, are springboards, metaphors that connect things and fly across orders of meanings. The twentieth-century neo-Thomist Jacques Maritain queried how can it be that "Things are grasped in the Self and the Self is grasped in Things?" And while we will not answer his question, we will seek to historically elucidate how indeed we know ourselves in and through things.[1]

On one count, this chapter's attention to the intellectual scaffolding of representation and meaning joins it to a long, but only speculative, narrative

that could have begun a hundred thousand years ago, with the first known human burials; or forty to thirty thousand years ago, when human cave paintings expressed a mind that had symbolically and aesthetically taken hold of being and man's place in it; or even ten thousand years ago, when Neolithic humans built permanent dwellings and made objects that declared both human and transcendent orders of being. But on another count, this chapter marks a fork in the book's narrative. I now turn from a more universal mode toward Europe and western civilization in particular for the sake of a more concise and progressive narrative. I begin by examining the people of the European Middle Ages as material artificers and creators of surfaces and metaphors. I outline a thousand years of the West's representation of meaning through surfaces, images, and thoughts, while charting the great division between medieval and modern minds in the conception, grasp, and rendering of surfaces.

I organize my discussion around protagonists and antagonists, starting with that great metaphoric structure the medieval cathedral. I set in opposition the artist and scientist Leonardo, the geometrician and master of eye and hand, and the philosopher Descartes, the proponent of clear and distinct ideas and infallible deductive logic. These two western masters staked out poles of the modern mind, whose impulse and form—as expressed by philosophy, science, biblical literalism, and political secularism—collectively opposed the medieval synthesis of faith and intellect, which rested on the immanence and transcendence of every surface, whose ultimate existence and form flowed from God's creation.

OF EARTHLY STONE AND HEAVENLY LIGHT

Like that of the civilizations before it, the work of the Middle Ages occurred both on the outer surfaces of the earth and in the inner depths of the spirit. And although medieval society built great churches and cathedrals, bridges, roads, castles, anchor walls and foundations, and entire towns (using all the skills that its Roman predecessors and material and intellectual benefactors had supplied it), the overwhelming majority of its members were rural dwellers who belonged to the land: the forests, foothills, soil, animals, crops, water, and climate.

The thousand-year civilization we call medieval Europe (roughly dated from A.D. 500 to A.D. 1500) was not static. With armed knights and

bowmen—and even an occasional armed and mounted bishop, as was celebrated in *The Song of Roland*—Europe defended its borders against the expanding Saracens, the pillaging Huns, and the first marauding and then centralizing and administrative Vikings. With monasteries leading the way and establishing settlements, Europeans advanced east into the deep forests. With the reintroduction of the modified and strengthened heavy-wheeled plow, they broke open the deep, fertile soils of northern Europe and farmed the Dutch, German, and Prussian seaside marshlands. With expanding populations, European peoples occupied the landscape, and with new trails, roads, bridges, ports, and quays, they subdued the environment. Eventually they developed riverways and established towns whose commerce, industry, and materials prepared river-rich central and northern Europe for their maritime entrance into the Mediterranean trading world.

Medieval Europe was both productive and innovative. It carried on traditional prehistoric methods of agriculture, pottery making, and cloth making, including felting and matting fibers, as well as spinning and weaving. In addition to writing, toolmaking, and fire use, it pursued fermentation, carpentry, and shipbuilding.[2] Additionally, medieval society continued and enhanced the practices of earlier civilizations, cultivating grapes and olives and using new food preservation methods, and it practiced metallurgy, writing, mathematics, and astronomy; engaged in engineering; and constructed cities.[3] With crafts and building skills inherited from the Romans, medieval Europeans borrowed and adapted other societies' technology. Starting in the tenth century, northern Europe again entered into Mediterranean trade after the stabilization of feudalism and the reign of Charlemagne and his heirs in the ninth century. The fruits of the trade included paper, silk, and gunpowder from China. Arabs, who introduced them to classical Greek books and scholarship, furnished new methods of bookkeeping, mathematics, and science while also instructing Mediterranean Europe in the art of irrigation and introducing a stunning lists of new crops, among them rice, sorghum, hard wheat, sugarcane, cotton, watermelons, eggplants, spinach, artichokes, sour oranges, lemons, limes, bananas, and more—making Sicily the true garden of the Mediterranean.[4]

On another count, medieval Europe proved itself to be the dynamic transformer of its own landscape. Its own inventions—including the horse collar, the development of the heavy plow, and the system of triple crop rotation— opened northern Europe to field agriculture. Refinements to tools and techniques associated with the spinning wheel, silk manufacture, blast furnaces,

movable type, and the printing press added to Europeans' knowledge and confidence in themselves as "makers of the world." Cranes, grinding stones, magnets, wheelbarrows, improved mortaring, and, significantly, bountiful windmills and watermills enhanced Europe's building and manufacturing energy. Important sailing innovations offered increased confidence in (and hopes of profit for) ventures on the changing surfaces of the ever-perilous sea: two types of compass, the stern-mounted rudder, and the articulate keel. The humble, all-purpose wooden barrel replaced the amphorae and increased the amount of cargo a ship could carry.

A string of other inventions advanced Europe's capacity for warfare. Knights rode forth on arched saddles, aided by stirrups and spurs and dressed in increasingly flexible armor. Rival European armies became formidable as they incorporated powerful and quick-shooting longbows and later equipped themselves with armor-piercing steel crossbows and great wheeled cannons, which combined gunpowder and metallurgy in wall-breaking instruments that denied the autonomous insularity of princely castles and town fortifications.

Yet the crowning achievement of medieval architecture—the structure whose face defined its age, even more than did prominent castles and pre-eminent kingly courts and cities with expanding walls that sprang up from the late eleventh century onward—was the cathedral. Looming over towns and the surrounding landscape and defining the horizon, the cathedral (here conceived of as one entity, though there were many variations by age and area) was evidence of the era's capacity and will to embody its faith. It represented the age's advancing arts and crafts and articulated its expanding iconography and theology and the latter's handmaiden, philosophy. To and within its walls came all the decoration, representation, and meaning the age could muster. The cathedral was the king, the parliament, and the university of faith.

Like the oldest human stone structures—barrows, cairns, and temples— the cathedral was rich in ontology. Its placement, size, volume, symmetry, and proportion declared power, majesty, wealth, and beauty; it evoked wonder, awe, respect, and reverence; and it offered space to express belief, faith, hope, and prayers of request, thanks, and praise. Occupying a preeminent place in the landscape of the living, the cathedral had an interior that was animated by relics and that served as a dwelling place for the dead. A repository and a sanctuary, it was a ship floating on the seas of time.

Specifically, the cathedral offered visible testimony to the wealth, power, and authority of Church, bishop, and God. A place of prayer and sacrifice,

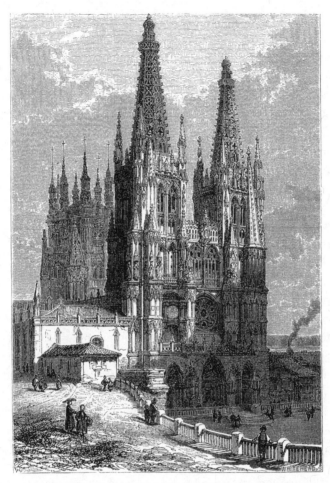

FIGURE 10. The Burgos Cathedral in Spain, shown circa eighteenth or nineteenth century, was a great Gothic cathedral, a delight joining and expressing on every surface the structure, symmetry, art, and symbols of its age. Marrying faith and hope in matter, it carried them as far as light could reach. From *L'Illustration,* November 28, 1857.

it bestowed grace and revelation and the intercession of Christ, his mother, the saints, and the prayers of the entire Church. The pride of its city and region, its construction required architects, builders, craftsmen, and artists. It gathered within itself the most valuable objects and works. It housed priests, monks, and students. The cathedral, like other churches, offered a place to participate in the rituals of the Sacraments, particularly the Eucharist. Aside from ringing out the hours and prayers of the day, the cathedral measured

the liturgical year, from Christ's birth to the Crucifixion and Resurrection, with its celebratory colored vestments and decorations. It staged the greatest events, including the coronations, marriages, and burials of kings and queens, and it drew supplicants and pilgrims, who wore fresh trails to its doors.

The cathedral was the most comprehensive work of medieval architecture, or, to quote the title of a book on the building of Chartres and the invention of the Gothic, it was a "universe of stone."[5] Made of matter, the cathedral was stone transformed into metaphor: it was the temple of Jerusalem and the body of Christ. ("Destroy this temple, and in three days I will raise it up" [John 2:19].) With its face of fashioned stone, strengthened and beautified by wood and metals, the cathedral, perhaps more than any other architectural work in western history, integrated decoration and representation in the name of the good, the true, and the beautiful. It was the house of God, its builders analogized. Mirroring creation, redemption, and everlasting life, the cathedral joined the faithful community to the path of sacramental salvation.

The cathedral expressed in its surfaces the power of monumental bigness. A hundred years or more in building, the imposing cathedral stood for a region's agricultural and commercial prosperity and a bishop's authority and financial strength. In a 250-year-long heyday of construction (from 1100 to 1350, approximately), the cathedral grew in volume, and its surfaces accordingly reached heights and levels of complexity and delicacy that had never before been seen. Its naves, unrivaled until about 100 years ago by our own skyscrapers, reached from 100 to nearly 150 feet high by the early fourteenth century.[6]

Though originally Romanesque in form—with rounded arches and compact and even fortresslike walls and columns—the cathedral eventually became what we today identify as Gothic, with not only unprecedented elevation, but also mastery over seemingly fabric-thin stone, with window-pierced walls and slender, reaching columns, atop which rose pointed, elevated, and complex ribbed vaulting. A visible cosmos constructed around Christian iconography, the cathedral's first appeal was to the eye.[7]

The High Gothic cathedral called attention to itself with its floral and rising walls, bountiful light, graceful pointing arches, refined stone tracery, and stained glass. The cathedral sought a higher synthesis of earth and heaven, the material and the symbolic, form and incarnation. It did this with the full range of crafts and materials at its disposal, namely painting, sculpture, metalwork, jewelry, tapestry, candlemaking, and bookmaking.

As in preceding civilizations, craftsmen fashioned the surfaces and objects of this luxuriant world. Carpenters, ever-dependent on metalworkers, plied their trade with nails, drills, and bits and with pounding hammers, prying wedges, drilling bores, and leveling planes. They and the blacksmiths furnished the church with joining bands of metal stands and holders for candles and torches, indispensable to lighting the dark Early Romanesque churches. Before they began to make fine chain mail and body-length plate armor in the fourteenth century, metal craftsmen had cast bronze church bells, which, starting in the eighth century, marked the hour, noted the time of prayers, and warned residents of approaching invaders. The tinkle of a single bell announced the Elevation of the Host, and the clapping tongues of a bell chorus rang in the liturgical seasons.

Metalsmiths also did essential structural work in joining and supporting columns and crossbeams, and they did so in an age when iron and the forge also played a paramount role in fashioning new agricultural tools and military weapons. Scholars have called the blast furnace the Middle Ages' great, though late, achievement, one that hitched the operation of bellows to the waterwheel.[8] Iron, as it did in antiquity, furnished bands to join stone blocks and was used to construct imposing gates, reinforced doors with locks, and holders for torches. Apparently a medieval invention, drawn wire (later to prove so important in the building of suspension bridges) held canopies, crucifixes, and chandeliers.

Wood, which was (after stone) the second-most important material of medieval Europe, played a role in almost all construction. It furnished tools and structures for framing, lifting, and erecting. Out of wood, carpenters built ladders, scaffolding, trusses, rafters, beams, and planking, and finish carpenters added decorative trim and facing and made furniture. Wood was also used for roofs, stairs, balconies, choirs, and vestries. Strong yet malleable, wood could be joined, carved, sculpted, inlaid, and painted for altars, triptychs, choir benches, and pulpits, whose graceful, curved, and ascending stairs gave, at least metaphorically, lift to authority and truth.

However, it was stone that made the cathedral monumental, made it a direct ancestor of the megalithic Neolithic walls, gates, gardens, palaces, tombs, and temples. Of varying hardness, divisibility, color, and refraction, limestone, sandstone, marble, and even harder granites not only provided the imposing cathedral with its bulk and strength, but also served as its interior and exterior surfaces, the sculpted outer and inner shells of this Christian egg. Coarser and harder local fieldstones filled in walls and provided flooring.

Naturally colorful, contrasting, and relatively easily carved marble was also incorporated into cathedrals—when it was readily available, marble even drove the design of certain cathedrals, such as the thirteenth-century Duomo di Siena, whose exterior and interior are composed of alternating strips of white and greenish-black marble, with red marble making up its eye-catching façade. Carved stone formed altars, baptismal fonts, tombs, and stairs leading upward to balconies and railings, and dragon-mouthed stone gutters and crouching stone gargoyles decorated roofs.

Stonemasons and sculptors sought to make stone speak to the eye and mind, to make it simultaneously decorate and represent. They shaped the cathedral with a geometric regularity of proportion and symmetry. With the aid of the measuring and dividing compass, they established both order and variation, using squares, circles, triangles, delineated figures, and lifting and pointed arches made from intersecting arcs. Their collective goal was to write in stone a text of illumination, a book of revelation. Sculpted individual figures in the forms of the prophets, the Gospels' writers, the loving mother and son, and the Holy Infant and the Christ Pantocrator decorated the cathedral's entrances, porticos, and crowning tympanums as if to announce the kingdom that lay within and beyond.

In the service of luminosity, feathering decorated stone, and refined leading was shaped to hold glass windows. One encountered great circular and patterned rose windows, such as those at Chartres and Strasbourg, and the windows of clerestory and lantern towers, such as those at the Ely Cathedral in Cambridgeshire, which was completed in 1340, all of them installed in the finest tracery. As windows replaced murals in Gothic churches, medieval stained glass conveyed via its colored and crafted surfaces both biblical scenes and the everyday lives and activities of parishioners.

Glass, indeed, was the fourth material of the cathedral. It gave the cathedral luminosity; it let in light, which for the medieval mind was associated with and was a first analogy with grace and the divine; and it formed, along with proportionality, the two characteristics of the beautiful for thinkers as wide apart as St. Thomas and Hugh of St. Victor.[9]

The Gothic cathedral joined luminosity with perfection.[10] Large vertical windows formed bays along the nave, tiered the balconies, and pierced the walls of the transepts and the ambulatory chapels that ringed the back of many cathedrals. Rose windows, enclosed in large cloverleaf ovals or circles and shaped and segmented into diamond-shaped or circular panels, might be the glory of a cathedral, defining the upper heights of the back of the church

and the transepts. Contained in leaflike stone tracery, they shed warming and intimate light throughout the rigorous and structurally imposing order of the cathedral.

Light, a miracle itself, is the antithesis of darkness and nothingness. It gives all surfaces their context and distinction. It makes faces change in brilliance and intricacy over the course of a day and across the seasons. We assign increased worth to those things that reflect and refract light and even more to those that are either completely transparent, such as modern glass, or colorful and translucent, such as medieval stained glass. Both types of glass join us—especially our eyes—to the luminous order that shines forth in the realm of the stars, the sun, and their invisible creator, God himself. Light declares the beautiful, the true, the good, and the everlasting.

In the Middle Ages, light served as the principal mediating metaphor between earth and eye, between intellect and divine creation. Deriving their argument from the metaphor of the sun's light that plays such a powerful role in the sixth book of Plato's *Republic,* medieval thinkers considered light the "principle of order and value." The worth of a thing was the degree to which it partook of light, and, in the words of the thirteenth-century theologian St. Bonventure, among corporeal things light was "most similar to Divine Light."[11]

A poet, visionary, and student of medieval philosophy, Dante founded his literary cathedral, the *Divina Commedia,* on the equation of light to love.[12] His journey across the afterlife leads from the dark, frozen, disordered, and loveless depths of hell to the highest luminescence and harmony of heaven. Divine light "penetrates the universe according to dignity," and it informs the radiating abode and love of God. Synonyms for "light"—such as *candore, facella, favilla, fiamma, fiore, folgore, fuoco, lucerna, lumera, raggio, scintilla, sole, splendore,* and *stella*—form steps on the stairway to the creator.[13] Beatrice, Dante's heavenly guide, instructs him that light "is an expression of God's Being. Every light . . . has its origin in God, and Heaven and all things below partake in light."[14]

Light put all things in contact with God's creation, grace, and redemption. Light, as it showered down, vertically graded existence, from the blinding luminescence of God to amorphous and melting surfaces that represented no object and permitted only shadowy and uncertain distinctions. Light made the form of things evident and yet was paradoxically blinding. Analogically, the transfiguring connection between light and things inspired medieval mystics, poets, thinkers, and artists as it did the builders of the cathedrals.

Light constituted, for Scholastic philosophers, the fifth and most perfect and sublime element.

Light, an object of protoscientific rational speculation, was considered to form the celestial ether. In the opinion of some thinkers, it was actually generative of life. (For example, it had produced seeds for "perfect animals," in contrast to those spawned by putrefactions resulting from light's power over dust and darkness.) The thirteenth century also gave thought to optics and meteorology, considering fire and air, shooting stars and comets, the rays of the sun, rainbows, false suns, light's passage through air and water, and related matters of transparency, refraction, illumination, and magnification.

Light poured forth from creation as a rain of divine grace and love. Its covenant permitted and joined being and consciousness. And through Christ, the light of the world, what had been concealed since the foundations of time was revealed. With its sources in Platonic thought, medieval thought fluoresced with Easter's hope. Light, whose path of truth led heavenward, drew intellect and spirit up from the formless faces of turbulence, muck, decay, and death—"the stinking pits of hell where resides 'the worm that does not sleep.'"[15]

Light did still more: It illuminated the glossy, shining, and beaming metals and jewels within the cathedral—the gold and precious stones of the portable altar, the burnished brass baptismal font, and the triptych of *champlevé* enamel on gilt copper. The altar might be screened and gated with colorful metals, although none, as we shall see in the following chapter, were equal to the golden-columned and canopy-covered altars of the luxurious Baroque and Rococo styles, which were made possible only by the abundant metals of the New World.

By the Middle Ages, a priest at a wealthy parish might perform his celebrations dressed in gold-woven vestments. His bishop might be crowned with a gem-laden gold miter and might display a golden pectoral crucifix with embedded rare stones. On the altar, he celebrated the Mass by elevating an ornate Bible.[16] As far back as Charlemagne's time, Bibles and holy books had been objects of the greatest handwork. Sculpted and embossed, they were covered with hammered precious metals, inlaid with gems, and decorated with white pearls and carved figures of ivory that came from distant places and were as white as an infant's or fair lady's skin. From great sculpted bronze doors to the stunning gold doors of tabernacles (miniature cathedrals unto themselves), fine metalwork joined the beauty of decoration with the significance of great treasure wrapped and concealed in gold lace and veil.

All this explains how analogical notions of God as light and order formed Christian ontology and provided the mental frame for the cathedral, an integrated work of geometry, stone, and glass. Mathematically proportioned through the systematic and rigorous application of ratios, the cathedral expressed the perfection of form. Derived from ancient Greek thought and resonating with the endorsement of the Old Testament, the cathedral represented the glory of God's universe as a system of eternal order and beamed forth the radiant and transfiguring promises of the risen Christ.

THE TELLING EYE AND THE MAKING HAND

But the cathedral, that amazing work of graceful stone and light built to the everlasting glory of God and his creation, did not cage the human mind. It did not still the roving human eye and moving hand or their desire to perceive, represent, and beautify anew. Nor did it sublimate new visual perspectives that were shaped by the measures of geometry and math, which in turn produced new ways of abstract reasoning about the knowable being and the form and movement of terrestrial and celestial phenomena. The emergence of this new eye and hand, as well as the abstract and reasoning mind, is epitomized by Leonardo da Vinci's drawings and René Descartes's meditations on reason. As I noted earlier, these two figures embody modernity's antithetical way of reading surfaces.

As Gothic cathedrals rose up, towns thrived, commerce flourished, and crafts multiplied and diversified. But after the Middle Ages, the artists, the most skilled of craftsmen, increasingly withdrew their work from the once near-exclusive patronage of the Church and their subordination to Christian iconography. They joined the spreading currents of secularism, decorating the faces and surfaces of things with classical allegories and serving the earthly glory and fame of the patron and the artist himself.

Renowned essayist Erich Kahler argues that the modern era began between 1250 and 1550, when art constituted itself as "an autonomous sphere of man's activity," just as reason and science did as a consequence of late-medieval Scholastic speculation and as religious thought did during the Reformation.[17] American historian of technology Lewis Mumford conceives of the late Middle Ages as a time of the adoption of rational and empirical conceptions of space, distance, and movement. For him, this shift occurred long before seventeenth-century mathematicians such as Descartes helped

to formulate calculus, which opened the door to mapping the small and the invisible—the curved line, the infinitesimal, and both regular and irregular movements.[18]

Medieval western artists and mapmakers, according to Mumford, framed objects, places, and persons in terms of their status. They represented space as free of reference to historical time. In medieval paintings, one enters an Italian town as if it were the Jerusalem of old. Events appear as manifestations, apparitions, visions, and miracles, and the surfaces of objects and landscapes are incorporated into symbolic worlds. Mumford concludes his analysis: "The connecting link between events was the cosmic and religious order: the true order of space was Heaven, even as the true order of time was Eternity."[19]

Another critical approach to the origin of modern art in the Italian Renaissance, that period from the late thirteenth century to the beginning of the sixteenth century, lies in the revolution in perception and in techniques for rendering surfaces. In Florence's Uffizi Gallery, it is possible to sketch that revolution in drawing and painting within and between the times of Giotto (ca. 1266–1337) and Leonardo da Vinci (1452–1519). Displayed in its first four rooms are the works of thirteenth- and fourteenth-century Florentine artists such as Giotto, Cimabue, and Duccio, which are fully alive to the decorative and suggestive powers of color, shape, and the unities of and contrasts between peoples and scenes. The painterly eyes and hands of these skilled craftsmen took up the rendering of such delicate and challenging surfaces as folded cloth, curly hair, still and gesturing hands, fair skin, and, especially, the touching, rosy skin of the Divine Infant, held cheek to cheek by the Blessed Virgin. Yet their virtuosity still exists in the frame of religious world, insofar as colors symbolize and value characteristics, scenes are drawn from the Bible and holy legends, and the scenes are rendered without an exacting use of perspective and shadowing. These paintings still belong to the subjects they depict—Holy Mother and Child look out at us as icons, inviting us to contemplate the eternal. Nevertheless, if we concur with art historian Erwin Panofsky, Giotto and Duccio are the true "fathers of modern painting" insofar as they ask us to view painting as a window and offer the world "a direct visual approach to reality." Parallel to their contemporary nominalists in philosophy, these painters, in Panofksy's opinion, "shook the foundation of high-medieval thought by granting real existence only to the outward things directly known to us through sensory experience and to the inward states or acts known directly to us through psychological experience. The painter is no

longer believed to work 'from the ideal image of the soul,' as has been stated by Aristotle and maintained by Thomas Aquinas and Meister Eckhart, but from the optical image in his eye."[20]

TO DRAW IS TO EXPLAIN

The two-century path from Giotto to Leonardo is not straight, and it is too long a tale of individual styles and innovations to tell here. The innovations were those of Giotto, Masaccio, Donatello, Verrocchio, Ghirlandaio, Botticelli, Filippino Lippi, Uccello, and Leonardo, working in different materials, techniques, models, schools, and even traditions. Quoting Vasari, Heinrich Wölfflin, in his *Art of the Italian Renaissance,* says that Masaccio (1401–28) "recognized that painting is but the imitation of things as they are."[21] To this realism Masaccio brought such innovations as the depth of space, background, shadowing, and geometry. In same breath that Wölfflin mentions Botticelli, he praises Filippino Lippi (1459–1504): "The outer surface of things attracted him. He treated flesh-tints more delicately than anyone. He gives softness and luster to the hair. What challenged Botticelli to draw lines tested Lippi to paint and join colors."[22]

For Lewis Mumford, the eccentric painter and mathematician Paolo Uccello (1397–1475) stands at an important juncture in the Renaissance's transformation of visual space. He removed space from a hierarchy of values and placed it in a system of magnitudes. Along with other emerging practitioners of the laws of perspective and proportional thematic organization, he "turned the symbolic relation of objects into a visual relation: the visual relation in turn became a quantitative relation." What is more, "In the new picture of the world size meant not human or divine importance, but distance. Bodies did not exist separately as absolute magnitudes: they were coordinated with other bodies in the same frame of vision and must be in scale." And to realize this scale and produce an accurate representation of the object, there must be "a point for point correspondence between the picture and the image. The division of the canvas into squares and the accurate observation of the world through this checkerboard marked the new technique of the painter from Paolo Uccello onward." His work influenced giants of this new realism and naturalism such as Tuscan geometer and mathematician Piero della Francesca (ca. 1415–92) and Albrecht Dürer (1471–1528), the German painter, engraver, printmaker, draftsman, mathematician, and art theorist.[23]

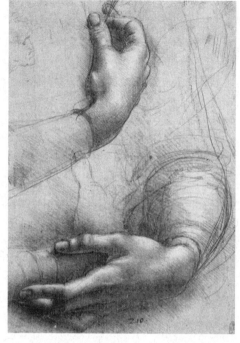

FIGURE 11. *Study of Hands,* Leonardo da Vinci, 1474 (Windsor Castle). This study supposedly anticipated the hands of his *Ginevra de'Benci* and *Mona Lisa.*

Eye of eyes and hand of hands, Leonardo da Vinci (1452–1519) was the culmination of the early Italian Renaissance way of seeing and conceiving of things.[24] Quintessentially pictorial, Leonardo defined the art of seeing and depicting surfaces as a way to explore, understand, and explain things. Treating drawing as if it had sovereign domain over all, he established the primacy of the visual and linear arts and natural sciences and, even more significant, made the "pictorial vision . . . the chronic habit of civilized man," for whom "seeing the world as a picture became a kind of *alternative* to ordinary perception."[25] Art historian Kenneth Clark characterizes Leonardo's powers of observation and drawing skills as arising out of "an inhumanely sharp eye with which he followed the movements of birds or a wave, understood the structure of a seed pod or skull, noted down the most trivial gesture or most evasive glance."[26]

For Leonardo, to render—to draw, sketch, paint, sculpt, and model—was to know. The seen, explored, understood, composed, and represented surface

was the face of the true form of things and the essence of the materials and forces that composed it. On this count, Leonardo belonged to the tradition of Plato, Pythagoras, Aristotle, Aquinas, Kant, and Goethe, which affirmed the primacy of form, pattern, and order in the knowledge of things; and he was in opposition to thinkers such as Democritus, Galileo, and Newton, who looked to the study of matter (its substance, structure, and quantity) and its laws for the truth of things.[27]

At the same time, Leonardo belonged to an era of competing virtuosities. Individual artists and schools sought to see and render what other artists and schools had not. Inescapably, their rivalries were fueled by emulation, superiority, and patronage on the one side, and new techniques and uses of materials on the other. In particular, their competition hinged on the rendering of light, proportion, and perspective. Accordingly, none of this escaped the diffuse influence of the *uomo universale* Florentine Leon Battista Alberti (1404–72). Historian, architect, town planner, and philosopher, Alberti made mathematics—the measuring of space and surfaces—the foundation of science and art. In *De Pictura* (1435), which guided Leonardo's work, Alberti counseled artists to learn in the workshop of nature. He joined beauty to the proportion and harmony of parts, and he drew on classical optics (with its medieval Arabic and European refinements) to determine perspective as a geometric instrument usable in artistic and architectural representation. Alberti scored the western pictorial mind with the draftsman's connecting lines. "Points joined together continuously in a row constitute a line. So for us a line will be a sign whose length can be divided into parts, but it will be so slender it cannot be split. . . . If many lines are joined closely together like threads in a cloth, they will create a surface."[28]

Working from the premise that things have and reflect forms, Leonardo made his art an inquiry into truth and the search for beauty. Without overlooking Leonardo's willingness to draw on ample analogies between things (e.g., rock and bone, soil and flesh, river and blood)[29] or to spin a moral from what is seen in order to describe hidden forces of geology (e.g., water dynamics and mechanics), anatomy, and the processes of embryonic growth and aging, we can argue that he essentially clung to the surfaces of things. On them truth stood before the scrutinizing eye, the agile hand, and the probing mind.

Leonardo was a "master of visualization," to echo historian Martin Kemp.[30] His work, to quote French writer Paul Valéry, was "a lifetime's advance toward a more perfect mastery of self and nature."[31] Leonardo's first

field of inquiry was the infinity of the world's forms, faces, covers, exteriors, and membranes. His goal was the representation of the true and beautiful. For him, the distinction between appearance and reality did not exist, except insofar as either sight or hand failed in its potential. In the spirit of medieval speculation, Leonardo looked on nature as manifest—as declared in its materiality and incarnation. The imposing wall of modern philosophy that divides mind from reality had not been erected in Leonardo's thought and, consequently, did not bisect his landscape. His wings of analogy flew free and high on a landscape rich in sensuous surfaces.[32]

Leonardo keenly observed the human body as a machine and stared into the human face as the mirror of the soul, which revealed inner worlds of emotions and tensions and the fruits of long habits of vice and virtue. He sketched and painted hair, manes, and branches and leaves moving in the wind. Nature filled the cup of his eyes and fueled his keen mind. He was drawn to and fascinated by vortices, whirlpools, whirlwinds, and serpentine spirals and helixes, where nature concentrates its powers and effects transformations of form and energy.

Famed for the quiet gracefulness of his composition *The Virgin and Child with St. Anne and St. John the Baptist,* Leonardo also stunned with the energy and even violence of his depiction of humans in movement and motion. According to Kemp, a student of his notebooks, "He studied men pulling, pushing, carrying, picking up, putting down, running, stopping, walking uphill and downhill, getting up and setting down, and, in one remarkably cinematic sequence of thumb-nail sketches, a man wielding his hammer to mighty effect."[33] As often as Leonardo depicted light, color, and what might be called the graceful airiness of things, he also aimed to capture their materiality and incarnation—the "thingness of things." He framed things by their shape, volume, size, position, and geometric measure and by their context. Things, for him, existed next to other things, and they belonged to a landscape. In opposition to the iconographic medieval artists, who sought meaning in relationship to the invisible (man to God, suffering to holiness, and so on), Leonardo sought meaning by visually representing things in detail, context, and perspective.

In accord with the geometric foundation of Quattrocento perspectivism, Leonardo proposed that composition was a matter of points, lines, planes, and bodies, in their "vesture of planes." "Painting does not, as a matter of fact, extend beyond the surface," Leonardo notes, "and it is by the surface that the body of any visible things is represented."[34] The problem of

perspective amounted to the representation of depth on a flat surface. As if to summarize the accumulated findings of fifteenth-century art on this matter, Leonardo argues in his notes for *A Treatise on Painting* that the painter must learn the art of transferring multiple three-dimensional objects onto a two-dimensional surface in such a way as to meet "the requirements of verisimilitude but also those of unification and harmony."[35] Perspective challenges the painter, correspondingly, to depict how things diminish in size, change in color, and disappear altogether in the remote distance.

The technical aspects of the *Treatise* should not conceal the fact that Leonardo took himself to be a craftsman, not an academic. He was not a student of Greek or Latin or of theology or advanced logic. As the cultural historian Eugenio Garin points out, Leonardo ran from blinding abstractions and the snares of argument.[36] For Leonardo, knowledge followed a circle from eye to mind to hand to bodily activity. The eye penetrated the deepest things only "to ascend again to numbers and reason in order to end up designing forms, which are not just the surface of things, a sort of skin, but the immanent force of things; thus the secret of the world is made manifest in an image which comprehends the whole of reality." Garin concludes with a paradox: "Leonardo's few pictures, therefore, represent a veil; but at the same time they also unveil the whole of being."[37]

Leonardo's curiosity led him from the outside to the inside of things. This progression fit his genius. It seems appropriate that he—who began his youthful apprenticeship by painting the wings of angels in the studio of Verrocchio and rivaled Botticelli in painting airy grace and fair skin—should in maturity take up such heavy matters as the effects of weight and aging and even the accumulation of vice and its effects on human physiognomy. Leonardo proceeded to investigate the inner workings of human and animal bodies. He pushed his inward explorations, with the help of anatomy, toward internal structures—measuring muscles, examining the womb and placenta. He inspected the tongue of a woodpecker, the jaw of a crocodile, and the function of eyes in humans and animals, including nocturnal owls.[38] His unrivaled work in anatomy produced drawings of tissue that were used for instruction in medical schools up to the last century.

His deepening probe inward received its impetus from medieval and Renaissance thought and technology. To take a single example, Aristotelian thought about the natural and the mechanical, as honed by Middle Ages thinkers (and quintessentially manifested in the era's creation of gears and clock movements), laid the foundation of and premises for Leonardo's

interest in the powers and motion of wind and water; his designs of moats, mills, lathes, and war machines; and his imaginary inventions for travel in the air and below the surface of the water.

Underlining the important role that Leonardo's naturalistic perspective on art played in the formation of our scientific mentality, the philosopher, mathematician, and historian Alfred North Whitehead asserts, "Leonardo was more completely a man of science than Bacon."[39] It is also possible to contend that Leonardo's work, as much as that of any other Renaissance thinker, outlined the spirit and agenda of emerging science, with its goals to organize space, explain movement, depict forces, and turn its empirical observations into contestable hypotheses, transmissible explanations, and practical inventions. Leonardo devoted his science toward explaining the sum of the world's manifestations. Instead of iconographic representation or abstract explanation, Leonardo chose an alternate vocation. A craftsman, scientist, engineer, and artist following eye, hand, and mind, the new universal man would systematically uncover the truths of nature—and he would seek wings to fly us free of the earth.

DESCARTES AND GEOMETRY'S DREAM

The origins of modern science must be sought beyond, if not away from, surfaces.[40] In opposition to Leonardo and late medieval and Renaissance art, which increased the richness of visual rendering of surfaces, emerging modern scientific theory reduced the properties and illustration of surfaces to extension, shape, volume, mass, and movement, which as units of an interlocking system could be measured, quantified, and calculated. This new science relied, accordingly, on geometry, mathematics, algebra, and, eventually, calculus for its means; its end was the formulation of rules and laws. Historian of science Herbert Butterfield writes in *The Origins of Modern Science* that the marriage of algebra (born among the Hindus) and geometry (born among the Greeks), which occurred at the end of the fifteenth and the start of the sixteenth centuries, was recognized as the greatest step ever made in the progress of the exact sciences. It reached its climax with Descartes, who "put forward the view that sciences involving order and measure—whether the measure affected numbers, forms, shapes, sounds or other objects—are related to mathematics." Kepler and Galileo, testifying to Pythagorean influences, concurred, the latter arguing that "the book of nature was written

in mathematical language and its alphabet consisted of triangles, circles, and geometrical figures."[41]

Across the course of the sixteenth and seventeenth centuries, the sciences, increasingly dependent on mathematics, washed the surfaces of the visible world clean of their sensuality and textures on the one hand, and of their reflection of heavenly being on the other. The concrete complexity of things was reduced to geometric lines and abstract formulas, neither of which existed in nature as first and immediate forms.[42] Conceptions of the medieval cosmos no longer prevailed, and its view of explainable regularity among appearances could not serve the intellectual causes of the Reformation and the Counter-Reformation. Science's rational explanations had no place for the miracles and revelations of the Old and New Testaments or the incalculable vicissitudes of time.

As the medieval mind had wrapped being in the truths of creation and salvation, so the scientific mind postulated an open and infinite universe.[43] Francis Bacon (1561–1626), the quintessential figure in many accountings of Renaissance science, turned away from eclectic yet universal medieval science. In its place he proposed homogeneous, accumulating, and applicable knowledge acquired by studying and generalizing from the basis of proven facts of nature.

Heir to both classical Greek and Renaissance thought, modern science was predicated on the autonomy of human knowledge and praxis. The human mind was made the first truth and authority. Reliant primarily on the outward-looking telescope rather than the inward and perplexing microscope, science sought calculable uniformity between the visible and invisible forces at work both on the surface of the earth and across the face of the heavens.

Modern science fused the forms of Plato, the experiential notions of Aristotle, and the symmetrical and magical mathematics of Pythagoras. It also drew on Scholasticism, which recaptured the work of Aristotle as an investigator of natural phenomena, promoted rational intellect, and res- urrected and refined logic. It also disposed medieval thinkers to conceive of nature as a coherent and rational order, subject to debate, deserving of rational methodology, and even, in some instances (as in the case of light), worthy of investigation. The late Middle Ages, thanks to Arabic influ- ence, also gave form to algebra, which in combination with geometry and trigonometry became instrumental in charting movement in earthly and celestial space.[44]

Triangles, especially as forms for calculation—as in the Pythagorean theorem, which affirms that the square of the hypotenuse of a right triangle equals the sum of the squares of its other two sides—became an instrument for measuring distant objects. Calculus, which arose out of the combination of geometry, algebra, and trigonometry in the sixteenth and seventeenth centuries, gave modern science a powerful instrument to compute irregular surfaces, spaces, and movements. It took up and successfully quantified such subjects as the accelerating ascent and descent of a cannonball, the curve of a river and the volume of its flow, and the elliptical path and movement of a planet. In effect, with the aid of calculus, physics extended human surveillance and control over things, forces, and motion. Together the two sciences offered real and hypothetical descriptions of mass, force, effect, distance, and speed. Aiding in computations of heat and pressure, physics and calculus spurred the design and increased the accuracy of instruments and machines. With his theory of gravity, Newton computed the attraction of most local and distant bodies to one another and crowned the work of heavenly observation and celestial mechanics. So, with space calculable and homogeneous, surfaces and objects were computed, made, regulated, designed, and integrated into machines and their work.

Scientific curiosity led the way, but practical needs also pushed forward knowledge and the control of surfaces. Warfare, commerce, sailing, mining and manufacture, and medicine and anatomy led mind and practice both inward and outward. Six inventions in particular, according to historian of science Alan Smith, took the human mind, eye, and hand below the surface of things and toward the outer horizons of space.[45] The telescope extended the vigilance of the astronomer's observing eye and the reach of Galileo's heliocentric solar system. The compound microscope, consisting of multiple lenses, irrevocably led science, as a collective body, into the realm of the small and the invisible. Galileo, who in 1609 and 1610 made a spectacular set of telescopic inventions and sightings of the stars and altered the world's conception of outer space, turned one of his own telescopes around to make detailed studies of insects. Dutch microscopist Anthony van Leeuwenhoek (1632–1723) magnified objects 270 times, catching the first glimpses of bacteria, blood cells, the metamorphosis of a flea, and the workings of an insect's eye. His contemporary, microscopist Robert Hooke (1635–1703), discerned the marks on a fish's scales, the structure of a bee's stinger, and the compound eyes of a fly and, drawing on metaphor, "was the first to observe that plants consisted of formations of small compartments, which Hooke called cells

FIGURE 12. "Mites between the Scales of a Flea," Abigail Rorer, 2000. Seventeenth- and eighteenth-century microscopists looked the insect in its compound eye and tumbled through its surface to the infinite stir of things below. Yet it has remained easier for humans to find purpose and order in a God above than in the endless living forms deep below us.

because of their resemblance to the small rooms in which monks lived in monasteries."[46]

Anatomist William Harvey (1578–1657) made the human body an inner continent to explore. He discovered that blood courses through the circulatory system, driven by the machinelike pumping heart, which deserves "to be styled ... the sun of our microcosm just as much as the sun deserves to be styled the sun of the world."[47] Marcello Malpighi (1628–94), the first to use a microscope to study anatomy, completed the map of the circulatory system with his discovery of capillaries and examined the hidden mysteries of reproduction with his studies of plant germination and the embryological development of a frog.

The thermometer, the barometer, the pendulum clock, and the air pump were, says Smith, the other four key inventions (among many others in the seventeenth century) that gave humans a means to measure the macrosurfaces of the earth and opened doors to knowledge of hidden and invisible elements.[48] According to Smith, Otto von Guericke (1602–86) invented the air, or vacuum, pump, which led Hooke and the physicist Robert Boyle (1627–91) to experiment with the properties of air and air pressure. The pendulum clock, patented in 1657 by the Dutchman Christiaan Huygens (1629–95), made possible the measurement of the smallest intervals of time and was indispensable to accurate scientific instruments and industrial

FIGURE 13. "Suction Pump," circa 1561, as drawn by Abigail Rorer. This water-driven mine pump suggests that the mechanical removal and bringing of water constitute an essential activity, one not only vital to mining, but one that, since Ancient Egypt, has underlain man's capacity to shape entire landscapes through agriculture, canal construction, and civic architecture.

manufacture. The barometer, invented by Galileo's pupil Evangelista Torricelli (1608–47) in 1643, read air pressure, which permitted the geographic charting of elevations and measured the proper conditions for chemical reactions. The thermometer, a multiform development rather than a single and identifiable invention, played a protean role in measuring climate, cooking, mechanical processes, chemical reactions, and the body itself.[49]

Spurred on by the growth of international correspondence and new scientific societies, science raced to know and explain the phenomena we perceive. Calculation, scopes, and machines enhanced its ends. It codified its results on paper in observations and laws. At the same time, science established its foundations with global expeditions that collected and classified rocks, minerals, shells, plants, animals, and even peoples. The concept of nature as God-given no longer provided certain or sought truths. Science, conversely, sought to assemble reality as a matter of observation, hypothesis, theory, and indisputable laws. It found validation in duplication and effective application.

Analogies and metaphors, which had centered human society since the Paleolithic, no longer governed. And the immediate surface of the everyday and the ordinary world did not offer either valid or important truths to science. In turn, the visual world, as expressed by Leonardo's eye and hand, did not stand at the center of scientific truth. On this count, modern science, in contrast to the medieval worldview and the Renaissance's aesthetic ways, presented an opposing mode of perceiving, conceiving, representing, and rendering the fundamental truth of things. The first disciplines of the scientific revolution—astronomy, physics, and emerging chemistry, rather than still-nascent geology, biology, and human medicine—sought to know and act in terms of the laws of measurement and calculated forces.[50] As no other philosopher and mathematician had done, Descartes proved to be the Leonardo of this new science.

Descartes is interpreted and reinterpreted in each description of the formation of the modern mind.[51] Descartes's philosophical project—articulated in full and with candor in his *Meditations on First Philosophy* (1641)—rested on utilizing systematic doubt to raze knowledge based on the immediate experience of the senses and replace it with a first philosophy established on the certain and indubitable foundations of uncontestable reason. Modeled on the proof of geometry and the economy of algebra, both of which he excelled at as a principal founder of calculus, his project proposed to set down the first axioms of all knowledge.

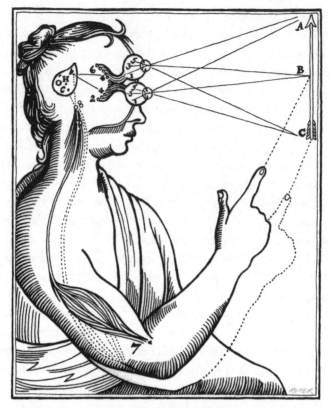

FIGURE 14. "Descartes's Theory of Perception," 1677, as drawn by
Abigail Rorer, 2000. This image shows the nerve impulse traveling
from the eye to the pineal gland, and then on to the muscles and to
the tip of the pointing finger. These operations went with Descartes's
ideas of sense perception, but they in no way supported his deductive
theory of truth.

Descartes consciously turned away from the classical learning that
had encapsulated the historical experience of Greece and Rome and the
premises of Scholastic philosophy, which had formed a large part of his
Jesuit education and rested on the interdependency of the senses, form, and
truth. Descartes, safe in the confines of tolerant Holland, where he know-
ingly pursued high revolt in the peaceful garden of his study, sought to
wipe the world clean of past truths. An epistemological warrior, he denied
(as seen in this chapter's second epigraph) the senses' foundational truth in
the surfaces and perceptions of the phenomenal world, and he denied there
was any foundational truth in experience and tradition. Surfaces of things

could account for no first, logical, and mathematical truths, although he imposed a logic and law on them and their functions.

In "Meditation I" and "Meditation II," Descartes challenges any truth value in authority, mores, poetry, history, and traditions. They are singularly and collectively fickle, relative, arbitrary, and mythic. He argues that foundational views of God could be the beguilement of a demon trickster, and that assumptions that there is a self could be figments of dreams and imagination. Displaying how earnest and ruthless he was, Descartes calls into doubt the validity of his putative allies, the emerging natural sciences of physics, astronomy, and medicine, insofar as their subject is constituted by "composite things" whose identifying characteristics, like the world of surfaces, things, and objects, are forever altered by mutations and changes. At one point in his argument, Descartes summons the famous example of protean wax, whose exterior properties mutate right before our eyes and senses. With an application of heat, wax changes its size, shape, taste, color, smell, feel, and even sound. Yet despite these transformations, wax, according to Descartes, remains wax, not because of our gathering senses, but rather because of our identifying mental judgment. Clearing the ground for his foundations of mind, he writes:

> I shall consider that the heavens, the earth, colours, figures, sound, and all other external things are nought but the illusions and dreams of which this [evil] genius has availed himself in order to lay traps for my credulity; *I shall consider myself as having no hands, no eyes, no flesh, no blood, nor any senses, yet falsely believing myself to possess all these things;* I shall remain obstinately attached to this idea . . . , with firm purpose avoid giving credence to any false thing, or being imposed upon by this arch deceiver, however powerful and deceptive he may be.[52]

He sets the foundation of his philosophy on the proposition "I think, therefore I am." He affirms it as being true and beyond doubt by arguing analogously on the basis of the primary, though abstract and puzzling, proposition of a complex numbering system that all are required to learn in Algebra I, but few grasp: A negative number multiplied by a negative number results in a positive number. So, equivalently, a thinking self—the conscious self, to restate Descartes's argument—cannot be negated without affirming itself. Negation cannot negate negation without becoming positive. The doubter, if the analogy from a numbering system to human knowledge holds, can doubt all but his own doubting, for by doubting his doubting he affirms the existence of his doubting self.

Descartes makes the self, stripped of all material and subjective content other than its own consciousness, the first principle of knowledge. His second founding certitude, again arguably tautological, harkens back to and reaffirms the medieval thinker St. Anselm's ontological argument. Anselm contends that the God we think of must exist; by virtue of being conceived of as perfect, he must exist to have complete and perfect being. As for Descartes, who postulates the self as being beyond doubting, the existence of a good and perfect God rules out deception and an illusory and deceiving world.

With these two foundational propositions, first of the conscious self and then the perfect God, Descartes sought to establish philosophy on the basis of irrefutable rationality. Doing so would establish philosophy as a system of truths beyond the limits and vagaries of incarnate flesh and the material and sensate world. Philosophy, as defined by axiomatic and universal propositions about nature, being, and knowledge, disposed of poetic, metaphorical, and theological intuitions and ontology. It established and assembled knowledge independent of the cathedral's correspondence of human thought and action and God's creation and revelation. On another plane, it rejected Leonardo's painterly eye and exploring hand. Furthermore, as Neapolitan historian Giambattista Vico argues in his *New Science* (1725), Cartesian philosophy ignored the principle of *verum factum,* which affirms that humans know best what they have done, and consequently it found no truth in history, law, language, myth, and tradition.

In the limited arena of modern philosophy, Descartes's rationalism identified meaning with discourse in abstract language. As his followers, the rationalists, sought truth in terms of innate ideas and logical systems, so opposing empiricists, such as the English thinkers John Locke (1632–1704) and Bishop George Berkeley (1685–1753), refused to identify truth with surfaces and objects and associated forms, analogies, and metaphors. Rather, they sought its sources in senses and sensations and the mind, which turns them into ideas. In his attack against Descartes, Locke swept the mind clean of preexisting, innate ideas, as well as universal ones, much as Descartes had doubted knowledge based on experience and the exterior world. Utilizing, not without paradox, the metaphor that the mind was a tabula rasa, an empty sheet, Locke held that the foundation of knowledge was ideas obtained through sensory experiences, which can be simple when direct and immediate or complex when constructed. As for metaphor and "all the [other] artificial and figurative application of Words Eloquence hath invented, [these] are for

nothing else but to insinuate wrong *Ideas,* move the Passions and thereby mislead the Judgment."[53]

. . .

So philosophy, in the guise of rationalism, delivers thinkers to the shore of abstract ideas and theory. Its equation of reason, logic, and mathematics promises the treasure of truth. In the wake of the profoundly divisive Reformation and Counter-Reformation, and buoyant in its crest-riding discoveries of science, the printing press, and its lay readership, philosophy posed as the definer and arbitrator of truth and justice—and yet also as the prophet of peace, tolerance, and progress—until and beyond the time of the French Revolution.[54]

The shores of philosophy had been swept clean of dogma and creeds. Gone too were the whorls and shells of analogies, metaphors, and symbols that had enwrapped entire peoples. Philosophy's contemplative shaping of geometry and calculations now incited earthly dreams of complete knowledge, subservient machines, coherent plans, and perfect societies. Here were the kernel of modern utopianism and, as the twentieth-century thinker Isaiah Berlin would argue, the embryo of totalitarianism.

Courts, Gardens, and Mirrors

SEEING AND BEING SEEN

A forest of mirrors, or a "desert of mirrors," overwhelmed the
twentieth century, constantly reminding men of the lesson
forged in the seventeenth century: Man is nothing other than
a reflection and vanity. But the mirror had been stripped of the
mystical significance it once had. "Mute surface" is what Borges
called the mirror—"uninhabitable, impenetrable, where all is
event and nothing is memory."

SABINE MELCHIOR-BONNET, *The Mirror: A History*

Human bodies are words, myriads of words.

WALT WHITMAN, "A Song of the
Rolling Earth"

WITH MODERN TIMES CAME SCIENCE. It calculated magnetism, baro-
metric pressure, water columns, celestial objects moving through outer space,
and light's and gravity's invisible movement and hold. In the same period, it
charted seas, islands, and continents and mapped, measured, and surveyed
all it could count on this earth.[1] Science advanced a general sense of control,
regulation, and knowledge.

As algebra and calculus offered the means to figure the movement and
behavior of things seen and unseen, believers grew more confident in Bacon's
prescription that it fell to humans to observe, understand, and reform the
world by measuring, counting, and analyzing it. In the wake of the Thirty
Years' War (1618–48), which settled, if only by futile exhaustion, the era's
religious wars and left new secular states competing for control of Europe,
the phoenix that arose from the ashes was natural science. Associated
with the advance of human reason, it removed the material world from God
(symbol, mythology, and analogical discourse) and gave over its apprehension
to observation and experiment.[2]

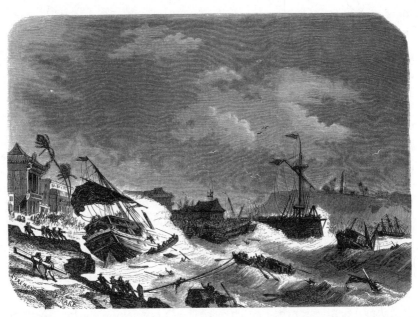

FIGURE 15. "Typhoon in Macao," Evremond de Brémond, 1857. Shipwrecks and vanished fleets remind ancients and moderns alike of disaster lurking just below the surface of being, and of the quiet that precedes the storm. They tell of the power of wind and sea, of the swallowing and erasing depths of water.

In conjunction with science, early modern technology, though still dependent on ever-scarce wood and stone, advanced in toolmaking and manufacture. This progress was manifested across diverse sectors and resulted in an enhanced capacity to construct landscapes, build structures, and make and engineer level, smooth, and joined surfaces.[3] Taking what surface energies offered, early modern technology exploited wind and water power to turn mills and sail ships. The prosperity of the seventeenth-century Dutch republic (which rivaled Britain on the sea) relied on wind to drive its immense population of mills, which aside from aiding in the production of goods, helped to clear its lands and level its waters. Holland's fleets of ships, recently improved with better sails, rudders, and compasses, helped put the world within the grasp of Europe. Yet while nature and society, commerce and transportation, were rationalized and systematized, the world remained largely unexplored and precarious.

Also enhancing seventeenth- and eighteenth-century power was a startling growth in mechanics and pumps and the dramatically improved

production and manufacture of glass, mirrors, and porcelain, along with increased textile manufacturing, shoemaking, furniture making, and iron casting. Modern machines such as lathes, bores, stamps, and screw-making devices permitted greater control over surfaces and materials and also drove forward the competitive economies of Europe. Iron refining and steel making, which came only in the last quarter of the eighteenth century, brought an increased use of metal tools and the standardization and interchange-ability of parts (notably in rifle making). Bores, cylinders, and compressed-air pumps all advanced what was to become, in the nineteenth century, the dominant steam engine industry.[4] These machines anticipated the Industrial Revolution and, as will be discussed in chapter 7, transformed the face of the world, and their conception and building would convince us of our mastery over things big and small.

The New World already displayed a plethora of new surfaces and interfaces. They appeared as products from a range of diverse crafts that mutated toward and into industries. In the last decade of the eighteenth century, the power loom spun textiles for the first phase of the Industrial Revolution. Weaving string to string and fabric to fabric, it dressed the world in European-made cloth and clothes. Glass, mirrors, and porcelain, as will be discussed later in this chapter, likewise put a fresh and dazzling face on public and private lives. And starting in the Renaissance, the printing press exponentially had covered the surfaces of the world with words. Transforming minds and spirits, printing permitted mass communication and made literacy the norm of the ruling elite of civilized society.[5]

Two Chinese inventions, the woodblock (on which letters and images were cut out) and inexpensive paper, met in fourteenth-century Italy and established a new paper industry. From this great interface of the modern world flew forth sheets, pages, and leaves covered with designs, figures, images, signs, words, facts, and ideas, which landed and stuck everywhere. The printed book (a particular composition of folded and gathered pages bound in cloth or leather) gathered, revealed, and stored on its interior sheets an infinity of words, pictures, and concepts. It assembled a second universe of surfaces rich in variety, differences, and juxtapositions. In early modern Europe, books, Bibles, missals, calendars, almanacs, and other reading material started to fill homes and churches. At the same time that government, commerce, landholders, and churches compiled archives and records, notifications and written orders were posted in public squares. Private libraries grew, and lending libraries (the forerunner of the public library in the United States)

multiplied in eighteenth-century colonial America. The great *Encyclopédie* of the French Enlightenment—*L'Encyclopédie, ou dictionnaire raisonné des sciences, des arts et des métiers,* published in France between 1751 and 1772—and its European imitators crystallized the idea that contemporary knowledge could form a community of the most recent, and accurate, thought, sciences, arts, and crafts. The nineteenth century accelerated the reach of the iron printing press with the inventions of the rotary press, the type-composing machine, and electrotyping. The combination of the steam engine and the printing press in the 1840s and the subsequent manufacture of paper from wood pulp and the use of paper rolls extended the press's power. Via the newspaper, the printing press made daily news global. Sped along by telegraph and telephone, the news was plastered across the face of the world. And increasingly as signs, symbols, and ideas, words intertwined with images and made what we call reality.

European mapmaking (not to discount the cartography—from a Greek root meaning "writing on papyrus"—of the Chinese, Arabs and many other peoples), given the era's expanding and competitive explorations of the world and its materials, more universally miniaturized and linked the world's locations on printed sheets with increased precision and comprehensiveness.[6] The European invention of modern clocks—which so radically redefined *horologia,* with its roots in sundials, water clocks, and Arab mechanical inventions—furnished more precise temporal measures and made mechanical time the increasingly universal coordinate of place. Their gears, springs, and levers decoratively displayed aristocrats' tie to the technology of the day and offered a magical, intricate, and nearly perpetual motion machine. With clockworks defining a distinct European industry and becoming increasingly indispensable to sailing, they became fit gifts for sultans and emperors.[7] A communicating face in the salons, on the desks, and on the wrists of the eighteenth-century elite, clocks started, in the most rudimentary way, to synchronize the world. By their intricacy and precision, clocks were the master machine of their time. If only other machines, contemporary inventors wished, could run as smoothly and effortlessly. Indeed, the clock set the mechanical world to imitate it. Neil MacGregor, director of the British Museum, ventures this opinion: "You can say that it is around 1600 that our understanding of the whole world as a mechanism begins to crystallize, seeing the cosmos as a kind of machine, complex and difficult to understand but ultimately manageable and controllable."[8]

As the clock defined the precision of machines, the pump displayed the singular power of machines to transform landscapes and generate working

energy. The pump drew upon and synthesized advancing knowledge about suction, vacuums, and air pressure and posed engineering problems regarding the fitting of cylinders into stroking steam engines. It offered a solution to the Herculean task of moving clean drinking water from river to well, and liquids and steam from boiler to tank and back.[9] Unless water could flow—and flow in, out, and through abundantly—the earth would remain an untamed surface of swamps, damp ground, and foul wastelands, and humans would not have a conduit to water their gardens, free themselves of waste, float their laden barges, or—among the other precious gifts of industrially transported liquids—enjoy a full draught of beer or whiskey.

SUSPICION, DOUBT, AND TURMOIL

Early modern times were, however, also seeded with doubts and suspicions, as well as counterdoubts and countersuspicions. The philosophies of Descartes and Spinoza questioned older truths of mind, history, and society. These uncertainties also belonged to the very architecture of the late Renaissance, especially the Reformation and the Counter-Reformation. The idealized medieval unity could no long combine nature, creation, revelation, redemption, and final times. The golden and ornate stitching of allegory and the pictorial, dramatic, and musical, which Baroque aesthetics used so generously in its churches, were snipped and trimmed and even pulled out by the sharp, linear edges of Newtonian formulas. Already, the French thinkers Montaigne (1533–92) and Pascal (1623–62) had looked away from shared surfaces and the canopy of coupling metaphors, and gazed both inward and to classical and religious texts for short and even epigrammatic insights into the varied human condition. In this way, they were children of the Reformation and Counter-Reformation.

The Reformation reacted against (among other things) Italian displays of humanism, secularism, and architecture and its pictorial display of papal preeminence. Northern lay Christians (although surely not homogeneously or even consistently) instead prescribed a modest explanation and presentation of faith. They evicted ornate images from their worship, and they stamped the Church and its service with the holy book and the cited verse.[10] With a commitment to preaching and reading scriptures and an idealization of the small Christian community, post-Luther Protestants moved away from the medieval church, which had visually and analogically

netted together this life, the next, the living and the dead, and materiality and grace through liturgy, metaphors, and symbols of creation, Christ's incarnation, the crucifixion, the resurrection, the Second Coming, the Last Judgment, the Communion of Saints, and Paradise. For art historian Mitchell Merback, the Reformation brought a reorientation of visual experience as expressed in devotional imagery: "Where [reformers'] iconoclasm failed to banish the image entirely, these formulators of the new imagery stripped the crucified body of its magical phenomenology and substituted for it the dry allegories of conversion and choice, true and false churches."[11]

From this perspective, what was at stake in the Reformation, Counter-Reformation, and the first phases of the Thirty Years' War was an attempt to resolve conflicting ways to visualize and verbalize the world—its surfaces and their relationships and significance—in connection with religious representation and expression. In one corner was the Catholic view, which conceived of surfaces as belonging to a hierarchy of being and a hierophany of symbols. In the other was the Protestant, iconoclastic view. Scriptural by determination, it expressed truth with the Bible and the preaching of the word. While not devoid of images in the service of explanation and devotional piety, it chose speech over sight and has argued, until the present day, for word over and against image (as we see in the case of the influential Protestant thinker Jacques Ellul, discussed in the conclusion).

Although not by any main and direct highway, the modern world finally had arrived at a third mode of knowing and being. Rather than hearing the word or seeing the truth, it chose to make the world. Though it was not fully articulated until the second half of the seventeenth century, the modern worldview arose out of the reinvigorated material life of the sixteenth century. Europe's population rebounded; new fields were plowed; agriculture again flourished; and villages expanded. The business, trade, and banking of Europe—once prospering mainly in northern Italy and northwestern Europe—began to thrive across much of Europe. Arteries of commerce flowed again, and the birth of new Atlantic powers—Spain, Portugal, England, and Holland—occasioned a shift from the Mediterranean and the Old World to the Atlantic and the New World. A new axis of Europe's maritime, imperial, and creative powers was established. Italy once had been the cockpit of Europe; now ambitions migrated north and sailed west. There were things to be done. Commerce, exploration, and colonization uncovered new quarries of wealth. Gold and goods meant both material rewards at home and new possibilities there and overseas. Success rewarded itself with

display and ostentation, and accordingly surfaces were taken in hand and a fresh face was put on people and the times.

THE BAROQUE

The Baroque, whose origins can be traced to High Renaissance Mannerism, arguably was the first full and complete aesthetic face of modern Europe, and it remained the only one throughout most of the seventeenth and eighteenth centuries. Somewhere around the mid-eighteenth century in style-setting France, and among its enthusiastic courtly and upper-middle-class imitators elsewhere, it gave way in architecture and the fine and decorative arts to the more delicate, playful Rococo style and a simplifying classicism.

The churches of the Catholic Counter-Reformation, whose building began around 1600, imprinted themselves, more than any other structure, on the definition of the Baroque. Initially sparse and functional, its churches became "overlaid by the ornaments of the baroque which gilded and embellished the barer simplicities of the first Tridentine buildings."[12] As New World silver and gold flowed in, their surfaces, especially their altars and ceilings, were adorned. It seemed decoration proceeded uninhibited: no surface was left uncovered, and all materials were summoned for ornamentation of cathedrals. Bernini's design of St. Peter's Chair (1656–66) utilized gilded bronze, marble, stucco, and stained glass.[13]

Unconfined to serving religious impulses to decorate and represent, the Baroque was a way to engineer. It drove the design of not only architectural structures, including churches, gardens, and palaces, but also that of cities, their buildings, and the sweeping flow of their roads, and that of mines, stairs, gardens, pools, and canals. The Baroque era showed advancing mechanical skills and increased control of the environment. As an accumulation of collective projects that unified teams of artists and diverse patrons, Baroque art produced "fictive worlds," which, in the view of art historian Martin Kemp, "were designed to stimulate and control viewer experience."[14]

At the same time, the Baroque also had great geographic reach, albeit with local variations. Its spirit was at play in the construction of royal courts' competing palaces, thriving churches, public buildings, and the large homes of the newly rich, which conspicuously displayed wealth that had not been publicly acknowledged through enhanced status. By the mid-seventeenth century, the Baroque had extended outward from more conducive and

animated Catholic societies to more solemn and subdued Protestant lands. As an architectural face of church, court, and home, it went from Italy and France to England and on to Poland and the diverse Catholic and Protestant principalities of Germany and eastern Europe, and from Spain to its colonies in Latin America and its key Mediterranean outpost, Sicily, which today abounds with Baroque churches, evidence of town planning, and great and small palaces from the Spanish era.[15]

Cultural historian Jacques Barzun returns us to the distinguishing visual powers of the Baroque under the rubric of "the opulent eye."[16] Bright, curved, proportioned, illustrious, and allegorical surfaces appeared inside and outside buildings. They were a designed and built testimony to the spirit and importance of their sponsors and owners. Owning, in effect, declared worth.[17] Accordingly, panels, rugs, draperies, bookcases, and paintings (a variable gallery of accumulated portraits, landscapes, and religious paintings) covered walls and elaborate wood floors. Sculpture likewise multiplied in the wealthiest homes and palaces. Busts were discreetly planted on mantles and tables, while whole blocks of combined marble accommodated more energetic scenes of subjects in action. Furniture, too, in contrast to sparser residences of the past, abounded in the form of ornate canopy beds, embroidered chairs, chaise longues, sofas, and highly crafted cabinets, tables, and—in accordance with the turn to paper, writing, and print—ornate writing desks.[18] Also displayed on tables, desktops, and other flat surfaces were clocks and figurines made of gold, silver, and burnished bronze. Cherished porcelain, whose production rose appreciably across early modern history, furnished decorative vases, figurines, full sets of highly decorated and designed dinnerware, and all-important bedroom commodes.[19]

As if to elevate dwellings to the ages and heavens, multifloored palaces aspired to fashion themselves into temples. Rich in rows of windows and mirrors, they bathed themselves selectively in light. With marble, parquet, and rug-covered floors, they made movement a revelation of opulent surfaces. Monumental stairways mediated movement between floors. Large hallways connected runs of specialized rooms (chapels, libraries, galleries, chambers, ballrooms, and so on) that displayed accumulated goods, books, instruments, art, and ornately designed furniture. Designed to entertain guests for long stays, the home advertised the host as best it could at every turn.

Sculpted, colored, thematic, and celebratory, ceilings formed rich canopies that made historical and even providential claims for the earthly temples they capped. Identified most singularly with the Baroque, heavenly, florid,

and even illusionist stucco ceilings beamed brightly in Catholic and Eastern Orthodox churches, whose exterior golden domes dominated skylines in Eastern Europe, making a singular earthly claim to represent creation and heaven. Standing above gilded and canopied altars and abundant side altars and alcoves filled with paintings, sculptures, and elaborate wood-works, Baroque ceilings, in a singular experiment, fused light, silver, and gold with colors, shapes, and forms in a curved geometry and movement.[20] Their principal effects derived from a dramatic use of strong light and shade (chiaroscuro); windows; ornaments made of gilded wood, plaster stucco, marble, or faux finishes; and multiple trompe l'oeil techniques, which turned flat surfaces into three-dimensional ones, as epitomized by crowning ceiling frescoes rich in illusionist effects.[21] Capping and capturing the upward glance for the sake of orthodoxy and theology, ceilings explicitly preached the encompassing glory and sovereignty of heaven. Michelangelo's Sistine Chapel and other ceilings in the Eternal City, such as those in the Vatican Library, Sant'Andrea, Sant'Ignazio, and the Palazzo Barberini, gave truth to the etymology that links *ceiling* to the French word for "heaven," *ciel*.[22]

Baroque architecture utilized volume, intricacy, and perspective to engage the eye. Palaces and courts of several stories drew the eye along their decorated windows and the perspectives they framed. Built in bountiful numbers throughout Europe by kings, nobles, and the rich after the Thirty Years' War, these lavish seventeenth- and eighteenth-century structures gave face to political confidence and accumulating wealth. In addition to their monumental size, symmetrical arrangement, and styles (ranging from principally linear and classically discreet to the fully curved and flamboy-ant), they focused viewers' sight with open or cloistered courts and palatial gardens, which were themselves articulated through curving hedges, pillared arcades, cascading waters and fountains, geometric walkways, and impos-ing interior and exterior staircases with elaborate banisters that joined the geometric designs of outer terrace and inner court. Walls and roofs were given rhythm by the flow of their linear windows and doors—of varying and contrasting size—which were alternately capped and accented by mansards of diverse size and shape.

Testifying particularly to Michelangelo and early-sixteenth-century Italy as the source of its optics, Baroque art utilized surfaces of varying shape, size, volume, movement, and light to express drama. Unprecedented energy and movement, as seen in the figures of Hals's and Rubens's paintings, were also found in the curving forms, undulating facades, and complex ground plans

of the churches of Borromini and Wren. Likewise, movement was at play in the intricate layers and the use of light and shade in the buildings of Guarini and Hardouin-Mansart.[23]

LIGHT AND COLOR

Light, too, brought Baroque surfaces to life. It achieved dramatic effects through the contrasts it created among painted, sculpted, ceramic, and metallic surfaces. Concentrated and nuanced luminosity characterized Rembrandt's portraits and the stunning achievements of Dutch landscape painting. Light uncovered and concentrated spots of color on the canvases of Caravaggio, Zurbarán, Georges de La Tour, and Rembrandt. Light both brightened and subdued color, as seen in the limpid, calm tones of Vermeer and Philippe de Champaigne, and in the warm, shimmering tones of Rubens, Claude Lorrain, and Pietro da Cortona.[24] Light framed subjects, accented motion, provided depth, and suggested emotional and spiritual dimensions. Light and shadow deepened the geometric and straight-line perspective of the Renaissance while adding texture to visual perception.

Utilizing a beam of light to draw the eye to a point on a surface, Baroque artists, especially seventeenth-century Dutch painters, made individual objects stand forth in distinct singularity. As if lit by lamps, their paintings became mirrors from whose surfaces subjects looked outward. In Rubens's religious paintings, teeming sensual surfaces overwhelmed viewers' senses. In Dutch portraits, lusty men pursued lush, busty, and welcoming women, who set inviting tables and poured fresh milk that seemed to splash and lap. As a result, to quote art historian E. H. Gombrich, in this art of beamed light, "trivial objects [made] perfect pictures"[25] and everyday life stood forth in detailed particularity.

In one painting that caught my eye in a September 2011 visit to Amsterdam's Rijksmuseum, a wrinkled older woman discharged the contents of her chamberpot out a window. Peering out from another gallery wall, the titular characters in Rembrandt's *The Sampling Officials* (1662) stood confidently and, with penetrating stares, peered out at me as if my affairs were theirs to examine. In another gallery, one of Rembrandt's almost one hundred self-portraits looked out to draw me in. Old, worn, and haggard, Rembrandt did what I dread to do: he begged pity—or at least solicited a sympathetic, brotherly glance—for what aging and a lifetime of seeing and

profound looking had done to him. In another gallery, one of greater cheer, I caught the subject of Paulus Moreelse's *Girl at a Mirror* (1627) at her toilette. She coquettishly turned her head from her mirror and invited me to join her in celebrating her good looks, of which she had no doubt.[26]

Attention to light also led Baroque artists to luminescence and incandescence—the sparkling and blazing campfire and its glowing embers; the shadowy realms of the frail, quivering candle; half-lit rooms; and mild, scintillating jewelry. Light placed these objects between the contrasting and dichotomous poles of white and black, bright and dark, and clear and obscure. The triumph of black and white in painting accompanied the victory of *disegno,* or sketching, over landscapes, things, and bodies amassed and shaped by voluminous coloring; printing's domination of coloration; and the Protestant Reformation, which, according to art historian Michel Pastoureau, threw in with the book and the printed image from its outset.[27] Acutely aware of how colors, which along with light are the elemental determinants of how surfaces are perceived, define the images by which cultures know and represent themselves, Pastoureau writes: "Historians can never emphasize enough the significance of the event that the diffusion of engraved and printed images represents in the history of Western culture. With regard to color it marked a crucial turning point; within a few decades, between the mid-fifteenth and early sixteenth centuries, the vast majority of circulated images, both inside and outside books, had become black and white. All medieval images, or almost all, were polychromatic; the majority of modern images were black and white henceforth. It was very much of a revolution."[28]

Scientist and art historian Philip Ball conceives of the late Renaissance and ensuing Baroque period as "an era of deep shadows, of brooding blacks, placed in dramatic counterpoint to fulvous highlights" (*fulvous* being a color described as dull reddish-yellow, brownish-yellow, or tawny). Joining the era's subjugation of colors to light and shadow, Ball adds, Correggio, Caravaggio, and Rembrandt proved themselves to be thaumaturgists of black and brown. Within the heavy gloom and golden glow of their canvases, somber new palettes of yellow, ocher, and brown pigments appeared, and with these colors they vied for their viewers' solemn glance.[29] They dwelled on the power of light and the surfaces of things, scenes, and landscapes.

Light in Baroque art sought elemental boundaries. It provoked supernatural illusions. And it evoked what was beyond penetration, hidden in the depths of darkness and within the brightest, finest heavenly luminescence. Select masterpieces of Rembrandt and his seventeenth-century Dutch

contemporaries achieved, in the judgment of historian Simon Schama, a state of being "physically weighty but spiritually weightless; solid and earthbound, but leavened by the redeeming light of grace."[30]

CITIES, COURTS, AND PALACES

Four centuries before the nineteenth-century French civic planner Baron Georges-Eugène Haussmann used wide, connecting boulevards to break the hold of narrow, twisting, and revolutionary Parisian streets on the nation, Leon Battista Alberti recognized a military use for wide and open city roads (Alberti called them *viae militares,* as the Romans did).[31] Nevertheless, beyond simply establishing garrisons, parade grounds, and esplanades for marching and mounted troops, the Baroque city's designers found straight, wide streets good for commerce, and recognized other spaces, such as parks, gardens, and flat, open squares, as useful for civic display.

Baroque cities, following Renaissance ideals, organized themselves around courtly values of magnitude and ostentation, doing so particularly with palaces. The Rome of Counter-Reformation Pope Sixtus V, who oversaw the completion of the Dome of St. Peter's, best epitomized the new city, with its long avenues and great piazzas centered by ancient Egyptian obelisks. The earlier building of St. Peter's Basilica itself, whose colossal size and mixture of classical and modern styles carried with it, according to contemporary artist and critic Giorgio Vasari, Pope Julius II's intention to surpass any previous building in "beauty, art, invention, and order . . . greatness, wealth, and ornamentation."[32] Succeeding popes, according to urban historians, also took up the role of stage designer, and they made Rome their theater.[33]

Other cities followed suit. In Paris, urban historian F. Roy Willis, writes, "bureaucratic absolutism tried its hand at design. Royal edicts created a riverfront lined by grandiose facades, and expanded the courtyard of the Louvre and linked it to the tall pavilions of the Tuileries palace and the controlled vistas of the regimented gardens beyond."[34] In Russia, Peter the Great built St. Petersburg for himself, a bright western-style capital constructed on a swamp at a phenomenal cost in human lives. In the service of authority and administrative control, monumental buildings, wide avenues, and exceptional art collections distinguished the new capital. Like the golden dome and the estates of great landed princes, the new city wore a sublime mask that concealed a despotic countenance.

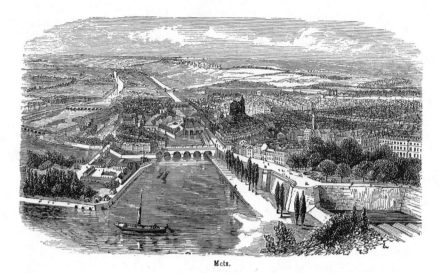

Metz.

FIGURE 16. Metz, shown circa the eighteenth or nineteenth century. Located at the confluence of the Moselle and the Seille rivers, near the junction of France, Germany, and Luxembourg, Metz and the remnant of its walls narrate an old history. The defensive walls of this port that was once a fort implied regional commerce, administration, and religious and cultural leadership. With ramparts, bridges, roads, gardens, palaces, churches, and population centers, such towns stood as autonomous cities and principalities until armies brought down their walls with cannons and they hosted central governments that took charge of roads, waterways, landscapes, commerce, and laws. From *Dictionnaire encyclopédique Trousett* (Paris: Girard & Boitte, 1886–91).

As it had done throughout the Middle Ages and the Renaissance, the court housed the abundant, the polished, the elaborate, and the ornate. It took control of the surrounding external environment, hosted the most grandiose ceremonies and games, became a stage for perfected chivalric codes and poetic expressions, and was a center for arts, architecture, literature, and learning. With its centralized military, legal, and administrative functions, the court was a beacon and symbol of royal preeminence. It testified to royal inheritance and monarchical sovereignty. By its size and opulence, and its manifest capacity to shelter, feed, and command laborers and craftsmen, its outer and inner structure constituted prima facie claims to power. Until improved cannonage could bring down their high and thick walls (thanks to a contemporary revolution in powerful horse-pulled wheeled cannons, improved roads, and a veritable modern revolution in gunpowder), the court was a social, economic, and political nucleus of the landscape.

City historian Witold Rybczynski writes that the growth of the central-ized military court, not without parallels to the growth of the city on the late Neolithic landscape and its triumph over clans and chiefdoms, overtook lands and principalities and annexed and subjugated cities. "At the beginning of the sixteenth century, some European towns started to lose their inde-pendence and to come under the authority of the aristocracy. This is what French historian Fernand Braudel calls the subjugated town. The Medici, the German princes, Louis XIV, and the Hapsburg emperor controlled Florence, Munich, Paris, and Vienna, respectively. They built their grand palaces (the Nymphenburg, Versailles, Schönbrunn) on the outskirts of walled cities and slowly but inexorably imposed their royal will on the towns."[35] The impo-sition of royal rule brought "huge construction projects: squares, avenues, promenades" for all to see. And, as Rybczynski further remarks, with this material and visual transformation gradually came a political transfiguration. "Citizenship, which had originally meant allegiance to the town, was trans-formed to the state, which eventually replaced the monarchy as the leading urban power."[36] Surfaces, spaces, and places were subjugated to the control of the pervasive state and the agents of that control. The king—and later the state—was becoming the very body and the ruling mind of the countryside.

Who could doubt that Louis XIV was the king of France, the most prestigious monarch in Europe, upon catching sight of his Versailles? Originally the site of a royal hunting lodge located twenty-five miles west of Paris, Versailles became the grounds of an extraordinary palace. Built on a Baroque scale but in a more reserved classical design, Versailles's splendor testified to France's glory and Louis's confidence that he could control both Paris and a rich land rife with centrifugal forces and engrained local autono-mies.[37] Begun in 1661, the Palace of Versailles expanded in stages—four in all—as costs mounted and crippling royal debt accumulated. It employed a pyramid-building number of workers (according to Weber, as many as thirty-six thousand in 1683, the year after Louis left Paris for good to inhabit his retreat at Versailles).[38] With a floor area of 6,700 square meters, Versailles had 2,300 rooms, 2,153 windows, and 67 staircases. "In 230 acres of its gardens, there were 1,400 fountains; approximately 2,500 trees had been transplanted in one year alone, to please the king, and the waters of the Seine were raised to supply Versailles's complex waterworks."[39]

Truly, surfaces made the show. Here was a singular palace for pageantry, theater, and high leisure. Here the elitest of the elite—the richest and most tasteful—gathered for plays, music, opera, and dance, which Louis XIV both

participated in and designed. Geometrically organized hedges and paving stones led eyes along level and scripted steps and to and from fountains, and then lured strollers out of the bright sunlight to shady gazebos and smaller buildings on slivers of land for private tête-à-têtes. Large stairs and walkways on the palace terrace staged residents' parading, promenading, seeing, and being seen; and gossip, following in vision's train, was ever alert to any surface irregularity of behavior. Rows and floors of decorated windows, the Hall of Mirrors, and ponds and lagoons reflected images and echoed words. This landscape of elaborately organized surfaces formed both scenery and stage for enacting a royal appearance and the highest codes of etiquette.

A master puppeteer, Louis made Versailles and its entourage his constant fixation—and a tool of his self-celebration, an enchanted palace, and a fit residence for the radiant Sun King. At Versailles, he took nature in hand and controlled its surfaces. With his rising and his going to bed, he set the palace's daily and evening regimes, and he rang the seasons in and out with festivals. Along with setting styles of dress, dance, and furnishings, as well as taste in music and drama, he defined noble appearances and elevated emotions, sights, sounds, scents, and even touch. Surely, this sublime world stood separate and far from rough, dirty, and rude Paris. The royal tableau prohibited the unkempt, rough, gaseous, belching, and poorly spoken commoner from entrance, and bodily intrusions, transgressions, infringements, or malapropisms were suppressed, ignored, and snubbed.[40]

Title, rank, dress, hat, and respect for body parts (perhaps none more than the queen's foot) regulated space and determined movement, encounters, and hierarchies of sitting and standing.[41] The court's order strove to put the present Louis on top. Flattering, fawning, and fanning glorified the king. Sycophantic artists plastered the king's deeds in war and peace all over the palace. The king fell asleep or awoke to a ceiling that commingled images of his reign with those of illustrious antiquity and placed him in the company of classical gods. All this ornate carrying on at Versailles, with its gold-leafed, mortal human surfaces, served royal and official propaganda, whose end was a veritable "monopoly over myths."[42]

STARS SO BRIGHT, ROADS SO DARK

The modern court cultures, which accelerated the entrance of the wealthy and talented middle class into government, projected a world in which

privileged humans lived amid bright, level, and shiny surfaces. The chosen ones had an abundance of things and ample means to amuse and glorify themselves.[43] In effect, courts and palaces shone like bright and magic stars in the dark, dreary, and toilsome land.

In the latter, surfaces were coarse, rough, and uneven, and things were scarce in amount and variety. In scattered rural settlements and villages, houses were small and rough-walled. Composed of one or two rooms, the second often shared in winter by heat-producing animals, these huts and shacks offered little space for their inhabitants, who lived skin to skin, too close for either comfort or enchanting intimacy. Without running water or toilets, with space heated only by stoves and fireplaces (when wood was available), their inhabitants trod on earthen or rough-planked flooring. They often slept not between sheets, but curled together under coarse blankets on roughly sewn straw and hay mattresses. Small, cramped houses meant some people slept outdoors in improvised lofts and dugouts. With only a single table and two corresponding benches for eating, most people learned to sit on their haunches, with their backs against walls. They had only a few pots for cooking, and no fancy utensils for eating—perhaps only a wooden spoon and a knife.

Outside, yards were not paved or covered in grass; instead they were worn hard by traffic, blown over with dust, engulfed in mud, and turned to mulch by rain and manure and other organic waste. Although relatively flat, dry, and large surfaces might support Breughel's peasant communities in dances and games, ordinarily surfaces in the countryside did not permit smoothly sliding dancing feet or even an easy run for versatile single-wheeled wheelbarrows. Because most lacked expensive horses or even the more common oxen, things were hauled by the power of human backs, whose load might be supported by aided by shawls or suspenders. Travel invariably was about stepping up and down precarious rocky, sandy, and other uneven surfaces.

Trips beyond the boundaries of parish, town, and *pays* remained onerous for even the wealthiest. Fickle weather, sickness, and unexpected happenings and encounters meant unforeseen adventures. Changing surfaces—jagged rocks, raging rivers, and sinkholes and wetlands—caused accidents. Then, too, one's shoes came apart, horses broke down, nasty dogs and animals appeared, insects swarmed, bridges collapsed, ferries capsized, and guileful road companions turned wicked. Sinister innkeepers spun their hostels into webs for looting, fleecing, and even murdering passing travelers and pilgrims. Even in the most advanced societies, such eighteenth-century

France and England, "travel" remained true to its etymological roots, which means *travail*.[44] Trips were always risky undertakings and testing projects, and they meant discomfort and pain. Even for those select few who traveled in vehicles, coaches and carriages never had enough padding, soft seats, or springs with the tensile strength needed to cushion the rider's bottom from the bumps of the road. Nothing helped the jostle and tedium of plodding and lurching across varied, uneven surfaces.

Carriages also collided with rocks, trees, and other carriages. They lost wheels when mired in wetlands, were blocked by mudslides, and fell off cliffs on the never-flat earth. Even the kings' highways, which carried long-distance traffic, did not offer even, well-graded, or cambered surfaces for smooth, dry, and level travel. Eighteenth-century journals report that travel conditions in Europe worsened as one went south and east. Travel in eighteenth-century Italy brought "extreme discomfort."[45] And travel in Russia required survivor's luck, plus, in some cases, the literary imagination to record one's adventures on the country's treacherous road surfaces.

EVERYBODY WHO IS ANYBODY BECOMES A SOMEBODY

While sparks rising from the hearth of a fireplace might ignite evening dreams of golden domes, fancy gardens, and silver slippers, in the morning the commoner awoke to hunger and itching, and his first steps reacquainted him with the daily pale of dust and dirt and a regime of hurt.

One's outer appearance announced oneself to the world and the world to oneself. Along that interface, appearances counted for most, if not all. Surfaces, as contours and countenances, formed a first foundation in community—one's being with and among others. Surfaces, myriad in their form yet singular and ineffable in appearance, were the basis of the first and most often enduring judgments. They declared a person as gifted, blessed, or graced; as living in ordinary pain and degradation; as deserving of condescension; or even as meriting scarce and overtaxed pity. Beyond manifesting wealth, wellness, and other aspects of one's life, surfaces—one's skin, eyes, lips, and facial and bodily gestures—confessed well-being, character, heart, intelligence, integrity, and dignity.

As were the faces of the ages' great new clocks, personal appearances were read with a speedy glance. Appearance (the noble Facebook of that time!) offered an outline of stature claimed and deserved. It indexed means, class,

education, and —depending on the twists and turns of body and cloth— whether a person was making an aggressive or a coy bid for higher place. Grace and balance, accented by clothing, a wig, and shoes, offered an initial profile, while etiquette, manners, and comportment, like the walls of one's home, made individual bids to win high appraisal. Yet the keen eye picked up disguises and concealments.

Discretion in step, articulateness in word, and speed of wit bolstered the individual. Reticence retained one's rank and differentiated oneself from ignorant, brash, and obsequious upstarts. As speech, diction, and conversation elevated, so gestures distinguished and ingratiated. The peasant found it difficult not to stomp, stammer, and spit his way through his days, even on the rare occasions he found himself in refined settings. Meanwhile the educated foot walked a learned path along the smooth surfaces of court, dance hall, and garden. The body of an aristocrat was an elegant platform; his or her movements transfigured the body into, I would say, a corporeal carriage that rolled through society with a royal and elite appearance. Walking was elevated in solemn parade, casual promenade, and organized dance (especially the minuet, sponsored at Versailles by dance master Louis XIV). Feet merited the most ornate decoration—high-heeled, shapely, colorful, and even sequined shoes. Sitting, too, became a cultivated and practiced art of the well-off as chairs grew in variety and abundance and leisure time increased. In the palace's and mansion's sitting rooms, elites reclined and increasingly indulged in refined conversations and took up sedentary hobbies. Reading and collecting grew in popularity, and paperwork, in its multiplying sheets and rolls, accompanied both public and personal affairs, just as meeting, planning, chairs, tables, desks, and sitting did.

Heir to Italian and Spanish manners, French *civilité, politesse,* and the more all-embracing *honnêteté* offered an increasingly comprehensive guide to bodily appearance.[46] Following their own path, the English further adjudicated the proper display of emotion, gesture, and posture.[47] Etiquette instructed the kingdom on the proper way to bow, doff a hat, kiss a hand, wave a fan, and kneel (on one or two knees). Its prescriptions furnished a catalog of proper surfaces and movements.

Making beauty less than skin deep, clothes, the body's outermost covering, made the person and complemented the elaborate and pompous Baroque culture of appearance.[48] Style and fashion—the forerunners of nineteenth-century glitz and glamour—wove an indispensable and obligatory shirt for the presumptive courtly actors of the age. They could not separate their

selves from their dress. Clothes enfolded and bannered a noble life. Perfumes suppressed repugnant body odors and obtrusive smells, just as powders covered blemishes and enhanced complexions and rouge and lipstick (made of beeswax) added color and dash to pallid faces.[49] Jeweled and crocheted collars ringed young and old necks alike, and wigs gave uniformity and dignity to defiant hair and bald heads. Women's high coiffures became elaborate structures of curled and bejeweled hair, which augmented height and elongated (and thus added elegance to) necks and faces.

Giving heart and purse to the cliché that clothes make the man, as well as the lady, the court dressed to the hilt. Wardrobes, whose hidden origins lay in medieval castles' latrines—where clothes were stored in the belief that pungent smells deterred moths—could occupy full apartments in modern palaces, and their care entailed servants' maintaining, storing, and preparing the day's selection of ever-bountiful ornate clothes. Folds and pleats, color and jewels offered an array of textured and thus intriguing surfaces. Jewelry, footwear, and canes and umbrellas were accessories for beautifying individuals and claiming the favorable glance of others.[50]

On a more philosophical tack, clothing, first and forever seen, also stimulated the human imagination. Clothes invited the ever-toggling mind to move back and forth between the body dressed and the body nude, the body raw and the body idealized.[51] Here, between the poles of surface and depth, perception and conception, real and imagined, was found (as etymologically analyzed and philosophically elaborated on by Heidegger) the meaning of the Greek word for "truth," *aletheia*—that which is unveiled.[52]

Aesthetically, the feminine body has always been the surface of surfaces, the inner temple of temples, the prize of prizes, the pearl among shells. And for the sake of beauty at rest and in motion, the woman was imprisoned in her dress. Clothes advertised her as one being in public halls, and altogether another (as modern art suggested) in her boudoir, her private bathing and dressing suite. Corsets, stomachers, crinolines, hoops, trailing skirts, rising embroidered collars, garters, gloves, fans, parasols, elaborate wigs, bonnets, and preposterous hats supporting exotic plumage—even model ships—all played their part in generously birthing and then tethering the Baroque Venus to her shell. Sitting or walking, she had a stiff neck, stilted posture, and restricted stride. Her clothing not only weighed her down, shortened her stride, and diminished her maneuverability, especially when dealing with doors and entrances to sedan chairs, but it offered obvious proof that she was splendidly beyond manual work.

From 1500 to the French Revolution, fashion held the upper-class woman in stern and contradictory bondage.[53] She was expected to move freely despite yards of encumbering cloth. She was to move through the world without blemish. Somehow, her image was supposed to make her invulnerable to the splashing mud of passing carriages, and she was never to lose her boot to sucking muck. (To protect against mud, the lady wore patterned wooden clogs with heels lofting her as much as a foot above the ground.) The ideals of Versailles did not shield the aspiring lady against Paris's besmirchment, if we are to trust Abigail Adams. She spoke of it as a town with unbearable pathways heaped with mounds of rubble; "the people themselves were the 'dirtiest creatures' [on whom she] had ever laid eyes"; and everywhere angelic women were degraded to prostitution.[54]

Appearance committed all, even the residents of Versailles, to a continuous battle. After all, the palace's quarters were small, cramped, confining, and without plumbing of any sort. Residents fought daily skirmishes on behalf of fragrance and beauty. Baths, combs, powders, and rouges were drafted into a lifetime of combat against uneven skin, fickle and disobedient hair, lumpy or bony bodies, and outrageous pimples, boils, and other protuberances. Beyond cosmetic wars against the resistant and repugnant body, residents also took up arms against rumpled, soiled, and sweaty clothes. But lurking just beneath the skin, resisting all efforts and the cleverest techniques of beautification—the premier superficial science—was the everlasting antagonist: the body stinker, the body prankster, the body sneezing, belching, farting, ill, aging, sick, and even dying, failing on so many counts to make the measure. Secondary layers of underclothes were inevitably soiled and bulky, while nightclothes, shirts, chemises, petticoats, and negligees (whose origin was an eighteenth-century French nightgown that mimicked the period's full-length women's day dress) forever struggled to secure the wearer's warmth and protection while concealing her unattractive lumps and gatherings.

Artifice had inherent limits in its contests against the beast body, as the many-eyed Argos public scrutinized and espied one. Eighteenth-century bustles, for instance, may have succeeded in stealing glances away from breasts (a focus of seventeenth-century costume) toward sumptuous derrières, but expanding hoops and lengthening and alluring trains tripped up or tightly entangled ladies. Sleuth and novelist Henry Fielding, an eighteenth-century satirist whose work exposed shams, frauds, and masks, judged it "impossible to convey seven yards of hoop into a hackney-coach, or to slide with it behind a counter."[55]

The modern individual was born looking into the face of the mirror. In the course of the seventeenth and eighteenth centuries, the mirror, which grew ever larger and more common, became the standard gazing pool for those in search of their aristocratic and courtly appearance—and for those seeking to render a judgment on who was "fairest of them all." The mirror itself had traveled a long and complex trail from late medieval Venetian glassmaking to early modern French plate-glass production and finally the successful manufacture of the large, flat glass mirror, which played a central role in palace design. It made it grand and most imitable entrance in 1678 with the construction of Versailles's Hall of Mirrors (La Grande Galerie or La Galerie des Glaces), which was installed during the third phase of the palace's construction.[56]

Adding light and perspective to a palace already rich in windows, colors, and gold and silver ornamentation, mirrors offered a reflective surface to exclusive people. Mass-made plate-glass mirrors came, in the following centuries, to mediate the gaze of every Tom, Dick, and Harry. Mirrors both provided the individual with an instant image of themselves as they were seen by others and showed them as a candidate for portraiture, which filled the walls, the statuary halls, and eventually the forgotten vaults of palaces.

French historian Sabine Melchior-Bonnet points out how technical advances in glassmaking in the fifteenth and sixteenth centuries and improved understanding of the mechanics of vision in the seventeenth century had made this "instrument of ancient and classic wonder" both ordinary in its existence and extraordinary in its effect. She clarifies the ambivalence of the mirror: "By shedding its mystery, the mirror [by then perfectly flawless but ordinary] became an instrument of social conformity and offered man the freedom of a solitary face-to-face encounter. The clarity and distance of the reflection offered a space of performance, a theater lending itself to disguise and show. All games, all illusions are now possible since the transparent mirror makes one forget its physical present, and the man manipulating space in this fashion delights in his power."[57] An engaging surface because of the immediacy of identity and recognition it made possible, the mirror also elicits keen-edged objectivity and mutating images of fathomless subjectivity. It moves back and forth with the speed of the eye and the dart of consciousness. It evokes fields of dichotomies and ambiguities between the body as it is seen and the self as it is thought, between the external countenance and the

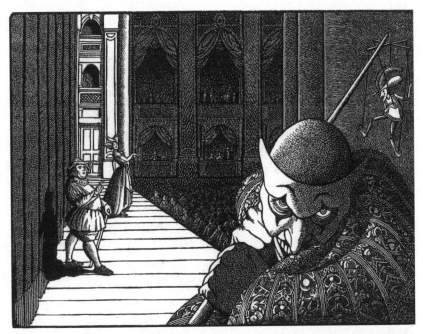

FIGURE 17. "Under the Aegis of the Great Stage Muse," Abigail Rorer, 1981. The artist says of this woodcut, "This is just an imaginary, somewhat absurd scenario." To the contrary, I find this provocative and fiendish, a Muse taunting all: "Come forth, I dare you. Wear your mask, carry puppets, and recite your soliloquies. Yes, step onto the big stage, which you dread and where you surreptitiously parade." This stage is a great mirror for the grand performance, the arrangement of surfaces for the full presentation and ultimate revelation of self and other. The Baroque era singularly and grandiosely frames the scene.

inner reality. Before the mirror, lover and hero strutted, vile and duplicitous individual and pitiful person slinked and slumped—and the message universally went out: Here, look at yourself, and judge yourself by your appearance.

Such cunning writers on the self as Montaigne and Pascal explored the splits of self occasioned and amplified by the dissemination of the mirror. The modern individual played peekaboo with himself in the mirror as he caught and fashioned images of himself at masquerades, dances, courtly entertainments, and official ceremonies. Even though many of Europe's kings sponsored masquerades, no place rivaled eighteenth-century Venice, of which a French tourist remarked, "The entire town is in disguise." Maskers of all ranks—nobles, clergy, imposters, seducers, and con men—entered the Venetian game, which, if only for the duration of a certain festival, permitted the masked person to believe that "identity is a performance and the self can

be refashioned by its possessor." In the labyrinth of Venice's Mardi Gras was found a chance to act out an alternative self.[58]

The mirror belongs to human creaturely sociability. The most self-conscious and self-regarding of animals, humans belong to our mirrors. Through the eyes of oneself and others, the mirror, which decoratively filled seventeenth- and eighteenth-century palace walls with reflected light, multiplied images of the seen and reinforced judgments of superior, equal, and inferior. A set of refracting surfaces, the mirror was propagated as décor, and it promised, though falsely, to validate the shifting relationship between appearing, seen, and judged.

The mirror also entered into the formation of modern aesthetics. Leonardo used it in his drawings, and it proved indispensable to Rembrandt's execution of ninety or so self-portraits. The mirror found its analogue in this consummate seventeenth-century Dutch painter, who operated on the premise that there was a sheer beauty to the visible world in all its forms.[59] The mirror buttressed portrait painting in its aesthetic presumption and commercial assumption that appearance equaled underlying substance and that the keen eye and hand could divulge that inner essence.[60] Portraits and mirrors hung in the same rooms, in close proximity, and thus numerous artists depicted their subjects looking at themselves in mirrors. From different angles, they all endorsed the same illusion: that this era's bright and passing surfaces, especially its nobles and its women, deserved lasting adulation and glorious admiration.

STEPPING OUT INTO THE GARDEN

Since Babylon, kingdoms had built great walls, and behind them great palaces and great gardens. Gardens made it obvious that the king had not only power, wealth, and abundance, but also a green thumb and an eye for the beautiful. More philosophically, the king's gardens reflected his willingness to spare no artifice in his nostalgic bid to regain Eden and restore the lost harmonious relationship with nature.[61]

Gardens (in forms originally established around Roman villas, and beautifully articulated on the Tuscan landscape) multiplied in the Renaissance, and the passion for them became infectious.[62] They became a matter of stylish necessity and competitive experimentation. Stating one's place, taste, and powers on the landscape, gardens figured prominently in an estate's presentation and supplied ample reason, as they did at Versailles,

to tax budgets beyond their limits. At the same time, their keepers practiced improved tillage and grafting, displayed exotic and beautiful plants from the Old and New Worlds, formed ornamental hedges and intricate labyrinths, and constructed stonework, stairways, pools, and architectural models in the form of temples, obelisks, pagodas, and Roman rotundas.

An extension of church, court, estate, and country home, the garden framed open-air stages for festivals, pageants, balls, concerts, fireworks, and other spectacles, and it projected idealized perspectives, grids, curves, contours, and images of orderly, established, and luxurious life. Organized by a combination of smooth stone walkways, decorative vegetation, and monumental statuary centered around fountains, gardens—with considerable variation among their Italian, French, and English versions—joined in building an idealization of nature. While the upper classes in the course of the eighteenth century spent increasing amounts of their leisure promenading on foot and carriage, they often took their first steps in their own and their neighbors' gardens.[63] The English garden pointed beyond itself toward nature. With grass lawns, artistically positioned trees and shrubbery, and gravel paths, English garden designers projected "the undulating line as natural." In some instances, they went as far as to disguise the border between the garden and the surrounding landscape "with the use of the haha, or sunken fence." The ritual walk through the garden of the country home fostered a desire in its inhabitants to shape the countryside itself and incited a tree-planting desire among the land's nobility, which eventuated in making England a land traversed by rides and avenues that were conceived of as visual extensions of garden paths.[64]

The garden offered a stepping stone into the surrounding countryside. Promenades in carriage and on foot that began in and around estates led out to smooth riding and walking lanes in the suburbs, and then even onto city ramparts and select city avenues. Gardens had birthed the ethereal proposition that the world was to be gone out into and enjoyed.[65] By the end of the eighteenth century, gardens (which also could be reclusive hideaways) had fostered the love of nature that accounted for generations of country walkers, botanizers, and romantic explorers and hikers.[66]

MORE THAN MEETS THE EYE

Garden walks belonged to the group of prominent, flat, and even surfaces that also included marble and wood floors, spacious and bending stairs, and

finely graveled pathways on which royalty, nobility, magnates, and ecclesiastical officials processed.[67] Radiating status by rank, order, gesture, and dress, they gracefully ascended and descended prominent stairs that joined garden and terrace, and the main floor and upper floors to the smooth parquet and stone floors of courts, palaces, and estates. On open parade grounds, located near sites of anticipated trouble, armies put their marching regiments and their choreographed, prancing show horses on display.[68] The assembled modern European army itself was an awesome machine to behold—an organism whose parts responded to the highest powers. As the court organized regimented dance, so armies were synchronized and choreographed as a single marching mechanical organism. (Frederick the Great dramatized military marching and parading with the goosestep.)

At the apex of place, ritual, and movement shone the king and his court. He was the brightest star in the sky. Beyond sublime ostentation, the king sought to beam forth power and keep his hands on the reins. The truth of this is evident if we take the Louises of France as our model. They used their armies and power to crush internal resistance. With improved cannons and gunpowder, they destroyed the walls of independent cities and renegade domains. At the same time, they exiled the Jews for their independence and sought to bring to heel insubordinate Catholic bishops. They took the nobles into the close embrace of the royal court and there granted them rank and influence. All the time, as Alexis de Tocqueville argues in his *Ancien Régime,* they (especially Louis XV and Louis XVI) vigorously pursued centralization through law, policy, and administrative control.

Nevertheless, more than integration of peoples and land was required to make kingdoms thrive. The growth of commerce, manufacture, and wealth in the eighteenth century increasingly compelled monarchies and republics alike to make their individual lands prosper. They had to foster production and commerce within their territories as well as discover and nurture beneficial relationships with their colonies. Overseas maritime rivalries grew, none equal to that of France and England for control of North America.

Inventories of resources and conditions, which all organized peoples must make, measured growth overseas and consolidation at home. In direct proportion to their wealth and power, kingdoms sought to make comprehensive surveys of their lands and water, censuses of their peoples and places, and calculations of their production and trade, and the resulting taxes were undertaken.[69] Maps, which joined lines, grids, and numbers, played an indispensable role in France's, and all kingdoms', measurement and

accounting. They took lands out of the realm of myth and made them named places, subject to a consistent topography, latitudes, and longitudes. Centuries in advance of global positioning systems, flat paper sheets provided uniform surfaces on which officials could survey, chart, classify, coordinate, and integrate the places, peoples, and activities of an entire kingdom. Maps provided an accurate, portable, and visual way to see, grasp, calculate, analyze, and plan the resources, assets, means, and powers of a kingdom. Far more than any book, a map was a precise tool—even a type of machine—to establish location, organization, and control of visible things.

Mapping and surveying blossomed under Louis XVI (1754–93). They complemented increased eighteenth-century travel, in which Louis XVI joined with his trips to confirm local contacts and observe the completion of regional projects. With geometry, geography, surveying, and mapmaking skills forming part of his youthful education, as historian Daniel Roche points out, Louis XVI, once he had become king, supported the continuing publication of surveying textbooks, lent his enthusiasm to the revisualization of space that went with new mapping, and initiated in embryo an administration based on social and economic surveys.[70]

In accord with the proposition that both kings and subjects benefit from knowledge of the land, Louis XVI supported the mapping and surveying of France. Field-trained engineers were sent to Versailles for advanced training before they dispersed across the nation to build roads, canal, cities, and manufacturing facilities and to complete the surveying of the nation's many large estates. Though public and always important, military mapping did not coincide perfectly with private mapping. France took a long step toward uniformity as it became an identifiable set of surfaces that could be located by a compass and ruler and then juxtaposed and superimposed on one another by calculable coordinates, transposable numbers, interlocking roads, natural boundaries, and overarching administrative units.[71]

More than any prior king could imagine, Louis was giving life to a whole and coordinated body, which the French Revolution would baptize and imbue with a different spirit. As Roche explains: "It was the historical process of the development of the monarchy that created the conditions under which the monarchy could be challenged. The royal administration juxtaposed seigneurial loyalties, local and customary forces, bureaucratic rationality, and programs of modernization. It was an unstable compromise between a modern state and the principles of social organization inherited from feudal times, a power at once modern and archaic."[72]

So the aristocratic and royal powers suffered an ironic fate, as those long in power usually do. Their intentions, insofar as they can be collectivized, were to make the kingdom a secure and luxuriant garden in their own service. Beyond organizing all things and places to serve their ends, they aimed to decorate visual surfaces to signal and confirm their superiority. But their actions, aimed at creating a single sovereignty and a harmonized and coordinated society, produced new classes that wished to share the power, rights, and wealth of the nation.

Outside the garden walls of the Baroque and within eighteenth-century walls, trouble stirred. In urban salons and under golden ceilings, philosophers talked about new secular orders of reason, harmony, and equality. Across the land, whole regions and classes discovered that France was one, whatever that might mean, and that they were ready to insist on their rights and on a fair division of things. Spurred by revolts and revolutions elsewhere, their leaders stood ready to climb on the stage of the nation and call for the removal of older orders, customs, and authorities. They would paint the entire nation red if they got a chance. And, as we will see in the next chapter, mills and machines were wreaking incalculable economic, social, and ecological transformations at the same time. Humanity stood ready to make over the world and recreate itself. Walls would be taken down; a previously unknown face would be given to things and people.

Fresh Faces and New Interfaces

FROM THE GROUND FLOOR UP

The belief in progress manifested itself in building.

TOM PETERS, *Building the Nineteenth Century*

Technology matters because it is inseparable from being human.
Devices and machines are not things "out there" that invade life.
We are intimate with them from birth, as were our ancestors for
hundreds of generations.... Martin Heidegger argued that in
the modern world technology provides a theoretical "horizoning
of experience."

DAVID E. NYE, *Technology Matters*

MODERN AND CONTEMPORARY HISTORY CONSTITUTES a narra-
tive of making, building, and inventing things both large and small. New
synthetic materials, powerful and precise engines, and fresh technologies
form chapters narrating the transformation of macro- and microenviron-
ments' surfaces. In the nineteenth century, society—on an unprecedented
scale and at accelerating speed—enwrapped itself in innovative struc-
tures, entire new industries, and myriad manufactured products, much as
early civilization had enclosed itself in walls and Homer's Mediterranean
had outfitted itself in bronze. So the century reshaped landscapes and
lives. Its surfaces, as singularities, contexts, juxtapositions, and entire
environments, became means to create identity, and innovative ways to think
and live.

However, this century of self-making, self-building, and glorious self-
creation, which is associated with the indisputable prowess and enhanced
powers of the Industrial Revolution, did not produce a unified and uncon-
tested view of reality. Rather, the advances of the century were interpreted
and debated through the antithetical lenses of Enlightenment rationalism
and Romantic organicism, and through the compound lenses of the French

and Industrial Revolutions. Consequently the world was resurfaced with unprecedented images and signs.

Compounded as a worldview in the second half of the eighteenth century, Enlightenment philosophy offered programmatic assumptions that humanity was systematic, rational, secular, radical, and utopian. In its most universal modes, it affirmed that progress could be realized in all theaters of human life and that humanity was in the process of becoming, in the shining words of the *philosophe* Bernard de Fontenelle, "more enlightened day by day so that all previous centuries will be lost in darkness by comparison."[1] Relying on science's expanding theories, as universalized by Newton's laws of gravity and light, Enlightenment philosophy expressed confidence that reason could create an improved society and humanity. Society's growing capacity to shape the surfaces of the earth and to supply itself with multiplying tools and goods gave the age's optimism a material footing. Roads, bridges, canals, gardens, ships, machines, tools, and transoceanic projects of exploration, colonization, and exploitation supplied energy and dreams to competing nations.

The Enlightenment's boldest assumptions included the concept that the mind had the capacity to discover the laws of nature and, in accord with them, to make things, design engines, and shape landscapes.[2] Surfaces no longer stood as uncompromising sentries along the absolute boundaries of God and tribe. They were not the guardians of fixed ways, custom, or nature. Rather, surfaces beckoned keen eyes, probing hands, and inquiring minds to observe, improve, and exploit the world for human purposes. Taking its hope from advancing science and technology, Enlightenment optimism resized the world to human measure, actions, and dreams.

Romanticism afforded a second worldview for the nineteenth century. Twentieth-century philosopher Alfred North Whitehead contends that the Enlightenment dualistically divided the world between the material and the spiritual. On the unoccupied middle ground, Romanticism counterattacked with "concepts of life, organism, function, instantaneous reality, interaction, [and the] order of nature."[3] Modern physics' ingenious explanations of light and gravity did not merit, as Enlightenment proponents had it, the reduction of being to space and mathematical abstraction.[4] Acknowledging the richness of the living world, Romanticism sought an understanding of nature and its processes in terms of singular entities and events. With a decided bias in favor of history and literature, Romanticism attributed primacy to the individual: *individuum est ineffabile*. With a predilection for the exotic,

eccentric, rebellious, dramatic, and heroic (as displayed by the German *Sturm und Drang* proto-Romantic aesthetic movement of the 1770s and 1780s, and by the narratives of early Romantic history, formed around themes of national uniqueness and destiny, which began to appear in the 1820s), Romantics defined phenomena by their unique origin, singular novelty, distinguishing unities, and organic wholes. Diverging from the "central values and cardinal doctrines, moral, historical, and aesthetic, of the Enlightenment," which postulated a universal philosophy and found its commanding goal in the fulfillment of humanity, Romanticism chose to depict in the present and past singular, foreign, and even exotic lives, cultures, traditions, and history.[5] Romanticism required metaphors, symbols, images, and even myths to bring the world alive, and in doing this it lent new images, interiorities, and associations to the decorative and representative arts. Literary critic M. H. Abrams argues that if the Enlightenment mind was a mirror that reflected reality, the Romantic mind is best understood as a generative lamp that illuminated and gave form to reality.[6]

As developing worldviews and expanding sensibilities, Romanticism and the Enlightenment furnished opposing lenses through which to view the nineteenth century, particularly its emergent nationalism and the impact of the spreading Industrial Revolution on nature, village, democracy, nation, and non-European peoples and tribes. They provided distinct optics to view and judge the protean surfaces of the faces and landscapes of the world.

THE REVOLUTION

Nothing transformed Romantic and Enlightenment fears and hopes as much as the French Revolution, which with words and deeds fashioned conceptions and judgments about where society stood in time. Defined as the explosive decade from the challenge of the monarchy's control in 1789 to Napoleon's singular ascent in 1799, the French Revolution put a dramatic face on society. It offered new facts, events, images, ideas, and dreams to narrate nations and humanity.

In the spirit of the age and of the American Revolution, the French Revolution elicited the world's attention by its unique deeds and universal declarations.[7] Its declarations of the birth of a new society provoked a flurry of opinions. In his *French Revolution* (1837), historian Thomas Carlyle dubbed the period 1789 to 1795 the "Age of Pamphlets," a time when

decrees, edicts, declarations, and manifestoes trumped attitudes, habits, and customs.

In August 1789, the National Assembly started the festival of declarations. With a set of dizzying proclamations, citizens were judged hereafter to be equal, free, and fraternal. It banished the state system of censorship. Citizens could speak, write, and print freely. Treating public surfaces like signboards, the revolution renamed streets, squares, and buildings and created, on the basis of expropriated church land, a brand-new paper currency, the *assignat*. (Paper currency, which had begun its ascent in value at the beginning of the eighteenth century, took on greater significance during the revolution.) Words, money, and revolutionary paper overflowed the banks of the Seine. The number of printing establishments in Paris tripled in the revolutionary period, with fifty-five new shops opening in the years 1789 to 1790 alone. Pamphlets on every subject were the sails of the racing ship of France. They ranged from treatises on finance and public administration to philosophical essays, political denunciations, eulogies, and *Les Cris de Paris,* the array of political pamphlets that accompanied the strife and promise of the unfolding revolution.[8] With trowel and hawk in hand, citizens plastered over surfaces with present commands and future intentions.

But the French Revolution seized minds with more than words. It made its boldest strokes in terror and blood. The drama of its events turned the nation into every citizen's theater. Matters proceeded too quickly to be reflected in architectural form or in the decorative arts; the revolution settled for taking crosses off graves, removing Christian symbols and signs, and even converting iconic Notre Dame into a place of worship for the new national religion, the Cult of the Supreme Being. The revolution's leaders renamed the months and used the revolution to mark the beginning of a brand new historical era, as Christ's birth had. The revolution also dressed itself anew: democratically, with far less ornate and expensive clothing.[9] Citizens shed the knickers and silk stockings of the elite and put on long, cuffless pants, so they became known as the *sans-culottes,* who trudged on foot to war across Europe as the first citizen army, parading under the revolutionary tricolor flag of blue, white, and red. Hence color too was mobilized.

The revolution also acted itself out in plain sight on the public square. At the Place de la Révolution, the revolutionists put into service its innovative and most efficient machine, the guillotine. Called by its advocates "the people's avenger," the guillotine, during the Reign of Terror (September 1793 to July 1794), decapitated the king and queen, approximately thirty thousand

more people in Paris and elsewhere in France, and eventually Robespierre himself. The revolution ran its course, and at Rheims Cathedral Napoleon ceremonially crowned himself emperor of France, with the pope as witness. The revolution had painted the town with bold words, stunning deeds, and terrifying images, and France's colors and armies now spilled over the rest of Europe. Was all this a stage play on the way to enlightenment, or a romantic happening?

VAST CHANGES

The nineteenth century was a fountain of change and images in all forms. Change put in play a civilization's entire treasury of conceptual resources and stimulated its aesthetic horizons. Around industry, in particular, arose a dual aesthetic. Its cyclopean works were celebrated as monuments erected to humanity's Promethean greatness. At the same time, industrial sites were judged to embody a demonic spirit. The mouth of a mine was the foreboding orifice to the underworld; a glowing foundry, the fiery jaws of hell; and industrial workers were chained in degrading bondage.

Artists and writers often reacted to the violence and brutality of the industrial world. Thoreau saw the train as slicing through the honest countryside of natives and frontiersmen, its loud and disruptive tracks annexing country people and the past to expanding urban and moneyed interests. Prima facie praise for industry's achievements was met by corresponding laments for forsaken villages and lost traditional communities. Indeed, opposing visions of emerging industry in the first decades of the nineteenth century turned on conflicts between rational engineering and a counterattacking and emerging Romantic sensibility. For instance, at the same time that French painter and caricaturist Honoré Daumier gave face to humble people huddled in a third-class train compartment in an 1864 drawing, Napoleon III's urban planner, Georges-Eugène Haussmann, sought to open Paris by building boulevards that would facilitate modern transport and permit the efficient movement of cannons and troops against rebellious masses and their proclivity to block streets with barricades and paving stones.

With their sensibilities antagonistic to Enlightenment rationalism and systematization, Romantics, led by Sir Walter Scott, turned their admiration to the Middle Ages and its spires, and they maligned Gothic intricacies. Both Neoclassical and Romantic public and domestic architecture filled the

post-Napoleonic world. Towering over all other contemporary examples, the British Parliament building, started in 1834, was constructed in the Perpendicular Gothic style, known for its vertical lines and flamboyant tracery.

Nostalgia and progress battled for and bifurcated the perception, conception, and valuing of surfaces. The built world was dichotomously interpreted as creative and promising or as uprooting and destructive. Each completed structure, be it a new factory, another cast-iron bridge, or a great metro trench, was an occasion to pronounce for or against the world that indisputably was in the making. The celebrated Crystal Palace of cast iron and glass, built in Hyde Park to house the Great Exhibition of 1851 and its fourteen thousand international exhibitors, drew the wrath of the antiwestern Dostoevsky, who judged the modern city to be an anthill.[10] Yet neither praise of progress nor apocalyptic pronouncements of imminent decline carried the day. Changing surfaces revealed to all that the urban West had become a construction zone, whether those surfaces were seen as epiphany or as apocalypse.

THE EYE AND HEART CONVERGE

As was true during the late Neolithic, which transpired over thousands of years, the nineteenth century, with its increased population and cities, marked an explosion of human productivity, although it was measured in a stretch of mere decades. Putting an urban countenance on humanity, the populations of megacities—the hubs of revolutionary change in the West—multiplied at a dizzying pace. In the cases of Paris and London, the city population doubled five and ten times, respectively, over the course of the nineteenth century. Ringed and laced by inter- and intraurban highways and railroad tracks, cities radiated out in concentric circles into suburbs and then into the surrounding countryside, inscribing a new geometry, new sets of looming structures, and new orders of exploitation, production, and consumption on the land. Urban centers compressed and swept aside nature and traditional ways of life.[11]

Industrial, financial, and political centers became global hubs. Europe, as well as North America and other modernizing nations, altered the world's accessible natural and village environments. Wetlands were drained; forests were harvested; land was opened for vast tracts of commercial agriculture,

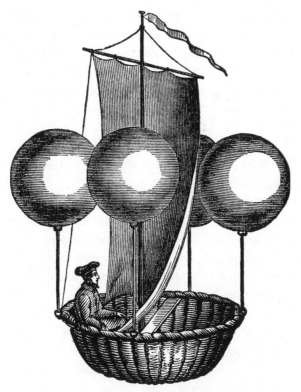

(Ballon de 1670.)

FIGURE 18. "Ballon de 1670." This airship never flew—it was never even built. So it joined such dreams as the wax wings of Daedalus and the ingeniously designed mechanical wings of Leonardo. The history of the hot-air balloon can be traced to China and elsewhere. However, eighteenth-century work on hydrogen produced the first manned balloon flights. In 1793, the French government added an air arm to its military, and balloons were used for reconnaissance during the French Revolution. From *Le Magasin pittoresque,* Paris, 1837.

mining, and lumbering; and whole regions in Europe and the world were annexed to transformative projects. The nineteenth century dramatically fueled human energy, harnessed the eye and hand, and took up the reaching, spatially redefining dreams of modern artists and inventors.

The revolution had both dark and bright sides. It was a beacon that shined beyond degraded landscapes and depreciated people. It signaled a hope that

things could be rich and bountiful for all. Machines and engines redefined human activity and consciousness: Industry offered a plethora of new objects. It presented people with pleasing and comfortable structures—new living quarters, workplaces, and public parks. It created cityscapes and landscapes. Its pipes brought fresh water and took away sewage; its power plants and electrical wiring illuminated the cities. Factories encapsulated human labor. Schools, with simple sheets of paper, blackboards, textbooks, and of course publicly paid teachers, promised to make nobodies into somebodies. Cities taught workers new disciplines and altered their appearance with fresh clothing and gestures. They offered opportunities never imagined in one's native, stick-in-the-mud village. Urban and industrial life also offered a new kaleidoscope of surfaces. Cement walls, poles, gates, police officers, street signs, flashing lights, and arriving and departing metro trains channeled bodies into the compulsory flow of city life. Paved roads, cement sidewalks, grassy parks—and a good pair of shoes to travel these and other surfaces—led almost all to fresh meadows.

Surfaces mediate life, and thus the great material and social revolutions of industry fostered a new spirit. Construction and production changed perceptions and conceptions. New materials, fresh forms, and popular objects wrapped lives and minds in unanticipated orders of senses, choices, and opportunities. The world evoked what until then were unimagined appearances and activities, birthing a democratic sensibility and aesthetics.

THE COMING OF THE ENGINEERS

Focusing on the Industrial Revolution in England, from the last decades of the eighteenth to the middle of the nineteenth centuries, Francis D. Klingender contends that steam-powered mine pumps, the increased production of iron and coal, and new canal systems, railroads, and bridges provided artists with new scenes, subjects, and materials for their art.[12]

A modern bike-and-barge trip through Belgium and Holland convinces one how much the face of the Netherlands, with its fields, towns, dams, roads, homes, yards, and gardens, was built and engineered. Every dike, dock, and canal testifies to the engineering of the land and the use of iron and concrete structures. As confirmed by Tom Peters's *Building the Nineteenth Century,* every lock and bridge evidences the engineering of rivers and building of canal systems, which began in earnest in the second half of the eighteenth

century and continued until the mid-nineteenth century.[13] Running through whole regions of Europe and North America, canals turned waterways into highways to transport natural resources, manufactured goods, and immigrant peoples, among whom canal diggers themselves numbered—including my Irish relatives, who dug canals across North America, starting with New York's Erie in 1825 and going west until, in the 1850s, they dug their last canals in Wisconsin's Fox River Valley.[14]

Canals also accounted for two of the century's greatest engineering feats: earth moving on a huge scale by human and steam power, and the leveling and joining of bodies of waters. The Suez Canal, completed by the French in 1859, reduced the shipping distance from Liverpool to Bombay from 10,680 to 6,223 miles. And the Panama Canal, started in the 1870s by the French and completed by the Americans in 1914, formed a new umbilical cord of transport between the Atlantic and Pacific.[15]

The all-purpose and increasingly omnipresent steam engine drove the first phase of the Industrial Revolution. It powered the repeating looms of small workshops that furnished cloth to society and empire. The steam engine drove pumps that channeled the earth, brought water, moved liquids, and cleared mines of water. It also drove the second, heavy phase of the Industrial Revolution, which began in England at the start of the nineteenth century with the manufacture of iron and the use of coal. This later revolution produced new tools that made things; cleared, built, and joined surfaces; and constructed visible and subterranean structures. The steam engine transformed shops into factories, wove nets of pipes and wires, and drove trains across the landscape and ships down canals and rivers and across oceans.[16] Steam power, in fact, geographically demarcated the older commercial zones of Europe from its new industrial zones, drawing a visual, historical line between those parts of the Lowlands that abided in the shadow of the more leisurely grinding windmill and those that belonged to the sterner and more regimented disciplines of steam, coal, and iron.[17]

By the 1840s, the revolution that had begun in Britain and Flanders already had spread to regions in Germany and was realized in the emergence of industrial zones in France. As French historian Eugen Weber notes, Paris, a quintessential city of craftsmen and artisans, witnessed the rise of manufacturing and factories by midcentury. By 1850, five thousand steam engines were already at work there; two thousand miles of railroad track had been laid down; and displaced craftsmen were experiencing competition from the cheaper and the machine-made.

In effect, it took engineers, materials, and machines to build the world we recognize as modern. Engineers, steam machines, and factories produced abundant metal tools and sculpted and incised the exterior and interior surfaces of the earth. With the validating power of science and technology, engineers redesigned the material face of human settlements. The engineer was no longer the isolated architect whose genius and mastery were identified with the creation of a single structure. Although he still utilized crafts to carry out his work, he no longer worked by rule of thumb, model, and intuition. Instead he belonged to a distinct, though evolving, profession that fused science and technology in the design and construction of sets of structures and even of whole environments.[18] Only at the start of the nineteenth century, however, did the term *civil engineering*, in contrast to *military engineering*, become the name of an official field of studies. In its 1828 Royal Charter, the British Institution of Civil Engineers declared its goals to be nothing less imperial than the control, use, command, and conquest of nature. The masters of great surfaces were to practice

> the art of directing the great sources of power in nature for the use and convenience of man, as the means of production and of traffic in states, both for external and internal trade, as applied in the construction of roads, bridges, aqueducts, canals, river navigation and docks, for internal intercourse and exchange, and in the construction of ports, harbours, moles, breakwater and lights, and in the art of navigation by artificial power for the purposes of commerce, and the construction and application of machinery, and in the drainage of cities and towns.[19]

With its self-appointed task to rearrange the skin of the earth, civil engineering summoned to itself a set of subdisciplines. In addition to relying on mechanical and eventually electrical engineering, civil engineering, in the course of the nineteenth and twentieth centuries, spun off subspecialties in coastal, earthquake, environmental, sanitary, and water-resources engineering. Always close by were structural and material engineering.[20]

Engineering worked with an iron hand, so to speak. An emerging field, structural engineering turned to analysis, design, and integrity of building, which meant first and foremost erecting structures that could support and resist loads. The engineer's business was the shapes, strength, surfaces, and interfaces of columns, beams, plates, arches, shells, and force-deflecting

catenaries to furnish skeletons for his creations, which notably included bridges, trestles, tunnels, and large buildings. Along with the challenge of joining and coordinating interior and exterior materials, the structural engineer faced exacting tests in adapting techniques and machines and exploiting the diverse properties of iron, steel, reinforced concrete, and glass.[21]

Iron (or, more correctly, wrought iron and cast iron) and steel (carbon-containing iron) formed both the spine and the decorative visage of modern structures and landscapes. By the middle of the nineteenth century, wrought-iron beams had displaced masonry, providing an efficient, prefabricated method of skeletal construction. Cast-iron buildings had a great capacity to support stone floors and to provide mills with fire protection. Starting in the 1850s, cast iron began to matched the midcentury Gothic Revival urge to decorate, as displayed in cast-iron detailing in commercial buildings in New York, churches in Liverpool, the Houses of Parliament, Joseph Paxton's Crystal Palace (which combined cast and wrought iron), and Victor Baltard's Halles Centrales, which he rebuilt in glass and iron according to Napoleon III's prescription.[22] Iron in its wrought form, such as that on display at the Victoria and Albert Museum in London, also served as ornamentation on machines, fences, and gates.

As cities grew and industry flourished, iron was used to construct bridges, ports, ships, sheds, and train stations, such as Antwerp's station, which—modeled on a decorative Baroque altar—declared to passengers their arrival at a truly modern city. Iron and then steel etched whole new horizons on the skyline. Steel, used previously to manufacture sharp and strong-edged swords, daggers, and tools, took up its place in macroconstruction in the 1850s, when it first became available in sufficient quantities thanks to the Bessemer process, which was the first inexpensive industrial method of mass production of steel from molten pig iron.

The iron and steel that shaped the macroworld also flooded microworlds with hand tools. Industry provided hammers, wedges, saws, pincers, drills, chisels, files, rasps, planes, scissors, wrenches, screwdrivers, and measuring devices. (Still cluttering my basement tool bench, as much heirlooms as they are usable instruments, are handheld devices to shovel, sweep, cut, chop, saw, shape, level, and smooth surfaces.) Nuts, bolts, nails, pins, and screws enlivened the language of work in the factory. And so metal things morphed themselves into the century's body and soul, a process led by England, which by 1848 was smelting almost two million tons per year—more than the rest of

the world combined.[23] The rest of the western world emulated British metallic supremacy throughout the middle and closing decades of the century.[24]

Concrete, another great material, texture, and surface, complemented and enhanced iron and steel in building structures and constructing surfaces. A far older building material, versatile concrete, a nearly all-purpose material (which Romans had used to supplement their stone, brick, and even wood structures), filled in riverbeds, lined water and sewage tunnels, and supplied pilings, foundations, basements, walls, flooring, and even roofs. Utilizing improved British formulas for cement, builders and engineers found concrete, by virtue of its strength, durability, malleability, and fire- and waterproof characteristics, an indispensable material for making the modern world.[25] Though lacking in brightness and smoothness, concrete compensated for its deficient aesthetic with its versatility in pouring and laying concrete foundations, beams, and flooring. It also proved a multipurpose interface, lining, and outdoor surface material. Reinforced by iron rods and steel I-beams, concrete was used to erect the great majority of bridges, viaducts, tunnels, wharves, docks, multistory buildings, roads, stairways, and sidewalks of the era. Nonhydraulic cement (notably Portland cement, also pioneered in England) created ports and lasting structures in wet climates, such as those of northwestern Europe. Concrete also served the expanding revolution in transportation, extending and superseding stone, macadam, and asphalt as foundation and surfacing for roads, highways, sidewalks, driveways, and, more recently, parking lots.[26]

GETTING UP TO SPEED

If any single invention joined iron and steel and steam, it was the train. A steam engine on wheels, the new horse of the age, it drove the nineteenth century forward. It got mulling and moving humanity up to speed. Additionally, its revolutions were truly many: it shaped the landscape, framed city and countryside with metal grids, joined resources and products, and accelerated the gathering, regimentation, and communication of regional, national, and world societies. Fired by wood and later coal, and executing a mechanical push and pull, it sent engines, containers, and passengers hurrying across the landscape at ever greater speeds, carrying ever greater loads, wailing its sovereignty over ever greater distances. Beyond linking places, it served the building of industries, the development of regions, and the very settlement of towns and peoples. The train, the "iron

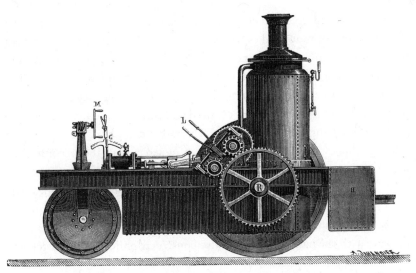

Fig. 99. — Locomotive routière, système Thomson.

FIGURE 19. "The Thomson Road-Steamer," A. Jahandier, circa 1876, which ran up to six miles an hour free of tracks and towed loads of up to thirty tons, illustrated that a steam engine could drive a land vehicle. Like its profoundly influential cousin the train, the road steamer traveled wherever individual dreams, land, and grades permitted. Its inventor, the civil engineer Robert William Thomson, who also designed a portable steam crane and was forever working toward efficient interfaces of earth and machine, added solid India rubber tires to his steamer in 1867. He held prior patents on the pneumatic tires so important to bicycles, automobiles, tractors, and other vehicles because they provided cushioning, quieted travel, and enabled the carrying of heavy loads.

horse," defied wind and weather as no team of living horses could. American poet Walt Whitman captured this awesome quality in his poem "To a Locomotive in Winter":

> Thee in thy panoply, thy measur'd dual throbbing and thy beat convulsive,
> Thy black cylindric body, golden brass and silvery steel,
> Thy ponderous side-bars, parallel and connecting rods, gyrating, shuttling
> at thy sides,
>
> Type of the modern—emblem of motion and power—pulse of the continent.[27]

The train was a wonder, a panoply of myriad surfaces. Its use necessitated the making of all sorts of surfaces. Steel had to be machined to make efficient pistons and perfectly round and balanced wheels, and eventually subsurface mines had to furnish the coal needed to run its steam engines.

Engineers headed up commercial, government, and joint railroad projects; they planned pathways and dissected and shaped landscapes to lay railroad beds, erect related structures, and establish railyards and stations. Integrating industry, business, travel, nations, and continents, railroads formed a primary grid of nineteenth-century experience. They taught society to see and participate in the world in terms of speed and constant, predictable motion. In words befitting the philosophical, the railways (as built structures and moving vehicles) defined a phenomenology of perception. They reconfigured matter and life with beds and tracks that set borders and defined myriad contexts. The young Hegelian Karl Marx connected the material and idealistic when, in 1842 (with the likely help of that other young Hegelian, his correspondent Arnold Ruge), he suggested that the same spirit that constructs railways with the hands of workers also constructs philosophical systems in the brains of philosophers.[28]

The train wove together things, perceptions, connections, and expectations in iron and steel. It gathered, joined, and bonded materials, commodities, places, and peoples while integrating commerce and society. It cast a web over realities, possibilities, and dreams. As affirmed by historian Wolfgang Schivelbusch's masterful *Railway Journey,* notably subtitled *The Industrialization of Time and Space,* it was in all senses phenomenal.[29] It metamorphosed the faces of the landscape, the environment, and society itself. Transforming means, materials, goods, and the very people who rode in and worked on it, the train structured cities, determined the life and death of villages and regions, and built modern industrial nations and democracies. Like the sparks, smoke, and sounds it spewed, it flooded the world and mind with images of our times.

It birthed an age of speed, dramatically shortening distances between cities already brought closer by the stagecoach.[30] Night and day, day in and day out, the train joined places. It hurtled passengers along at bewildering speeds of twenty or thirty miles an hour. It changed perceptions and conceptions of space, while both fragmenting and joining surfaces moving across swathes of lands, accelerating and decelerating as it went.[31] Out a compartment's glass window, scenes were sequenced, juxtaposed, and blurred together, depending on the speed of the train and whether one sat within it or at the platform it passed. From any perspective, the train signified, to awakened senses and the analytical mind, the speed, motion, and commotion of the ever-accelerating Industrial Revolution, and the demarcations it drew between past and present.

The train remapped the earth. It set a new grid of latitudes and longitudes. Goods that had been scarce because of their remoteness, and thus cost of transport, became accessible to remote villages and the suppressed masses— or accessible, at least, to their eyes, envy, and longing. Outlying regions were knitted to central and synchronized national clocks whose ticks syncopated transportation, travel, commerce, and government. However, as Schivelbusch reminds us: "The speed of the railway train was not simply a process that diminished space but it was a dual one . . . the diminution of space (i.e., the shrinking of transport time) caused an expansion of transport of space by incorporating new areas into the transport network."[32]

In the 1840s, railways overtook canals as the main routes and punctuating clocks of national transportation. Steam and rail technology improved predictability and put nations on the railroads' timetable. Railroads entered into the nineteenth-century organization of nations in yet other ways. Aside from integrating industry, capital, and government, they rewrote the text of the physical landscape with signature embankments, bridges, and tunnels. In Britain, the commercial and industrial leader of the modern world, railroads grew a hundredfold from 1830 to 1860—total track length expanded from 98 to 10,433 miles. In 1853, the first Union Station was established, in Indianapolis. In 1869, a gold spike joining the Union Pacific and Central Pacific lines completed the U.S. transcontinental railway at Promontory Summit, Utah.

As early as the 1850s, railways established national networks. Feats of heroic engineering, ever in need of solid and level beds for their tracks and rolling wheels, railroads sent their lines through mountains, over passes and wetlands, and across rivers and bays. The surface of the earth was shaped and tricked to serve the passage and wants of the nation. Defining national control centers and outposts, railroads served as primary instruments for integrating places, resources, goods, and the execution of military goals, as Bismarck so adroitly showed in his railroad *Blitzkrieg* against Austria in 1866. Railroads also formed urban hubs around which cities could construct and develop metropolitan rail systems. Located around the points of the compass, terminal train stations served as ports to the city.[33] Also in the last decades of the century, railroads met at ports their watergoing cousins, the iron steamships, which carried unprecedented volumes of cargo—as well as tourists and steerage immigrants, at great economy and extraordinary predictability—joining places and colonies across the globe.

Besides the expanding railroad and its multiplying stations was another invention, one that truly transcended space and connected places. The

telegraph grew out of early-nineteenth-century experimental work with electricity and magnets, and the first telegraph company was established in 1851 in Rochester, New York: the New York and Mississippi Valley Printing Telegraph Company, which became Western Union in 1856. The telegraph delivered a startling truth, one that the age of computers claims as its own: Information could be sent across the world at speeds approaching that of light. Electronic signals (encrypted in the Morse code of dots and dashes) were sent through strands of wire hung from poles reaching from horizon to horizon or encased in cables laid between continents along ocean beds.[34] In this way, places and surfaces were almost universally captured in a net of nearly simultaneous deeds and all that they portended, and words and all they conveyed. The world of mutating surfaces and images now was an open, rushing river of words, descriptions, interpretations, and meanings.

FACES OF THE NINETEENTH CENTURY

Creating artificial interfaces between things natural and things made, factories, machines, coal, steam, iron, steel, and concrete occasioned new perceptual and conceptual worlds. They filled the air and senses with sensations, phenomena, and apparitions; they provoked novel categories and means to see and think. They offered up new images, words, ideas, and explanations. They offered and stimulated designs of such elemental realities as space, materials, motions, and functions. And they entered into debate, interpretations, judgments, and ideologies of society and its will, intention, means, and ends. They even provoked the question—one still without resolution—of whether life imitates machines or machines copy—or should be designed to copy—life.[35] Machines and the factories—with their standardization, regimentation, mechanization, energy, and productive powers—contested the nature and future of society as much as political revolution itself could do. They transformed old cities, and they created new cities out of old towns.

The young Karl Marx of the 1840s, who so severely criticized the social degradation caused by the Industrial Revolution, joined a band of utopian thinkers who believed that the agency of destruction, the machine, would also prove to be the maker of a new humanity. Machines, which constituted an unprecedented *mode of production,* to use a favorite term of Marx's, dialectically enhanced human potential. It would liberate humans from their very subservience to nature, scarcity, and toil and overturn the authority,

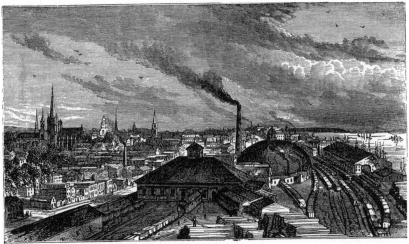

Detroit

FIGURE 20. As illustrated by post–Civil War, nineteenth-century downriver Detroit and its new railroad station and yards (image circa 1891), the train reorganized the space, supplies, movement, time, and life of large cities and the countryside. In the aftermath of the Civil War, the train mapped, platted, integrated, and settled the Trans-Mississippi West and joined villages and towns to cities, which were equipped to serve a new industrial order and rewrite the face of urban life. From *Dictionnaire encyclopédique Trousett* (Paris: Girard & Boitte, 1886–91).

institutions, and orders based on previous means of production. Liberating machines proved to be both actual engines and revolutionary metaphors for achieving an idealized society, discarding the divisions of class, and overcoming the constrictions of marriage, government, and authority. For the young Romantic Marx, nothing extrinsic to man—nothing in nature, past, or tradition—would any longer keep humanity from its self-realization. Ahead lay a culminating *telos,* a perfecting revolution.[36] Such a metaphysical revolution, predicated on the jump of Hegelian dialectics, fused the panorama and perspective of the apocalyptic French Revolution to the developing Industrial Revolution. All surfaces were to be erased and drawn anew.

Opposing aesthetics, or ways of seeing and interpreting the face of the changing world, sprang up as evidence indisputably testified that one world was being exchanged for another.[37] Though hidden causes and final outcomes could be disputed, the machine and factory were repackaging society and life. Goods and work, profits and wages, dress and dust distinguished what was seen. Class distinctions deciphered bodies, street habits, homes, and neighborhoods. Every mass-made object invited debate. Builders and

boosters wrapped their engines and projects in the high rhetoric of humanity's progress, or made their point more directly with a flood of abundant and cheap goods. A contradicting aesthetic dissented. The cost of mechanization and standardization had to be viewed in light of perishing crafts, small shops, communities, and the very traditions and goods of the handmade, all of them relentlessly displaced by industrial production. Craftsmen now survived, if at all, as producers of decorative goods and fine arts. As an example, the young craftsman Pierre-Auguste Renoir left his small Parisian atelier, dedicated to the diminishing craft of decorating porcelain bowls and dishes with stylized and delightful figures, for a new vocation. *En plein air* (in open air), he would depict on canvas rosy and opulent flesh and landscape scenes bursting with color.[38]

LET SURFACES BE FLAT AND SMOOTH

As the world was gathered, standardized, regimented, and remade, ready for the faster and easier distribution of things and people, so micro- and macrosurfaces were prepared for quicker motion and safer, less encumbering movement. The even, level, smooth, and ideal garden path, ballroom floor, palace floors, and promenade ways of the Baroque, discussed in chapter 6, remained a first premise of innovation, design, comfort, and luxury. It held on both the macro- and microlevels. The inner surfaces of a machine—be they the gears of complex lathes or the ball bearings of wheels—must be frictionless and fast-running. So too must be the flow of a gutter, the fit of a cover, and the floor of an indoor bowling alley, a late-nineteenth-century creation. The history of smooth, even, level, and predictably, yet attractively contoured, surfaces and colors played out in the design of urban landscapes. Broken walkways, pitted roads, open cesspits, rickety and precarious stairs—all had to be repaired, for foot and wheel had to advance efficiently and fashionably. Society could not progress in a dirty, uneven, and tripping world.

Paved roads, accompanied by sidewalks, declared advancing, safe, and dignified democratic equality. Open and passable surfaces, roads, and sidewalks fulfilled some rights and wants. They gave democratic access to work, shopping, leisure, and travel. In the second half of the nineteenth century, cities, with the support of police and public transportation, progressively offered more equality and improvement in the forms of connecting, paved,

dry, lit, and safe ways. Of course, cities battled against increasing crowds; the growing distance between work and home; slums; and the congestion that followed when carts, stagecoaches, and other horse-drawn vehicles jockeyed for position as they moved to and out of the center of town. Orderly traffic was a product of the twentieth century, when public transportation systems were completed and street routing, traffic signals, city cops, and city-wise and mannerly pedestrians and commuters kept democratic passage running somewhat smoothly.[39] Jaywalkers and gazing bumpkins were chastized for being out of the flow of things.

Roads, which often followed and usually supplemented the routes of railroad tracks, refined and sped up the integrating grids of national life in the countryside and city.[40] Roads multiplied at the end of the nineteenth century, serving carts and bicycles and increasing numbers of gasoline-driven automobiles and commercial trucks. The smooth ways, still generally made of level gravel and asphalt rather than concrete paving, were claimed by the rolling wheel and tire. But well in advance of the car, the bike had put in its claim on level roads. As an alternative to the expensive horse, whose wastes filled the streets they traveled on and proved a central attraction for sparrows, the bicycle integrated the outskirts of village and town with the city. It was first a single- and then a two-wheeled self-propelling vehicle. Under the alternative name *velocipede,* it was first powered by the rider's running, balancing feet, and later by pedals. Although each of its components—frame, handlebars, gears, and brakes—is worthy of a separate history, its light spoke wheels and pneumatic tires played a special role in accelerating speed, leveling one's ride over bumps, and providing traction on uneven surfaces, from hard clay to light gravel to cobblestone.[41]

With the human body its source of energy, thrust, and acceleration, as well as of its slowing and braking, the bike belonged to those machines, like the potter's foot- and hand-driven wheel, that linked moving circles and even surfaces. An efficient long-distance vehicle, it opened the countryside to rolling wheels. The young, recently married Marie Curie tells us how in 1895, in the first years of her marriage, she and Pierre loved to leave their Paris laboratory and the radiant milieu of radioactivity to go for a bicycle tour in the countryside. She would roll up her skirt (whose cloth could tangle in the gears) and away they would go. These beloved cycling escapades contrasted sharply with that tragic day in the spring of 1896 when, during a heavy rainfall, the young Pierre stepped off a curb and was struck and killed by a horse-drawn cart on the congested streets of Paris.

The car pushed the bike off or to the side of the road in the new century, just as it is doing in China today. Yet the car stumbled its way into existence. A mechanical composition of joined and interrelated stable and moving surfaces, the automobile was the fusion of a thousand inventions. First came the matters of a chassis, number of wheels, steering wheel, and brakes; and then there was the question of an engine for this new rolling land horse. Eventually inventors settled on the small, light, economic, and powerful cylinder-driven gasoline engine.[42] But no one yet conceived of the car as the vehicle of democratic transportation. Where were the roads on which to run it and the mechanics to keep it going? Experiments went on in barns, storage sheds, and bicycle shops across America, France, Germany, England, and elsewhere as the car drew dreams of new purposes and surfaces out of its inventors. A car could be a truck, a tracked tractor, a tank, a speedy roadster, or a touring vehicle. Unlike the train, it followed no schedule but its own, traveling whenever weather permitted and wherever smooth surfaces allowed. Its primitive headlights pierced the night, and later, windshields and cabs protected its driver and passengers from the elements and darkness. And yet breakdowns, collisions, and horrific accidents, rivaling shipwrecks, came with the rise of motorized land vehicles.

Henry Ford, who profoundly changed the face of Detroit, was the first to standardize and mass-manufacture the car and thus produce it at an affordable price. He lured the many into cars, and after he had put them behind the wheel, they would not relinquish control. Henceforth cars began their enduring dictatorship over the road and affirmed people's freedom and well-being. Simultaneously the icon of manufacture, design, speed, freedom, and so many other acquired attributes of contemporary life, the automobile concretely (road by road, intersection after intersection) defined urban planning, created suburbs, and organized the life of farmers and villagers in the countryside. Moreover, it served and dictated contemporary life, work, commerce, and leisure.[43] Its individual make and model defined the wealth, well-being, shopping, visiting, leisure, and romance of person and family. Like early man's biface tools, the car organized the space and time of work, production, and society. At the same time, like an elemental wrapper, it enclosed driver and passengers in a complete environment of speed and comfort. Its cockpit constituted not just a focus, but also a multifaceted prism for seeing, conceiving of, and being in the world. As no other object has done, the car has encapsulated human experience, society, and future within itself.

Civilization lives in layers of filth. It covers surfaces with dust, grime, and human and animal wastes. With modernity's growing populations, spreading industry, massive construction, enhanced use of coal, gas, and lubricating oil, and growing traffic congestion, filth, trash, muck, and waste piled up, veneers of dust and ash accumulated, and haze and smog shrouded everyday life.

In the very hot summer of 1858, the Great or Big Stink engulfed London, disbanded Parliament, and drove the government to undertake the cleansing of the metropolis.[44] Heat, rain, overflowing cesspits (some two hundred thousand in total), primed directly by runoff from newly installed flush toilets, had turned sodden soils into waste-saturated air. All city surfaces were slippery and putrid. Driven by health, taste, and commerce, London took up the cleaning of its streets. Because its hygiene soldiers were not yet equipped to think molecularly or bacterially, their attack was launched primarily on, in, and below surfaces. The cleanup relied on hand tools—brooms, shovels, rakes, pitchforks, and scrapers. It called into service rags, whiskbrooms, brushes, bins, and carts. The labor force devoted themselves principally to gathering waste and manure, cleaning streets, and digging and sinking new water mains that would spare citizens, the Thames, and city wells from degrading and contaminating waste.

In their memories and fears, Londoners thereafter existed only a whiff away from another Great Stink. Indeed, the brooms and shovels of that year had swept and dug in the city's minds as well as its streets. Yet in a counterdirection, stores took pride in their new shiny glass windows, and citizens enjoyed having open spaces and clean floors. Foot scrapers, overcoat racks, and vestibules stood vigilant guard at the doors of better dwellings, and people of means wore gloves and hats and scented themselves with perfumes to be certain that they did not smell or appear like the roads they traveled. Of course, hands were smudged, fingernails were contaminated, and wastes from skin, scalp, nose, and ears intruded everywhere, making no body or home picture-perfect. And citywide stinks reoccurred when certain conditions prevailed.

In the second half of the nineteenth century, the modern urban West launched other wars against the foul, dirty, and indecent. Utilized like great shovels and brooms, civic projects—new roads, metros, squares, and buildings—intentionally sought to clean great swathes of cities. In the 1850s

and 1860s, as noted earlier, French civic planner George-Eugène Haussmann redid Paris in an immense campaign. He planned open and intersecting boulevards to accelerate traffic and commerce on the one hand, and on the other to free the city of the dark, lower, and quarrelsome masses, who would at a momentary rumor erect barricades in narrow, old streets and lanes. London accomplished much the same with its building of the slum- (and swamp-) clearing Underground.

City planning, however, played a far less decisive role in cleaning up metropolises than did the simple admission of water and light into urban areas. When used on a large scale and in tandem, these two elements trans-figured the darkest and dirtiest faces of the city. Water—blue, white, silver, sparkling; all that dirt, muck, coal ash and dust are not!—flushed through late-nineteenth-century urban life like the cataracts of a fresh river. Each extension of the water system enhanced people's life, health, and scenery. It offered a refreshing lease on life. Driven by steam engines and equipped with pressure valves and interconnected piping, city water systems supplied the public at large with an inexhaustible spring. Systematic sewerage systems swept away waste.

Water, the earth's first and oldest cleanser of surfaces, defined modernity—so antithetically to industry's given definition—as fresh and clean. Moved by cast iron, steel, and cement pipes and plumbing technologies, public water became the most docile, powerful, and ubiquitous baptizer. It made fields fertile, turned grass green, filled gardens and parks with flowers, and cleaned towns, homes, and their residents. Historian Asa Briggs judges the hidden network of pipes, drains, and sewers, which were built one layer under the streets, to be a higher accomplishment than the new transportation systems and truly one of the greatest achievements of the age. According to nineteenth-century historian David Pickney, Parisians unanimously repeated Jean-Jacques Rousseau's farewell, "Adieu, ville de boue!" (Good-bye, muck city!) without having to leave Paris as he did a hundred years or so ago. For the first time in the whole course of human history, the bulk of humanity smelled and dressed reasonably well. Dirt, filth, and waste became by consistent laws actionable nuisances and a matter of public health.[45]

However, before people could present themselves, and their dwellings, goods, and occasions, as clean and sparkling, they needed a great mirror—and electrical lighting provided it. With just the flip of a switch, darkness was purged from the corners and the black of night sent fleeing. Light, which changed every surface on which it fell, was industrialized, to reference the

subtitle of historian Wolfgang Schivelbusch's *Disenchanted Night*.[46] In the previous century, lamps already had begun to play an important role in homes and on streets. Pope Pius IX progressively introduced streetlights to Rome in 1846. Lighting meant that people could shop, stroll, and play after dark and lurking criminals were no longer concealed by night. Systematic gas and electric led people to presume a lit-up world; beams could be directed to select surfaces, objects, and spaces. Humanity, in the words of French thinker Gaston Bachelard, had for the first time stepped into an "age of administered light."[47]

Light illuminated roads, guided ships, and provided signals and beacons to direct and synchronize a moving society. Headlights were added to cars, trains, and other moving vehicles. It changed the meaning of stagelights and allowed nighttime surgeries. It cast penetrating light even into previously pitch-black mines, basements, and farmyards. Lighting put a luminous glow on things; goods and surfaces became effulgent; colors stood forth; and the world shined and was as translucent as never before.

A GREAT FACELIFT

Industry now supplied tools, containers, and fabrics for sanitation, hygiene, and beauty. Commerce profited from the democratizing notion that all should be clean and good-looking. Paradoxically, as one wing of industrial society kicked up dust of every sort, so another provided an arsenal of cleansers and cleaners: the use of soap increased multifold in the nineteenth century, as did the use of bleaches to turn clothing white, waxes, and polishes of all sorts. Small companies made their fortunes with innovative abrasives, paints, files, sandpapers, brooms, brushes, combs, razors, toothbrushes, carpet sweepers, and vacuum cleaners.

Tools and a pipeline of chemicals diversified women's cleaning regimens. They also equipped women to scent, shape, and disguise themselves for day jobs and for intimate lives at night. Such products enhanced their daily and seasonal obligations at home, which were all about washing, cleaning, polishing, and shining surfaces. Soaps, shampoos, dyes, toothbrushes, pastes, combs, and razors joined the battle for clean body, hair, and teeth, while cosmetics, fragrances, and mouthwashes prepared people for their day's bid for public decency and respectability. Glamour, which sought the searchlight of larger beacons, chased not a mere glance, but riveted public attention and prolonged discussion of itself.[48]

Between 1870 to 1930, the surfaces of people and things, indoor and out, were cleaned up. In his essay "Commonplaces," the French and European historian Eugen Weber anatomizes this "superficial transformation" of the skin of things.[49] There were progressively fewer sparrows in Paris because two hundred thousand horses, which annually had produced untold tons of manure, were steadily replaced by metro, cars, and trucks. Cleansing water and cleaning sewerage lines, the former arriving a decade or two before the latter, multiplied and steadily reached more public buildings and private dwellings. Households and their dwellers voted for cleanliness and decency by the simple act of flushing: all went down the drain—*tout à l'égout.* Trash, another sort of waste, was disposed of in uniform and universal metal garbage cans *(les poubelles)* and taken away via regular urban collection, organized by Eugène Poubelle, a Parisian administrator who introduced hygiene measures near the century's conclusion. In turn, electricity, starting up in the 1890s, lit up homes thanks to transformers and miles of copper wire; it ended the light-stingy dukedom of sooty, flickering, and dangerous candles.

The streets of Paris and the appearance and manners of Parisians were altered. The introduction of *pissotières* in the 1880s diminished spontaneous public urination. Defecation, spitting, nose picking, hand wiping, itching, genital scratching, and other uncouth activities went from common and thus ignored to noticed and thus worthy of remark. Wooden clogs fell silent, and only the poorest of the poor still padded along barefoot. Shoes increasingly fit, were repaired, and even were polished at home for parades along the street. Young country girls, less prone to expose the fleshy cheeks of their derrières or smell like the beds in which they had slept, dressed colorfully and were scented like bouquets of flowers. The blind, deaf, handicapped, lame, and maimed who once populated the streets were increasingly displaced by the healthy and wholesome young, alive in their antics and proud peacocks in their promenades. Surfaces shined, visual scenes stood out, and pleasant sensations multiplied.

THROUGH GLASS BRIGHTLY

Contemporary cleanliness and brightness were reflected particularly by and through glass. The third building material and surface of the nineteenth century, glass joined iron and cement in building the nineteenth century. Mass-produced in the later stages of the Industrial Revolution by a

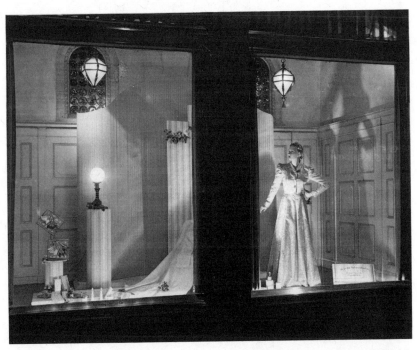

FIGURE 21. Window display, Minneapolis, photograph, Walter S. Norton and Clifford E. Peel, 1940. In the city and then in the countryside, the world increasingly was put on display in print and in images. Window-shoppers knew themselves by looking through the plate-glass windows of storefronts. Through the glass they saw their wants materialized, and in the glass's reflection they saw their idealized self-images crystallized.

combination of mechanical technology and scientific research, glass had a set of desirable properties: It could be colored, was nonconductive, and was highly resistant to weathering. It could be shaped to enclose liquids and display goods. Adding a new dimension to democratic life, transparent glass, used in windows, doors, floors, and ceilings, mediated between the inside and outside of things and dwellings.[50]

Glass pierced walls to admit light and multiplied angles of vision. Sheets of glass and later plate-glass windows perforated walls, letting healing, waking, drying light in. It enabled the construction of whole environments of high-rise buildings and skyscrapers. A versatile material, increasingly manufactured in varying sizes, thicknesses, strengths, opaquenesses, and tints, it mediated ordinary glances and permitted the long stares of perceiving and conceiving minds. Glass windows, refined and relatively inexpensive, appeared in abundance in homes and businesses thanks to the mass production of flat glass.[51]

Serving as the mirror of consumer democracy, glass became decoratively and structurally indispensable to domestic and public architecture from the turn of the twentieth century onward. It became a common portal.

Society increasingly looked out through glass—through eyeglasses to see oneself and one's neighbor, through photographic lenses to perceive the world and our place and actions in it, and through telescopes and microscopes to see the incomprehensible. From the end of the century onward, photographic albums captured storeowners, workers, and families dressed in their best or gathered proudly around shining glass showcases laden with goods. Store windows defined want and dream, while the windows of vehicles provided optics for travel and vacations. Doctors, dentists, and scientists peered inward and downward through glass instruments.

Glass became a second set of human eyes. It was a medium through which people saw surfaces near and far. Up close, eyeglasses guided hands and needles. They focused on the avalanche of books and paper whose printed sheets and turning surfaces fed minds. In the form of opaque peepholes, glass shut out the intruding eye; and in the form of invasive lenses of varying magnification, it shattered privacy. A revealing surface, glass validated truth as visible, out in the open, there to be seen—etymologically, it revealed the *evident*. It supported the argument that reality was a set of surfaces, appearances, and images to be seen. As a metaphor, glass was equated with consciousness and light.

In the closing decades of the nineteenth century, the glass industry (particularly that developed at Jena by Carl Zeiss and his associates) made specialized lenses for looking and study.[52] Field glasses and periscopes scanned field and sea and perceived surfaces anew. New optical devices were mounted on surveyors' platforms, on artillery pieces, and on medical devices. Telescopes, which had over the centuries probed the canopy of the heavens and charted its movements, were refined, and at the same time made affordable to serve the starry wonder of the many. Microscopes turned minds to look inward and downward toward other infinities—toward, as we will examine in the following chapter, the surfaces and interfaces of atoms, molecules, and cells.

LET A THOUSAND FLOWERS BLOOM

The second half of the nineteenth century found its brightest and most distinct mirror in the arts with Impressionism. Impressionism expressed

everyday society's growing goods, abundance, and leisure. It reflected the increasing roles of water and light and the resurfacing of streets and people. In contrast to the dark staging of Romantic art and the shadow-filled and somber chiaroscuro landscapes of seventeenth-century Low Country art, the Impressionists Manet, Monet, Renoir, Pissarro, Van Gogh, Cézanne, Gauguin, and even the highly pictorial Degas brought color and a "new reign of light" to their canvases.[53]

The Impressionists did not come forth as beautifiers or decorators. Their art was not tasteful imitation and did not follow codified rules. Their portraits did not belong to a studio-cultivated craft whose tradition had an "emphasis on drawing, on line and form, light and shaded—a triumph of *disegno* over *colore* that was secured in the French Academy of the seventeenth century."[54] Though in part inspired by the work of preceding generations, particularly the colorful canvases of the Romantic Délacroix and the Realists Camille Corot's and Gustave Courbet's luminous images of everyday rural life, the Impressionists chose, in style and interpretation, to be rebels.

The Impressionists won public recognition as a result of eight independent exhibits in Paris between 1874 and 1886. They did it without the sponsorship of official salons or of the Académie des Beaux-Arts, which judged their work as crude and harsh. Their canvases were criticized for their short and abrupt brushstrokes, unmixed colors, and unshaded landscapes. Rounding out the criticism were the facts that they chose their subjects from everyday life and that they painted on the spot, without much studio refinement. In truth, the Impressionists, starting with Manet, undertook an elemental break with the tradition. They redefined the function of a picture's surface. Since the Renaissance, the picture had been conceived of as a window through which the viewer looked at an illusory space developed behind it. By minimizing the effects of perspective and modeling, Manet forced the viewer to look at the painted surface and to recognize it as a flat plane covered with patches of pigment. This "revolution of the color patch," combined with Manet's cool, objective approach, pointed painting in the direction of abstraction, with its indifference to subject matter, its emphasis on optical sensations, and the technical problems of organizing them into form.[55]

On a second front, Impressionism could be interpreted as conducting a war against emerging photography, whose images increasingly dominated the world of democratic perception. Photography's grave, solemn black-and-white images, composed of both sharply delineated details and grainy, gray texture, offered dramatic and vivid eyewitness accounts to nineteenth-century social

and war scenes. At the same time, photography produced images instantly and everywhere a camera could be lugged. Its work bannered and even drove words and stories. On the front page of newspapers were portraits of politicians, wrecks, and wars (especially notable was photography's role in the coverage of the U.S. Civil War). Photography also captured the local, familial, and intimate (it even created a fashion for images of young ladies looking at themselves in mirrors); photographs accompanied letters proposing marriage; and they captured parades of people, horses, and vehicles looking their best. The motion picture, which made its debut in 1896 in New York, made photography kinetic, making the lens a second eye to see, frame, and remember the surfaces and faces of the world.

Painters fought back, just as artisans had fought losing rear-guard actions against industry throughout the middle decades of the nineteenth century. Impressionists contested with vivid color and the full flush of immediacy. Offering itineraries of cities, suburbs, and countrysides, they created a rush of fresh and cheery canvases. They celebrated rainy streets, fresh water, morning baths, and clean skin. They sought out, experimented with, and rendered the day's changing light, be it on the facade of Rouen Cathedral, on the outer layer of a haystack, or across the face of a white tablecloth amid a flowery garden. They offered singular views of everyday Paris and its nearby suburbs, and they exalted in select visions of the countryside. Out there, they relished fields, pines, mountains, placid ponds, idle canals, and luminous seas whose roiling waves broke on the flat, sandy beachheads of northern and eastern France. Impressionists in southern France (some call them post-Impressionists, with reference to Van Gogh, Pissarro, Gauguin, and Cézanne), which they saw as the land of light, took up the task of rendering tapestries of flowering wheatfields and olive orchards and the contrasts between tall trees and distant mountains.

Their portraits broke free of the frame of laboriously produced studio art. In the flow of the new age's impulse to clean up streets and light up lives, they banished from the face of their canvases manure-covered urban streets choked with congestion, the oily tracks of the rail station, and the pungent, choking dust and smog of industry at work. One does not find in their work dirt and muck, rotting trees, impenetrable brushes, collapsing shacks, or outhouses in disrepair. Surfaces one and all stand redeemed in light and color. Monet's haystacks appear ready to take flight in the changing sunlight. Van Gogh's night booms with a heaven whose stars are vortices of white, yellow, and golden light. Renoir's women wear billowing and dazzling white dresses.

Sporting colorful parasols, well-dressed women enter florid lanes. Women incarnate are fresh, voluptuous, with generous rosy-pink skin. Impressionist surfaces are epiphanies.

Impressionists worked *en plein air* thanks to newly invented and indispensable malleable tin tubes of paint, a substitute for paint kept in pigs' bladders.[56] In the open city, Monet converted the celebration of the inauguration of the Third Republic, on June 30, 1878, into scenes of streaming red, white, and blue flags that hang and flap and below which blocklong crowds of indistinct stick figures move. A contrasting contemporary street scene, Gustave Caillebotte's *Paris Street; Rainy Day* (1877), depicts a well-dressed couple joined under an umbrella, moving along a complex intersection that illustrates the new connecting system of boulevards that moved Paris into urban modernity. Impressionist canvases catch reflections from glass mirrors, windows, and water. Light goes with brightly dressed youth dancing, boating, and sunbathing. And as the Impressionists rendered a world awash in color, with palettes of vivid yellows, oranges, vermilions, crimsons, violets, blues, and greens, young children joined the new century, coloring the world brightly with new nickel boxes of blue, red, purple, orange, yellow, green, black, and brown crayons.[57]

Impressionism was, arguably, the last school of western art that painted to please the seeing eye rather than to engage the mind. Its end came with the critical mind it itself had fostered by laying the groundwork for Expressionism, Modernism, and Cubism. In his *History of Modern Europe,* Eugen Weber expresses the nascent intellectuality of the Impressionists. He likens their aesthetic inquiries to those of contemporary scientists who reduce objects to sensations, and stable wholes to shifting, relative, and microscopic parts. Assenting to the notion that "the world was an illusion," they embrace the propositions that "the senses provided the only reality" and "immediate sensations counted more than any possible significance." Like musicians and poets, painters' phenomenology of surfaces began "to transmute the beautiful into its possibilities, increasingly musical and increasingly abstract." (Whistler called his works "Harmonies, Symphonies, and Nocturnes." Camille Pissarro's scientific "neo-Impressionism," which influenced Gauguin and Cézanne, converged with Seurat, who explored the possibilities of optics and sensations. Gauguin discovered the colors that evoke certain emotions, while Cézanne, a native of Aix-in-Provence who came to be considered the founder of Cubism, conducted "a search for the geometrical symbolism underlying nature.")[58]

Although the Impressionists practiced an open-air sacrament of light and color, at the same time analysis and principles did underpin their art, as Phillip Ball concurs. Their experimentation with surfaces fostered the avant-garde ideas of early-twentieth-century Expressionism, Symbolism, Modernism, and Cubism, which responded to accelerating speeds and differentiating senses of times, deciphered inner forms (which coincided with, as treated in the following chapter, science's discoveries of the inner worlds of atom and germ), and expressed the mounting presence of warring ideologies. At the same time, Ball notes, advanced aesthetics gave matter and things "their own intrinsic worth and symbolic significance," making them both the covering of the canvas surface and the significance of the work of art.[59]

THE CITY'S FULL EMBRACE

The nineteenth-century city had done nothing less than embrace—circumscribe, encircle, and enclose—humanity with a new ring of structures and things. The aim of its projects was to renovate, clean, and perfect. By the measure of action, accomplishment, and dream, it made the ordinary extraordinary. The urban world was filled with new and fresh spaces, objects, and surfaces.

Dynamic engines, brand-new materials, immense mass processes, and pervasive design laid a new democratic foundation of society and things. Environments were transformed and landscapes were transfigured as paved roads ran wider and farther; buildings and structures grew in size and height; subterranean foundations and networks of tunnels, water mains, sewerage pipes, and wires ran deeper and longer; businesses and transportation systems grew; governments multiplied; and its organizations, bureaucracies, and laws organized lives. Schools, libraries, armies, public health efforts, and new taxes made a new citizenry. New emotions, sensibilities, uniforms, fashions, and styles articulated new uniformities and loyalties.

In this great built world, constructed before one's eyes, wheels ran, factories hummed, and the promise of work and wages raised hopes that stamped promise on the face of things. Despite preachments of the reality of class warfare and the loss of tradition, which were heard from both sides, the majority persisted in believing in the city and had faith that with a "little luck" and "hard work," they or their children had a chance of becoming a citizen, a consumer, an individual, and even an intimate person. Homes, steadily and

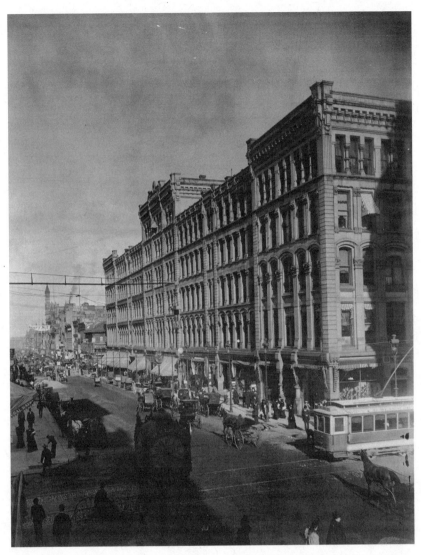

FIGURE 22. Downtown Minneapolis, circa 1925. Led by civil engineering and architecture, late-nineteenth and early-twentieth-century urban life accelerated organization of space and surfaces and concentrated the flow of human activities. Ordinances and public health combatted overcrowding, disease, congestion, crime, and nuisances of every sort. Paved roads, sidewalks, parks, public transportation, and public lighting accommodated new lives, while large buildings and skyscrapers redefined horizons. Note in this image that all move under the shadow of a great clock, like those on display at the city's train station and everywhere else.

approximately, were becoming not just places where one belonged, but true cocoons of soft, clean, safe, and kind surfaces. A very few even got a bedroom of their own. The majority, at least on Sundays, were enfolded in clean, bright, and colorful dress and a decent pair of shoes, and enjoyed a chance to put them on display. So, especially through the city, the industrial democratic nations offered a contract exchanging work for goods and dreams that won the modern person over hand and foot, heart and soul.[60]

At the interface of skin and world, smoother, brighter, and varying surfaces redefined the ordinary, stealing eyes and winning hands as they multiplied. They arrived as a plethora of objects to be bought or, while strolling the avenues or window-shopping, at least envied. Myriad moving machines, engaging appearances, and inviting occasions, accompanied by blinking lights and flashing signs, won the attention of the majority. The printing industry gathered and sheeted over the world with the printed page. Headlines announced the day to the world. Societies, increasingly dependent on literacy, transmitted information, offered education, spewed out and churned with ideologies, and disputed orthodoxies and covenants. Paperwork, which accompanied the explosion of chair manufacturing that started in the eighteenth century, filled stories of high-rise buildings and was performed by great armies of white-collar workers. Words were woven into images, and images into words, and of course numbers remained a vital part of the mix; and so the fabrication and fabric of the modern mind took place.

Nothing revealed, however, the modern city's suasion of the hearts and mind of its dwellers more than the clock. As we saw at the beginning of the chapter in the case of canals and trains, clocks synchronized and sped up the movement of the modern citizen in modern national society. The face of the clock, the big and little hand alike, made punctuality the heartbeat of industry and nation. Clockmaking itself, if we concur with the American historian of technology Lewis Mumford, was not "merely a means of keeping track of the hours, but of synchronizing the actions of men. . . . The clock, not the steam engine, is the key machine of the modern industrial age," Mumford contends, for accurate timing is indispensable to standardization, automation, and, alas, nationally integrated military mobilization and wartime production.[61]

Amid the growing array of surfaces and words, the commanding global face of the clock became omnipresent and held an indisputable place in the second half of the nineteenth century.[62] In ports, railroad stations, factories, schools, kitchens, and bedrooms and on wrists, the clock dictated people's

actions according to standard time. "The best proxy measure of moderniza-
tion," the clock wrote time on the inner impulses of both the urban and,
belatedly though ultimately, rural citizen.[63] Time increasingly became a
category of everyday perception and action. It doled out sleep and leisure,
work and vacation. An instructing surface, the clock told citizens what was
next in the place and order of things.

AT CENTURY'S END

The nineteenth century had traveled far and built itself high, wide, and deep.
By 1900, the beneficial effects of the Industrial Revolution, supported by
commercial agriculture, social organization, and public health, had been
felt. Europe's population had approximately tripled in a century, from 180 to
500 million. People had been set in motion. They migrated from countryside
and village to town and from town to city. The metropolises, the greatest
of the cities, were the biggest magnets, multiplying five-, ten-, even twenty-
fold over the course of the century. London, foremost in growth among the
world's cities, had been a great death mill up to 1850, with a death rate far
in excess of its birth rate. It ground up rural immigrants until midcentury,
when things reversed themselves. People ate and were housed better, became
healthier, and lived longer.

Urban skylines proclaimed the dramatic change in the metropolitan
order. Buildings, bridges, roads, and other structures announced new con-
struction, as had the spires and towers of the twelfth- and thirteen-century
cathedral. The four Expositions Universelles, held in Paris in 1855, 1867,
1878, and 1889, all served as occasions to erect structures of steel and glass.
The Eiffel Tower, built for the 1889 exposition, declared an unprec-
edented order of building. A self-erecting mechanical frame, it pronounced
construction a work of modular assemblage. Additionally, its height and
illumination were novelties.

Seeking to stand tall on the landscape of nations, France joined the United
States in the latter's centennial celebration of 1876. France erected a visual
portal to the New World in New York Harbor. A massive work of freestand-
ing copper, the Statue of Liberty, a single transmitting surface, signaled to
millions of immigrants that before them lay a land of fresh opportunities.

In Chicago, the cradle of the skyscraper, the 1893 World's Fair used archi-
tecture to declare the preeminence of the New World. On the exposition

grounds, filled with the pride of places and nations, a great Ferris wheel circled. However, it was not the spinning wheel that made the American prophet Henry Adams dizzy. Instead, he puzzled over the meaning of another turning invention: the dynamo, whose rapid revolutions generated electricity. In his notoriously pessimistic *The Education of Henry Adams* (published posthumously in 1918), he asserted that no metaphor at hand could grasp the wild, savage exponential change that machines and the human accumulation of power augured. He found no icon to minister to this rush of images and power.

A decade later, in 1903, on a North Carolina beach—so distant from the urban skylines of London, Paris, Chicago, and Detroit—the Wright brothers, Ohio bicycle-shop owners, launched their *Flyer* at Kitty Hawk. Powered by a specially made sixteen-horsepower gasoline engine, with a spinning propeller and a set of light, strong surfaces, the *Flyer* took flight—its wings lifted the dream that humanity would someday fly itself to the stars.

Engineering the Small, Designing the Invisible

The dance floor of being truly is its smallest surfaces.

ANONYMOUS SCIENTIST

Engineering surfaces is an old art, relevant to disciplines as diverse as microelectronics, mechanical engineering and medicine; but today we can do it with molecular-scale precision.

PHILIP BALL, *Made to Measure*

A PREMISE OF THIS WORK and this chapter is that human history can be written as the story of human recognition and control of both natural surfaces and made and designed surfaces. These surfaces define human environments and, at the same time, become the images, signs, and metaphors by which humans construct and transcend their world. A second premise, one that additionally justifies this work's increasing focus on modern western history, is that in the last two centuries the West, by invention, design, and production, has achieved a true revolution in the making, control, and distribution of artificial surfaces.

To find a similar revolution one must, arguably, return to the late Neolithic. In that era came domestication, agriculture, urbanization, and civilizations. On multiple fronts, cities and civilizations encapsulated and rationalized lives and local cultures in unprecedented orders of organized, shaped, and created surfaces. On this count, this narrative of modern and contemporary worlds joins the deep history that unfolded across millennia to the history of the nineteenth century and especially to that of contemporary times—a period that is programmatically committed to carrying out an accelerating, systematic, and reorganizing revolution of the world. Humanity, without precedent, now insists that the world be remade into its exclusive home, and humanity is realizing its idealized image of itself in this particular place in time.

Manifest for all to see is the fact that this profound revolution amounts to one of made things and designed images. Yet it can be grasped only by analytic historical attention. As images of things made, designed, and represented, surfaces have extraordinarily multiplied during the past two centuries. Images grow by leaps and bounds as more surfaces are produced for more varied purposes and ends. Images, in turn, leapfrogging with surfaces, result from more synthetic materials, ever-multiplying inventions, manifold machines, and unprecedented production. Argus-eyed research and all-commanding design create more exterior and interior surfaces. Cumulatively, they testify to the integration of science, technology, industry, commerce, and art.

Surfaces have been squared many times, and they constantly are perceived anew by probing lenses. Waves of avant-garde artists have experimented with materials, collages, means, and subjects. Moved by varying mixes of fashions and ideologies, they have called forth unique visual and tactile orders of perception and conceptions on surfaces. They have adopted and mutated photography, filmmaking, and (increasingly in the last decades of the twentieth century and the first decade of the present century) the full range of graphic, visual, and computer arts. In service of a message or in search of significance, artists continually reface the world.

Design itself has expanded its goals from making, illustrating, and decorating objects to reenvisioning life and society. It has found full employment in the service of industry, markets, and styles. Design has come to envelop entire landscapes and societies, vast ranges of goods and products. Design, perhaps singularly, accounts for our familiar notions of lifestyle. One measure of the difference between the nineteenth and twentieth centuries lies in the contrast between the mechanical typewriter and the "friendly and functional" surfaces of the computer.[1] An even simpler measure of increasing human invention, control, and imagination is found in the history of flight, as noted at the end of the last chapter. The twentieth century began on a few hundred yards of North Carolina beach, thanks to a set of light and strong surfaces, mechanically adjustable planes, and a small gasoline engine. It concluded with probes and robotic journeys into deep space. New surfaces stand forth on information satellites and on the hull, guidance systems, cockpit, quarters, and engines on spaceships; and they equipped the Mars *Explorer* with its six cleated wheels, lasers, and turrets mounted with robotic arms.

To enter through a wider historical door, let me suggest that in its creations and destructions, the twentieth century increasingly relied on

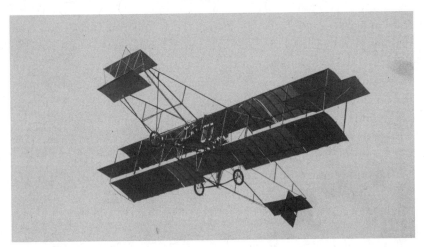

FIGURE 23. This is the first flight of an airplane in Montana, September 26, 1910, as presented in the Montana State Fair booklet. This humble structure of surfaces—light, fixed, and moveable planes—with a small gasoline engine and compact cockpit, soared on heavenly dreams, spurred innovations, and concentrated industry's attention on flight. It can be seen as a first surveyor's stake in the heavens, measuring the distance and time to man's first step on the surface of the moon in 1969.

synthetic materials and design, just as the twenty-first century is doing. Tanks, submarines, torpedoes, airplanes, parachutes, poison gases, bombs, rocketry, and surface-to-surface missiles suggest one path for our newly engineered surfaces and interfaces. Meanwhile, with bold techniques, small, powerful engines, and immense, renewable sources of energy, industries—from agriculture, forestry, and mining to manufacturing, chemical production, and electrical utilities—have reshaped natural environments, built landscapes and cities, and determined the size, means, and life of society. Following the impulse of nineteenth-century building and engineering, twentieth-century transportation and communication increasingly made contemporaneity synonymous with instantaneity.

Mind increasingly joined the mutated surfaces and images of a world in revolution. Increasingly, both perception and conception focused on what was made, designed, and imagined. Bodies, minds, and lives were remade into the surrounding world. Humans, individually and collectively, joined our eyes, spirits, and hearts into what we see and what is projected. Just as early humans made themselves into their tools and wrappers, so contemporary people and society become the made, engineered, and designed surfaces around us. Design makes an ever-greater bid to win both the eye—its glance,

stare, and gaze—and the hand—its feel, touch, and grip. Images flow from making, planning, legislating, idealizing, and dreaming up surfaces and their interfaces and compounded contexts. Newly generated perceptions, conceptions, and images flow from the investigations of eyes, hands, scopes, and instruments into the depths of earth, sea, space, and matter itself. Humans are becoming our own identifying, probing, and surveillant machines—and with photography, movies, television, and computers, our inventions have filled our minds and ringed us in captivating and idealizing images.

The world humans make and idealize engulfs us. Apropos of this, Hal Foster, author of *Design and Crime,* argues that design makes identities; commodities increasingly belong to specialized niches; and there is almost "a seamless circuit of production and consumption."[2] Surfaces, coincidentally, are transformed into whole environments—Disneylands—of images, blatant symbols, and overarching icons, while advertisement occupies ever more sensual outer space and receives great attention in our minds. Making a bolder affirmation of the power of things over mind, the Canadian writer, philosopher, and rhetorician Marshall McLuhan offers the notion that "the medium is the message." He contends that the surfaces of all objects become designed and thus, through the medium of their transmission, they are perceived, constructed, and relayed.[3] In other terms, we become what is shown to us. In a society of mass media, we are woven into the cocoon of designed surfaces and generated images—much as (as I discussed at earlier points in this work) Neolithic minds became the houses in which people lived and the vessels in which they placed things.

However, homogeneity and standardization do not entirely net the contemporary mind. Surfaces are altered and toss up discrepancies and divisions. Images collide. They create unsettling juxtapositions, disjunctures, incongruities, and ambiguities. Furthermore, rude and raw appearances and events constantly expose, trump, and reorder images, disrupting whole fields of surfaces and images. Additionally, certain geographies, cultures, traditions, religions, ideologies, and sciences resist both the contemporary medium and the message—the surfaces, images, and appearances before us. They insist on beliefs, prospects, and stubborn intellectual distinctions made on the grounds of argument, evidence, ideas, logic, and metaphors. Philosophy and religion continue to query the certitude of eye and hand. Advancing science and technology transform cultures into multiplying paradoxes and ambiguities. Contemporary physics and chemistry puzzle and dispute the real and imagined and, as we will later examine, now as never before probe,

investigate, classify, and, yes, design and transform the invisible: things ever so small and profoundly volatile have propelled us into a world of hope and dread.

PROTEAN DESIGN

In our times, design enters into everything. We can say of design what Paul Valéry writes of science in his 1919 essay "The Intellectual Crisis": "Our science, becoming a means of power, a means of concrete domination, a stimulant of wealth, a device for exploiting the capital of the planet, ceased to be an artistic activity, and an end in itself; instead it has become an exchange value."[4]

Nurtured by science and technologies that enhanced its potential to make things, design marched under progress's proud banner, with the goal of meeting society's expanding wishes. At the same time, designers worked for science's humbler goal of satisfying commerce's quest for larger markets, bigger profits, and diminished costs.

Identified at the start of the twentieth century with visual architecture and eye-catching dress and fashion, design later mutated. Design took up the tasks of both making practical things and satisfying dreams. With substance, function, shape, color, and other properties within the ken of manufacture, design found everything from the factory floor to window displays worthy of improvement. New products, materials, and tools had to be joined, if design were to succeed, to product labels, expanding and diverging markets, and changing competition. Design at all points mediates, as the historian of technology Henry Petroski points out, a variety of factors, whether its product is an automobile or an airplane or an everyday common object such as a paper bag, bathroom, or toothbrush. In *Small Things Considered,* Petroski writes, "Designing anything, from a fence to a factory, involves satisfying constraint, making choices, containing costs, and accepting compromises. These givens necessarily introduce individual characteristics and anomalies into the resulting artifact."[5]

However much design is about surfaces, I suggest that it truly begins and ends at and on the surface of things. Surfaces' singular, combined, and even antithetical properties—hardness, malleability, impermeability, color, and shape—must always be taken into account. Surfaces define the appearance, fit, and use of things. They are integral to one's choice of materials, selection

of a manufacturing process, establishment of a price, and marketing appeal. Born out of a matrix of materials, chemistry, physics, and engineering, products also belong to a context, which is composed of mutual use, a surrounding world, and the sight, touch, and even self-image of the consumer.

Design in manufacture was originally conceived of as inseparable from "advancing machines" and mass manufacturing techniques.[6] Increasingly, designers stepped down from the drafting board and tool-and-die-making machines. Though they belonged to mass society, they increasingly annexed design to all that could be thought to have style or craft, and they showed careful interest in such divergent things as games, pharmaceuticals, the Web, and software. Suggesting the exploding range of design, a book from the London Design Museum separates its products into fashion, architecture, interiors, furniture, lighting, homeware, singular products (such as the Swiss Army knife), transport (from steam engine to space rocket), and sports.[7]

Design shows a literally strong adhesion to surfaces. It makes tapes, paints, sealants, inks, paper, and Kleenex, which must be put in a box and easily pulled out. Design shapes packaging, which provides a product's first, protective layer. Design forever worries about presentation and display. A smartphone or computer case must sell the consumer at first glance and touch. Design, in turn, must be brought to bear on the message. It utilizes the same pack of tricks that signage for roads and subways, slogans and icons on political posters, and images and animation on television and computer screens all use. Beyond satisfying clever intelligence, a product must be designed to meet the test of searching eyes and plying hands. It must meet consumers' concerns about durability, repair and maintenance, and the always important but elusive matter of style.

With each generation, design again takes the ordinary in hand and tries to make it extraordinary, or at least special. It gives more attention to, for example, kitchens—real stone and composite countertops, wood and imitation flooring, and various kinds of cupboards require design. Bathrooms shine with design in their myriad mirrors, forms of lighting, and tiling, as well as tubs, showers, toilet bowls, and even urinals (whose color and shape Marcel Duchamp's 1917 *Fountain* raised to an aesthetic form). And then, too, there is innovative sports gear. The tennis shoe, a union of colorful surfaces, of uppers and soles, leads the way. Golf equipment, too, illustrates scientific advances in grips, shafts, club faces, different types of balls, and magnified claims to rule ever-smoother fairways, closer-cut greens, and professionally designed courses.

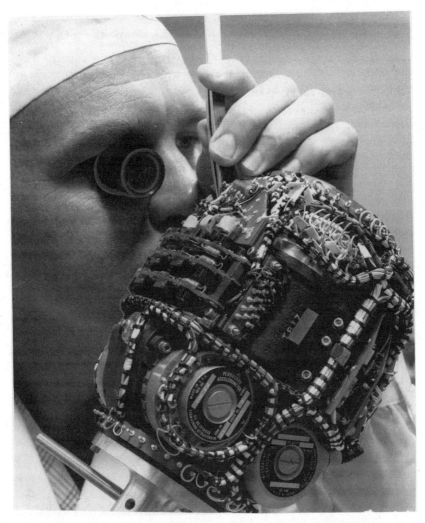

FIGURE 24. In this Minnesota Historical Society photograph, 1965, we see a Honeywell technician making a wiring check on an inertial guidance system for a *Centaur* space vehicle in 1965, and we realize that we invent and envision ourselves through machines and instruments of all sorts.

Design is about invention, and invention, for a set of reasons, seeks different and better surfaces. The illuminating lightbulb, the solar panel, and the giant blades of windmills form the face of our use of energy. Camera lenses and screens are singular surfaces offering distinct visions. New plastic joints for hips and rotator cuffs supply smoothly moving replacements for worn and creaking natural joints.

Arguably—and despite my bias as a Detroit native—the car was the central object of twentieth-century design. It changing forms and styles exceeded those of the airplane, with its expanding sources of power and amazing wings, and even those of the naval aircraft carrier, which by dint of its size, motors, cables, fuels, personnel, logistics, and functions constitutes a floating city. In the early years of the twentieth century, small shops assembled cars piece by piece, feature upon feature, body size after body size. Henry Ford succeeded in standardizing the car's economical production. Plans for motors, chassis, bodies, steering wheels, brakes, dashboards, roll-up and -down windows, the alternating windshield wiper, a rash of electrical and computer parts, and much more filled up patent offices. Democracy drove into the twentieth century in the car and followed paved roads and highway systems into a new order.

As illustrated particularly by the history of the automobile and its use, contemporary inventions, like tentacles, reached out in every direction. They took hold of production, drove design, and were shaped to suit application, production, and consumption. They even took hold of what is deemed as today's reality and projected as tomorrow's utopia. Following the impulse of the continuous interplay between made and used things and imagined selves, communities, and worlds, that we have traced since our first chapters, humans on an ever-greater scale and at accelerating rates have shaped, joined, and bent small and great surfaces to form lives, meanings, and dreams.

OUT OF THE BLACK BOX

Twentieth-century design participated in making and representing the world from the bottom up. Its ability to bring forth properties on the surface turned on the atomic and molecular depths it had reached. However, as Ivan Amato reminds us in *Stuff,* we must realize that creating synthetic materials has a history.[8] Already in the nineteenth century, western humanity entered steelmaking full-scale to create superior tools, structures, and concrete walls, floors, and roofs. At the same time, the emerging science of chemistry directed mass industrial manufacture toward production of dyes, textiles, and coverings, and chemists even found that coal tar waste could be used to coat wooden ties against decay. Anticipating twentieth-century polymers (which will be discussed later), rubber, more formally known as elastomer, was plastic and rich in potential properties. Once treated, it became smooth,

stretchy, elastic, impermeable, and either hard or soft. Introduced as natural latex, it was vulcanized (in a process that adds sulfur) by Charles Goodyear in 1839. Thereafter, rubber incrementally put a black and elastic face and interface on domestic and commercial worlds. Rubber erased, wrapped, and protected goods. It provided flexible joints, waterproof clothing, boots, and table and floor coverings (particularly for the food and meat-processing industries, where water and blood continuously flowed). It dressed sailors for high seas and let the rest of land-loving humanity labor and promenade in the rain. Likewise, it furnished industrial and medical linings and tubing.[9] However, in the form of tires, rubber, as the interface between wheeled vehicles and surfaces of all sorts, truly set the world speeding forth on rolling wheels. And worn-out tires, even before today's recycling and reprocessing, found use across the landscape, buffering marina piers and the dockside hulls of boats, weighting down grain tarps, and providing children with swings.[10]

Although rubber was only fully synthesized once the armies of expansionist Japan had taken control of the rubber plantations of Southeast Asia and the Second World War became imminent, industry's search for synthetic materials and its marriage of research and invention, which anticipated the broadening scope of design, had begun much earlier. This shift, according to Ivan Amato, began in 1876 with Alexander Graham Bell's founding of his laboratory at Menlo Park, New Jersey. From this outpost of invention, Bell promised "a minor invention every ten days and a big one every six months or so." The German dye and chemical industry took up systematic research in the 1880s, and General Electric, determined to sell lighting for those unseen surfaces in homes, offices, theaters, hospitals, and on the street, followed suit in 1900. In rapid succession, DuPont stirred its chemical pots, while steel baron Andrew Carnegie turned metal's advancement over to chemistry's amazing molecular brews. American Telephone and Telegraph, Eastman Kodak, and Corning Glass too pledged their resources toward the invention of new materials, including transparent, translucent, and highly reflective glass, which supplied materials for table settings and decorative objects, among other functions. Urban humanity increasingly looked into the world and saw itself and its possessions and desires through lenses, sheets, and plates of glass. At home and along the street, glass-filtered light penetrated and reflected the world to itself; the epidermis between thing, appearance, image, illusion, and outside and inside surfaces grew ever thinner and more transparent. The world increasingly became both the lens and the image of itself.[11]

By the beginning of the twentieth century, the stage was set for the making of polymers and for treating the things of the world as if they were plastic. In the interwar years, chemistry, as Ivan Amato indicates, began to synthesize molecules. Slowly at first, and then at an accelerating rate, the chemical industry began the dramatic alteration of products. In 1926, a chemist at B. F. Goodrich made polyvinylchloride for adhesives and sheets. In 1930, I. G. Farben introduced polystyrenes, which were transparent, tough, and strong enough to replace glass in the cockpits of fighter planes. Within the next ten years came Teflon, new nylons, and epoxy resins, also known as polyepoxides, which can be formed into reinforced plastic used for painting and coating, adhesives, molding and covers for electronic materials, and fillers and strengtheners for inner layers of marine surfaces, as well as structures for other covers and glues for wood.[12]

Although legitimized as the creative and ongoing science of molecules, chemistry inadvertently added to people's growing disdain for surfaces. In a world in which wishes increasingly only *seemed* true, surfaces were taken for granted; they were degraded in our minds, becoming simply a dress we put on and take off. They were temporary, disposable, and interchangeable. Perhaps the equation of laboratory and analytic work with interior and even secret profundity causes us to lose sight of the importance and the primacy of surfaces. Science writer Philip Ball gets at part of this when he writes:

> Somewhere in our past we acquired a disdain for surfaces. To be unable to see beyond the surface of a matter is regarded as a failing, and no one wants to be considered superficial. The natural state of most surfaces is dirty, yet we expend a great effort [some of us] in trying to make them otherwise. But when I started doing scientific research on surfaces I realized that, on the contrary, *surfaces are everything*. . . . For it is at surfaces and interfaces that we conduct almost all our interactions.[13]

Ball strengthens his case by affirming that the main action happens at surfaces and between surfaces: at interfaces. Most often the structure and composition of external surfaces are not identical to those found within, but rather form an outer boundary (such as a margin, border, the edge of a field bounding a forest, or another ecological zone). "So scientists of all persuasions," he elaborates, "have found the study of surfaces to be a particularly rich playground, one that brings to light new fundamental phenomena that often have extremely important ramifications. Whenever two materials are brought together, whether that be in fabricating a transistor, painting a

wall, or applying a Band-Aid, . . . we must expect the unexpected."[14] Even an explosion!

THE SMALL EXPLODES BIG

Far removed from the epidermal portals or biosurfaces of cruds, crusts, molds, scabs, and infections encountered on the face of things by the observant physician, cook, or hiker, theoretical physics found a entirely different rabbit hole into the worlds of the small. Stunningly, in the half century between the last decade of the nineteenth century and the 1940s, physics, along with chemistry, initiated an inventory of the awesome subatomic world. The path to its classification and manipulation of the atomic universe, undertakings about which the ancient Greeks could only speculate, led through the classic laboratory of early modern history with experiments on such invisible phenomena as temperature and pressure, magnets and electricity. As if they were a new breed of Greek, Indian, or Chinese metaphysicians, theoretical physicists began to dice up the classical, and etymologically indivisible, atom (*a tom,* meaning in Greek "that" which "can't be cut") into types of particles, movements, and forms of energy. With mathematics and micromeasurements (especially of revelatory atoms), cyclotrons and reactors—helped along, of course, by considerable government aid and the competitive urgency of the mounting arms race—applied physics to actually split the "indivisible atom." In 1942, under Stagg Field—the oldest football stadium at the University of Chicago—Italian physicist Enrico Fermi carried out, as witnessed by a small group of scientists assembled in an adjoining racket court, a chain reaction. He put in human hands the implications of observations—the conjectures, traces, forms, and activities of the smallest particles: protons, neutrons, electrons, neutrinos, and photons. In this way, the divisible, fragile, and ever-so potent atom became a second sun glaring down on a precarious planet.

REDEFINING THE INVISIBLE

The most truncated history of atomic theory can only suggest the profound plunge beyond the visual and tactile surface of things that contemporary science has taken in the past two centuries. With his theory of atomic weights, English chemist John Dalton (1766–1844) theorized and diagrammed

as a table of atomic weights the notions that atoms of each element were identical but different from those of other elements, and that atoms determined weight by the law of multiple proportions. In 1869, the Russian chemistry professor Dmitri Ivanovich Mendeleev further accounted for surface appearances and phenomena with a calculable scheme of atomic interactions and a periodic table (and his work was bolstered independently in 1870 by the German chemist Julius Lothar Meyer). The table identified and arranged the elements along horizontal rows and vertical columns on the basis of their repeating characteristics, increasing weight, and thus larger atomic numbers. Confirming its own veracity, the table predicted the appearance of undiscovered atoms by leaving gaps within itself. In assigning a larger size to the interior of an atom, it accordingly postulated an outer quantum shell of electrons, which determine an atom's interaction with other atoms.

Obviously, filling in Dalton's chart and Mendeleev's table set an agenda for chemistry and physics labs for following generations. Coincident with the organization of the exterior world by states, democracies, markets, industries, and transportation systems (elaborated on in the preceding chapter), scientists took to organizing matter, energy, and light at the molecular, atomic, and subatomic levels. Field theories had grown ragged around the edges; the fences of Newton could no longer corral and confine growing herds of phenomena. Gas molecules, vaporous and steamy, move like fickle water or wind. Microparticles and their energies—whatever they are—increasingly baffled scientists with their anarchic and chaotic ways. Select atoms even come apart or leak or continually transmute. In the form of energetic particles or waves, radiation travels through space. French scientist Henri Becquerel first discovered radioactivity in 1896 when working on phosphorescent materials. Collective research by Becquerel, Ernest Rutherford, Paul Villard, Marie Curie, and Pierre Curie soon discovered that the decay of different materials produces different types of radiation. Aware that this seemingly magical decay process results in the transmutation of one element to another, Rutherford returned the wandering unicorn of radioactivity to its rational pen by showing that decay occurs in all elements, and always with the same mathematical exponential formula. Proof of the human grasp of the life and behavior of particles came from the medical application of radioactive rays. They were used to capture shadowy but sure images of alien and abnormal things deep in tissue, skin, bone, and organs—especially shrapnel embedded in victims of the raging First World War.

One other matter required a theoretical accounting: light itself. As Scottish physicist and mathematician James Maxwell already had shown in 1864, in what might be considered the single most important discovery in electromagnetism's long and intriguing history, light belongs interchangeably to electronic and magnetic fields, which together produce electromagnetic waves. Joined in some way to all we see, associated with so many phenomena, and integral to millennia-old reflections on its nature and connections (to plants, heat, lightning, electricity, magnets, fire, etc.), light lit up inquisitive minds with questions. How, with, and through which medium does light move? Are there different kinds of light? Is it a predictable wave (as traditional optics had it), or is it a body—some sort of charged light particle, or light quanta? How do they move and interact in the forms of heat and energy with other things? What, in effect, are the mechanics of light?

Such questions nagged at the mind of the young and rebellious Albert Einstein. An officer in the Swiss patent office, with no place in the academy, Einstein found an intellectual abode in untangling the great whirl of particles. In a single and marvelous year, 1905, Einstein visualized the Newtonian world afresh. In five papers, he undid the Newtonian frame of things and reenvisioned the world from the bottom up.

In his biography, Walter Isaacson introduces these topics via a summary that Einstein himself offered in a spring 1905 letter that he wrote to his friend Conrad Habicht. "The first [paper] deals with radiation and the energy properties of light and is very revolutionary," Einstein wrote. "Yes," Isaacson comments, "it was indeed revolutionary. It argued that light could be regarded not just as a wave but also a stream of tiny particles called quanta." Einstein then boldly claims, "The second paper is a determination of the true size of atoms." "The third," Isaacson says, "explained the jittery motion of microscopic particles in liquids by using a strict statistical analysis of random collisions. In the process, it established that molecules and atoms really exist." In effect, the third paper brought to the attention of physicists Brownian motion, which had been discovered by botanist Robert Brown in 1827, when he observed under his microscope that pollen grains suspended in water release minute particles that move in a jittery motion, similar to the enchanting movement of glittering, tumbling small dust particles in the gentlest currents of air. The fourth is, Einstein wrote, "an electrodynamics of moving bodies, which employs a modification of the theory of space and time."[15] With this theory, known to the world as the special theory of relativity, Einstein hypothetically quantized light and other electromagnetic

waves in bursts and waves of photons. In the execution of his argument, Einstein discarded Newton's concept of absolute space and time. In the fifth paper, which Einstein was yet to conjure up before that extraordinary year's end, he formulated the best-known equation in all of physics: $E = mc^2$. He had outlined the unification of energy, mass, and speed.

In one fundamental way, Einstein kept physics loyal to the tradition of Newton. He continued to assign mathematics the task of describing the invisible—and he used light and energy to measure and unify all. Following from Maxwell's identification of electricity, magnetism, and light as transporters of energy, objects and forces had mutually calculable properties. In this way, physics created a conceptual and mathematical sheath, abstract as it was, into which the hosts of invisible matter fit. Nature's epiphanies could still be calculated.

At the same time, Einstein opened the cellar door to a Wild West of particles, whose types, roles, and behavior eluded consistency, predictability, and Einstein's own taste for order and certainty. Post–World War I physics bristled with paradoxes, conundrums, and contradictions. Still grappling with whether light was wave or particle and whether it bent to gravity, they found themselves arguing over the inner structure of the nucleus of the atom (the numbers and positions of protons and neutrons), its relation to circling atoms, the leakage of neutrinos, and the difference among alpha, beta, and gamma radiation. And more: Physicists found themselves before particles that spun like tops, in reverse directions, and came together and stayed apart and moved free of any fixed orbit; physicists were unable to separate what they observed from how they described it. Heisenberg, an architect of quantum mechanics, became most famous for his uncertainty principle, which asserts in regard to a single measurement of a particle, "The more precisely the position is determined, the less precisely the momentum is known."

IN THE VALLEY OF NANO

Physicists successfully had made city- and nation-shattering atom bombs (and also the medically useful magnetic resonator) by 1945, but chemists found their fame in dwelling on how electrons reacted and combined, not in splitting the atom's nucleus.[16] Philip Ball argues that in the second half of the twentieth century, scientists entered into the complex business of making materials. The control of what is essentially the surface interaction of

materials has afforded contemporary makers and designers a choice ranging from forty to eighty thousand materials.[17] Designers launched a full-scale invasion into the realm where atoms and molecules interact, and where surfaces—measured by $3r$ in spheres—function as the reactive nerve endings of matter. At this level, the smallest forces (even a photon of light) pack more punch. Molecular interfaces ignite extraordinary interactions and marvelous events take place; and contemporary historians must take account of them to grasp both the scientific roots of everyday things and the human condition.

Molecular and atomic design constituted a profound and irreversible step into making the built world afresh. Surfaces' properties (color, strength, elasticity, luminescence, hydrophobia, etc.), seen in objects, structures, and whole environments, were made over. Before us were erected synthetic walls, floors, furniture, paints, textures, covers, wrappers, membranes, and inner linings of solids, liquids, and gases. Synthetic products now fill our homes and shape the places we work and play; with them come fresh sights, touches, smells, sounds, and images. With plastics alone, we make new skins and artificial joints and organs; we pay with the swipe of a plastic card; and with sheets of microcrystals and polymers, we miniaturize the machines by which we calculate, know, and talk to the world.

Atoms and molecules define our environment and encapsulate our bodies. They increasingly define our conditions and ignite our dreams. Science itself finds means, purpose, and ends in the microcosm; it finds a way, to quote physicist and Nobel laureate Jean Perrin, "to explain the complex visible by some simple invisible."[18] The discovery of DNA (deoxyribonucleic acid) in 1953 by Watson, Crick, and Franklin was the culmination of a long process of discovery, beginning with nucleic acids, proteins, and RNA. DNA has proven to be the key to life itself—the origins of both the everyday and such exotics as the quagga, zebra, dodo, and moa, and veritable zoos of animals and gardens of plants the earth will never see again.[19] This descent into the microscopic has matched and, in many significant ways, surpassed any other event in our times. It has delivered us, at terrifyingly accelerating speed, into the depths of being: the deepest structures and innermost surfaces of matter and life. It gives the historian a cosmological theme: a creature of the earth has become the earth's lord and designer.

Like Jack and Jill tumbling downhill, humanity has delivered itself into the whirl of things below. We did not achieve this because we now somehow think more deeply or imaginatively, but because we now have instruments that measure more precisely and in more varied ways than we had in the

past. Instruments now count red and white blood cells, measure plasma, and calculate numbers of atoms, which, though of diverse diameters, all have 99.9 percent of their mass in their nucleus. To explore such structures and represent and image the surfaces below our perception, machines use more than light. They utilize the whole electromagnetic spectrum. Radiation led to microwaves, which in turn proved to be essential to radar, long-distance telephone, and cable television. Particle radiation—alpha and beta rays in radioactivity, and other kind of rays from atomic and subatomic particles—serve, like extra eyes and hands, in radiotherapy, photoelectric cells, and electronic eyes. To see what we can't see, we use lightmeters (interferometers) to measure things as small as half a light wave, the very limit of measurement by light.[20]

Contemporary science's first instrument of descent into the nanoworld was the traditional optical microscope, which, as noted in chapter 5, in the seventeenth century already had illuminated such invisible phenomena as mites between the scales of a fly. The microscope was improved notably with enhanced illumination in 1890s and better lenses in the 1950s. Electron microscopes, which date from the 1930s and 1940s, use electrons in place of light for magnification. Two major variants of electron microscopes are the scanning electronic microscope, which looks at the surface of objects with fine electron beams that measure reflections, and scanning tunneling microscopes, which view surfaces at the atomic level. Scanning probe microscopy and atomic force microscopy, dating from the 1980s, form composite images of surfaces using a physical probe of the specimen.[21]

So the twentieth century notched downward in its descent. At the nano level, a billionth of a meter, we encountered molecules. Science then proceeded to subatomic particles and forces measured in numbers as infinitesimal as 10^{-30} and below (or is it beyond?). Scopes, scans, and probes optically, atomically, and with electrons and electromagnetic particles and waves opened interior journeys into molecules, which atomic scanners move and arrange. This interior voyage was paralleled by medicine's penetration of skin, bone, organs, and cells with x-rays; nuclear magnetic resonance imagery, which perceives the nuclei of atoms inside the body; and x-ray-computed tomography, which since the 1970s has supplemented ultrasound. Additional instruments have entered and imaged the depths of our bodies.[22] All surfaces have become porous to our penetrating atomic gaze.

Nanosurfaces and their interfaces, where things happen, are known to be only a molecule or two thick. On that plane of reaction, things marry, live

together, divorce, oxidize, and explode. On nanosurfaces, the smallest crystals blossom; liquids stir, move, form solutions and films, and vaporize; molecules exchange atoms; and, as late-nineteenth-century physics first determined, these atoms emit and admit energy, shedding electrons and radiation.[23]

In the proximate vicinity of this small kingdom, give or take a few hundred or even a thousand nanometers, the theoretical jurisdictions of physics and chemistry become inextricably intermingled—or wander like two drunks helping each other down a strange microscopic alley. Both physics and chemistry have something to say about interfaces and capillarity, bubbles and foams, surface viscosity and elasticity, interfaces of detergents, lubrications, monomolecular films on water, liquid-to-liquid interfaces, the adsorption of gases by solids, the structure of water on near-solid interfaces, and aspects of emulsion polymerization.

Mid-twentieth-century scientists heeded the invitation of Nobel Prize–winning physicist Richard Feynman's 1959 talk on miniaturization, "There's Plenty of Room at the Bottom: An Invitation to Enter a New Field of Physics."[24] Proponents of new technologies pitched their tents in the valley of the nano in the 1980s. They took the term *nanotechnology* from Norio Taniguchi, who in 1974 defined it as signifying "machining with tolerances of less than a micron, a millionth of a meter."[25] In 1986, nanotechnology received its first full popularization in K. Eric Drexler's *Engines of Creation*. Scientist and president of the (presumptuously prophetic) Institute of Foresight, Drexler puts forth a transformative dream of the unlimited potentiality of nanotechnology. Assuming the ultimate possibility of clear vision, untainted will, and perfectible institutions, he defines *nanomachines* as fulfilling engines of abundance, healing, and learning. Hurdling with words over the limits of nature, design, and cost, Drexler transcends fears of nanotechnology accidents or tragedies, and his hopes are not paralyzed by fear of a Frankenstein's monster lurking among docile nanorobots and their masters.[26]

Although Drexler's dreams were not realized in the 1990s, the decade did witness a long string of inventions of nanomaterials and nanoproducts. A list includes catalysts, layering for storage in disk drives, lipids used for anticancer drugs, and nanocrystalline particles used in tough ceramics and in transparent sunblocks to screen out infrared and ultraviolet radiation. Displaying human hands' advancing control over the invisible, scientists "wrote" with individual (xenon) atoms. And carbon nanotubes (CNTs, or Bucky tubes) found multiple uses, starting with transistors. Recently, in 2011, nanotubes were used to produce synthetic synapses for brain prostheses and

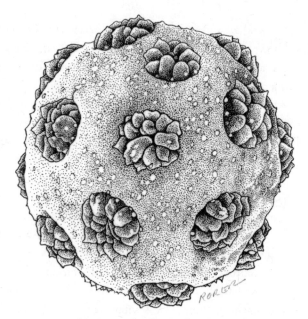

FIGURE 25. "A Grain of Pollen," Abigail Rorer, 2000. We now peer ever deeper into the forms and surfaces of the smallest things. We manipulate seeds, cells, crystals, and molecules to make the world and ourselves, outside in and inside out, as we want them to be.

artificial brains; and scientists discovered the promising idea that single molecules can act as molecular switches.

LIGHTING UP THE BOTTOM

Measurement and observation has guided science ever since Galileo and his contemporaries first reversed the direction of their scopes' glass lenses and peered down into the magic small kingdom of crystals and the whirl and stir of microscopic life. By the nineteenth century, optically armed doctors and early epidemiologists were scanning the crust, mold, and scum of liquids and solids for sources of infection and disease and had discovered a riot of life and foul deeds done by propagating and parasitic microorganisms. Parasitology, bacteriology, and virology began to sketch an outline of germ theory.

Chemistry, too, investigated downward. While not independent from physics, chemistry persisted in exploring the surfaces, interfaces, and interactions of molecules and used them to explain the materials, surfaces, and processes above them. Surface science chemistry took up the atomic world and its outer ring of electrons. As explained by chemistry professor Lee Penn of the University of Minnesota, at the interface of atoms, heat, pressure, magnetic bands, and catalysts have an immediate and powerful effect as reactions arise out the covalence of electrons and interaction of ions. Energetic particle interactions occur where the surfaces and interfaces of particles have a big area/volume ratio ($3r$), which is magnified profoundly at nanolevels 10^{-9}. More simply, surfaces (often only a molecule or two deep) offer more exposure for interaction than the inner and concentrated bulk of substances. Ergo, the fine particles floating in the air inside grain elevators or leather factories form a mist, and with one spark—pow! Similarly, aluminum milled to millimeters can be oxidized with power sufficient to fuel rockets.

The nanoworld is increasingly the focus of industries both small and large, as I learned on a day tour with onetime 3M technical director Tim Farrell and a visit to his friend Willie Hendrickson. Hendrickson, also a former 3M engineer, is the founder of a small Twin Cities firm, Aveka, which offers encapsulation and microencapsulation services.[27] Devoted to the interactions of particle interfaces (mixing of gases, liquids, and solids), Aveka focuses its work in surface chemistry on colloidal phenomena and colloids' bonding, joining, and encapsulation.[28] Industry in general is served by surface chemistry's interests in foams, liquids, solid aerosols, emulsions, paints, gels, suspensions (sols) such as ink and blood, and surfactants (active surface agents) that lower the tension within or between liquids, and accordingly are used in such products as detergents, wetting agents, emulsifiers, foaming agents, and dispersants. Solid, liquid, or gaseous colloidal solutions, associated with aerosols, emulsions, foams, dispersions, or hydrosols, are known in the vernacular as fogs, mists, and smokes. Liquid drops and solid particles are found in ordinary paints, mud, curds, lubricants, jellies, and glasses. Polymeric aggregates of microcosms are pervasive biofilms that coat the surfaces of ponds, teeth, factories, and hospitals with slime. Everyday colloids are found in soaps, liquid crystals, blood corpuscles in serum, and synthetic intravenous fluid expanders and replacements. With both a sublime and vulgar side, colloids marry upward to iridescent pearls, nacres, and rubies, yet also slum on the dark side with molds, scum, slimes, crusts, slicks, and scabs.

With some analogy to colloids, crystals (found not just in bedrock, but throughout nature, even at atomic—and iconic—levels) reveal a dazzling array of forms and account for the structure of solids. If they are no longer taken as evidence that God created the world's forms, crystals are still, for chemists, epiphanies of molecules. Surely contemporary chemists, showing some affinity to their alchemist ancestors, seek in crystals the secret recipes of interactions and structured forms. (Just fifty years ago, as my chemist friend Edward Carberry pointed out to me, simply identifying the molecular structure of a single crystal would win one a Ph.D. Today one can crack a crystal's "code" with a good afternoon's work—a measure of contemporary science's advancement in understanding the invisible faces and forms of small chemistry).[29]

POLYMERS' CREATION: NEW AND PLASTIC FACES

Polymers form the first narrative of inner engineering and design. The icon of chemistry's conjuring, polymer chains link inward delving and outward transformation. Polymers make outer faces that are great and small, bent and straight, and transparent, translucent, and opaque. They also produce an ugly tale of waste and pollution—"a toxic love story," to quote the subtitle of Susan Freinkel's book *Plastics*.[30]

Like the materials used by early potters, cooks, and sculptors of the earth, plastic permitted humans to shape the small and the common into the useful and the magical. Plastic makers too gather and mix select grains of soil, mud, and sand into new substances, and with crafty fire they fashion strong, smooth, light, waterproof, diversely shaped, and beautiful objects. Just as Chinese porcelain first appeared in Europe's royal kilns and prompted the ceramic revolution of early modern Europe, so polymers, two and half centuries later, set contemporary democratic and commercial agendas for research, design, and manufacture.[31] Plastics manifested a new order of democratic abundance and taste.

Plastics are composed from a range of synthetic or semisynthetic materials: polymers, which are macromolecules of high molar mass and repeating structures (the latter can be crystalline in liquids and solids). Plastics, their name derived from the Greek word *plastikos* because they can be molded or shaped, first appeared in the nineteenth century in natural forms, such as chewing gum and shellac, and in chemically modified natural materials such as nitrocellulose, rubber, and Bakelite. Rubber, an elastic hydrocarbon

polymer, was found as a natural colloidal suspension in the sap of some plants. Vulcanized in 1839 by Charles Goodyear, rubber was indispensable to the dramatically expanding rolling dominion of the wheel over the flat, paved surfaces of roads and highways.[32]

Rubber was a transformed polymer, but Bakelite was a true synthetic polymer. Invented at the start of the twentieth century as a cheap substance used to coat the outside of wires, Bakelite was found by its inventor, Leo Hendrik Baekeland, to have additional desirable properties: it was inexpensive, strong, and durable. Soon polymorphic Bakelite appeared in molded cases for radios, telephones, and clocks and in telegraph operators' transmission pads and keys—and it also composed dense, round billiard balls that rolled nearly flawlessly over the improved surfaces of felt-covered, slate-topped tables.

Starting in the 1920s, a long string of polymers were synthesized from coal tar and later petrochemicals, and they took over all sorts of everyday surfaces. Plastics, beginning with Lucite, vinyl, and Bakelite, proved the powers of chemistry by resurfacing our environments, goods, tools, and machines. After nylon had led the way in the 1930s—from legs up to parachutes down— its younger cousin Velcro, patented in 1955, put people and things under tight wraps, appearing in place of older hooks, loops, snaps, buckles, and zippers. Showing a vast array of diverse, even opposing properties, the polymer Teflon lined pots and pans so food would not stick to them, while polymer superglues and adhesives held tight all that could be joined surface to surface. Omnipresent polymers formed waterproof fabrics and covers, replacement parts in medicine, and the capsules of pills and spaceships. Plastics became the synthetic surface and artificial skin of our lives.

Silk, with its coveted properties of elasticity, strength, durability, refractivity, and more, has proven to be the equivalent of the magic golden thread that Rumpelstiltskin spun. Scientists still seek to synthesize novel forms of it for potential medical and surgical uses.[33] Among its first synthesized forms was nylon, invented by DuPont. The company first introduced it to the smiling world in 1938 in the form of toothbrush bristles. DuPont won a bigger smile in 1940 as nylon stockings rolled up women's legs: tight, transparent, and riveting, nylons provided suggestive and curving surfaces that riveted a nation on the eve of a great war. The long, slender, hairless, nylon-covered legs of movie star Betty Grable graced the nosecone of more than one crew's B-17. After the war, when the men came home and the women aimed to please, shortages of nylons literally provoked riots.

Other wartime recruits, such as polyethylene, acrylic, and Styrofoam, were demobilized with war's end. They found uses for it in packaging, cups, microwavable dishes, disposable diapers, and car parts. Another chemical prize, acrylonitrile, an acrylic backing for surfaces, covered playing fields with bristly, greener-than-green AstroTurf. DuPont, which had made explosives since the start of the nineteenth century and equipped the U.S. army in World War II with parachutes, tires, and other supplies, led democracy into peacetime with useful synthetic materials. Dating from 1965, Kevlar emerged as DuPont's second most important synthetic material after nylon. Extremely light, Kevlar is five times stronger than steel of the same weight. Versatile—it can be used as an inner or outer layer—Kevlar also reinforces the belting on tires, forms the core of bulletproof vests, covers and lines underwater cables, and strengthens brake linings, space vehicles, and parachutes. It forms an ideal interface for the smooth glide of skis, and fourteen-ply Kevlar laminates are ideal hulls for boats and canoes.

DuPont is but one company among thousands working with molecules to achieve, in the opinion of Philip Ball, "a seeming limitless variety of properties." Their successes include products with tensile strength comparable to that of steel; products that can dissolve in water or be eaten by microbes; products with electrical conductivity; ones that flex and contract like muscle; and others that dazzle the eye with rainbows of color and horizons of textures.[34] These illustrate, to quote Ball, an "explosion of interest in material science in recent years," a determination to work "at the molecular level to design properties useful at the engineering level"; and they are extraordinary materials that endow us with a capacity to control the growth of materials atom by atom and open possibilities for still more innovation in semiconductor microelectronics and in mimicking the structure of natural materials such as bone and shell.[35]

The chemical industry now produces seventy thousand different products, with polymers and plastics constituting about 80 percent of the industry's worldwide output. Rubber and plastic products, textiles, apparel, petroleum, refining, and pulp and paper production form the core of the nearly three-trillion-dollar worldwide enterprise (with the United States and the European Union housing the largest companies). Accounting for 33 percent of each earned industry dollar, polymer products have resurfaced the world and taken us into their embrace. Major applications for plastics include packaging and containers; home and commercial construction (including great varieties of indoor and outdoor flooring, siding, coverings, and linings); and

piping and hoses vital to the transport of air, water, and other liquids and to agricultural drainage. Crucial to all facets of transportation, plastic forms the interiors of cars, planes, ships, and trains. Polymers are also used in paper, inks, tapes, signs, and other materials that form the colorful, changing, and instructive face of industrial society. In a longer essay, I would add to this list by offering a snapshot of Minnesota's own 3M (and its fifty thousand products), whose hundred-year production has traveled from sandpapers and abrasives to masking tape, Scotch tape, sound-recording tape, reflective signage, Post-It notes, and Thinsulate, a web of fine polymer fibers that reduces heat flow and allows moisture transmission, making it ideal for insulation in jackets, gloves, and camping and hunting clothing. 3M also designed Neil Armstrong's signature boot soles, which left those first, unforgettable lunar footprints, linking the face of the earth and the surface of the moon.

Plastics provide the surfaces that pervade advanced contemporary life. They supply the carpets and rugs on which society treads. They fill racks of clothes and compose boots and shoes. In sporting stores, they are the materials of canoes, duck boats, and tents, and give new forms to composite bows, fishing poles, lures, and even tackle cases. Ten percent of the industry is medical: plastics supply hospitals with such humble creations as IV bags, tubing, syringes, diapers, surgical covers, and bedpans. They also fill more ennobling roles in the construction of dialysis machines, incubators, synthetic arteries, and plastic hips, knees, and hearts. And, as science writer Susan Freinkel writes, "Plastic scaffolding is used to grow new skin and tissues; plastic implants change our shapes, and plastic surgery is no longer just a metaphor."[36]

Yet nothing so revolutionary can be entirely benign. Plastics litter oceans, inland waters, and landscapes and choke entire environments with new, impermeable, and nondegradable materials. The scarlet letter of a throwaway economy stands for the sins of self-contamination and the degradation of the earth. There is also the dread that the oil from which plastics are made will doom sealife—and that our discarded plastic trash will shadow the earth.

"BUBBLE AND DOUBLE TROUBLE"

In the past two decades, nanotechnology has set its eyes on the repair of cells and the installation of miniature therapeutic machines within the body. The proposition that cells themselves are molecular structures and machines composed of proteins, lipids, carbohydrates, nucleic acids,

and other molecules, has already led one researcher to declare that all biology is nanotechnology—biology itself knows, engineers, and defines the small.[37]

Our age is stamped by the double helix of DNA. It has imprinted our times almost as powerfully as the mushroom cloud of the atomic bomb did the mid-twentieth century. The helix icon peers out from the depths every time a crime is resolved on the basis of DNA identification; it describes early humans of two million years ago; it dates termites' origins to twenty-five million years ago. On the basis of DNA, companies can now obtain patents on microbes such as those (developed in 1972) that gobble up oil spills. And stunningly, in 1997, the world was introduced to Dolly, a lamb cloned from a specialized cell from a six-year-old ewe. After this first successful cloning of a mammal, human imagination—quickly followed by a host of institutions—began to dream of engineering the parts and the whole of life itself.

Since biology married chemistry a half century ago, medicine too has entered the sciences of surfaces and synthetic materials. With plant and animal cells and transplanted and artificial organs, biomedical engineering has enabled transformative medicine.[38] It has provided instruments and computers that monitor all facets of somatic activities; and it lights up the interior of the body to guide surgery.[39] Medical engineering has afforded us materials and devices to repair, structure, and replace skin, bone, nerves, and even some organs. And it now promises, through the manipulation of stem cells, to someday grow, harvest, and implant any other tissue, structure, or organ that is medically vital or cosmetically desirable for a long and wholesome life.[40]

I wrote to my friend, writer William Hoffman, about my questions on stem cell research as a kind of inquiry into sets of interacting surfaces. Bill responded:

> The key is the cell membrane, a well-organized bilayer of lipids (self-assembled fat molecules that enclose all the constituents of the cell. Think of the outer layer of a bilayer membrane as constituting a surface in contact with the extracellular environment). Molecules come into contact with the cell's outer surface, transmitting signals into the cell through cell-surface receptors. Some molecules are allowed entry into the cell through endocytosis (invagination). Ions (e.g., calcium) are exchanged through the cell membrane. Signaling molecules inside the cell may exit through the membrane and enter the extracellular environment.[41]

In the specific case of stem cells, he continued,

> cell differentiation, development, and self-renewal programs are utterly
> dependent on signals moving from the cell nucleus to the cytoplasm and
> from the cytoplasm through the cell membrane to the extracellular space.
> Cell-surface receptors are like traffic cops.... Without the appropriate
> signals entering and exiting the stem cell, it does not know whether to self-
> renew (make self-copies) or to differentiate into a special cell type—say, an
> eye cell or a skin cell or a kidney cell (in the case of the embryonic stem cell)—
> or to migrate to the site of a wound or injury and begin the repair process (in
> the case of the adult stem cell). In sum, it is very difficult to visualize how
> stem cells differentiate into specialized tissues without taking into account
> the role of surfaces—membranes, cell-surface receptors to regulate inter- and
> intracellular signaling, and the stem cell niche, the microenvironment in
> which stem cells reside. All this implies productive microsurfaces.[42]

Nascent stem cell science, which grows by leaps and bounds each year, has
not learned to manufacture a stem cell, or any other cell, from scratch, but
synthetic biologists already have begun to examine cells as complicated
circuits that differentiate themselves by throwing "switches, mastery of
which would be a very big deal."[43] Subsequent to our discussion, the 2012
Nobel Prize in medicine honored John B. Gurdon and Shinya Yamanaka for
their discovery that mature cells can be reprogrammed to become pluripo-
tent; that is, specialized cells can be reprogrammed to become immature cells
capable of developing into all tissues of the body. After writing his *Stem Cell
Dilemma*, Hoffman further conjectured that in our capacity to throw the
switch of genetic development lie the secrets of human immunity, as well as
the threat of biological bombs such as new plagues and influenzas.[44]

Physics, in some worried imaginations, conjures up images of chthonic,
clandestine laboratories; chemistry, fantasies of gurgling Etnas; and biology,
cauldrons of wicked brews. Molecular pots, with all their abundance and
cherished bounty, maliciously spill over. Atoms split and fuse. Polymers
propagate across and pervade the world. Plants and animals belong only to
genetic sequences and human design. And, in fact, there is reason to tremble
at such bubbling dreams.

Other sets of questions, which we will take up in the conclusion,
whirl about: Has not cunning and artifice entrapped contemporary
humanity—imprisoned it in a shell, leaving us at arm's length and mind's
remote abstraction from nature? Do not contemporary humans lose the
powers of their own myriad surfaces—their earthly body, eyes, hands, and

immediate embrace of things—in this new world? Or, to try another set of provocative metaphors, has not the making of surfaces and objects encircled humans in a new labyrinth? Are not its walls higher and yet less visible than any in the past? From which pockets will humans fumble out saving string and wind-lifting feathers in time to free us from the abhorrent Minotaur? How do we reconcile the proud towers we erect with the sinkholes that appear at our garden's walls? Which metaphors will lift us free of our own works?

CONCLUSION

Encapsulations

> Man, the "king of creation," manipulates the rest of his creation
> for his benefit, the pinnacle of biological evolution, "master and
> possessor" of the other biological orders, who has multiplied the
> species that he has domesticated and decimated those which
> have remained wild, drawing energy from inert matter, over-
> turning whole landscapes and transforming the planet—this
> is our portrait of ourselves at the end of the twentieth century,
> when abuse of our privileges has begun to stir disquiet.
>
> JACQUES CAUVIN, *The Birth of the Gods and the*
> *Origins of Agriculture*

We can examine this stirring disquiet in the light of the history of surfaces
and contemporary society's ever-expanding design, production, and creation
of encapsulating surfaces. Humans become in body and mind the surfaces
they acknowledge and make, as I've argued. Now we can turn our atten-
tion to three questions. Are humans, in some elemental way, losing contact
with nature and local community, and, if so, what are the material and
intellectual implication of this loss? What are the possible meanings of
human encapsulation in manufactured and designed landscapes and things?
Third—drawing on Jacques Ellul, the contemporary French sociologist and
Christian theologian—are mass-produced and manipulated surface images
diminishing—crowding out and strangling—language, and thus depriving
the contemporary person of his footing in being and the reach of metaphor?

I conclude in a voice so far unexercised in this book. I ask the reader to
confess to being a set of surfaces—bodily experienced, socially instituted,
and mentally incorporated—living in a world of surfaces. Indeed, it is
through this living connection—this incarnate interface—that a person
enters by birth into a joyous epiphany of myriad real and signaling surfaces. I
also urge an acknowledgment that surfaces (as given by nature, presented by
flesh, designed by mind, and crafted by hand) can be for awakened spirits and
alert minds wonderful surprises of presentation and juxtaposition. All this

requires a recognition that surfaces, at least in their foundational relations to body and mind, are anything but superficial. On a less ecstatic plane, humans ordinarily live in and among a senseless jumble of surfaces as a matter of necessity and a basic condition. They have no choice but to perceive, think, and express themselves through surfaces. Among many other things, surfaces are the face and interface of pleasure, work, and society; surfaces compose the texture and horizon of extraordinary ordinary days and lives. They are the skin of love, the wrappings of earthly days, and the golden thread of heavenly dreams.

Surfaces cannot be inventoried. Surely they approach the infinite. They exceed the grains of sand on all beaches, all droplets of the ocean, and all interfaces of atoms and molecules, for each surface has numerous sides and forms. Who can count autumn's falling leaves? Not even Archimedes could calculate real and imagined surfaces.

Surfaces emerge, take form, and vanish. They accompany the feel of freshly laundered sheets, the touch of skin, the erratic fall of hail, a rough scrape against the sand particles in cement, a scab that won't heal, and the thudding bump of two lovers' hips. Then, too, juxtapositions appear between surfaces, each one the advance and retreat of a wave of being. Surfaces catch eyes, excite hands, signal fresh combinations and potential happenings. And forests of activating neurons shape brains. As I have suggested throughout this work, surfaces are a many-tongued revelation; they decorate, represent, and argue about the meaning of things. Catch an image of Che Guevara tucked away in a corner of an exclusive jewelry shop in an upper-middle-class shopping mall, and you'll find yourself pondering the migrations and convergences of images, meanings, and self-selected illusions.[1] Surfaces can stimulate the rendering of blatant and tacit forms, and they still portend—as they did for tellers and repeaters of superstitions—fates and fortunes. In *Moon Palace,* surfaces disorient Paul Auster:

> A fire hydrant, a taxicab, a rush of steam pouring up from the pavement— they were deeply familiar to me, and I felt I knew them by heart. But that did not take into account the mutability of those things, the way they changed according to force and angle of light, the way their aspect could be altered by what was happening around them.... Everything was constantly in flux, and though two bricks in a wall might strongly resemble each other, they could never be construed as identical. More to the point, the same brick was never the same. It was wearing out.... All inanimate things were disintegrating, all living things were dying. My head would start to throb

whenever I thought of this, imagining the furious and hectic motions of molecules, the unceasing explosions of matter, the collisions, the chaos boiling under the surface of things.[2]

There is no periodic table of surfaces. As we saw in chapter 8, they do not simply rest on a fixed number of positive and negative electrons or a single, predictable chain reaction. There is no way to model their infinity and variety. They belong to the sum of all visible and invisible nature, all that is made and built; or, more to my way of thinking, they include light, sight, touch, dimples, contours, and perspectives. Surfaces belong to and define the air, liquids, raindrops, and ice crystals that fill the skies; the water, with its resonating depth and wind-ruffled, reflective surface; and the earth, with its plants and animals. And surfaces also include the faces of the planets, the burning cores of stars, and all the translucent and transparent surfaces that serve as doors in and out of the world around us. In the gaps of surfaces lies surprise. Interfaces join and separate things everywhere; rocks and minerals are earth-defining and tell the planet's story through the granite and basalt left behind by great cataclysms. Feathers, scales, fins, leaves, skin, eyes, and all other living surfaces are alert to movements. From still and time-bred beauty, unexpected chaos arises; and soft eyes instantly mutate, beaming terror.

To restate the first part of this work, humans—sensate and active creatures—belong to active and reactive interfaces as a matter of our evolution and our deepest historical development. Our body, skin, nerves, eyes, brain, feet, arms, and hands, all of them differentiated and integrated sets of surfaces, signal and are alert to perceived, conceived, real, emerging, and even potential surfaces. Surfaces are the keyboards on which creatures play.

Interior and exterior surfaces, a relation explored in chapter 1, reveal and send the impulses that develop and integrate our nervous system and brain into a receiving and transmitting unit. Surfaces are broadcast as our senses encrypt and relay an array of messages—strong and weak, mixed and singular, blurred and sharply delineated—about conditions, situations, and reactions occurring within and outside the body. Monitoring the body's internal functions and reactions, surfaces indicate the body's position and engagement with single and multiple things and conditions. Perceptions, which occur in no strict or mechanical order, especially not in advanced animals with elaborate nervous systems, are multiple and do not automatically afford us conceptions, which solicit, combine, and juxtapose additional observations, images, ideas, and conjectures.

Human consciousness itself arose out of the interplay of body, skin, senses, eyes, and hands on the piano of surfaces. Surfaces, and their interfaces and interactions, are a first source of similarities and differences, analogies and metaphors. Social animals that humans are, our countenance, posture, and gestures declare and mask messages. On this count, a mother's touch, a nest's softness, a stone's weight and sharp edge, or a neighbor's angry gesture defines the elemental borders, conditions, and dispositions by which humans experience and understand life and ourselves. Over time, as human society developed, objects, tools, covers, and containers also structured and communicated relations.

Surfaces are the primary workshops of infancy. A child's early activities include standing things up and swatting them down; shaking, hugging, biting, and pinching the family cat; and smearing and scattering food. Surfaces come to form a lexicon of living and dead, moving and still, fresh and stale, friendly and inimical. They form in the adult an automatic, continuous conversation between the outside and inside of life. In the countryside, the child who grows up to become a farmer knows by heart the slope of his land, the tilth of his soil, and the rise and fall of his groundwater.

As we discussed in chapters 2 and 3, over two million years ago, early humans, with their feet differentiated from their hands, utilizing found tools, and making specialized ones, extended their reach, touch, power, and control over their environments (though they did so over vast periods of time and in diverse ways across various cultures). As early as forty thousand years ago, Neanderthals, or possibly Europe's early *Homo sapiens,* as suggested by recent finds at the Spanish cave Il Castillo, made artful and symbolic measures of and rituals regarding their place in being.[3] In the Holocene era (which began with the retreat of the glaciers approximately twelve thousand years ago and encompasses the present day), humanity, first in the Near East and then in Europe, Asia, and elsewhere, transformed itself into a self-making creature. This linkage of deep history to the present drives the advance of humanity as a knower and maker of surfaces and as a self-conscious, self-directing, and self-designing animal.

In a veritable explosion lasting three or four thousand years, humanity, ever more populous, established permanent settlements, initiated agriculture, and ordered our communities. Wherever this occurred, humans transformed the surfaces within which we lived and traveled into homes, fields, villages, cities, and civilizations. This increasingly domesticated world was composed and wore the face of built, planned, decorated, and symbolic things. Increasingly, humans came to know and classify the world in terms

of organic and made, and we built our understanding through analogies and metaphors drawn from our tools and containers and the walls, fields, ships, houses, villages, temples, and cities in which we encompassed ourselves.

Mastery over multifaceted surfaces on a large scale arrived and advanced in the early civilizations of the Near East, Far East, and the Mediterranean. We built objects, constructed structures, organized natural and human landscapes, and studied the movements of the skies. In our discussion of representation and decoration, the subject of chapter 4, humans were seen to have perennially decorated the surfaces of our tools, containers, and structures. We utilized color, light, texture, proportion, and symmetry, each of which embodies and resonates with beauty. At the same time, surfaces represented cultural, social, and political orders. We delineated articulated symbols and styled icons; and we carried and conveyed signs, numbers, languages, and writing surfaces that afforded polyvalent meanings.

Civilizations further organized surfaces of structures, tools, containers, and objects through specialized crafts and increased manufacture. For the sake of local and distant markets, we scored surfaces to make them into instruments used in sea and land travel and devices used for quantification and measurement. We assured validity and trust by using special marks, seals, and coins. We inscribed images and symbols to display ownership, and we learned to construct walls, gardens, and temples in straight lines, curves, grids, and other geometric shapes. On a far more abstract level, surfaces held decorative and representative symbols, signs, icons, names, ideas, and codes expressing the secret, hidden, or lasting essence of things. As exemplified in the Old Testament, texts pointed toward the God no man can see and live; or, to use the echoing words of the New Testament, writing recorded faith in a being "no eye has seen, nor ear heard, nor human heart conceived."[4]

Having introduced early civilizations and Greece, we chronologically narrated and selectively demonstrated the advancing, though not direct or linear, progress of the knowledge, control, and use of surfaces in western civilization from the Middle Ages and the Renaissance to modern Europe and the contemporary West. Finally we examined twentieth-century science and technology's deep descent into the atomic world. Humans have begun at an incredible rate to encapsulate ourselves in artificial worlds, made environments, synthetic materials, manufactured and designed objects, engineered structures, organized societies, and regulated lives. We live in the penumbra of self-generated images and assertive ideologies, which shadow the natural and traditional world of our eyes, senses, and hands.

In my dreams, I hear eighth-millennium B.C. hunters indicting sedentary, village- and city-controlled farmers as weak, regimented, and enchained. Indeed, throughout the nineteenth and early twentieth centuries, complaints about the eclipse of crafts were common. Large-scale production, industrial manufacturing, and government- and capital-driven economies built walls between hands and eyes and nature and materials. The time doomed singular works and unique creations, and deracinated craftsmen from place, tradition, and guild. I hear this complaint voiced, though modified and refined, by the Catholic thinker Romano Guardini in a 1920s letter about the lost craft of sailing:

> Take a sailing vessel on Lake Como. Though it is of considerable weight, the masses of wood and linen, along with the wind, combine so perfectly that it has become light. When it sails before the wind my heart laughs to see how something of this sort has become so light and bright of itself by reason of its perfect form. . . . Those who control this ship are still very closely related to wind and waves. . . . We have here real culture—elevation above nature, yet decisive nearness to it. We are still in a vital way body, but we are shot through with mind and spirit. . . . However, each new machine means that something we previously mastered with the help of our organic intellectual equipment is now left to a technical construct. . . . This means release—we are freed. But it means also that we have lost a possibility of creating, of experiencing the world, and of self-development. So long as we had only sailing ships, sea journeys were often dangerous, but they also brought to life the enhancement that goes along with risk.[5]

Spanish philosopher José Ortega y Gasset issues a similar but more generalized complaint in his 1930 *Revolt of the Masses*. Mass production, he contends, transformed modern society and mind. Moreover, it produced a new social entity, *the masses*. According to Ortega's view, the masses took themselves and the world to be the fulfillment of the past and the necessary measure of the future. In more concrete terms, according to Ortega y Gasset, the masses lived and thought based on the assumption that the freedom they had, the benefits they enjoyed, and the automobiles they drove were not the fruit of struggle and genius, but were progress's certain and irrevocable benefaction to them. In his 1941 *History as a System,* Ortega y Gasset deepens his analysis. Modern society, he contends, transfigured human relations to nature with networks of machines and social and regulatory organizations. And in doing

this, it afforded man a "new and artificial nature" in life and thought. Man now lives by the presumption that "aspirins and automobiles grow on trees like apples."[6]

Rather than assign an engulfing cultural malignancy to the masses (who have been held responsible both for tearing down Rome from within its walls and composing the great mob that erupted through the surface of political life with the French Revolution), why not place blame elsewhere? What of commercial, technocratic, and political elites whose arrogant projects and belief in progress transgressed the boundaries of nature and removed the axis of life from the "commons," tradition, and locality? Perhaps a deeper etiology of this transgression is found among we humans who, as Cauvin states in this conclusion's epigraph, have taken ourselves since the end of the ice ages to be kings of creation.

Humans, I argue, take ourselves to *be* the instruments we utilize and think with—the cars we drive, the books we read, the movies we see, the surfaces we dwell among and act through. We are the landscapes we farm, the animals we domesticate, the plants we grow, the villages we build, and the buildings and temples we erect. Here on the prairie where I live, for instance, people drive across the midwestern grid, which was laid out square mile by square mile: 640 acres, quarters of 160 acres, and quarters of quarters of 40 acres (the latter filled the landless poor with great hope for a century). We locate ourselves on intersecting roads, which most often were constructed to follow the railroads through horizontal monocultures of corn and soybeans. Farmsteads, though ever diminishing in number, are huddled behind and encircled in groves, and the vertical thrust of grain elevators and water towers means a town is nearby. Here and there, at least in southwestern Minnesota, rivers born of retreating glaciers and the draining of great lakes cut deep valleys in the shadows of the huge land mass of Buffalo Ridge, known as the Coteau des Prairies.

Built landscapes and architectural structures express, gather, and embrace lives and memories. The fold and warp of built spaces form the protective outer covering and enclosing inner surfaces of our everyday lives. Houses, schools, and churches are distinguishing canisters of both private and public existence. Furthermore, organized spaces and places and built things, all presenting themselves through surfaces, shape perceptions, state conceptions, stimulate memories, and even generate dreams. Distinguishing private from public spaces, they channel movement and invite social exchanges. They are subject to cleaning and health regimes. However, built and constructed

surfaces, which fashion perspectives and focus attention, do more than partition lives, establish routines, and form a familiar environment: they decorate and represent, and they bear signs and enunciate symbols to communicate class and privilege, law and authority. Increasingly, bountiful artificial surfaces encircle bodies, encapsulate lives, and engulf minds.

AN INVENTORY OF SELVES AND SURFACES

Modern society progressively remade the world's macro- and microsurfaces. Agricultural, demographic, industrial, capitalist, urban, democratic, and national revolutions transfigured the surfaces of both localities and the world at large. Humans mapped and explored the polar caps; we settled and exploited jungles, forests, grasslands, and wetlands. We colonized, annexed, and exiled the diverse peoples of the continents. Entire ecological zones and regions were transformed, and fields, plants, animals, and rural villages vanished. Cities projected new lines and grids of transportation, communication, centralization, systematization, and regimentation. Factories spewed smoke and noise across the landscape and proposed new models of organization. They also offered a wealth of goods and the promise of work and wages. Rural peoples—poor, dispossessed, at wit's end in an economy requiring money, and with ambitions unsatisfied at home—flocked to the factories. In the 1800s, towns grew, some of them into cities, and then doubled, tripled, or even grew tenfold in size—and first in the West and then across much of the world, life found new surfaces and put on new faces in these new towns.

By the nineteenth century's end, cities—the focus and vanguard of a humanity committed to making and doing and transforming the face of things—had turned on, distributed, and administered water and light. Concrete, iron, and steel bifurcated and transformed the city above and below the ground with transportation systems and redrew urban skylines with high-rise structures of steel and transparent glass. Paved streets and sidewalks enabled smooth walking, and glass windows and electric lights illuminated store windows and interiors and threw open the night to fun and frolicking. Here were new sets of surfaces, and thus places, experiences, and metaphors, for conjuring and redefining self, society, and humanity.

Western society put on a new mask and went to the ball. Its imitators, who eventually included the rest of the world, reluctantly, enthusiastically,

necessarily, or aggressively followed suit. Cities became stages for celebrations, spectacles, banquets, marches, and parades, and the middle class made them its palatial and gardened court. Through their dress, manners, and appearances, the middle class made bids for fame and glamour. They promenaded on boulevards, marched in parades, waved banners, and wore decorated uniforms. Etiquette, good dress, and cleanliness put a fresh face on social encounters. While school disciplined learning and factory regimented work, theaters, nightclubs, and sporting events provided outings—occasions for engaging in what the American social thinker Thorstein Veblen calls "conspicuous consumption." Surfaces were manifestations and revelations; looks and glances determined the truth of things. Ideas and styles were put on and taken off like coats and finger rings.

The dominance of nature, once assumed to impose permanent conditions and boundaries, dwindled. By the start of the twentieth century, nature had been reduced—it was a mere stage, frame, or horizon; a malleable substance in the hand; and a plentiful and varied resource for science and technology to explore, metamorphose, and utilize. Nature, wild and savage, was corralled in national parks, confined to reservations, and placed in zoos and botanical gardens, though it was still occasionally conscripted into a novel. The dramatic and cataclysmic aspects of nature, which shattered the surface of placid everyday life with the 1908 Messina earthquake and in 1912 split the *Titanic* and took it deep under, were relegated to the depths of the seas and heavens. In the academy, theorists promised accurate sciences of society, and on the streets, insurers believed they could statistically calculate irregular happenings. The surfaces of life and time were regulated, smoothed, washed, and swept.

But no calculation anticipated the sudden and violent destruction brought by the First World War. Organizing national and industrial states wrought a catastrophe that exceeded the ravages of nature and even those of the old wars of religion and the dynastic states. Yet the manifest works of peace and war made humans the central protagonists of meaning. And, as we saw in the last chapter, the momentum to know and make the surfaces of life continued. Government and society, industry and commerce, science and technology, physics and chemistry, biology and medicine did not relent, but pushed forward. The Second World War accelerated humans' progress toward becoming the architects, designers, and creators of surfaces; the makers of the world, things, and life; and the propagators of signs, signals, images, advertisements, and ideologies.

ENCAPSULATION À LA 1960

Events in the first half of the twentieth century did not disassemble belief in humans' capacity to create our world and ourselves to our own measure, beyond and even despite nature. The crushing global depression of the 1930s, obscene interwar statism, the awesome destruction of two world wars, and the reality and looming mental presence of the atomic bomb—none of that retracted humanity's self-affirmed covenant.

With the enhanced scientific and building capacity brought by the Second World War and the arms and space races, two shows of encapsulation captivated the attention of American culture in 1959 and 1961, which straddled my senior year at the University of Michigan. In a popular 1959 *Scientific American* essay called "Joey: A 'Mechanical Boy,'" Bruno Bettelheim told the story of a patient, a boy who couldn't do anything without having a machine mediate his most rudimentary bodily actions. For more than one cultural commentator, Joey was the symbol of future humanity. In April 1961, the iconic, short, and bubble-helmeted Russian astronaut Yuri Gagarin orbited the world in his encapsulating, constricted metal cocoon, *Vostok* I. With a 108-minute orbit and a safe return to Earth, Gagarin initiated an era of space conquest and dreams.

More mundane surfaces then gave rise to the sense that we belonged to encircling surfaces, walls, bubbles, and interfaces of human hand and design: rings of redundant suburbs, grids of parking lots and shopping malls, store windows filled with televisions all on the same channel, and hordes of cruising teenagers prowling favorite roads and stopping off at neon-lit haunts. In conjunction with urban roads and state highways, President Eisenhower cast an immense system of highways—and a real and cognitive net—across the nation. A succession of sociology books informed us that we were conformists—the businessman was an "organization man"; our goods had "built-in obsolescence"; and we were a "throw-away" society. Conditioned and shaped to be superficial—in gray flannel suits—we were hollowed out and filled with a plethora of mass-produced commercial and Hollywood images. We embodied Eliot's "Hollow Men"—to cite the opening lines of his 1925 poem: "Hollow men / . . . stuffed men / leaning together / headpiece filled with straw. Alas!" We had become St. Paul's "outward man," who, in the words of Corinthians 2, 4:16–17, wastes away, looking to visible and transient things.

German philosopher Martin Heidegger, who spent much of his writing time ensconced in a small three-room cabin in a wooded valley in the Black

Forest of southern Germany, offered a metaphysical definition of encapsulation: an engulfing and "pre-conditioning horizon of experience."[7] This horizon was now about electronic sight, information, and interconnections; the regulation and transformation of earth and water; the manipulation of weather; renewable and programmable bodies; and even the transfer of brains themselves. Contemporary historian of technology David Nye, who offers an excellent survey of real, imagined, and literary post–World War II fears of technology, inventories the "psychological effects of living within a technological society that wraps society in a cocoon of machines and conveniences":

> A child born since 1950 finds it "natural" to use electric light, to watch television, to ride in an automobile, and to use satellite-based communications.... In contrast [to earlier generations], the child unquestionably accepts these technical mediations of experiences as the pre-theoretical "horizon" of perception.... As the technical domain encroaches on or mediates all experience, it overtakes and delegitimizes both traditional society and older perceptions of the world. In place of familiar cycles of the everyday in a more direct relationship with nature, "technological character is concentrated in its liberating powers to be anything, that is, to be new, to never repeat itself."[8]

The threat of electronic transplantation of the perceiving eye to the screen and the enslavement of the hand to devices' screens and keyboards spreads and looms, and such interfaces have become another cocoon around the middle class and their children. People increasingly transmit and incorporate ourselves into external images to know and convey ourselves. With faces glued to screens and headphones plugged into ears, people become the artifice of manufactured appearances (phenomena) and instant supporting texts. The mind plays tag with the virtual. If we can see it, or at least envision it, in the real world, we lend it little attention or credence. The media, outward and superficial, weave the veils and spells of Circe. Meanings arrive wired to colorful and obediently designed images, bundled in controlling, enticing, and manipulating language.

In this condition, small, particular surfaces, things, and people go entirely unheard or must insert themselves into immense textures and contexts. The sources of mass society are great. They include, to mention a few, technological and scientific specialization; institutionalization; capitalism and its quest for resources, finance, manufacture, and sales; democracy as a condition of freedom and the accompanying demand for equality and goods; and the efficiency of the central state and its manifold bureaucrats and politicians

vying for attention and control. All of these conditions are spreading across the globe. As an example, contemporary China is equal to none in the speed and force of changes sweeping over it. With a government that is dictatorial, cruel, insidiously intrusive, controlling, and sternly centralizing, the country now explodes with more than two hundred cities of a million inhabitants each, all shadowed by mounting numbers of ghost towns and failed development zones. Cars multiply, force bikes off the road, and produce traffic jams sometimes measured in days. And, outscaling almost all historical measure, each decade another hundred million repressed Chinese peasants become a constitutionally unprotected, but hopefully prospering, entitled middle class.

A different tyranny now rules almost everywhere on earth, whether openly or covertly. It now takes a machine to correct and monitor a machine, as anyone knows who has fallen afoul of state-run computers such as those of the IRS or lost his plastic identity to a distant electronic pickpocket. Only the technical can remedy the technical; specialists in the employ of banks, insurance companies, government, and the law drive citizens to electronic and paper drudgery. Society places an abstract face on most things and interactions, and thus the contemporary world becomes an abstraction of relations and a complexity of means. The momentum of manufacture, design, commerce, and government rules increases. Today prescribes our collective tomorrows. Locality is increasingly experienced and lived through specialized laws and industries. The perimeter, as place, thing, and surface, is held ever tighter by and drawn ever deeper into the vortex of the epicenter, like a hollowed-out dark star. The surfaces we read are the pages that governments, politicians, and corporations write. Singular, traditional, and local surfaces belong—by materials, function, and images—to megamachines and cyclopean systems. So our bodies in the harness of our minds and our minds in the embrace of our bodies are encapsulated in standardized goods, systematized work, and official nations. Somehow, all of us live in the house that Jack built.

Surfaces, slowly and pervasively, though surely not linearly or progressively, have been taken into the industrial lexicons of hand and eye, the institutionalized wrapper of attitudes and ways, and the rhetorical folds of social, political, and intellectual languages. Surfaces, though not necessarily or universally turned into imprisoning grids, do form an interlocking set of contexts, signals, signs, and metaphors that channel and routinize emotion, thought, and imagination. Great makers—those of bold reach and brilliant design—enshroud life in materials, things, images, and idealizations of creation—and political slogans claim to announce fresh and open fields.

The most chilling fictional dystopia of the last half of the twentieth century, at least for me, was not the social tyranny of *1984* or the more sinister, controlling psychic control of *Brave New World*. Rather, it was Erick Seidenberg's 1950 *Post-Historic Man*. He describes a time-freezing encapsulation of all life within the walls of built and regulated space and society. He suggests such a thorough and systematic organization of surfaces and space that surprise is squeezed out of happening, events are denied a place in time, and change is taken from life itself. Perfect predictability forbids freedom, tragedy, and hence human experience itself.

Such a conception of the encapsulation and death of time resonated in concurrent analyses suggesting the death of communal and human space. Global rule has tilted the balance to the side of "the idolatry of giantism," to borrow a phrase from E. F. Schumacher's *Small Is Beautiful*.[9] Humanity, the older Lewis Mumford prophesies, has a rendezvous with its own constricting technology and with its expanding "megacities"—with, in fact, its own "necropolis."[10]

THE WORD ON THE CROSS OF IMAGE

A generation younger than Mumford, the French Protestant intellectual Jacques Ellul (born in 1912) directs his own dystopian tract in a different way. His concern is the death of the word on the cross of images. He suffers the loss of the vitality of the word in a world that swarms with images in the service of sensuality, power, production, commerce, and ideologies. (In effect, he means images of kitsch, which is alien to beauty, art, transcendence, and a living community.)[11] In his 1954 *La Technique* (published in English to considerable fanfare as *The Technological Society* in 1964), Ellul conceives of encapsulation (at least in its most constricting and suffocating form) as a state of mind; that is, mental bondage to *la technique*. Not a machine or instrument, *la technique* is a condition of spirit and a predisposition toward action.[12] He identifies it more precisely as a reflexive predilection of those in control to formulate the entirety of all being as a matter of numbers, machines, and processes.

In a subsequent work, *La Parole humiliée* (1981), Ellul addresses the limited reach of eye and hand.[13] He argues—I would contend, of course, ahistorically and without regard for how the depth of being and experience are embedded in the forms of nature and life—that sight and space, born of eye

and hand, cannot displace the fruits of mouth and ear, for they conduct conversations about being, about what is and is not. He dedicates his attention to words, the power of language, and the truth of meaning. A critic of the contemporary world, Ellul identifies and judges the oppressive, enclosing, and tyrannical visual image, especially the surfeit of images provided by photography, film, art, television, and screens. In the service of commerce, ideologies, and power, these images encompass the mind, displace experience, and serve as a surrogate for thought, reflection, and deliberation. At the cost of the truth, the compelling power of images rests on the convincing associations they evince and the emotions they solicit. A thinker who serves the primacy of the biblical word and who has written against propaganda as a controlling agency of modern society, Ellul argues against the ersatz, artificial, and synthetic communication of images, while acknowledging that the prophetic and iconic power of biblical visions rests on eschatological revelations on the end of the earth and the fulfillment of time.

There remains a line of questioning that contradicts Ellul's contention that words are lost to contemporary imagery. Is not sensation born and developed around what I have called the epiphany of surfaces? Would not the denial of this source of experience deny contact with form and beauty and dry up language's source and its connective tissue of analogies and metaphors? What would be lost if words and wit had no foundation in the sensual interplay of body and world, and the forms and orders that exist between them?

Additionally, I surmise that a person who is detached from surfaces perceived and worked over eons cannot speak or analogize—not from the wood he whittles, the cane he weaves, or his daily contact with campfire, hearth, furnace, soils, fields, grasses, foxes, pheasants, stars, the moon, or his envious or gossiping neighbors. I believe that one of the greatest losses that peasants experience in the city is the surrender (which might occur over generations) of a concrete and tactile language for new and official languages of literacy, abstractions, systems, and rules. Storytellers go unheard; proverbs that speak of cows and bulls, snakes and birds, landowners and strangers are no longer repeated. The hand forgets the gardens and berry patches and no longer works the surfaces of wood, stone, and metal; the foot no longer follows the long and uneven trail or fords the boulder-filled rapids. The nature-imitating tongue falls silent. It now repeats what announcers and experts say. The person now talks in opinions, inventions, reports, and fancies.

Progress, some argue, completes the dulling work of the village. It steals not just eyes and wit but tongue. Parables based on common experience are

forgotten. The loss, in sum, is caused not only by mind-pilfering images but false, counterfeit, and clumsy abstract words. Without sensual, tactile, and tangible frames, language turns on a daily life and a media presentation that lack nature, tradition, and fleshy experience. Changes in products, the altered fortunes of the glamorous, repeated professional talk, and mass games fill up conversations. Life is no longer rooted in surfaces seen, lived, and handled. Rather, life increasingly belongs to the tools, images, and command of commanding distant worlds and images from afar.

Despite such leveling and integration, the world has not been smoothed, rounded, or turned into an egg that holds no surprises. The knowledge, control, and invention of surfaces—both made objects and built landscapes—which have surely advanced in the sixty years since Seidenberg wrote, have not yet mastered inner and outer space or even found a way to inventory the plethora of natural, made, interpreted, and imaged surfaces. And humanity, even in its most advanced points of knowledge and control, science and technology, has not captured time or walled out events. Events—whether natural or historical—still prove savage. They continue to elude the divisions and meanings we impose on life and society. War, terrorism, revolution, and economic collapse still loom; tsunamis, earthquakes, and ecocatastrophes still break the surface. And fear coils deep in our fretful minds and ripples through the surfaces surround us.

We do not exist in an unbroken egg. Events break shells. Time degrades wrappers. We are not subordinated to our goals; our actions veer, and right from the start we invariably fail to precisely design or fully calculate our plans. We have only thin prospectuses. However much we read one set of surfaces on one day, the following day will bring us another book of them to rifle through. Fresh orders—springs of human and natural happenings—break forth. The membranes of life are not static. Whole walls are pierced and come down, and their inhabitants seek other lands. Concentrations of energy and meanings, and disproportionate resources and disjunctive ideas, explode social, political, ideological, and even police-state encapsulations. And beyond their rings—and indeed, within the rings of expanding cities and control centers—shells are broken, pages are turned, and surfaces are scrambled, seen, and manipulated anew.

Although mind is born out of perceptions, conceptions, and images of surfaces, it is not circumscribed by them. Mind never limits itself to the covering face of things; nor does it reduce being to the dialectics of outside and inside or seen and made. As much as humans know and tame

the world with technology and administration of surfaces, the mind forever poses analogies and metaphors that hurtle beyond the immediate connections and correspondences of the sensual world as experienced and even as imagined. Mind speaks of heart, is leavened by hope, predicts and expects the unanticipated, and lives by time, which has no identifiable face or certain interface, but is the sum of all changing and interacting surfaces. And we learn over and over again that events surprise us. History eludes order. The explanation follows rather than precedes the happening. Truth resides below and beyond the surface, lurking and then revealing itself from the depths of time.

. . .

Only a conclusion remains. I have argued and narrated, starting with evolution and the deepest human history, that in knowing and making surfaces, humans across time and cultures have made ourselves at the same time that we made surfaces to express, represent, and create ourselves. This back-and-forth—mixing and joining the made and known worlds and selves with things, goods, perceptions, images, and ideas—proceeds with rising intensity in contemporary times. As the deepest history suggests, humans are a set of natural surfaces that self-assemble ourselves as lives and minds among a world of natural and made surfaces. This makes mind an interface among body and world, self, nature, and society, though it is not determined or circumscribed by them. Yet speculations falter before the meaning and implications of contemporary encapsulation in a being of our own definition, making, imagination, and administration. As much as contemporary society presumes to know and create itself, what is truth when it is torn from nature and tradition? Has humanity (to fumble and stumble with clumsy metaphors) deposited itself into a global labyrinth of our own creation and description? Are we enslaving ourselves by work and instinct in a growing ant's nest, as the nineteenth-century Russian reactionary Dostoevsky foresaw when he traveled in the West? Or, to offer a question proposed by the twentieth-century Jesuit paleontologist and evolutionist Teilhard de Chardin's *Phenomenon of Man* (1955), are humans devolving into hard-shelled, specialized, instinct-driven insects, which we primates surpassed in terms of size, plasticity of frame, play, and individual determination sixty million years ago? To invoke Teilhard's spiritual vision of the omega point, will we continue our spiritual ascent into consciousness, freedom, and love?[14]

To such prophecies, I can rely only on the earthly crutch of paradox. Surfaces are anything but superficial. Possessing all properties and attributes, surfaces belong to no single table of classification. They are individualities. They have, or can be given, collective names, but each, when considered in detail and with exactitude, fits no single category; nor can it be comprehended by its place in a graph. Like teeter-totters, surfaces move up and down—outside and inside, animate and inanimate, bright and shadowy, small and linearly distinct and great, looming, and airy. Natural and made, rock-solid and scaly, transparent and reflective, they signal and require differences, opposites, and polarities. They are touched and identified as things, objects, juxtapositions, and contexts seen, sensed, touched, picked up, handled, and even bitten. They are recognized and spoken of by the images they evoke, and so they become signs, icons, words, and metaphors of what they represent. They are stimulating; they evince and become one with appearance, and at the same time they offer the first and subtlest clues to and the sharpest evidence of being.

This acknowledgment of the presence, power, influence, and, in sum, the irreducible role of surfaces in life and experience squares with human embodiment in flesh and among things. For nonbelievers, who do not ambitiously or blindly look beyond themselves to locate divine rules, laws, or abstract ideas, surfaces are the face of reality and the food of experience and thought. Yet so too are they for believers, who find joy in believing that surfaces—such as the faces of St. Francis's Sun, Moon, and Death—carry the imprint of God's creation and constitute the skin of fleshy incarnation. And yet there is one thing more. I would have the reader, believer or nonbeliever, acknowledge that we humans are a living set of surfaces among a world of surfaces, and that surfaces are both the dull brown wrappers of life and also the gracing epiphanies of light, sense, and being.

Beyond this, I can only exhort readers who fear their encapsulation in political, social, and electronic labyrinths to take the world in hand and read deep in forgotten truths. Commit yourself to a rural community, a patch of woods, or an unobserved stretch of water, and make it your own Walden Pond. Collect seeds, as Thoreau did, and "defend the commons." Learn a craft, take up traditional tools, devote your attention to hidden mounds and crypts. Become an artist who can draw a line, or a lyric poet like Whitman, who celebrates the myriad faces of surfaces, catches the updraft of connecting and rising metaphors, and, like a surveying turkey buzzard, rides and hovers on tipping wings over the deep valley below.

And yet, if your day is anything like the lovely spring day on which I wrote this page, quit these words immediately and do what I did. Abandon your slumped crouch in your chair and the sticky surfaces of the page or screen and go out. Go out now, while your energy is full and your senses awake. Go into the teeth of the wind. Let your jacket flap and your hair blow. Observe the vegetation dressed in tender spring green. Scrutinize the black field for protruding tips of corn. Stop at the nearby river park. Listen to woodpeckers tapping on the hollow trunks, and echo them with your trudging steps as you cross the sturdy but loose-planked bridge. Then move cautiously along the riverbank. Mind your shadow as you search out the moving, gently bending tailfin of an elusive trout.

In your imagination, make a precise and careful cast, just to the threshold of the trout's dark hermitage of logs and boulders. Keep the tip of your pole up; hold your line firmly but gently. Treading your way home, with the wind at your back, dream of the trout you might have caught, and take consolation: You were out under a blue sky, on a bright, fresh day. You participated in spring's epiphany of surfaces. You refreshed your eye and hand. You learned again to talk and think about the world in terms of a gravel path, a river and a fish, a string and a current—and take these images to heart and commingle them with words and metaphors rising from streams of old books.

NOTES

PREFACE

1. Joseph Amato, *Dust: A History of the Small and Invisible* (Berkeley: University of California Press, 2000); idem, *On Foot: A History of Walking* (New York: New York University Press, 2004).

2. Gaston Bachelard, *The Poetics of Space: The Classic Look at How We Experience Intimate Places (La Poétique de l'espace)*, trans. Maria Jolas (Boston: Beacon, 1994 [1958]).

3. Milton Glaser, *Drawing Is Thinking* (New York: Overlook, 2008).

4. Clive Gamble, *Origins and Revolutions: Human Identity in Earliest Prehistory* (Cambridge: Cambridge University Press, 2007).

5. Thomas Campion (1567–1620), "Cherry-Ripe," in *The Oxford Book of English Verse, 1250–1900*, ed. Arthur Thomas Quiller-Couch (Oxford: Clarendon Press, 1904).

6. Roger Scruton, *The Face of God: The Gifford Lectures* (New York and London: Continuum, 2012).

INTRODUCTION. THE SURFACE IS WHERE THE ACTION IS

"The surface is where most the action is": American psychologist James J. Gibson, *The Ecological Approach to Visual Perception* (Boston: Houghton Mifflin, 1979), 23. This is also true on the molecular level, as is shown in chapter 8.

1. Ibid. An additional and useful article by James J. Gibson is "Pictures, Perspective, and Perception," *Daedalus* 89 (1960): 216–27.

2. Gibson, *The Ecological Approach,* 16–32, 303–06.

3. A physicist friend, Basil Washo, instructively offers these technical definitions of *made surfaces*: "A *surface* can be defined, at its simplest, as a 2-D, flat, discrete substrate of given materials of construction. Often found as repetitive units or small

'building blocks,' surfaces in this form have both a front and back, are comparatively thin (composed internally of materials in layers and striations and of a homogeneous or a heterogeneous composite mix), and are joined and strengthened by reinforcing elements and internal design." He adds similar definitions for *transformed surfaces,* which have been formed into three-dimensional structures with exposed interior and exterior surfaces; and *complex transformed surfaces,* which are today's multifaceted, multisurfaced architectural triumphs, the modern buildings and other urban structures that, based on a vast and accumulated repertoire of construction techniques and a rich inventory of natural and synthetic materials, form contemporary cityscapes and skylines (email, Basil Washo to the author, October 29, 2010).

4. For details on the great cleanup of urban areas, see Stephen Halliday, *The Great Stink of London: Sir Joseph Bazalgette and the Cleansing of the Victorian Capital* (Stroud: Sutton, 1999); and idem, *The Great Filth: The War against Disease* (Stroud: Sutton, 2007); Michael Welland, *Sand: The Never-Ending Story* (Berkeley: University of California Press, 2009); David Montgomery, *Dirt: The Erosion of Civilizations* (Berkeley: University of California Press, 2007); and Joseph Amato, *Dust: A History of the Small and Invisible* (Berkeley: University of California Press, 2000), 67–91.

5. On the industrialization of light, see Wolfgang Schivelbusch, *Disenchanted Night: The Industrialization of Light in the Nineteenth Century* (Berkeley: University of California Press, 1988).

6. Filippo Tommaso Marinetti, "Futurist Manifesto," in *Paths to the Present: Aspects of European Modernism from Romanticism to Existentialism,* ed. Eugen Weber (New York: Dodd, Mead, 1960). Originally published in *Le Figaro,* 1909.

7. Ariane Banke, review of Martin Kemp's *Seen/Unseen: Art, Science, and Intuition from Leonardo to the Hubble Telescope* (Oxford: Oxford University Press, 2006), in *Financial Times,* November 17, 2006.

8. Amato, *Dust,* 62.

1. WE ARE SURFACES AND SURFACES ARE US

1. A very informative book on the use of fossils to establish a chronology for and to trace the origins and development of humans is Ian Tattersall, *Masters of the Planet: The Search for Our Human Origins* (New York: Macmillan, 2012).

2. This approach could be identified as a type of empiricism not alien to Aristotle, Aquinas, or, to a degree, modern John Locke in that it contends that our knowledge is rooted in sensual experience. However, with this approach's accent on surfaces rather than sensations, it stresses the primacy of light, forms, and shapes rather than diverse and inchoate sense.

3. I don't believe that surfaces should be discarded from knowledge on the grounds that we perceive them with inchoate senses and as incoherent images. Nor do I wish them ignored in preference for such abstract and homogeneous theoretical

categories as space, time, and causality, which philosophers such as Descartes, Kant, and other rationalists consider to be the sources of the true, mathematical, and thus universal properties that underlie Euclidian geometry. At the same time, I cannot elevate surfaces and the material, natural, and human worlds they manifest to provide the substance, laws, and truths from which the common sense philosophers—most notably the eighteenth-century Scottish thinker Thomas Reid—derive the axioms of math and logic, and even the true principles of metaphysics, morals, and politics. Sympathetic to Aristotle and an advocate of William James's radical empiricism, Scott Phillip Segrest (*America and the Political Philosophy of Common Sense* [Columbia: University of Missouri Press, 2009]), writes affirmatively of the common sense school of thinking: "It takes space and time . . . to be not Kantian categories but real world relations" (149). For an introductory discussion of philosophers and space, see Roger Scruton, *Modern Philosophy* (New York: Penguin, 1994), 355–65. For a view of the reach of the common sense school and Reid, see Segrest, *America and the Political Philosophy of Common Sense,* 21–63]; Simon Blackburn, "Reid," in *The Oxford Dictionary of Philosophy* (Oxford: Oxford University Press, 1994), 324; and Frederick Copleston, *A History of Philosophy,* vol. 5, *Modern Philosophy: The British Philosophers,* part II, *Berkeley to Hume* (Garden City, NY: Image, 1964), 167–78.

4. For the Aristotle quotation, see Segrest, *America and the Political Philosophy of Common Sense.* Also, as noted in the chapter, I find myself in accord with other empirical philosophers' thinking, such as Reid's common sense philosophy, in which he contends that "the sensations of primary qualities of objects"—which I translate first and principally as surfaces perceived by the seeing eye and touching hand—"speak to us like words, affording us 'natural signs' of qualities of things. The mind passes naturally over word[s]," he continues, glossing over realms of complexity, "to consider directly the qualities they signify." Quoted in Blackburn, "Reid," *The Oxford Dictionary of Philosophy,* 324.

5. Illustration located in Ludwig Wittgenstein, *Philosophical Investigations* (New York: Macmillan, 1953), part 2, sec. 6, 194, 195.

6. In a three-part program on human evolution—*The Human Spark*—directed by Alan Alda and first aired on the Public Broadcasting System in January 2010—humans are shown, by their evolution and brain, and in comparison to their alleged ancestors of six million years ago (chimps, orangutans, rhesus monkeys, apes), to be distinctly different from those ancestors. Through laboratory tests, select scientists in the United States and Germany have shown that human children, in contrast to similarly aged chimps, immediately perceive the world as a set of surfaces and objects that pose problems to be solved. And both by imitation of others and by their own hands' movements, children learn that there can be either a single or multiple solutions. More notably, human children can grasp the general notion of weight based on the difference between heavy and light. In addition to such fundamental abilities to identify, find, combine, and use tools and language, humans, starting as children, collectively learn and cooperate in complex tasks.

In *See What I Am Saying: The Extraordinary Power of Our Five Senses* (New York: W. W. Norton, 2010), professor of psychology Lawrence D. Rosenblum

finds proof of the integrative powers of the mind in its ability to turn clues and sensations from one order of sensation to another. For example, the blind can "see" through "batlike echolocations"; pheromones subliminally signal and attest to lovers' compatibility; and people may hear things that don't make sound, feel things without touching them, smell things not present, and visualize things without form.

7. For a keen overview and history of skin, see Nina Jablonski, *Skin: A Natural History* (Berkeley: University of California Press, 2006); for an anatomical introduction, see Mike Edwards and Rona Mackie, "Skin," in *The Oxford Companion to the Body,* eds. Colin Blakemore and Sheila Jennett (Oxford: Oxford University Press, 2001), 623–25.

8. Pacinian corpuscles (nerve endings) sense pressure and vibration changes on the skin. Meissner's corpuscles, enclosed in a capsule of connective tissue, are located in the skin of the palms, soles, lips, eyelids, external genitals, and nipples and are responsive to light touch.

9. Graham Barnes, "Vestibular System," in *The Oxford Companion to the Body,* 711–12.

10. Our general orientation in space and among surfaces and things is supported by a range of senses tied up with proprioception. These senses are rooted in autonomic systems and deliver information to the parietal and temporal lobes from the muscles and joints and from skin and limb positions. At the same time, unimpaired autonomic motor reactions inform us about our position and movement in space and our exertion.

11. For an up-to-date summary of interpretations of bipedalism, see Tattersall, *Masters of the Planet,* 6–44. Emerging an estimated six to seven million years ago in early hominins in Africa, bipedalism freed hands from the ground, where they had been used for locomotion. Shaping the brain itself, the powerfully gripping hands and arms and the precise manipulating fingers picked up and examined things and made a variety of tools in order to alter the environment. At the same time, the upright posture of bipedal hominins, in comparison with quadruped animals, freed the brain from the dominance of the olfactory sense, allowing the head and the eyes to rotate freely and constantly switch focus between immediate things and distant horizons. For one introductory and conjectural discussion of bipedalism, see Joseph Amato, *On Foot: A History of Walking* (New York: New York University Press, 2004), 21–23, notes 4 and 5.

12. The crucial evolutionary development, involving the arrangement of muscles, bones, and joints, that allowed us the gripping movement is known as *opposition*— the ability to bring the thumb across to meet any of the four longer fingers. Sarah Goodfellow and Sheila Jennett, "Hands," in *The Oxford Companion to the Body,* 334.

13. Diane Ackerman, *A Natural History of the Senses* (New York: Vintage Books, 1991), especially 65–124.

14. Colin Blakemore, "Vision," in *The Oxford Companion to the Body,* 716–20.

15. Life goes with light. Even bacteria react to it. The eye itself, which may have evolved out of chemoreceptors and photosensitive cells, appeared first in the Cambrian era, but it has evolved fifty to one hundred times since. The eye adapts

and changes itself to serve the organism that bears it—hence the near-perfect and complex human eye comes out of a simply coated optic nerve. The most primitive eyes, eyespots, which are photoreceptor proteins, can decipher light but not shape or the direction of light. With the Cambrian explosion emerged eyes that recognized the direction of light and began to process images. For an introduction to the evolution of the eye, see Ivan R. Schwab, *Evolution's Witness* (Oxford: Oxford University Press, 2012).

16. More technically, visual perception focuses light on the retina, whose outer cones permit night vision, while central clustered rods decipher high acuity and color vision. "The optic nerve carries sensations via the thalamus to the cerebral cortex, where perception occurs, but it also delivers information to two sites in the brainstem" that respond to light intensity by alteration of the pupil and the movement of the eyes, which occurs as a short set of jumps—at a rate of thirty per minute—called saccades. Ashish Ranpura, "Brain Connection," http://brainconnection.positscience.com /topics/?main+anat/vision-work (accessed October 2012).

17. Paul Shepard, *Man in the Landscape: A Historic View of the Esthetics of Nature* (New York: Knopf, 1967); also of use for a discussion of how we see and look is John Berger, *About Looking* (New York: Pantheon, 1980); and idem, *Ways of Seeing* (New York: Penguin, 1972).

18. Shepard, *Man in the Landscape,* 7.

19. Ibid., 23.

20. For a searching but very short introduction to sources and definitions of the beautiful, see Roger Scruton, *Beauty* (Oxford: Oxford University Press, 2011).

21. Michael Welland, *On Sand* (Berkeley: University of California Press, 2008).

22. For a recent study of the transformation of select images into icons, see Martin Kemp, *Christ to Coke: How Image Becomes Icon* (Oxford: Oxford University Press, 2012); of interest in matters of perception and image is his *Seen and Unseen: Art, Science, and Intuition from Leonardo to the Hubble Telescope* (Oxford: Oxford University Press, 2006).

23. Of interest for the role of metaphors and prayer in the Old Testament is William P. Brown, *Seeing the Psalms: A Theology of Metaphor* (Louisville, KY: Westminister John Knox Press, 2002).

24. The idea of a hierarchy of being, so dependent on Plato's work, was articulated in Arthur O. Lovejoy's classic *The Great Chain of Being: A Study of the History of an Idea* (Cambridge, MA: Harvard University Press, 1936).

25. Ernst Cassirer, *An Essay on Man* (New Haven: Yale University Press, 1944), 77.

26. Joseph A. Amato, *Compass of Twos,* unpublished manuscript.

27. Christopher Alexander, *The Timeless Way of Building* (New York: Oxford University Press, 1979), 144.

28. Ibid., 145.

29. Mary Douglas, in *Purity and Danger: An Analysis of Concepts of Pollution and Taboo* (London: Routledge and Kegan Paul, 1966), identifies objects of taboo in the Old Testament, such as ostriches, mud puppies, and animals with cloven hooves.

30. The common mode of synecdoche (using a part to refer to the whole) makes evident the mind's powers to substitute and juxtapose. Using the word *plank* to mean a ship, *horse* to mean cavalry, *faces* to mean a whole crowd, or *rag* to mean dress illustrates the power of the mind to move from realm to realm. When we say he is not on the "high ground" but "rolling in the mud"—or "I'll take the high road, and you the low"—we cross realms of meaning. "When Aeschines says, belittling a character, that he changed not his disposition but his position," he practices paronomasia (punning) by tauntingly comparing a change in space with one in spirit. James Morwood, *The Oxford Grammar of Classical Greek* (Oxford: Oxford University Press, 2001), 239.

31. Ibid., 238.

32. The first mechanical or wind-up toys were made in Grecian times, but the art was revived by European clockmakers during the fifteenth century.

33. See Jonathan Miller, *The Body in Question* (London: Jonathan Cape, 1986); and R. B. Onians, *The Origins of European Thought: About the Body, the Mind, the Soul, the World, Time and Fate* (Cambridge: Cambridge University Press, 1988).

34. I first gave form to this approach in Joseph Amato, "A Superficial Evocation," *Historically Speaking* 10, no. 4 (September 2009): 2–4.

35. For a history of Fabergé eggs, see Toby Faber, *Fabergé Eggs: The Extraordinary Story of the Masterpieces That Outlived an Empire* (New York: Random House, 2008).

36. Matthew 10:26–27.

37. Horace, *Ars Poetica* (ca. 18 B.C.): "The role of art is to inform and delight."

38. Italo Calvino, *The Path to the Spiders' Nest,* rev. ed. (New York: HarperCollins, 2000), 31.

39. Joseph A. Amato, "A Crow on the Snow," illustrative unpublished poem written August 2010.

40. Thorlief Boman, *Hebrew Thought Compared with Greek* (New York: W. W. Norton, 1960), 85–91.

41. See especially chapter 4, "Bodies, Instruments and Containers," in Clive Gamble, *Origins and Revolutions: Human Identity in Earliest Prehistory* (Cambridge: Cambridge University Press, 2007), 87–110.

2. THE GRIP AND GRASP OF THINGS

1. Nicholas Humphrey, *A History of Mind: Evolution and the Birth of Consciousness* (New York: Copernicus, 1992).

2. For a thoughtful survey of the central role of genetics in discussions of evolutionary developmental biology, see Sean Carroll, *Endless Forms Most Beautiful* (London: W. W. Norton, 2005), especially 10–14. For arguments suggesting that an animal's activity can shape its environment, its adaptation, and the gene selection of its descendants likely to carry on that activity in the future, see literature about Baldwinian evolution: J. Mark Baldwin, "A New Factor in Evolution," *American*

Naturalist 30, no. 354 (June 1996); 441–51; and Daniel Dennett, "The Baldwin Effect: A Crane, Not a Skyhook," in Bruce H. Weber and David J. Depew, eds., *Evolution and Learning: The Baldwin Effect Reconsidered* Cambridge, MA: MIT Press, 2003), 69–106. For a recent application of Baldwinian evolution to toolmaking, language, and underlying genetic dispositions that favor the expansion of the forebrain and the cerebral cortex, see Christine Kenneally, *The First Word: The Search for the Origins of Language* (New York: W. W. Norton, 2007), especially 250–51, where she draws on and cites Terrence Deacon, *The Symbolic Species: The Co-Evolution of Language and the Brain* (New York: W. W. Norton, 1997).

3. Teilhard de Chardin, *The Phenomenon of Man* (New York: Harper & Row, 1964), 127.

4. Humphrey, *A History of Mind*, 46–51.

5. Ibid., 37.

6. Ibid., 40. Apropos of the proposition that all living entities mediate inside and outside exchanges, Linda Gamlin, biochemist and journalist, writes that the cell is a sealed unit, like a submarine in which "the internal conditions can be closely controlled. Only certain substances are allowed in and out." And she adds that, in opposition to those who declare that the earliest forms of life were "naked RNA molecules, not surrounded by any membrane, . . . a membrane of some sort came first before RNA. . . . Certain large molecules spontaneously form droplets, inside which other molecules could accumulate." Linda Gamlin, *Evolution* (New York: Dorling Kindersley, 1993), 56.

7. Humphrey, *A History of Mind*, 217.

8. Nina Jablonski, *Skin: A Natural History* (Berkeley: University of California Press, 2006), 25–26. Also see Mike Edwards and Rona Mackie, "Skin," in *The Oxford Companion to the Body,* eds. Colin Blakemore and Sheila Jennett (Oxford: Oxford University Press, 2001), 623–25.

9. Paul Warwick Thompson, *Skin, Surface, Substance, and Design*, ed. Ellen Lupton (New York: Princeton Architectural Press, 2002), 25.

10. Lupton, in ibid., 29.

11. For a short introduction to the differentiation among the interior and exterior surfaces of the skin, see these diverse articles: William Tyldesley, "Mouth," 476–77; Allan Thexton, "Tongue," 689–90; and Gemma Calvert, "Lip Reading," 434–35, in *The Oxford Companion to the Body.*

12. Bacteria that exhibit motility, i.e., self-propelled motion, achieve it by one of three mechanisms: flagella, rotating axial filaments, or the yet-to-be-understood secretion of copious slime.

13. The fundamental bilaterian body form is a tube with a hollow gut cavity running from mouth to anus, a nerve cord with an enlargement (a ganglion) for each body segment, and an especially large ganglion at the front, called the brain. All bilaterians are triploblastic, which means they acquire three germ layers during embryonic development: the ectoderm, the surface of the embryo, which forms the outer covering of the animal and the central nervous system in some phyla; the endoderm, the innermost germ layer, which lines the digestive tract and

outpocketings that gave rise to the liver and lungs of vertebrates; and the intermediary mesoderm, which forms the muscles and most of the organs located between the digestive tract and outer covering of the animal. The circulatory and, in vertebrates, skeletal systems stem from the mesoderm.

14. See Laurence Garey, "Central Nervous Systems," and idem, "Brain," *The Oxford Companion to the Body,* respectively 145–47 and 115–17.

15. Jablonski, *Skin,* 25–26.

16. Ibid., 27.

17. Ibid., 29.

18. For a recent discussion of the formation of the feather and follicles, see Mingke Yu et al., "Skin Development," *International Journal of Developmental Biology* 48, special issue (2004): 181–91.

19. Three properties of the owl's feathers—all of them an inspiration to contemporary aeronautics—make it a stealthy winged hunter. Its leading, edge, or primary feathers are serrated like a comb; the trailing feathers on the back end of the wings are tattered like the fringe of a scarf; and the rest of the owl's wings and legs are covered in velvety down. T. Bachmann, S. Klän, W. Baughmgartner, et al., "Morphometric Characterisation of Wing feathers of the Barn Owl *Tyto alba pratincola* and the Pigeon *Columba livia,*" *Frontiers in Zoology* 4, no. 23 (2007).

20. Jablonski, *Skin,* 186, note 22.

21. Occasionally the chimpanzee and gorilla are erroneously taken to be "first cousins," not because of a binding genetic endowment, but because of their shared residence: the forests of equatorial Africa that sheltered their shared ancestor. In the time since the human and chimp lineages diverged from a common ancestor, humans have undergone dramatic and relatively rapid anatomical change. Humans became long-limbed, small-toothed, and big-brained, with effectively hairless bodies. These changes, Jablonski contends, are results of natural selection that produced adaptations to more open environments, such as the woodland savannah in which most human ancestors are thought to have lived. On the basis of these changes, underlain by a few genetic changes and a variance, occurring over thousands of years, in their amount of pigmentation and abundance of hair and sweat, humans differentiated themselves from the chimps with which we still share 98 percent of our genes. Ibid., 36, 96.

22. Byron and Keats quoted in Bergen Evans, ed., *The Dictionary of Quotations* (New York: Delacorte Press, 1968), 68.

23. Maurice Merleau-Ponty, *The Phenomenology of Perception* (London: Routledge & Kegan Paul, 1962), 146.

24. Hands can be understood to be the midwives of a pluralistic and multivalent reality. From their work comes comprehension born of action and yet derived from thoughts and metaphors. On this count, philosophy, religion, and science might be understood as crafts rather than abstract theories. On this point, Heidegger and the whole of pragmatism find common ground. Martin Heidegger, "Letter on Humanism" (1946), in *Pathways* (Cambridge: Cambridge University Press, 1998), 240.

25. Ibid., 240–41.

26. Charles Bell, *Anatomy of Expression* (London: H-H Brackenridge / Gazette-Publications,1806), especially 108–60.

27. For a review of literature suggesting, contradictorily, that the mouth (through eating and cooking) might define our species, see Peter Lucas, Kai Yang, et al., "A Brief Review of the Recent Evolution of the Human Mouth in Physiological and Nutritional Contexts," *Physiology & Behavior* 89 (2006): 36–38.

28. For a discussion of the importance of bipedalism to the development of the human hand, see Joseph A. Amato, *On Foot: A History of Walking* (New York: New York University Press, 2004), 21–24.

29. Frank Wilson, *The Hand* (New York: Vintage, 1998), especially 15–23, 36–37; for sources utilized for his discussion, see 321–22, note 9.

30. Canadian psychologist and neurologist Merlin Donald postulates a pluralistic human consciousness for *Homo sapiens*. He contends that in several early stages spanning millions of years, human brains were first enlarged not by toolmaking but by social interaction. First mimetic skill allowed the duplication of voluntary action. In the second stage, with spoken language, humans composed "mythic cultures" that still exist today. Finally, humans made a great leap to become "a symbol-using creature" who deals with the creation of simultaneous "mosaics of meanings." Merlin Donald, *The Origins of the Modern Mind: Three Stages in the Evolution of Culture and Cognition* (Cambridge, MA: Harvard University Press, 1991). Following Donald's lead, Henry Plotkin seeks to join knowledge to biology. He conceives of adaptation as a process of constant iteration, an act of repetition that approximates the goal (teleology), assuring an ever more successful fit with the world and the structure of learning and organization of life. In this way, the organization of an organism—its limb structure, camouflage, and means of movement—is informed by the environment. Henry Plotkin, *Darwin Machines and the Nature of Knowledge* (Cambridge, MA: Harvard University Press, 1994), 51, xv. Philosopher Barry Allen critically notes that for Plotkin, knowledge operates in the gene pool and is expressed as adaptations that constitute what Plotkin calls the "Darwin machine." Barry Allen, "Knowledge and Adaptation," *Biology and Philosophy* 12, no. 2 (1997): 233–41.

31. Pinker quoted in Wilson, *The Hand*, 326, note 5.

32. A half century ago, *Scientific American* published "Tools and Evolution," in which physical anthropologist Sherwood L. Washburn contends that the hand cleared and led the way from *Homo erectus* to *Homo sapiens*: "On the human species, with special reference to its origins: It is now clear that tools antedate man, and their use by prehuman primates gave rise to *Homo sapiens*." Sherwood L. Washburn, "Tools and Evolution," *Scientific American* (September 1960): 62.

33. The origins and nature of toolmaking humans are topics of much speculation. They have been a subject of controversy since Mary and Louis Leakey, in 1959, announced the discovery of a fossil *Australopithecus* hominin, nicknamed "Zinj" (to which they initially assigned the name *Zinjanthropus boisei,* but which was later renamed *Australopithecus boisei*), in the Olduvai Gorge in eastern Africa. Leakey called it *Homo habilis* (handy man). Three years later, in 1962, as if to electrocute those he already had shocked, he and Mary announced the excavation, from the

same gorge, of three specimens approximately 1.75 million years old. Each of these deserved the title *Homo habilis* more than did the small-brained *Zinjanthropus boisei*. Furthermore, these specimens' skeletons and teeth unreservedly qualified them for the majestic appellation *Homo;* and their brain size (which does not directly correspond to mental functions) of 650cc overlapped *Homo erectus's* brain size of 500 to 800cc, even though it fell considerably short of today's humans, equipped with brain capacities from 700 to 1,250cc. Donald Johanson and Maitland Edey, *Lucy: The Beginnings of Humankind* (New York: Simon and Schuster, 1981), 97–106. For an attempt after the Leakeys' discovery to distinguish human toolmaking by its pattern and degree of complexity from the precision grip of *Homo habilis,* see Abraham Gruber, "A Functional Definition of Primate Tool Making," *Man,* new series 4, no. 4 (December 1969): 573–79.

34. With a shared belief that productive forces defined the age, a fellow radical Hegelian, Arnold Ruge, wrote in an 1840 essay that thought itself was being realized in the praxis of industry, which was incorporating all past labor and transforming the entire world: "Industry," Ruge wrote, "has no other meaning than does the work of the spirit; . . . its principle is none other than that of idealism itself." Marx himself wrote even more pertinently in an 1842 letter, "The same spirit that constructs railways with the hands of workers constructs philosophical systems in the brains of philosophers." Both the translator and source of these quotations is Allan Megill, *Karl Marx: The Burden of Reason* (New York: Rowman & Littlefield, 2002), quotations on 198 and 204, respectively.

35. A rich two-volume collections of essays authored by such thinkers as Carl O. Sauer, Lewis Mumford, Karl Wittfogel, Teilhard de Chardin, and Charles Darwin and edited by William Thomas Jr. was published in 1956 under what then was a prescient title: *Man's Role in Changing the Face of the Earth* (Chicago: University of Chicago Press, 1956).

36. Museums of early Mediterranean civilizations (such as the one adjacent to the amphitheater of Epidaurus) display the bronze forerunners of contemporary surgical instruments. On display at Epidaurus and other museums are medical tools for penetrating and treating the body: saws, loops, scalpels (with various blades and handles), blunt and shark hooks (for probing and holding veins and separating tissue), crushing forceps (for uvula removal), bone drills and forceps (for removal of bone and objects embedded in bone), catheters (for men and women), and vaginal specula, the most complex instruments employed by Greek and Roman physicians, consisting of screw devices. Of additional interest on ancient and class medicine is James Longrigg, *Greek Medicine: From the Heroic to the Hellenistic Age* (London: Routledge, 1998), especially 168–77; and John F. Nunn, *Ancient Egyptian Medicine* (Norman: University of Oklahoma Press, 1996).

37. See George Basalla, *The Evolution of Technology* (Cambridge: Cambridge University Press, 1988), especially 1–25. Basalla argues convincingly that the diversity of tools (e.g., the multiple forms of hammers, of Australian aboriginal weapons, etc.) was not driven by necessity, but by the accumulation of tradition, modifications, and invention.

38. Especially for walking sticks, canes, and decorated and symbolic staffs, see Amato, *On Foot,* 45–46, 89, 284, note 65.

39. For a relevant discussion and illustrations of the evolution of various Australian aboriginal weapons and their development from simple to specialized tools, see the chart offered in A. H. Lane-Fox Pitt-Rivers, "Evolution of Technology" (Oxford: n.p., 1906), reprinted in Basalla, *The Evolution of Technology,* 19. Also, on the Pitts River Museum in Oxford, which the author visited in September 2012, see Chris Godsen et al., *Knowing Things: Exploring the Pitts River Museum, 1884–1945* (Oxford: University Press, 2007); illustrations of the weapons noted above are on 112.

40. The thesis that man defines himself through hunting and killing is implicit in the work of Sigmund Freud; it is central to social biologist Konrad Lorenz's writings; and it is articulated by Walter Burkert, *Homo Necans: The Anthropology of Ancient Greek Sacrificial Ritual and Myth* (Berkeley: University of California Press, 1983; orig. German, *Homo Necans* [Berlin: Walter de Gruyter, 1972]).

41. The biface is identified with several controversial theories and discoveries. These include the idea that *Homo habilis,* an omnivorous scavenger and meat eater, broke into animal and human bones 1.8 million years ago, and the disputed idea that a branch of early humans at Gran Dolina in present-day Spain cannibalized and broke into skulls to harvest the brains of other humans in the mid-Pleistocene ice age, 780,000 years ago. Other suggestive discoveries include the largest site of stone tools—numbering seventeen thousand—of "Peking Man," now known as *Homo erectus,* dated to between a half and quarter million years ago; evidence that Neanderthals (who coexisted with *Homo sapiens* in Europe to the eve of the Neolithic, ten thousand years ago) dressed out animals and prepared hides at an excavated campsite in Gibraltar forty thousand years ago; and the discovery of spear points made by paleo–North Americans whose creation was dated to the end of the ice age and was associated with the extinction of large ice-age mammals twelve thousand years ago. See Douglas Palmer, *Evolution: The Story of Life* (Berkeley: University of California Press, 2009), especially 220–29. For a case for advances in Africa equal to those in Europe, one critical of "Euro-centric approaches to the past," see Sally McBrearty, "The Revolution That Wasn't: A New Interpretation of the Origin of Modern Human Behavior," *Journal of Human Evolution* 39 (2000): 453–563.

42. Bifacial artifacts can be made out of large flakes or blocks, and are defined in four classes: (1) large, thick bifaces reduced from cores or thick flakes, which are referred to as blanks; (2) thinned though unformed blanks; (3) preforms or crude tools, such as adzes; and (4) finer, formalized tool types such as projectile points and precise bifaces. See Robert Boyd, *How Humans Evolved* (New York: W. W. Norton, 2008).

43. Various chronologies of tools suggest that bifaces, in the form of small pebbles, first appeared in East Africa. The Oldowan (a term used to refer to the oldest stone tool industry used by hominins) system dates from 2.6 million years ago up until 1.7 million years ago, and it was followed by the more sophisticated Acheulean industry, which dates to approximately a million years ago and is

associated with early humans in the Lower Paleolithic era across Africa, West Asia, and Europe and with migratory *Homo erectus*. In North America, bifaces made up one of the dominant tool industries, starting from the terminal Pleistocene and lasting to the beginning of the Holocene, twelve thousand years ago, and the beginning of the history of ferrous metallurgy, with the earliest surviving iron artifacts (made from meteorites) found in the fifth millennium B.C. in Iran and second millennium B.C. in China. See E. Photos, "The Question of Meteoric versus Smelted Nickel-Rich Iron: Archaeological Evidence and Experimental Results," *World Archaeology* 20, no. 3 (February 1989): 403–21; and Joseph Needham, *Science and Civilization in China,* vol. 4, parts 2 and 3 (Taipei: Caves Books, Ltd.).

44. Basalla, *The Evolution of Technology,* 14. It should be mentioned that birds and chimps also transform diverse objects (usually sticks, analogous to man's use of sticks and walking staffs) in their environment into instruments to accomplish tasks. To mind comes Jane Goodall's ant-fishing chimps and chimpanzee toolmaking, the latter described by Christophe Boesch and Hedwige Boesch, "Tool Use and Tool Making in Wild Chimpanzees," *Folia Primatologica* 54 (1990): 86–99. In addition to nest-decorating bowerbirds, maze-solving cuttlefish, and ingenious hunting ants and whales, notables in the annals of smart animals include other primates, self-aware pigs, elephants, dolphins, magpies, and gray parrots. Prominent in recent research are New Caledonian crows. They use, invent, combine, and modify tools to achieve their ends. They use the wheels of passing cars to crack open nuts, and they pass their learned innovations on to other members of their group. A particular crow called Betty, when confronted with a task that required the use of a curved tool to procure food contained in a bucket stored in a vertical pipe, spontaneously (and with no prior training in pliable materials) bent a wire to achieve her end. Next this female Daedalus repeated the same trick nine times out of ten to retrieve the bucket, as is reported by A. A. S. Weir, J. Chappell, and A. Kacelnik, "Shaping of Hooks in New Caledonian Crows," *Science* 297 (2002): 981.

45. Trotskyite anthropologist Evelyn Reed expresses a materialist and historical dialectical approach to anthropology. Assessing Louis and Mary Leakey's revolutionary work in East Africa, Reed argues that "the only satisfactory criterion for distinguishing man from ape is toolmaking." She takes their discovery of *Zinjanthropus* (later named *Australopithecus boisei*) as marking the great divide between man and ape. Man's hand, with its flexible fingers and opposable thumb, she writes, furnishes "the missing link" and convincing proof of the truth of Benjamin Franklin's intuitional definition of man as "the tool-making animal." She also finds resolution to the great anthropological debate of brain versus hand that emerged during the nineteenth and twentieth centuries. Reviewing past and present literature, she declares for the hand (although in later stages of history, the expanded brain took control of the toolmaking hand that had created it). In arguing this, she is not in disagreement with anthropologists Louis Leakey and Sherwood Washburn. Evelyn Reed, "New Light on the Origins of Man," *International Socialist Review* 24, no. 3 (Summer 1963): 81–83; above quotations on 82.

46. Stanley H. Ambrose's "Paleolithic Technology and Human Evolution," *Science* 291 (March 2, 2001): 1748–53, connects human biological and cultural evolution with technological innovations. Stone tool technology, robust *Australopithecines*, and the genus *Homo* appeared together in Africa 2.5 mya (million years ago); in Java, 1.8 mya; and in China, 1.6 mya. Toolmaking, he writes, led to preferential handedness, which "may have led to lateralization of brain function," and, he infers, "set the stage for the evolution of language" (1749). Once this adaptive threshold had been crossed, technological evolution was accompanied by increased brain size, population size, and geographical range. Complex toolmaking, which requires fine motor skills, problem-solving, and social task planning, may in turn have influenced the evolution of the frontal lobe and resulted, he conjectures, in grammatical language approximately three hundred thousand years ago. Thereafter, the pace toward *Homo sapiens* quickened exponentially (1753).

47. In the past ten years, Dietrich Stout, whose interests are brain and language evolution, lithic technology, ethnoarchaeology, and cognitive neuroscience, has been refining Ambrose's proposition that man made himself, physically, mentally, socially, and culturally, with his own hands. Prefatorily using a quotation from Frederick Engels's assertion, in his *Part Played by Labour in the Transition from Ape to Man* (1883; trans. from articles in *Die Neue Zeit* [May–June 1876]), that "mastery over nature began with the development of the hand ... [and its] labour that necessarily helped to bring the members together by increasing cases of mutual support," Stout joins the tradition of Darwin, Ralph Holloway, and Sherwood Washburn in conceiving of "tool-use and tool-making ... as *prime movers* in a uniquely human evolutionary package linking bipedalism, dexterous hands, articulate language, culture, and a larger brain." Dietrich Stout, "Tools and Human Brain Evolution," *General Anthropology* 15, no. 2 (Fall 2008): 1–5; quotations on 1. On the basis of recent brain imaging, Stout postulates an overlap between language and toolmaking as alternative expressions of an underlying human capacity to make sense of the world in increasingly complex ways. D. Stout and T. Chaminade, "Making Tools and Making Sense: Complex, Intentional Behaviour in Human Evolution," *Cambridge Archaeological Journal* 19, no. 1 (2009): 85–96. He adds to this proposition by arguing that toolmaking and language are joined in more general human capacities for complex, goal-directed actions, and are "consistent with the co-evolutionary hypotheses linking the emergence of tool making, ... functional lateralization and association of cortex expansion in human evolution." Dietrich Stout, Nicholas Toth, Kathy Shick, and Thierry Chaminade, "Neural Correlates of Early Stone Age Toolmaking, Technology, Language, and Cognition in Human Evolution," *Philosophical Transactions of the Royal Society* 363 (2008): 1939. Yet in an earlier article with Thierry Chaminade, Stout contends that tools arose out of sensimotor adaptation to perception of clues in the environment rather than abstract conceptualization and planning. Dietrich Stout and Thierry Chaminade, "The Evolutionary Neuroscience of Tool Making," *Neuropsychologia* 45 (2007): 1091–1100. In numerous other articles, Stout fills out his exploration of toolmaking as based on finding and quarrying particular rock, and on stone knapping as a

learned craft in which one enrolled and that required learning and the social support of a particular community over long periods of time.

48. Gordon Childe, *The Story of Tools* (London: Cobbett, 1944), especially 1–14; *What Happened in History* (New York: Penguin, 1942), 13–120; and *The Dawn of European Civilization* (New York: Knopf, 1958).

49. Anthropologists, historians, and archaeologists lack evidence and have fallen short of writing discrete narratives of the first five or six millennia of the Neolithic, yet the drama of early cities and their actions and effects call for such narratives, which would exceed conjectures based on fact, generalization, theory, and law. A recent collection of probing essays on prehistory, featuring new themes and interpretations of matters such as climate, settlement, agriculture, domestication, and the Neolithic in general, are found in Andrew Shryock and Daniel Lord Small, eds., *Deep History: The Architecture of Past and Present* (Berkeley: University of California Press, 2012), which I critically review in a forthcoming issue of the *Journal of Social History,* focusing especially on the matter of theory versus narrative, a topic I take up as well in "Then and Then Again," *Historically Speaking* (November 2011): 27–28.

50. Jacques Cauvin, *Naissance des divinités: Naissance de l'agriculture: La révolution des symbols au néolithique* (Paris: CNRS Éditions, 2010), 13. Cauvin conceives of the Neolithic as involving a symbolic construction of being, society, and man's place in it, as is found especially on 43–56.

3. WALLS AND HOMES

1. Gordon Childe, *New Light on the Ancient East* (London: Routledge & Kegan Paul, 1952 [1934]). See Thomas Levy, "The Neolithic and the Chacolithic (Pre-Bronze Age) Periods in the Near East," in *The Oxford Companion to Archaeology,* ed. Brian Fagan (Oxford: Oxford University Press, 1996), 491–94. For a useful chronology across continents from 10,000 B.C. to the present, see Colin Renfrew, *Prehistory: The Making of the Human Mind* (New York: Modern Library, 2007), 190–91. For an overview of the Neolithic period—especially domestication—see William A. Haviland et al., *The Essence of Anthropology* (Beverly, MA: Thomson/Wadsworth, 2007), 97–114.

2. We note the domestication of plants and animals, from 9000 to 8000 B.C.; the first settlement of and the building of the walls of Jericho, from 8350 to 7350 B.C.; and early experiments with copper ores in Anatolia, 7000 B.C. And at Çatalhöyük, Anatolia, a site of 32 acres, we encounter the largest settlement of its day, from 6200 to 5400 B.C. Beginning in 5000 B.C., we see agriculture and irrigation in both Mesopotamia and Egypt; in 4000 B.C., we see bronze casting in the Near East and the first use of the plow; and in 3100 B.C., King Menes united Egypt and thus stands at the beginning of what we know as the dynastic period. In parallel developments, around 3000 B.C., we witness the growth of major cities in Sumer, Mesopotamia. This chronology was adopted from Geoffrey Barraclough, ed., *Atlas of the World,*

2nd rev. ed. (New York: HarperCollins, 1998), 16–17. For Çatalhöyük, see Michael Balter, *The Goddess and the Bull: Çatalhöyük: An Archaeological Journey to the Dawn of Civilization* (New York: Free Press, 2004).

3. Andrew Shryock and Daniel Lord Small, eds., *Deep History: The Architecture of Past and Present* (Berkeley: University of California Press, 2012), 220.

4. For an early elaboration of the human transformation of the earth in prehistoric and ancient times, see Carl O. Sauer, "The Agency of Man on the Earth," in William Thomas, ed., *Man's Role in Changing the Face of the Earth*, 2 vols. (Oxford: Oxford University Press, 1967), vol. 1, 3–66.

5. A useful synopsis of plants and animals is found in two tables in J. R. McNeill and W. H. McNeill, *The Human Web* (New York: W. W. Norton, 2003), 26, 30. They chronologically place the domestication of sheep at 10,000 years ago in the Taurus Mountains of modern-day Turkey, and of goats at the same time in the Zagros Mountains of modern-day Iran, whereas pigs' domestication is identified at 8,700 years ago in both Southwest Asia and China; cattle, 8,000 years ago in an unidentified location; donkeys, 7,000 years ago in Egypt; horses, 6,000 years ago in modern-day Ukraine; the two-humped camel, 4,700 years ago in Central Asia; and the one-humped camel, 3,000 years ago in southern Arabia.

6. For a recent book of essays on the prehistory of food, kinship, migration, goods, and the scale of population and things, see Shryock and Small, eds., *Deep History*, especially parts 3 and 4, 131–272.

7. The organizing and hierarchical powers of these new cities are stressed in ibid., 250–61.

8. According to anthropologist Gordon Childe ("Urban Revolution," *Town Planning Review* 21 [1950]: 3–27, cited in Clive Gamble, *Origins and Revolutions: Human Identity in Earliest Prehistory* [Cambridge: Cambridge University Press, 2007], table 1.2, 20), the profoundly transformative "agricultural revolution"—the formulation of which is criticized as too intellectual rather than of necessity tied up with food supply, climate, and other long-term interlocking forces (see Shryock and Small, eds., *Deep History*, especially 250, 252)—fostered a second revolution. This was the "urban revolution," a term Childe first coins in his *Man Makes Himself* (Bradford-on-Avon: Moonraker Press, 1981 [1936]). He goes on to define the urban revolution in terms of ten characteristics that marked the face of the world humans experienced and explained: increased populations, the accumulation of centralized capital through tribute or taxation, monumental public works, the invention of writing, the articulation of elaborate and exact sciences, long-distance trade in luxuries, the emergence of stratified societies, the formation of urban centers, new state organizations based on territory, and the appearance of naturalistic art. Expanding agriculture, increased production, and multiplying settlements ultimately produced dynamic, hegemonic, and competitive cities in the Near East, according to McNeill and McNeill, *The Human Web*.

9. For a brief summary of archaeologist Colin Renfrew's "sedentary revolution," see Renfrew, *Prehistory*, especially 105–06, 126–30 and Gamble, *Origins and Revolutions*, 207–08.

10. For this formulation of building in one's cosmic image, see Trevor Watkins, "Building Houses, Framing Concepts, Constructing Worlds," *Paléorient* 30, no. 1 (2004): 5–23.

11. Gaston Bachelard, *The Poetics of Space: The Classic Look at How We Experience Intimate Places (La Poétique de l'espace),* trans. Maria Jolas (Boston: Beacon, 1994 [1958]), quoted in Renfrew, *Prehistory,* 122.

12. Ian Hodder, *The Domestication of Europe* (Oxford: Blackwell, 1990), especially 41–43.

13. "Appropriating the Cosmos" is chapter 9 in Renfrew, *Prehistory,* 153–71.

14. Quoted in Renfrew, *Prehistory,* 122.

15. Lewis Mumford, *The City in History* (New York: Harcourt Brace, 1961), 17.

16. Ibid.

17. For early decorative and subsequent utilitarian use of pottery, see Gamble, *Origins and Revolutions,* 198–201.

18. For introductory definitions and short histories of pottery, ceramics, glass, glazing, enamels, and related terms, see entries in Lucy Trench, ed., *Materials and Techniques in the Decorative Arts: An Illustrated History* (Chicago: University of Chicago Press, 2000); Harold Osborne, ed., *The Oxford Companion to the Decorative Arts* (Oxford: Oxford University Press, 1975); Frank and Janet Hamer, *The Potter's Dictionary of Materials and Techniques,* new rev. ed. (New York: Watson-Guptill, 1986); and Alan Macfarlane and Gerry Martin, *Glass: A World History* (Chicago: University of Chicago Press, 2002). For metallurgy's origins and development, see Childe, *Man Makes Himself,* 104–05, 142, passim.

19. For Gamble's discussion of "bodies, instruments, and containers," see his *Origins and Revolutions,* 104–10, 169–204; for a specific list of instruments, see table 4.4, 108; and tables 7.3, 7.4, and 7.5, 170, 172–73, 174.

20. Ibid., 170.

21. Ibid., 123; for Gamble's explicit use of Claude Lévi-Strauss's term *bricolage*—the practical joining and making do with what is available—see 255–57 and passim.

22. For Bronze Age commerce and transactions in the Mediterranean, see Marlene Suano, "The First Trading Empires: Prehistory to c. 1000 B.C.," in *The Mediterranean in History,* ed. David Abulafia (London: Thames, 2003), 67–98. Also for the Mediterranean, see Michael Grant, *The Ancient Mediterranean* (New York: Meridian, 1988), 3–132, especially useful for a survey of geography, peoples, travel, commerce, and shipping.

23. Implements of bronze from before 3000 B.C. have been found in Mesopotamia and Egypt. Bronze implements from the third millennium B.C. have been found in Minoan Crete. Until the introduction and widespread use of iron, bronze was the sole metal used for wide and varied utilitarian purposes: sculpture, domestic objects, and even coinage by around 500 B.C. See Frederick Norman Pryce, "Bronze," in N. G. L. Hammond and H. H. Scullard, eds., *The Oxford Classical Dictionary,* 2nd ed. (Oxford: Oxford University Press, 1970), 182–83. The Bronze Age, which was in the Near East and Europe a stage of technology—not a stage of social evolution—is the second age of the Three Age System. It followed the Stone Age (which itself

is subdivided into three ages: the Paleolithic, the Mesolithic, and the Neolithic), and it preceded the more recent Iron Age, according to Brian Fagan, "Three Age Classification," in *The Oxford Companion to Archaeology*, 712–13. Also useful in the same volume are Anthony Harding, "The European Bronze Age," 218–19; Timothy Champion, "The European Iron Age," 219–21; and Paul Craddock, "Metallurgy in the Old World," 461–62.

24. Two useful surveys of copper and bronze metallurgy are Ian McNeil, ed., *An Encyclopedia of the History of Technology* (London: Routledge, 1990), 45–95; and Ervan Garrison, *A History of Engineering and Technology: Artful Methods* (New York: CRC Press, 1999), 90–96.

25. Pryce, "Bronze," 182–83.

26. Homer, *The Iliad*, trans. Robert Fagles (New York: Penguin Books, 1990), book II, lines 576–79, p. 115.

27. Ibid., book XXIV, lines 267–68, pp. 595–96.

28. Emily Vermeule, *Greece in the Bronze Age* (Chicago: University of Chicago Press, 1964), 24–29.

29. Homer, *The Iliad*, book XX, lines 305–13, p. 512.

30. McNeill and McNeill, *The Human Web*, 34.

31. For the place of ships from the Bronze Age to eve of Roman times, see Suano, "The First Trading Empires: Prehistory to c. 1000 B.C.," 67–98; and a following article, Mario Torelli, "The Battle for Sea Routes," in *The Mediterranean in History*, 99–126.

32. Frederick Hocker and Cheryl Ward, eds., *The Philosophy of Ship Building* (College Station: Texas A&M University Press, 2004), 5.

33. For a classic volume seeking to integrate the invention and development of the ship into the history of technology, see S.C. Gilfillan, *Inventing the Ship* (Chicago: Follett, 1935). For an excellent outline of seminal Egyptian ship construction, see Cheryl Ward, "Boatbuilding in Ancient Egypt," in Hocker and Ward, eds., *The Philosophy of Ship Building*, 13–24.

34. The Battle of Salamis was immortalized by Herodotus in *The Histories*, Robert Strassler, ed., Andrea Purvis, trans. (New York: Anchor Books, 2009), 97; and the story of Athenian democracy and the golden age of the bronze-tipped trireme is told in terms of equipping and manning Athens' citizens' navy (with Themistocles in the guise of a classical Churchill) by John Hale, *Lords of the Seas* (New York: Viking, 2009).

35. A partial inventory of other shipbuilding and ship-maintenance skills and arts at port and sea included joining and strengthening skeletons and frames; establishing gangplanks, hoists, and ropes to load and unload ships' cargo and personnel; making and attaching anchors; setting and arranging ships' ballast; making instruments to bail and discharge water; and making materials to repair breached surfaces, sails, roping, spars, and other broken or lost units. And then there were all the skills of seasoned captains and sailors: dead reckoning (reading the face of the water and sky to ascertain position), the art of following dangerous coastlines, the ability to adhere to and revise routes, and the cunning to survive the treacherous, storm-filled eastern Mediterranean.

36. A *Nova* program, "Building Pharaoh's Ship," aired October 2010, took up the matter of caulking: www.pbs.org/nova/pharaoh (accessed August 31, 2011).

37. Matthew 3:4–7.

38. For animals, travel, roads, caravans, and chariots in the Near East, see Georges Contenau, *Everyday Life in Babylon and Assyria* (New York: W. W. Norton, 1966), especially 54–55, 62–63, 82–83, passim.

39. This treatment of the wheel is taken from George Basalla, *The Evolution of Technology* (Cambridge: Cambridge University Press, 1988), especially 7–11, 12. It coincides with the general view of walking as the primary mode of travel until recent times, as articulated in Joseph A. Amato, *On Foot: A History of Walking* (New York: New York University Press, 2004). Also, for the great travel and trade routes and a history of the world's roads, respectively, see Irene Franck and David Brownstone, *To the Ends of the Earth* (New York: Facts on File, 1984); and M. G. Lay, *Ways of the World* (New Brunswick, NJ: Rutgers University Press, 1992).

40. Mumford, *The City in History*, 61.

41. For the connection between settlement and sacrifice, see Walter Burkert, *Homo Necans: The Anthropology of Ancient Greek Sacrificial Ritual and Myth* (Berkeley: University of California Press, 1983 [orig. German, Berlin: Walter de Gruyter, 1972]), especially 35.

42. There were Mycenaean walls of rough and immense rocks made through Cyclopean masonry, and subsequently there were walls made of diversely sized stones that had even rows and close joints, and polygonal assemblages that used either sharp or curved stones. Additionally, the Greeks employed trapezoidal construction and isodomic construction (using blocks of identical size), and later built walls with drafted joints, edged for fitting and mortaring, as is illustrated nicely in Robert Boulanger et al., *Greece* (Paris: Hachette World Guides, 1964), 60–62. For a brief overview, with illustrations, of Greek wall- and roof-building techniques, including joining methods, see Lesley Adkins and Roy Adkins, *Handbook to Life in Ancient Greece* (Oxford: Oxford University Press, 1997), 227–32.

43. Among monuments, the Great Pyramid of Giza, the tomb of Pharaoh Khufu, is 756 feet wide and 481 feet high. Containing over two million stone blocks, each with an average weight of two and half tons, it required, according to Herodotus, ten thousand men and twenty years to build. Herodotus, *The Histories*, 174. For a written and visual survey of the structures of the ancient Near East and Egypt, see S. Lloyd and H. W. Müller, *Ancient Architecture* (New York: Electa/Rizzoli, 1980).

44. For the walls of Jericho, see "Jericho," in Michael Coogan, ed., *The Oxford History of the Bible* (Oxford: Oxford University Press, 1998), x, 14–15.

45. O. Siren quoted in in Joseph Needham, *The Shorter Science and Civilisation in China,* abridged ed. by Colin A. Ronan (Cambridge: Cambridge University Press, 1995), vol. 5, 31–32.

46. Herodotus, *The Histories*, 97. Elsewhere in his work, Herodotus notes that in the wake of the Persian invasion, the defense of Athens hinged on quickly rebuilding its long walls, which covered 6,000 yards, or approximately more than three miles, in extending to its vital port at Piraeus.

47. Lost to time, these most primitive and early defensive walls, built to buttress a system of earthworks and trenches, first surrounded the Palatine Hill and then, prompted by imminent war with the neighboring Sabines, were linked by ditch systems and extended walls to include the Capitoline Hill, which made the wall, in the words of the Greek historian Dionysios of Helicarnassus, who lived in Rome, "that enclosed the two hills in one city." Quoted in John Henry Parker, *The Primitive Fortifications of the City of Rome* (Oxford: James Parker, 1878), xiv.

48. Numa Denis Fustel de Coulanges, *The Ancient City,* eds. Arnaldo Momigliano and S.C. Humphries (Baltimore: Johns Hopkins University Press, 1980; original French, *La Cité antique,* 1864), 133.

49. As we will see in chapter 4, walls invite design: They are planes, grids, and lines that intersect and curve. They require the insertion of doors and windows, they have tops to decorate, and they are faces upon which to illustrate texture. And, as graffitists prove, walls offer blank spaces to decorate. They are also barriers that delineate hostile zones, as was annealed in my generation's memory by the Wall between East and West Berlin. And, as a rich source of metaphors, walls lead us out into empty space, as Lucretius argues in *De Rerum natura* [conveniently read in *On the Nature of the Universe,* trans. R.E. Latham (Baltimore, MD: Penguin, 1951)]. We cannot postulate coming to the end of one wall without postulating a next wall, and so grasp infinity.

50. For the palaces of Knossos and those of Crete and Mycenae, with illustrations, see Peter Thonemann, *The Birth of Classical Europe* (New York: Penguin, 2010), 18–26.

51. Werner Jaeger, *Aristotle,* 2nd ed. (Oxford: Oxford University Press, 1970), 327–28; also see "Aristotle," in *Encyclopedia Britannica* (Chicago: Encyclopedia Britannica, 1970), vol. 2, 1992.

52. Herodotus's work covers a compendium of Mediterranean societies. They are seen as knitted together by communication, trade, diplomacy, styles, envy, and war. His travels not only inventory and speculate on natural phenomena and geographical features, but also offer an anthropological portrait of cultures, customs, crafts, skills, technology, and human building. Contemporary humanity becomes the object of his panoramic view.

53. *Tekne* may have come from the Indo-European base *tek*—"shape and form"—which also produced the Greek word *tekton,* associated with the words for "architect" and "carpenter." Later, in Marxist theory, *praxis* (derived from Greek *prattein,* to do) became the idealized and collectivized sum of human action and energy by which mankind built itself and its world across time.

54. Sophocles, *Antigone,* in *Greek Tragedies,* eds. David Grene and Richmond Lattimore (Chicago: University of Chicago Press, 1960), vol. 1, verses 363–65, p. 193.

55. Plutarch, *The Lives of the Noble Grecians and Romans*, trans. John Dryden, rev. ed. Arthur Hugh Clough (New York: Modern Library, 2001), paraphrased in E. Roy Williams, *Western Civilization* (New York: Heath, 1973), vol. 1, 28–29.

56. Jeremiah Genest, "Aspects of Greek Mythology: Craftsmen Figures," www.granta.demon.co.uk/arsm/jg/crafters.html, 1–8 (accessed September 5, 2011).

57. For Homer's description of Achilles's shield, see Homer, *The Iliad*, book XVIII, lines 483–87, 566–720.

58. Ibid., book III, lines 446–49, p. 140.

59. For the place of craftsmen, see Emile Mireaux, "Public Workers and Craftsmen," in his *Daily Life in the Time of Homer* (New York: Macmillan, 1959), 148–69. Also see Marjorie and C. H. B. Quennell, *Everyday Things in Ancient Greece* (New York: Putnam's, 1954).

60. Mireaux, *Daily Life in the Time of Homer*, 149–53. In the opening lines of Gong Li, *Jiao she kao bian*, a book dating from the second century B.C., when the Great Wall was under construction, the Chinese state is understood to have six classes of workers composed of hundreds of artisans. Its introduction reads:

> There are those who sit to deliberate on the *Dao* [Tao] of society and there are those who take action to carry it out. Some examine the curvature, the form and the quality [of natural objects] in order to prepare the few raw materials [presumably metal, jade, leather, wood and earth] and to distribute them [in a manner useful for] the people. Others transport things rare and strange from the four corners [of the world] to make objects of value. Others again devote their strength to augment the products of the earth, or to [weave tissues from] silk and hemp.

Needham, *The Shorter Science and Civilisation in China*, an abridgment of vol. 5, part 2, 4.

61. Mireaux, *Daily Life in the Time of Homer*, 149.

62. With no central list that graded or qualified musicians, goldsmiths, carpenters, dyers, leatherworkers, curriers, braziers, weavers, potters, cooks, and so on, Greek crafts were not consistently classified or awarded status. Extant classifications were a hodgepodge of traditions, fashions, and accomplishments, which produced anomalies. One example was that traditionally sculptors (perhaps because they worked with stone and split things) were held in lower repute than painters, whose crafts required multiple skills: creating brushes and mixing materials, and delicately making and applying lasting colors to the surfaces of objects. Architects and contractors were not held in the high esteem that they are today. These examples, but not possible explanations of them, are found in Hannah Arendt, *The Human Condition* (New York: Anchor Books, 1959), chap. 3, 323–24, note 7.

63. Distinguishing between traveling and sedentary craftsmen of diverse sorts, and tying crafts to various stages of urban development in Italy, Albert J. Nijboer offers a start toward a history of the appreciation of crafts in his "The Role of Craftsmen in the Urbanization Process of Central Italy (Eighth to Sixth Centuries B.C.)," in *Urbanization in the Mediterranean in the Ninth to Sixth Centuries B.C.* (Copenhagen: Collegium Hyperboreum, 1997), 383–406.

64. In her seminal work *The Human Condition*, Arendt argues against Karl Marx's attempt to join work and labor and to elevate them in terms of their ultimate creative power. In counterdistinction, Arendt contends that the Greeks, in the full maturity of their classical thought, dismissed the most ordinary tasks and the majority of crafts as neither assuring independence nor producing lasting work. On

this basis, the Greeks classified members of the household—women, children, and slaves—as subordinated to the base and repetitious functions of our biology. As such, they belonged to the depreciated economic realm of necessity (*economical* is rooted in the Greek word for "household," *oikos*) and were set in opposition to the ennobling political sphere, in which free, male full citizens acted out in daylight their thoughts and wills. Obviously, Arendt was engaged in an important ideological battle over how much the political realm can be reduced to the social-economic realm.

65. Martin Heidegger, "Letter on Humanism" (1946), in *Pathmarks,* ed. William McNeil (Cambridge: Cambridge University Press, 1998), 246.

66. This idea was borrowed from the peer-reviewed Internet site *The Internet Encyclopedia of Philosophy:* see Hannah Arendt, "Humanity as *Animal Laborans,*" in "Hannah Arendt (1906–1975)," www.iep.utm.edu/arendt/ (accessed September 2011).

67. Archimedes of Syracuse quoted in Heidegger, "Letter on Humanism," 240.

4. DECORATION AND REPRESENTATION

1. I offer a fuller statement of epistemology in the opening chapters of my manuscript *Compass of Twos.*

2. Larry Zimmerman, *American Indians: The First Nations* (London: Duncan Baird, 2003).

3. In a February 2011 e-mail exchange with me, Carl Knappett and Clive Gamble, two archaeologists of widely divergent interests, responded to my question about whether decoration and representation can be divorced from each other and assigned a distinct chronology as early humans selected camps, used tools, made homes, and established settlements. Knappett, who sees body and skin as constituting permeable interfaces that interlace humans with the world, replied:

> Is decoration rooted in the body? I would say so, yes, taking a long-term archaeological approach. There are the famous Blombos shells from 75,000 years ago. Traces of ochre in Upper Paleolithic burials. The plastered skulls from the very early Neolithic of Jericho. There does seem to be a particular connection between death, ritual, the body, and decoration in early prehistoric societies. I would be inclined to the view that it precedes representation, though that is a risky thing to argue, of course.

Independently, Gamble replied to me:

> The question you ask about decoration is a tricky one, but fundamental. Some have argued that decoration only starts with language and the ability to self-reflect. [But] rather than follow or precede the representation of self, I see it as a co-evolutionary process that amplifies the self, and this is best seen in our ability to live apart yet adhere to social rules.

I interpreted neither of their replies as contradicting the assumptions that with eyes, body, skin, hands, and tools, humans participate in the bountiful surfaces

of the earth—its plants, soils, rivers, and skies—and these surfaces are made into images, symbols, and dreams.

4. Christopher Tilley offers this description of Merleau-Ponty's phenomenology in *The Materiality of Stone: Explorations in Landscape Phenomenology* (Oxford: Berg, 2004), 29; he offers his own elaboration of an anthropology based on phenomenology on 1–32. See also idem, *Body and Image: Explorations in the Landscape* (Walnut Creek, CA: Left Coast Press, 2008), especially 19–32, 255–71. Seeking a middle way between the division of mind and body, Tilley utilizes French philosopher Henri Bergson to affirm that the body mediates perception, and Merleau-Ponty to conceive of being as experienced in and through the prism of a living and moving body (see *The Materiality of Stone*, 10–20). For Bergson's positions, see Henri Bergson, *Matter and Memory* (Mineola, NY: Dover, 2004 [1910]). He writes there: "I only experience [the universe] through my body by the medium of particular images, the type which is furnished me by my body" (3).

5. I develop the idea that humans experience the world by walking in Joseph Amato, *On Foot: A History of Walking* (New York: New York University Press, 2004); and also see a collection of essays, Tim Ingold and Jo Lee Vergunst, eds., *Ways of Walking* (Hampshire, UK: Ashgate, 2008).

6. Tilley, *The Materiality of Stone*, 29; also see James J. Gibson's classic consideration of perceptions, objects, spaces, and surfaces, *The Ecological Approach to Visual Perception* (Boston: Houghton Mifflin, 1979).

7. Tilley, *The Materiality of Stone*, 29.

8. For Tilley's world of experiential metaphorical dyads, see ibid., 5–9; and one of his major sources, George Lakoff and Mark Johnson, *Metaphors We Live By* (Chicago: University of Chicago Press, 1980). Also see Eva Feder Kittay, *Metaphor: Its Cognitive Force and Linguistic Structure* (Oxford: Clarendon Press, 1987).

9. Anthropologist Steven Mithen argues that humans communicated long before they spoke words or formed languages. He conceives of two stems to human communication: emotionally expressive music and symbolic language. Both have their source in protocommunication, whose "egg," in which music and language are incubated, is the protean "hmm," which celebrates the breastfeeding mother. "Hmm" constituted the primordial vocalization of bipedal and migratory humans, who were known collectively as *Homo ergaster* and appeared approximately 1.8 million years ago. This first vocalization coincided with their development of a brain able to initiate holistic declarations of emotion, need, want, insistence, and condition. Steven Mithen, *The Singing Neanderthals: The Origins of Music, Language, Mind, and Body* (Cambridge, MA: Harvard University Press, 2006), 192–204.

10. Tilley, *The Materiality of Stone*, 4–5.

11. Ibid., 4.

12. James Geary, *I Is an Other* (New York: HarperCollins, 2011), 17.

13. For a rich collection of photographs of tribal decoration from Africa, see Hans Sylvester, *Natural Fashion* (London: Thames and Hudson, 2006).

14. Alfred Gell (1945–97) contends that art is a collective phenomenon: art produces distributed objects, and artworks belong to cultures. He writes,

"Artworks . . . come in families, lineages, tribes, and whole populations. . . . Each individual work of art is the projection of certain stylistic principles which form larger unities." Alfred Gell, *Art and Agency: An Anthropological Theory* (Oxford: Clarendon Press, 1998), 153–54.

15. Quoted in Z. S. Strother, *Inventing Masks* (Chicago: University of Chicago Press, 1998), 27.

16. Walter Burkert, *Homo Necans: The Anthropology of Ancient Greek Sacrificial Ritual and Myth* (Berkeley: University of California Press, 1983; orig. German, Berlin: Walter de Gruyter, 1972), 35–36.

17. Mithen, *The Singing Neanderthals,* 164.

18. Ibid., 188–91.

19. Tim Ingold, *Lines: A Brief History* (London: Routledge, 2007).

20. Douglas Palmer, *Evolution: The Story of Life* (Berkeley: University of California Press, 2009), 230–31.

21. Ibid., 226; and Mithen, *The Singing Neanderthals,* 250–53.

22. Donald Jackson, *The Story of Writing* (New York: Taplinger Publishing, 1981), 14.

23. Ingold, *Lines,* 2.

24. In *The Curves of Life* (Mineola, NY: Dover, 1979 [1914]), Theodore Andrea Cook seeks to establish the laws of art; in *On Growth and Form* (Mineola, NY: Dover, 1992 [1942]), D'Arcy Wentworth details elemental laws governing biological formation.

25. Jacques Cauvin, *The Birth of the Gods* (Cambridge: Cambridge University Press, 2000), 29–33, 67–71.

26. In an article that supplements his email of February 2011 (see note 3), Clive Gamble postulates four levels of self-development. In level 1, Ego is self-aware. Level 2 is intentionality, in which (prior to the encephalization event of increased brain size, which occurred six hundred thousand years ago), Ego recognizes another person's states and beliefs. In Levels 3 and 4, Ego wants the other to recognize its beliefs, and believes that the group understands that another recognizes Ego's own belief states. Clive Gamble, "Technologies of Separation and the Evolution of Social Extension," *Proceedings of the British Academy* 158 (2009): 29.

27. In *A Phenomenology of the Landscape: Places, Paths, and Monuments* (Oxford: Berg, 1994), Christopher Tilley seeks to offer a vital phenomenology of the landscape as a consequence of our actions, walking paths, naming systems, and conceptual thought (8, 34, passim).

28. Clive Gamble, *Origins and Revolutions: Human Identity in Earliest Prehistory* (Cambridge: Cambridge University Press, 2007), 100–2.

29. Peter Wilson argues that built houses and permanent settlements became widespread just twenty to fifteen thousand years ago. Human domestication (i.e., humans dwelling in their own homes and settlements) arose, arguably, from a shortage of wild herds. And although agriculture was not a prerequisite for sedentism and human domestication, settlement, on the other hand, was essential for agriculture and favorable for the development of herding. Peter Wilson, *The Domestication of the Human Species* (New Haven, CT: Yale University Press, 1988), 59.

30. Ibid., 4–5.

31. Ibid., 10–13.

32. Gibson, *The Ecological Approach to Visual Perception*, especially 16–32, 303–06, note 14.

33. André Leroi-Gourhan, "The Art of Living Primitive Peoples," in *The Larousse Encyclopedia of Prehistoric and Ancient Art: Art and Mankind,* ed. René Huyghe (New York: Prometheus Press, 1962), 80.

34. Wilson, *The Domestication of the Human Species,* 69.

35. Ibid., 68.

36. For early homes and structures of the Near East, see Georges Contenau, *Everyday Life in Babylon and Assyria* (New York: Norton, 1966), 25–40; David Wengrow, *What Makes Civilization? The Ancient Near East and the Future of the West* (Oxford: Oxford University Press, 2010), 39–87; and Joan Aruz, ed., *Art of the First Cities: The Third Millennium from the Mediterranean to the Indus* (New Haven, CT: Yale University Press, 2003), 3–41.

37. Sarah Pomeroy, Stanley Burstein, et al., *Ancient Greece: A Political, Social, and Cultural History* (Oxford: Oxford University Press, 1999), 76.

38. Alasdair Whittle, *Europe in the Neolithic: The Creation of New Worlds,* 2nd ed. (Cambridge: Cambridge University Press, 1996), 370–71; for an earlier and substantial construction of the Neolithic transformation of life and worldviews, see Robert Redfield, *The Primitive World and Its Transformations* (Ithaca, NY: Cornell University Press, 1953).

39. Donald Yerxa, "What Makes Civilization? An Interview with David Wengrow," *Speaking Historically* (January 2011): 8–9.

40. We read in Samuel 17:4–8:

> And there came out of the camp of the Philistines a champion named Goliath, of Gath, whose height was six cubits and a span. He had a helmet of bronze on his head, and he was armed with a coat of mail, and the weight of the coat was five thousand shekels of bronze. And he had greaves of bronze upon his legs, and a javelin of bronze slung between his shoulders. And the shaft of his spear was like a weaver's beam, and his spear's head weighed six hundred shekels of iron; and his shield bearer went before him.

41. Wengrow, *What Makes Civilization?,* 94–97; and Yerxa, "What Makes Civilization?," 9.

42. Wengrow, *What Makes Civilization?,* 144–45, passim.

43. At that time, metals still retained metaphysical and magical properties, and they could not be forged or fashioned without the secrets of craft, the transformations of fire, and even tributary sacrifice. At least such notions are suggested by Mircea Eliade, who writes that mineral substances were considered to have a sacred tie to the earth. The belated appearance of iron declared a whole new mythic age of the smith as a magical alchemist, suggesting why Christ, in folklore, is the master of fire. Mircea Eliade, *The Forge and the Crucible* (Chicago: University of Chicago Press, 1978), 8, 25, 32, 107, 169.

44. Such an Egyptian cosmetic spoon, made from wood and dating to ca. 1300 B.C., represents the consummate skill of the Egyptians, who were so talented in clothesmaking, hairdressing, and jewelry-making, and it offers a naturalistic scene that joins sensuous decoration to an image of a woman gracing the landscape. See Jaromir Malek, *Egypt: 4000 Years of Art* (London: Phaidon, 2003), 163. Paul Nicholson and Ian Shaw, in *Ancient Egyptian Materials and Technology* (Cambridge: Cambridge University Press, 2000), call attention to Egyptian craftsmen's ability to depict, sculpt, and color, and to order and beautify with a range of inorganic materials, including stones, mud, clay, sands, minerals, and metals, as well as organic materials such as plants, reeds, trees, and hides. Masters of surfaces, they produced baskets, textiles, papyrus, mats, roofs, leathers, and skin goods; they also carpentered and sculpted wood, decorated ostrich shells, mummified bodies (human and animal alike), styled hair, and fashioned wigs. In addition to oils, fats, resins, ambers, and bitumen, they used multifold, pliant, and waterproof wax and diverse adhesives and binders to join, seal, caulk, and imprint the world of surfaces.

45. Job 41:10, 14.

46. Karl Jaspers introduced the notion of the "the axial age" in *The Origin and Goal of History* (Westport, CT: Greenwood Press, 1977 [1953]).

47. For a short history of the Greek temple, see René Huyghe, "Art Forms and Society"; Charles Picard, "The Origins of Greek Art"; and François Chamoux, "Greek Art from the 6th to 4th Centuries," a succession of essays in *The Larousse Encyclopedia of Prehistoric and Ancient Art,* respectively 234–45, 246–50, 251–84.

48. Wilson, *The Domestication of the Human Species,* 152–53.

49. British calligrapher Donald Jackson offers this account of writing: For him, writing is first "a series of pictures strung together" aimed at telling a story, leaving a message, or recording information for future reference. "The next stage," he continues, "is the reduction and stylization of such pictures, so that they can be drawn quickly with as few strokes as possible." Such a picture is known as a pictogram, whereas the symbol for an idea is an ideogram. The Sumerians articulated two thousand symbols to record transactions and happenings on clay. Donald Jackson, *The Story of Writing* (New York: Taplinger Publishing, 1981), 16–17.

50. David Wengrow identifies the use of clay across the Fertile Crescent. Beginning in Neolithic times, clay figurines of pregnant women and domestic animals, along with geometric tokens, provided communities with condensed signs of significance and value. They were even used as tokens of social transactions involving exchange of kin, animals, and other goods. By 7000 B.C. in northern Mesopotamia, decorated clay served as seals that validated documents and identified owners and places. Such seals evolved (often through decoration with a bestiary of animals and scenes of copulation) to convey threats associated with violating taboos and provoking religious curses. Likewise, broken seals could serve as receipts of transactions. David Wengrow, "The Changing Face of Clay: Continuity and Change in the Transition from Village to Urban Life," *Antiquity* 72, no. 78 (December 1998): 783–95.

51. Jackson, *The Story of Writing,* 16–18.

52. Wengrow, *What Makes Civilization?*, 25. For a brief consideration of Egyptian hieroglyphics and its relation to cuneiform, see Penelope Wilson, *Sacred Signs* (Oxford: Oxford University Press, 2003).

53. The select band of those Chinese who could write ideograms remained small until the invention of printing. "One result of this was that the themes of pictorial representation remained remarkably few and indeed until the fifth century B.C. were restricted to sacred and semi-sacred subjects. It was not until the fourth century B.C. that prose and poetry began to come into their own as art forms, and not until the second century B.C. that literacy became obligatory for officials." Werner Speiser, *The Art of China* (New York: Crown Publishers, 1960), 22–23.

54. David Hunter, *Papermaking: The History and Technique of an Ancient Craft* (Mineola, NY: Dover, 1978), 48.

5. THE EYE AND HAND

1. Jacques Maritain, *Creative Intuition in Art and Poetry* (Cleveland: Meridian Books, 1954), 30.

2. Frances Gies and Joseph Gies, *Cathedral, Forge, and Waterwheel* (New York: HarperCollins, 1994), 19–21.

3. Ibid., 37.

4. Crop list in ibid., 102.

5. Philip Ball, *Universe of Stone: Chartres Cathedral and the Invention of the Gothic* (New York: HarperPerennial, 2008).

6. For the dimensions of medieval church naves, see Ervan Garrison, *History of Engineering and Technology*, 2nd ed. (New York: CRC, 1999), 121.

7. For a classic introduction to Christian iconography, see Adolphe Napoleon Didron, *Christian Iconography: The History of Christian Art in the Middle Ages*, 2 vols. (New York: Frederick Ungar, 1965), especially the introduction to vol. 1, 1–21. Also of considerable use on architecture as the articulation of a sacral cosmos is M.-M. Davy, *Initiation à la symbolique romane (XIIs siècle)* (Paris: Flammarion, 1977). Also see Emile Mâle, *The Gothic Image* (New York: Harper & Row, 1972), a classic on religious art in thirteenth-century France, which is based on the premises that in the Middle Ages art was didactic, man was the microcosm in the macrocosm, and iconography formed a script.

8. Gies and Gies, *Cathedral, Forge, and Waterwheel*, 200–22.

9. Light, according to medieval architectural historian Otto von Simson, transfigures the appearance of things, supplementing the richly analogical qualities of the church's forms and figures while enhancing the overall metaphoric powers of the church as "the model of the cosmos and celestial and city." Otto von Simson, *The Gothic Cathedral* (New York: Harper & Row), 37.

10. Von Simson writes, "The Gothic may be described as transparent, diaphanous architecture." Ibid., 4.

11. Ibid., 52.

12. For Dante's tie to medieval thought, see Etienne Gilson, *Dante and Philosophy* (New York: Sheed & Ward, 1949).

13. List of synonyms is taken from Jeffrey Russell, *Storia del Paradiso* (Rome: Editori Laterza, 1996), 186.

14. Ibid., 185.

15. This image is found in the early Christian *Apocalypse of St. Paul,* reproduced in Alice Turner, *The History of Hell* (New York: Harcourt Brace, 1993), 87.

16. There was a great debate over the use of gold in the Church, pitting the Cluniac reformer St. Bernard, seen as the spirit of Europe around the middle of the twelfth century, against the great builder Abbott Suger, who was regent of France during the absence of Louis VII on crusade and was considered the first patron of Gothic architecture. See Jean Gimpel, *The Cathedral Builders* (New York: Harper & Row, 1980), 7–25.

17. Erick Kahler, *Man the Measure* (New York: George Braziller, 1961), 273. Identifying the birth of modernity with the Italian Renaissance, the master cultural historian Jacob Burckhardt, in his classic *The Civilization of the Renaissance* (orig. German, 1860), finds in the period 1250 to 1300 determining conditions for the collapse of the power of the Holy Roman Emperor and the papacy itself in Italy, and a new era of rivaling principalities coincident with the rise of individuals in search of glory and fame. Other historians tie the emergence of secularism to the rise of humanism, namely a civic humanism that fused classical literature and contemporary political activities in such city-states as Florence and Venice.

18. Lewis Mumford, *Technics and Civilization* (New York: Harcourt, Brace, 1963), 18.

19. Ibid., 19–20.

20. Quotations in above paragraph found in Erwin Panofsky, *Renaissance and Renascences in Western Art* (New York: Harper & Row, 1972), 120.

21. Vasari quoted in Heinrich Wölfflin, *The Art of the Italian Renaissance* (New York: Schocken Books, 1963), 8.

22. Ibid.

23. Mumford, *Technics and Civilization,* 20. Like Leonardo, Dürer did not have a formal education, but was greatly interested in intellectual matters. He produced books on measurement (mathematics), fortification, and the proportionality of the human body.

24. For Heinrich Wölfflin, a set of polarities account for the difference between the Renaissance linear way of drawing and the Baroque colorist way of painting. Respectively, they rest on plane versus recession, closed versus open, multiplicity versus unity, and absolute versus relative clarity. More economically, he writes, "Dürer is a draughtsman and Rembrandt a painter." Heinrich Wölfflin, *Principles in Art History,* trans. from 7th German ed. (1929) by M. D. Hottinger (New York: Dover Publications, 1932), 18.

25. James J. Gibson, American psychologist and author of *The Perception of the Visual World* (Boston: Houghton Mifflin, 1950), quoted with emphasis in E.H. Gombrich, *Art and Illusion* (London: Phaidon, 1960), 328.

26. Kenneth Clark, quoted in Fritjof Capra, *The Science of Leonardo* (New York: Anchor, 2007), 161–62.

27. For this comparison, see ibid., 168.

28. Leon Battista Alberti, *De Pictura* (1435), quoted in Tim Ingold, *Lines: A Brief History* (London: Routledge, 2007), 39.

29. These analogies were taken from Leonardo's notebooks, on display at London's Victoria and Albert Museum in the summer and fall of 2007. The display was developed in conjunction with the museum's publication of Martin Kemp, *Leonardo da Vinci: Experience, Experiment, and Design* (London: V&A Publications, 2006).

30. Ibid., 106.

31. Paul Valéry, *Introduction to the Method of Leonardo da Vinci* (London: John Rodker, 1929), 11.

32. Anthropologist Christopher Tilly conceives of this approach to place and locality as essentially being that of nonwestern and precapitalist peoples. They saw space as multiple, social, mutating, and as an agency for viewing and valuing the world rather than a neutral position to be determined mathematically and uniformly. Christopher Tilly, *Phenomenology of Landscape: Places, Paths, and Monuments* (Oxford: Berg, 1994), especially 10–11, 18, 21.

33. Kemp, *Leonardo da Vinci*, 9.

34. *Selections from the Notebooks of Leonardo da Vinci,* ed. Irma Richter (Oxford: Oxford University Press, 1952), 125. Leonardo, in the same section, writes: "Surfaces, which represent bodies and delineate the common boundaries of all visual things, are limited by other surfaces" (126); "The limiting of one body is the beginning of another" (126); and "the limits of two coterminous bodies are interchangeably the surface of one and other, as water and air" (127).

35. Ibid., 107.

36. Eugenio Garin, *The Universality of Leonardo: Science and Civic Life in the Italian Renaissance* (Garden City, NY: Doubleday, 1969), 61–62.

37. Ibid., 62–63.

38. Amato, *Dust,* 56–57.

39. Alfred North Whitehead, *Science and the Modern World* (New York: Macmillan, 1925), 45.

40. On the elements and forms of emerging science, see George Sarton, *Ancient and Medieval Science during the Renaissance, 1450–1600* (Philadelphia: University of Pennsylvania Press, 1955); idem, *Six Wings: Men of the Science in the Renaissance* (Cleveland, OH: Meridian, 1966); and Robert Mandrou, *From Humanism to Science, 1480–1700* (New York: Penguin, 1978).

41. Herbert Butterfield, *The Origins of Science* (New York: Colliers Books, 1962), 102.

42. Etienne Gilson, "Concerning Christian Philosophy," in *Philosophy and History: The Ernst Cassirer Festschrift*, Raymond Klibansky and H.J. Paton, eds. (New York: Harper and Row, 1963), 63.

43. A classic reconstruction of the new world of science is found in Alexander Koyre, *From the Closed World to the Infinite Universe* (Baltimore: Johns Hopkins University Press, 1967).

44. For a short history of mathematics' forms and uses, see Marie Boas, *The Scientific Renaissance* (New York: Harper, 1962), chap. 7, 197–237; for the new mathematics of the sixteenth and seventeenth centuries, see Alan Smith, *Science and Society in the Sixteenth and Seventeenth Centuries* (London: Thames and Hudson, 1972), 67–76.

45. Smith, *Science and Society*, 72–81.

46. James Geary, *I Is an Other* (New York: HarperCollins, 2011), 168.

47. This material and quotation are drawn from Amato, *Dust*, 58–62.

48. The inventions Smith names, all of which altered man's knowledge, relation, and control of the surfaces of the world, include, in chronological order, the refracting telescope, the human-powered submarine, the slide rule, a method for blood transfusion, the steam turbine, the micrometer, Pascal's adding machine, the barometer, and the air pump, all of which belong to the first half of the seventeenth century. The second half of the century produced the pendulum clock, the reflecting telescope, Leibniz's calculating machine, the microscope, the pocket watch, the universal joint, the pressure cooker, and, in 1698, the steam pump, which, as it progressively developed, facilitated deep mining, industrial manufacturing and movement of liquids, new public water supplies, and the steam-driven train and ship.

49. Smith, *Science and Society*, 76–78.

50. For a short history of measurement, key to the shape of surfaces and to their movement and other properties, see Herbert Arthur Klein, *The Science of Measurement: A Historical Survey* (New York: Dover, 1974).

51. Two of the many critics who influenced my interpretation are Giambattista Vico, an early founder of modern historical theory, who wrote his *New Science* (1725) in direct opposition to Descartes's proposed philosophy; and the neo-Thomist Jacques Maritain, who two hundred years later wrote "Descartes ou l'incarnation de l'ange," in *Trois Réformateurs: Luther, Descartes, et Rousseau* (Paris: Plon, 1925), 78–128.

52. René Descartes, "Meditation I," in *Philosophical Works of Descartes* (New York: Dover, 1955), vol. 1, 148; italics mine.

53. John Locke, *An Essay Concerning Human Judgment* (1690), Essay III, X, 34.

54. A militant narrative constructed around the notion that there was a true enlightenment whose tradition was rationalism in the exclusive service of freedom, tolerance, and peace is offered by Jonathan Israel, *A Revolution of the Mind: Radical Enlightenment and the Intellectual Origins of Modern Democracy* (Princeton, NJ, and Oxford: Princeton University Press, 2010).

6. COURTS, GARDENS, AND MIRRORS

1. For a historical survey of measuring, see Herbert Klein, *The Science of Measurement* (New York: Dover, 1974). In addition to gauges and meters, modernity introduced the telescope and the microscope. At sea, the improved oceanic and military sailing ships relied on ever-more accurate and complete maps. On land, surveying, increasingly important for laying roads and digging canals, depended on the compass and Gunter's chain (1620) of a hundred links. Recently invented logarithms (1614) and the Vernier scale (1631) were used for angle measurement and further refinement of surveying, along with the telescopic sight with a level bubble (1723), rules, compasses, dividers, protractors, rods, other chains, pins, and tripods. See Ervan Garrison, *A History of Engineering,* 2nd ed. (Boston: CRC Press, 1999), 158–59.

2. In such terms as these, with reference to "a new heaven and earth," Frederick Nussbaum begins his revealingly titled *The Triumph of Science and Reason, 1660–1685* (New York: Harper & Row, 1953). For a work that traces the intellectual crystallization of the new order of thought, see Paul Hazard, *La Crise de la conscience européenne: 1680–1715* (Paris: Boivin, 1935).

3. For technology in modern history, see Ian McNeil, ed., *An Encyclopedia of Technology* (London: Routledge, 1996); Abbott Payson Usher, *A History of Mechanical Inventions,* rev. ed. (New York: Dover, 1954), 332–81; Maxine Berg, *The Age of Manufactures* (New York: Oxford University Press, 1986); and Lewis Mumford, *Technics and Civilization* (New York: Harcourt Brace, 1962 [1934]), 107–50, especially for Dutch mills, 116, wood tools, 119–20, and European ships, canals, and waterways, 120–21.

4. Usher, *A History of Mechanical Inventions,* 358–59.

5. For communications and culture, see Elizabeth Eisenstein, *The Printing Press as an Agent of Change* (Cambridge: Cambridge University Press, 1979).

6. For a short history of maps in the seventeenth and eighteenth centuries, see Jeremy Black, *Maps and History* (New Haven, CT: Yale University Press, 1997), 11–26.

7. Neil MacGregor, *A History of the World in Objects* (New York: Viking, 2002), 495.

8. Ibid.

9. For pump and steam engines, see Usher, *A History of Mechanical Inventions,* 332–57; and J. L. Hammond and Barbara Hammond, *The Rise of Modern Industry* (New York: Harcourt, Brace, 1926), 110–30.

10. For the reception of the Italian Renaissance by the northern Reformation, and the matter of art and visual images, with particular attention to the development of Luther's view on liturgical and devotional use of images, see Thomas DaCosta Kaufmann, *Court, Cloister, and City: The Art and Culture of Central Europe* (Chicago: University of Chicago Press, 1995), chap. 2, 116–37.

11. Commenting on Protestant and Catholic visual participation in pain and spectacle, Mitchell Merback prefaces the above quotation by remarking,

"Reformers connived to remove from view the positive image of the body-in-pain . . . and the purifying potential of that pain." Mitchell Merback, *The Thief, the Cross, and the Wheel* (Chicago: University of Chicago Press, 1998), 298.

12. The new Jesuit Tridentine design, as exemplified by its motherhouse, the Church of Jesus in Rome, was simple, convenient, and economical. It sought, in the words of historian Eugen Weber, "visibility, light, good acoustics, for a congregation which should be able to follow every moment of the liturgy, every word of the preacher, and every line of their missals." Eugen Weber, *A Modern History of Europe* (New York: Norton, 1971), 351.

13. Ibid., 352.

14. Martin Kemp, *The Oxford History of Western Art* (Oxford: Oxford University Press, 2000), 196.

15. For the appeal and use of the Baroque in Eastern Europe, see Kaufmann, *Court, Cloister, and City,* 138–65.

16. Jacques Barzun, *From Dawn to Decadence* (New York: HarperCollins, 2000), 333–58.

17. For the role of objects and their place in everyday life, see Tara Hamling and Catherine Richardson, eds., *Everyday Objects: Medieval Culture and Its Meaning* (Burlington, VT: Ashgate, 2010).

18. The desk, which could center a room, had varied drawers and shelves, compartments, and locks. In their most ornate form, desks sported gold decorations, florid and geometric veneers, marquetry, and varied inlays. On Baroque and Rococo decoration and furniture, see Jacqueline Viaux, *Le Meuble en France* (Paris: Presses universitaires de France, 1962); and Galen Cranz, *The Chair: Rethinking Culture, Body, and Design* (New York: Norton, 1998), especially 41–45.

19. With their ultimate origins and inspiration in China, porcelain factories received royal sponsorship in Germany and Russia, and porcelain became an enthusiastically received novelty for European middle classes by the eighteenth century. For a history of porcelain from East to West, from the highest social classes to the upper middle class, see Robert Finlay, *The Pilgrim Art: Cultures of Porcelain in World History* (Berkeley: University of California Press, 2011). For the pottery industry, see Hammond and Hammond, *The Rise of Modern Industry,* 162–77.

20. George Hersey, *Architecture and Geometry in the Age of the Baroque* (Chicago: University of Chicago Press, 2000).

21. These characteristics of Baroque architecture are found in "Baroque Art," in *The New World Encylopedia,* www.Newworldencyclopedia.org/Baroque_art (accessed August 1, 2007).

22. *Ceiling* derives from *ciel,* which also means "roof" and "overhang" in French, and *caelum,* which in Latin means "heaven."

23. "Baroque," in *The Columbia Encyclopedia,* 3rd ed. (New York: Columbia University Press, 1963), 169.

24. Ibid., 169–70.

25. E. H. Gombrich, *The Story of Art* (New York: Phaidon, 1956), 323.

26. Depiction of paintings based on a September 2011 trip to Amsterdam's Rijksmuseum and select pages from Simon Schama, *The Embarrassment of Riches: An Interpretation of Dutch Culture in the Golden Age* (Berkeley: University of California Press, 1988), 375–480, especially 430–31.

27. The color black, as opposed to white, was used to represent public and private lives. Joining the tradition of medieval reformers, new reformers judged red—though the most vivid color in the Bible and medieval theology—as "the color that symbolized the height of luxury, sin, and human folly. Luther saw it as the color emblematic of papist Rome, scandalously decorated in red like the infamous Whore of Babylon." Michel Pastoureau, *Black: The History of a Color* (Princeton, NJ: Princeton University Press, 2009), 124.

28. Ibid., 119. Elsewhere Pastoreau writes of the multivalent powers of black in modern history. It stands for good and bad, rebellion and conformity; it clothes penitents and sinners, the proud, diabolical, and magical. In the twentieth century, it was favored by serious artists and designers, and by Fascists.

29. Philip Ball, *Bright Earth: Art and the Invention of Color* (Chicago: University of Chicago Press, 2001), 134–35.

30. Simon Schama, *Rembrandt's Eyes* (New York: Knopf, 1999), 620. Commenting on Rembrandt's *Supper at Emmaus,* a chiaroscuro (light-and-dark) scene depicting the appearance of the risen Christ to his disciples, Schama (declaring the work "sensational") judges it "a transformation of the knowledge conveyed by the senses; a transformation of the senses by knowledge" (252–53). Rembrandt captured on canvas what for us remains the unexplained magical point at which perception and conception join and interact.

31. The Baroque city produced a new order of traffic. Designed to serve the movement of wheeled cannons, it also facilitated the passage of carriages on their way to conduct business, parades, and leisure strolling. Squares and fields, such as the Champs de Mars in Paris and the white, sandy grounds behind Whitehall in London, furnished training grounds for marching troops and cavalry. See Lewis Mumford, *The Culture of Cities* (New York: Harcourt Brace Jovanovich, 1970), 95. For an introduction to modern cities and their designers, see Mark Girouard, *Cities and People: A Social and Architectural History* (New Haven, CT: Yale University Press, 1985), 113–54; and Yi-Fu Tuan, *Topophilia* (New York: Columbia University Press, 1974), 158–59.

32. Vasari quoted in Michael Levey, *High Renaissance* (Baltimore: Penguin, 1975), 42.

33. F. Roy Willis, *Western Civilization: An Urban Perspective,* 2 vols. (New York: Heath, 1973), vol. 2, 483.

34. Ibid.

35. Witold Rybczynski, *City Life: Urban Expectations in a New World* (New York: Scribner, 1995), 48.

36. Ibid., 49.

37. Weber, *A Modern History of Europe,* 357.

38. Ibid., 359–60.

39. Ibid.

40. To start an exploration of these two poles of courtly definition, see William Ian Miller, *The Anatomy of Disgust* (Cambridge, MA: Harvard University Press, 1997); and Joseph Epstein, *Snobbery* (Boston: Houghton Mifflin, 2002). For a consideration of the shifting but underlying role of the senses in human experience and savoring, see Diane Ackerman, *A Natural History of the Senses* (New York: Random House, 2000). She points out that Louis XIV had a stable of servants to wash his clothes in a stew of scents, perfume his room, and invent a new perfume daily to disguise him and make him a pleasing source of scents and aromas at royal dinner parties (61).

41. For the definition and function of hierarchy at Louis XIV's court, see Emmanuel Le Roy Ladurie, *Saint-Simon and the Court of Louis XIV* (Chicago: University of Chicago Press, 2001), 23–62.

42. Édouard Pommier, "Versailles: The Image of the Sovereign," in Pierre Nora, ed., *Realms of Memory: The Construction of the French Past,* 3 vols. (New York: Columbia University Press, 1998), vol. 3, 293–323.

43. Peter Reitbergen, *Europe: A Cultural History* (London: Routledge, 1998), 330–33.

44. What historian Thomas Macaulay wrote of seventeenth-century travel in England remained true in the following century for much of England and Europe. Of the best lines of communication, he wrote, "The ruts were deep, the descents were precipitous and the ways often such as it was hardly possible to distinguish, in the dusk, from the unenclosed heath and fen.... It was only in fine weather that the whole breadth of the road was available for wheeled vehicles. Often only a narrow track of firm ground rose above the quagmire—coaches stuck fast until a team of cattle could be procured to tug them out of the slough." Macaulay quoted in M. G. Lay, *Ways of the World: A History of the World's Roads and the Vehicles That Used Them* (New Brunswick, NJ: Rutgers University Press, 1992), 66. For a short history of English roads, see Christopher Savage, "Road," in *The Chambers Encyclopedia,* rev. ed., 15 vols. (Oxford: Pergamon Press, 1967), vol. 11, 705–12.

45. Even in mid-eighteenth-century France, which at the time had the best roads in Europe, travel in carriages averaged only two to three miles an hour. The fastest journeys covered only twenty-five miles a day. In France, composed of approximately thirty-six thousand parishes, local routes were still by far the busiest ones—and these amounted to a collection of footpaths, mule paths, and local roads named for their functions as salt or contraband paths, fish-cart roads, vineyard tracks, sheep trails, cattle routes, or even potters' ways. Joseph Amato, *On Foot: A History of Walking* (New York: New York University Press, 2004), 96–98.

46. This complex story of manners, etiquette, and appearance has been richly told by many, but it is most effectively taken up in German sociologist Norbert Elias's two-volume pioneering *Über den Prozess der Zivilisation* (Basel: Haus zum Falken, 1939), trans. into English as *History of Manners,* vol. 1 (New York: Urizen, 1978), and *Power and Civility,* vol. 2 (New York: Pantheon, 1982). A complementary

volume followed, *Die höfische Gesellschaft* (Berlin: Hermann Luchterhand Verlag, 1975), trans. into English as *The Court Society* (New York: Pantheon, 1983).

47. If the French taught the eighteenth-century western world proper ways to walk and talk, the British upper classes proved themselves to be the most adept students and disseminators of the French way. In turn, British etiquette was adopted by the Victorian middle class and then popularized throughout the British Empire and the ever-imitative upper classes of North America.

48. For clothes and appearance, see Daniel Roche, *La Culture des apparences: Une histoire du vêtement (XVIIe–XVIIIe siècles)* (Paris: Fayard, 1989); and Rose-Marie Fayolle and Renée Davray-Piekolek, eds., *La Mode en France, 1715–1815: De Louis XV à Napoléon 1er* (Paris: Bibliothèque des Arts, 1990).

49. For the complex history and interplay of rouges and lipsticks, which went in and out of English and French aristocratic fashion, see a Harvard student paper: Sarah Schaffer, "Reading Our Lips: The History of Lipstick Regulation in Western Seats of Power" (2006), leda.law.harvard.edu/leda/data/788/Schaffer06. pdf. (accessed May 19, 2006).

50. For fashion, see James Laver, *Costume & Fashion,* rev. ed. (London: Thames and Hudson, 1995), especially 74–154; and Kenneth Clark, *The Nude: A Study in Ideal Form* (Princeton, NJ: Princeton University Press, 1955). For a general introduction to footwear, see *All about Shoes* (London: Bata Museum, 1994). To see how clothes and fashion radiated throughout Colonial and Federal America, see Linda Baumgarten, *What Clothes Reveal* (New Haven, CT: Yale University Press, 2002).

51. For the contrast and interplay between dressed and undressed, which spatially is played out between public halls and private boudoirs and dressing rooms, see Jean Starobinski, "Le Rococo," in Fayolle and Davray-Piekolek, eds., *La Mode en France,* 13–15.

52. For the interplay of clothing and nudity, see Clark, *The Nude;* and Anne Hollander, *Seeing through Clothes* (New York: Penguin, 1978). For Heidegger on truth's etymology *(aletheia),* see Martin Heidegger, "On the Essence of Truth," in *Basic Writings* (San Francisco: HarperCollins, 1993), especially 124, 130, 137–38.

53. Doreen Yarwood, "Dress and Adornment," in *The New Encyclopaedia Brittanica* (Chicago: Encyclopaedia Brittanica, 1997), vol. 17, 489–93.

54. David McCullough, *John Adams* (New York: Simon and Schuster, 2001), 303, 328.

55. Fielding quoted in C. Willett and Phillis Cunnington, *The History of Under-clothes* (New York: Dover, 1990), 71.

56. For a short introduction to mirrors, see S. Roche, "Mirrors," in Harold Osborne, ed., *The Oxford Companion to the Arts* (Oxford: Oxford University Press, 1975), 570–74; and Sabine Melchior-Bonnet, *The Mirror: A History* (New York: Routledge, 2001), 70–98. An additional luxurious Hall of Mirrors is at the Amalienburg hunting lodge at Nymphenburg Palace in Munich, constructed from 1734 to 1739 by François de Cuvilliés.

57. Melchior-Bonnet, *The Mirror,* 270–71.

58. James H. Johnson, *Venice Incognito: Masks in the Serene Republic* (Berkeley: University of California Press, 2011), especially 242–43.

59. Gombrich, *The Story of Art,* 323.

60. To take a single example, the popular European portrait painter Alexander Roslin (1718–93) painted the comtesse d'Egmont Pignatelli in 1763 with reference to a set of opulent surfaces. The rosy-cheeked and fair-skinned *comtesse* sits gracefully at home amid comfort and elegance. She wears an ample white dress rich in lace and folds. Pearls decorate her hair, her ears, her neck, and her dress from bodice to waist. In her hand is an open gold-leafed book. Her white-heeled shoes with bowed ribbons, which rest on a parquet floor, protrude from under the ample crocheted lace hem of her dress. To her left, a small, playful black-and-white dog looks up. Above, on the same side of her golden, jewel-bordered loveseat, is an ornate flat gold table holding a white rosary and centered and crowned by a bouquet of colorful flowers. On her other side, sharing the sofa, is a guitar with sheet music and a blue-and-white ribbon. In effect, in this portrait, placed, decorated, and seen surfaces became equivalent to declared truths.

61. For gardens as nature sought and invented, and for life itself as a subset of gardening, see Robert Pogue Harrison, *Gardens: An Essay on the Human Condition* (Chicago: University of Chicago, Press, 2008), especially 25, 47, 87.

62. For a set of essays on four centuries of gardens in European and American art, see Betsy Fryberger, ed., *The Changing Garden* (Berkeley: University of California Press, 2003).

63. Mark Girouard, *Life in the English Country House* (New York: Penguin, 1980), 210.

64. Quotations cited and text paraphrased from Amato, *On Foot,* 83. Also, an important source for this discussion of the garden is Derek Plint Clifford, "Garden and Landscape Design," in *The New Encyclopaedia Britannica* (Chicago: Encyclopaedia Britannica, 1997), vol. 19, 662–67.

65. The English garden, which invited walking, had the effect of defining wilderness as a place where humans never set foot. John Hanson Mitchell, in *The Wildest Place on Earth: Italian Gardens and the Invention of Wilderness* (Washington, DC: Counterpoint, 2001), 20–22, 90–103, argues that nineteenth-century American thinkers formed their conception of wilderness in opposition to the Italian garden.

66. Various facets of the development of walking are found in Amato, *On Foot,* 71–124; Laurent Turcot, *Le promeneur à Paris au XVIIIe siècle* (Paris: Gallimard, 2007); and Walter Benjamin, *The Arcades Project* (Cambridge, MA: Harvard University Press, 1999). I reviewed Turcot's work in the *Journal of Social History* 43, no. 2 (Winter 2009): 488–91.

67. For processions and the use of open space in France, see Thomas Munck, *The Enlightenment: A Comparative Social History, 1721–1794* (New York: Oxford University Press, 2000), 35–45.

68. The greatest of the horse displays was Il Mondo Festeggiante, performed in 1661 in the Boboli Gardens in Florence on the occasion of the marriage of

Cosimo III to Marguerite-Louise d'Orléans. Ruth Sander, "Horse Ballet," in *The International Encyclopedia of Dance* (New York: Oxford University Press, 1998), vol. 3, 381–83. For a history of European horses, also see Sylvia Loch, *The Royal Horse of Europe: The Story of the Andalusian and Lusitano* (London: J. A. Allen, 1986). In Vienna, Lipizanner horses were drilled as far back as the time of Emperor Maximilian II, who introduced the breeding of Spanish horses in 1562.

69. Daniel Roche, *France in the Enlightenment* (Cambridge, MA: Harvard University Press, 1998), especially part 1, "Time, Space, and Powers," 11–250.

70. Ibid., 29.

71. Ibid., 3.

72. Ibid., 421.

7. FRESH FACES AND NEW INTERFACES

1. For this argument and quotation from Bernard de Fontenelle, see Kim Sloan, ed., *The Enlightenment: Discovering the World in the Eighteenth Century* (London: British Museum Press, 2003), 12.

2. Alfred North Whitehead offers this definition of the difference between the Enlightenment and the Middle Ages: "The contrast is symbolized by the difference between the Cathedral of Chartres and the Parisian salons, where D'Alembert conversed with Voltaire. The Middle Ages were haunted with the desire to rationalize the infinite; the men of the eighteenth century rationalized the social life of modern communities, and based their sociological theories on an appeal to the facts of nature." Alfred North Whitehead, *Science and the Modern World* (New York: Macmillan, 1925), 57.

3. Ibid.

4. Utilizing Einstein and Bergson, Whitehead contends that despite its glory, classic physics relied on "the fallacy of misplaced concreteness" when it defined nature in terms of its location in space and time. Ibid., 5; also see 52–54.

5. Isaiah Berlin quoted in Roger Hausheer, introduction to Isaiah Berlin, *Against the Current* (Princeton, NJ: Princeton University Press, 2001), xxxv.

6. M. H. Abrams, *The Mirror and the Lamp: Romantic Theory and the Critical Tradition* (New York: Oxford University Press, 1953).

7. For a short history of power statements, especially in the modern world, see Maurice Richards, *The Public Notice: An Illustrated History* (New York: Clarkson N. Potter, 1973).

8. For these materials, see the French Revolutionary Pamphlet Collection, Australian National Library, www.nla.gov.au/selected-library-collections/french-revolutionary.

9. For the representations and role of dress in revolutionary France, see Richard Wrigley, *The Politics of Appearances* (Oxford: Berg, 2002).

10. For a short description of the Crystal Palace and its celebration in the arts, see Francis Klingender, *Art and the Industrial Revolution* (Frogmore, St Albans,

UK: Paladin, 1975), 144–46. For Dostoevsky's reference to the Crystal Palace, see his *Notes from the Underground,* trans. Mirra Ginsberg (New York: Bantam Books, 1974), 39.

11. See Tom Peters, *Building the Nineteenth Century* (Cambridge, MA: MIT Press, 1996), especially the conclusion, 347–58. On invention, objects, and consumption, which, along with construction and building, were so important to the nineteenth century, see Edward de Bono, ed., *Eureka! An Illustrated History of Inventions from the Wheel to the Computer* (New York: Holt, Rinehart, and Winston, 1974); and Charles Panati, *The Extraordinary Origins of Everyday Things* (New York: Harper & Row, 1987). See also Charles Robertson, *Temple of Invention: History of a National Landmark* (New York: Scala, 2007).

12. Klingender, *Art and the Industrial Revolution.*

13. In *Building the Nineteenth Century,* Peters advances the thesis that construction informed the century's ideas and ideals. Offering a history of civil engineering, which includes docks, ports, bridges, canals, tunnels, railroads, and other structures, he draws attention to the mind-catching marvels of nineteenth-century building, such as the Crystal Palace and the Mont Cenis Tunnel under the Alps. Peters also dwells on the techniques, the materials, and the beams and plates, foundations and floors, and nuts and bolts that underpinned experimentation and allowed the act of assemblage to supersede that of construction. Older volumes offer overviews of nineteenth-century industries, engineering, and technology: e.g., Richard Kirby, *Engineering in History* (New York: McGraw-Hill, 1956; republished Mineola, NY: Dover, 1990); and T. K. Derry and Trevor Williams, *A Short History of Technology* (Oxford: Oxford University Press, 1960; republished Mineola, NY: Dover, 1993). Also of use are W. O. Henderson, *The Industrialization of Europe, 1780–1914* (New York: Harcourt, Brace, & World, 1969); and David Landes, *The Unbound Prometheus: Technological Change and Industrial Development in Western Europe from 1750 to the Present* (Cambridge: Cambridge University Press, 1969).

14. Joseph Amato, *Jacob's Well: A Case for Rethinking Family History* (St. Paul: Minnesota Historical Society Press, 2008), especially 155–58.

15. Kirby, *Engineering in History,* 450–51, 452–56.

16. For the connection between eighteenth- and nineteenth-century manufacture, see Maxine Berg, *The Age of Manufactures, 1700–1820* (Oxford: Oxford University Press, 1986).

17. With their origins in the early seventeenth century, windmills in the Zaan River region, numbering more than a thousand, kept the land above water while processing barley, rice, paper, wood, cooking oil, mustard, tobacco, and hemp and making chalk, abrasives, and dyes. Though windmills abounded in the center and south of the Netherlands, they were later abandoned; for a region-by-region census of the fate of the 15,500 registered windmills in the Netherlands, among which more than 500 structures still exist, see www.molendatabase.nl/nederland/index_e.php (accessed May 2012).

18. Peters, *Building the Nineteenth Century,* 348.

19. Quoted in "Civil Engineering," en.wikipedia.org/wiki/Civil_engineering (accessed October 2012).

20. For a brief survey of engineering in modern and contemporary history, see, in addition to works previously mentioned, Ervan Garrison, *A History of Engineering and Technology* (Boston: CRC Press, 1999), 141–326; Ian McNeil, ed., *An Encyclopedia of the History of Technology* (London: Routledge, 1996), 227–428; and Melvin Kranzberg and Carroll Pursell, eds., *The Emergence of Modern Industrial Society: Earliest Times to 1900: Technology in Western Society* (New York: Oxford University Press, 1967), vol. 1, 217–321.

21. The work of the highly acclaimed English architect Christopher Wren (1632–1723) testifies to an increased use of iron in early modern building. In the last decades of the seventeenth century, he used iron hangers to suspend floorbeams at Hampton Court Palace and iron rods to repair Salisbury Cathedral and strengthen the dome of St Paul's Cathedral. At the same time, an experimental hydraulic mortar came into existence. However, the latter was not the equal of Roman concrete. In England, France, and Holland, brickwork still provided detailed and ornate facades. Methods of construction relied, as early those of modern and medieval Europe had done, on timber structures for scaffolding and cranes.

22. Derry and Williams, *A Short History of Technology,* 407–11.

23. Landes, *The Unbound Prometheus,* 95.

24. For the Industrial Revolution in England and Europe, with select data on growth, see ibid., 40–192; and E. J. Hobsbawm, *The Age of Capital, 1848–1875* (New York: Charles Scribner's Sons, 1975), 29–68. See also chap. 8, "Guns and Rails," in Arnold Pacey, *Technology in World Civilization* (Cambridge, MA: MIT Press, 1990), 131–49.

25. The word *cement* can be traced to the Romans, who used the term *opus caementicium* to describe masonry (resembling modern concrete) made from crushed rock, with burnt lime as binder. The volcanic ash and pulverized brick additives that were added to the burnt lime to obtain a hydraulic binder were later referred to as *cementum, cimentum, cäment,* and *cement.* Modern "empirical cement mixtures had been made with great success in Britain" (Derry and Williams, *A Short History of Technology,* 406). Engineer M. Brunel, in 1828, put Portland cement—that powerful, dull-gray equivalent of the Portland stone from which it took its name—to work to fill in parts of the Thames's riverbed and, later, to make the London drainage system (ibid.).

26. For an introduction to roads and their surfaces, see M. G. Lay, *Ways of the World: A History of the World's Roads and of the Vehicles That Used Them* (New Brunswick, NJ: Rutgers University Press, 1992), especially 121–332; and Joseph Amato, *On Foot: A History of Walking* (New York: New York University Press, 2004), 158–59, 242–43.

27. Walt Whitman, "To a Locomotive in Winter," in *Leaves of Grass* (Philadelphia: David McKay, 1900).

28. The connection between the youthful Hegelians Marx and Arnold Ruge is found in Allan Megill, *Karl Marx: The Burden of Reason* (New York: Rowman & Littlefield, 2002), especially 196–99.

29. Wolfgang Schivelbush, *Railway Journey: The Industrialization of Time and Space* (Berkeley: University of California Press, 1986).

30. The stagecoach profoundly accelerated land travel in the eighteenth century, with travel time cut in half between major English towns from 1770 to 1830. Ibid., 7.

31. Ibid., 33.

32. Ibid., 35.

33. Ibid., especially 178–82. For the organization of transportation in London and Paris, see Amato, *On Foot*, 153–228.

34. For a discussion of the telegraph, see Peters, *Building the Nineteenth Century*, 11–15, 16–17, 20, passim. The American professor of art and design Samuel Morse (1791–1872) made the "magnetized magnet" practical and commercial, creating the language of dots and dashes that bears his name, the Morse Code.

35. Historian of technology George Basalla argues that as once the mechanical was used to describe the organic world, by century's end the organic had come to describe the mechanical world. George Basalla, *The Evolution of Technology* (Cambridge: Cambridge University Press, 1988), 15.

36. For a short introduction to the young Marx, see Megill, *Karl Marx*, especially 198–210; and Joseph A. Amato, *Ethics: Living or Dead?* (Marshall, MN: Crossings Press, 1982), 25–34.

37. For a view of the machines that changed the United States, see Steven Lubar, *Engines of Change* (Washington, DC: National Museum of American History, 1986).

38. For Renoir and his move from craftsman to painter, see Jean Renoir, *Renoir, My Father* (Boston: Little, Brown, 1958), 59–122.

39. Amato, *On Foot*, 153–78, 229–54.

40. For the development of nineteenth-century transportation, particularly in London, see ibid., 167–68.

41. Scottish inventor Robert Thomson developed the pneumatic tire with an inner tube in 1845, but his design was ahead of its time. The pneumatic tire was reinvented in the 1880s by another Scotsman, John Boyd Dunlop, and became immediately popular with bicyclists. Natural rubber is the main raw material used in manufacturing tires, although synthetic rubber is also used. In order to develop the proper characteristics of strength, resiliency, and wear resistance, however, the rubber must be treated with a variety of chemicals and then heated. American inventor Charles Goodyear discovered the process of strengthening rubber, known as vulcanization or curing, by accident in 1839. See "Tire," www.madehow.com/Volume-1/Tire.html (accessed August 2007).

42. Amid a long history of building engines fueled by oil, kerosene, and gasoline, in 1885 the German Gottlieb Daimler invented the prototype of the modern gas engine, with a vertical cylinder and with gasoline injected through a carburetor (it was patented in 1887). Daimler first built a two-wheeled vehicle, the "Reitwagen" (riding carriage), with this engine, and a year later built the world's first four-wheeled motor vehicle. See Derry and Williams, *A Short History of Technology*, 393–94.

43. On transportation and tourism, see Amato, *On Foot*, 120–21, 125–33, 268–69, passim; Orvar Löfgren, *On Holiday: A History of Vacationing* (Berkeley: University of California Press, 1999); and Alain Corbin, ed., *L'Invenzione del tempo libero* (Rome: Editori Laterza, 1996).

44. Stephen Halliday, *The Great Stink of London: Sir Joseph Bazalgette and the Cleansing of the Victorian Metropolis* (Stroud, UK: Sutton Publishing, 1999).

45. Joseph Amato, *Dust: A History of the Small and Invisible* (Berkeley: University of California Press, 2000), 83–84.

46. Wolfgang Schivelbusch, *Disenchanted Night: The Industrialization of Light in the Nineteenth Century* (Berkeley: University of California Press, 1988).

47. Gaston Bachelard, *La Flamme d'une chandelle* (Paris: Presses universitaires France, 1961), 30.

48. For a historical exploration of glamour born of celebrity, style, design, and commerce, see Stephen Gundle, *Glamour: A History* (Oxford: Oxford University Press, 2008).

49. Eugen Weber, "Commonplaces: History, Literature, and the Invisible," *Stanford Review* (Winter 1980): 315–34.

50. For a general history of glass, see Alan Macfarlane and Gerry Martin, *Glass: A World History* (Chicago: University of Chicago Press, 2002).

51. On the automation of glass manufacture and the production of modern flat glass and safety glass at the start of the twentieth century, see http://glassonline. com/infoserv/history.html; and www.serviceglassandmirror.com/History.html. See also Derry and Williams, *A Short History of Technology*, 598–99; and Tyler Stewart Rogers, "Glass Manufacture," *Encyclopaedia Brittanica*, vol. 10 (London: Encyclopaedia Brittanica, 1970), 470–76.

52. In the field of optical glass, Otto Schott (1851–1935), who studied the effects of numerous chemical elements on the optical and thermal properties of glass, teamed up with Ernst Abbe (1840–1905), a professor at the University of Jena in Germany and joint owner of the Carl Zeiss firm, to make significant technological advances in optical lenses, as can be seen in lenses on display at the Optical Museum in Jena.

53. I draw my interpretation of the Impressionists from Ruth Berson, ed., *The New Painting: Impressionism, 1874–1886* (San Francisco: Fine Arts Museums of San Francisco, 1986), especially Richard Shiff's essay "The End of Impressionism," 61–92; *The Larousse Encyclopedia of Modern Art*, ed. René Huyghe (Paris: Libraire Larousse, 1965), 177–97; E. H. Gombrich, *The Story of Art* (New York: Phaidon, 1995), 982–1003; *Gardner's Art through the Ages*, eds. Richard Tansey and Fred Kleiner (New York: Harcourt Brace, 1996), 511–28; Martin Kemp, *The Oxford History of Art* (Oxford: Oxford University Press, 2000), 330–34; and Phillip Ball, *Bright Earth: Art and the Invention of Color* (Chicago: University of Chicago Press, 2001), especially 168 for quotation and 181–96.

54. Ball, *Bright Earth*, 169.

55. Taken from comment on Manet's *A Bar at the Folies-Bergère* (1882), in *Gardner's Art through the Ages*, 982.

56. Ball, *Bright Earth,* 180.

57. In 1903, an American manufacturer joined the rush toward color and coloring by putting eight bright, safe, and solid colored crayons, called Crayola Crayons, in a box that it sold for a nickel to children. Thereafter kids—and artists too—posted their primary-colored crayon creations on many plain surfaces. Crayons were handy and cheap, hardly equal in cost to the paper they decorated. See www.crayola.com/about-us/company-profile.aspx.

58. Weber, *A Modern History of Modern Europe* (New York: W. W. Norton, 1971), 1062–64.

59. "For the twentieth-century artist, the medium carries its own message. Collage, explored by the Cubists ... injected the fabric of the world into composition. It spoke directly of the artists' social environment: the newspapers, the cigarette packets ... all lending the work an urbanity and immediacy.... The artist simply selects. It is not what one sees that matters but the question posed by its identity as a workshop product or its placement in a gallery. What is art?" Ball, *Bright Earth,* 316.

60. For an introduction to the city as the definer of modernity, see, for example, Yi-Fu Tuan, *Topophilia: A Study of Environmental Perception, Attitudes, and Values* (New York: Columbia University Press, 1974), especially 186–224; and Witold Rybczynski, *City Life: Urban Expectations in a New World* (New York: Scribner, 1995). Also of use are Mark Girouard, *Cities and People: A Social and Architectural History* (New Haven, CT: Yale University Press, 1985), 255–324, and Sir Peter Hall, *Cities in Civilization* (New York: Pantheon, 1998), 291–502.

61. Lewis Mumford elaborates: "The clock has been the foremost machine in modern technics; and at each period it has remained in the lead.... It marks a perfection toward which other machines aspire" (Lewis Mumford, *Technics and Civilization* [New York: Harcourt Brace, 1962 (1934)], prefatorily quoted in David Landes, *Revolution in Time: Clocks and the Making of the Modern World* [Cambridge, MA: Harvard University Press, 1983], xix). Also on clocks and the ordering of time and lives, see Stephen Kern, *The Culture of Time and Space, 1880–1918* (London: Weidenfeld and Nicolson, 1983); and for a very insightful review of Kern's and Landes's works, see David Cannadine, "Time," in his *The Pleasures of the Past* (New York: W. W. Norton, 1989), 209–18.

62. Landes, *Revolution in Time,* 287. Production occurred across stages of national competition: though competitive by nation, with Britain the definer of official time on land and sea due to its paramount roles in sailing and railroads, the Swiss and Americans led advances in the crafting and manufacture of watches in the nineteenth century. For competition among nations, especially Switzerland and the United States, which truly mechanized clock manufacture, and the associated eclipse of England as the world's clockmaker, see ibid., 274–337.

63. "The clock proved a better measure of modernization than even energy consumption per capita, which varies significantly with the relative cost of fuel, climatic requirements, and product mix." Ibid., 325.

1. Biographer Walter Isaacson characterizes Steve Jobs's genius and success at Apple in terms of his fusion of aesthetics and technology, of eye and hand; and in terms of the company's design of simple, useful, and appealing surfaces and objects. See Walter Isaacson, *Steve Jobs* (New York: Simon & Schuster, 2011).

2. Hal Foster, *Design and Crime (and Other Diatribes)* (London: Verso, 2002), xiv.

3. In his widely known *Understanding Media: The Extensions of Man* (New York: McGraw-Hill, 1964), Marshall McLuhan argues that the medium, more than the content it relays, most affects society.

4. Paul Valéry, "The Intellectual Crisis" (1919), in *Selected Writings of Paul Valéry* (New York: New Directions, 1950), 120.

5. Henry Petroski, *Small Things Considered: Why There Is No Perfect Design* (New York: Knopf, 2003), 13. Also of interest is idem, *The Evolution of Useful Things: How Everyday Artifacts—from Forks and Pins to Paper Clips and Zippers—Came to Be as They Are* (New York: Vintage, 1992).

6. For a collection of classic statements on design, see Carma Gorman, *The Industrial Design Reader* (New York: Allworth Press, 2003); and for a set of guidelines on design, see Donald A. Norman, *The Future Design of Things* (New York: Basic Books, 2009).

7. For a delineation of the areas of design, as well as 360 examples of modern design, see Catherine McDermott, *Designmuseum: 20th Century Design* (New York: Overlook Press, 1997).

8. Ivan Amato, *Stuff: The Materials the World Is Made Of* (New York: Avon, 1997), 9–10.

9. Ibid., 47–51.

10. Ibid.

11. Ibid., 61.

12. Ibid., 63.

13. Philip Ball, *Made to Measure: New Materials for the 21st Century* (Princeton, NJ: Princeton University Press, 1997), 384.

14. Ibid., 385.

15. Letter quoted in Walter Isaacson, *Einstein: His Life and Universe* (New York: Simon & Schuster, 2007), 93; the meaning of an electrodynamics of moving bodies is elaborated upon on 93–139.

16. For a reconstruction of interwar physics told through a life of the genius Sicilian physicist and mathematician Ettore Majorana, see João Magueijo, *A Brilliant Darkness: The Extraordinary Life and Mysterious Disappearance of Ettore Majorana, the Troubled Genius of the Nuclear Age* (New York: Basic Books, 2009).

17. For the range of properties and types of choices (including those of engineering and economics), see Ball, *Made to Measure*, 5–12. Chemistry professor F.M. Fowkes elaborates on the capability of surfaces to interact "with a force

field extending from the surface into each material." F. M. Fowkes, "Predicting Attractive Forces at Interactive Faces," *Chemistry and Physics of Interfaces II,* ed. David Gushee (Washington, DC: American Chemical Society Publications, 1971), 154.

18. Jean Perrin quoted in preface, Sean Carroll, *Endless Forms Most Beautiful* (New York: W. W. Norton, 2005), ix.

19. Ibid., 304–05.

20. Joseph Amato, *Dust: A History of the Small and Invisible* (Berkeley: University of California Press, 2000), 133.

21. For a guide to nanotechnology, see Mark Ratner and Daniel Ratner, *Nanotech: The Next Big Idea* (Upper Saddle River, NJ: Prentice Hall, 2006), 39–44.

22. Additional devices include the angiogram—an x-ray test that uses fluoroscopy to measure blood flow in arteries and lungs. Lasers, which emit light (electromagnetic radiation) through a process of optical amplification based on the stimulated emission of photons, are medically used to treat kidneys, eyes, and teeth. In industry, lasers are used to cut, weld, join, and make parts. The military utilizes lasers to mark targets, guide munitions, and substitute for radar. Lasers also are now omnipresent in printers, optical discs, and barcode scanners.

23. Hans-Jürgen Butt, Karlheinz Graf, and Michael Kappl, *Physics and Chemistry of Interfaces* (Hoboken, NJ: Wiley, 2003), 4.

24. Feynman's paper was given in December 1959 at the American Physical Society meeting at the California Institute of Technology; it was first published in Caltech's *Engineering and Science* 23, no. 5 (February 1960): 22–36.

25. This chronology is from "A Few 10^{-9} Milestones," in Gary Stix, "Little Big Science," in *Understanding Nanotechnology,* eds. *Scientific American* (New York: Warner Books, 2002), 12–13; quotation from Norio Taniguchi is found in the same chronology, 12. In 1968, Alfred Y. Cho and John Arthur of Bell Laboratories and their colleagues invented molecular beam epitaxy, which permitted the deposition of a single layer of atoms on a surface. In 1981, Gerd Binnig and Heinrich Rohrer created the scanning tunneling microscope, which images single atoms.

26. K. Eric Drexler, *Engines of Creation: The Coming Era of Nanotechnology* (New York: Doubleday, 1986).

27. My visit to Aveka occurred on July 11, 2011. Aveka's website adequately explains its diverse businesses in microparticle processing; see www.aveka.com (opened in 2008; redone November 2011).

28. The interaction of colloid particles involves repulsion, electrostatic interaction, van der Waals forces and dipoles, entropic forces, and steric forces involved in distorting molecular crowding.

29. Edward Carberry, two lengthy telephone interviews with the scientist in the early evening of July 21 and late morning of July 23, 2011.

30. Susan Freinkel, *Plastics: A Toxic Love Story* (Boston: Houghton, Mifflin, Harcourt, 2011).

31. For a recent global history of porcelain, see Robert Finlay, *The Pilgrim Art* (Berkeley: University of California Press, 2011).

32. For a treatment of the advance of the wheel in the nineteenth century, see chap. 9, "Wheels and Cars," in Joseph Amato, *On Foot: A History of Walking* (New York: New York University Press, 2004), 229–54.

33. Having identified the sequence of DNA in genes that form spider silk, David Kaplan and his colleagues at Tufts University, following a long tradition of researchers, are now seeking to duplicate silk's ideal properties of strength, elasticity, hydrophobia, and hydrophilia. Synthetic silks potentially are of wide medical application. "Does Even More Than a Spider Can," *Economist* (January 31, 2009): 87; and email, David Kaplan to the author, July 30, 2010.

34. Philip Ball, *Designing the Molecular World: Chemistry at the Frontier* (Princeton, NJ: Princeton University Press, 1994), 5.

35. Ibid.

36. Freinkel, *Plastics,* 82.

37. The notion that "all biology is arguably nanotechnology" is advanced by A. Paul Alivisatos, "Less Is More," in *Understanding Nanotechnology,* 57.

38. For a short history of and introduction to bioengineering, see Ervan Garrison, *A History of Engineering and Technology,* 2nd ed. (Boston: CRC, 1999), 310–26. Also see W. French Anderson, "Gene Therapy"; Robert Langer and Joseph Vacanti, "Artificial Organs"; Nancy J. Alexander, "Future Contraceptives"; and Arthur Caplan, "Commentary: An Improved Future," in *Key Technologies for the 21st Century,* part 3, special ed. of *Scientific American* (New York: W. H. Freeman, 1995), 55–60, 61–66, 67–76, 77–82, respectively.

39. "Illuminating Surgery: Treating Cancer," *Economist* (April 25, 2009): 84.

40. In July 2011, Swedish doctors built a trachea from a man's own stem cells. Thomas H. Maugh II, "How Swedish Doctors Built a Trachea from Scratch," *Minneapolis Star-Tribune* (July 10, 2011): A3.

41. The concept of tissues cannot be understood without that of cell membranes, which possess an outer and an inner surface. William Hoffman, email to the author, July 6, 2011. For an introduction to cell differentiation, see Lewis Wolpert, *The Triumph of the Embryo* (Mineola, NY: Dover, 2008).

42. William Hoffman, email to the author, July 6, 2011.

43. Hoffman initiated his lengthy email to the author with a quotation from Princeton stem cell scientist Ihor Lemischka: "For almost every decision that a stem cell makes, there is an analogous situation in an electronic circuit." Lemischka and colleague Ron Weiss engineered a "toggle switch" system that directed mouse embryonic stem cells to differentiate into muscle cells, nerve cells, and insulin-producing pancreatic beta cells. More than five thousand cellular and genetic components, modules, circuits, relays, and switches are available to synthetic biologists through a clearinghouse called the BioBricks Foundation. William Hoffman, second email to the author, July 6, 2011.

44. William Hoffman, *The Stem Cell Dilemma* (New York: Arcade, 2009), especially the chap. "Harbinger of Destruction," 195–232. According to Hoffman, George Church, a Harvard genetics professor and director of the Harvard-Lipper Center for Computational Genetics, pioneered a direct genomic sequencing method

two decades ago and helped to get the Human Genome Project off the ground. He is presently concerned about the potentially deadly combination of the availability of genetic sequencing information on dangerous viruses and the availability of DNA chemicals that can be used to build these sequences. Designing a lethal pathogen, Church believes, has become easier than building a nuclear device. William Hoffman, second email to the author, July 6, 2011.

CONCLUSION. ENCAPSULATIONS

1. For a lengthy discussion of images and icons, see Martin Kemp, *Christ to Coke: How Image Becomes Icon* (Oxford: Oxford University Press, 2012).

2. Paul Auster, *Moon Palace* (New York: Viking, 1989), quoted as epigraph in Carl Knappert, *Thinking Through Material Culture* (Philadelphia: University of Pennsylvania Press, 2005), chap. 1, 1.

3. Stephen Pappas, "Did Neanderthals Create Europe's First Cave Paintings?" *Christian Science Monitor* (June 14, 2012): 1.

4. Corinthians I, 2:9.

5. Romano Guardini, *Letters from Lake Como* (Grand Rapids, MI: Eerdmans, 1994), 12–14.

6. This summary of José Ortega y Gasset's *History as a System* (New York: W. W. Norton, 1941), especially chap. 3, "Man, the Technician," 87–161, was borrowed from David Nye, *Technology Matters: Questions to Live With* (Cambridge, MA: MIT Press, 2006), 190. Ortega y Gasset offers what must seem to be a paradoxical definition of encapsulation: he sees civilization as engulfed by its ignorant masses and controlled by the belief that the present is a simple and necessary gift of the past and a completely malleable subject, open to wish and act alike. Inspired by the work and fruit of technology, the masses, in Ortega y Gasset's opinion, embrace as historically inevitable the idealized aspirations of the Industrial Revolution and the French Revolution.

7. For the meaning of Heidegger's ensconcement in this cabin, see Adam Sharr, *Heidegger's Hut* (Cambridge, MA: MIT Press, 2006); for an introduction to Heidegger on technology, see his "The Question Concerning Technology," in *Martin Heidegger's Basic Writings*, ed. David Farrell Krell (San Francisco: HarperSanFrancisco, 1993), 307–42. Specific phrase quoted in Nye, *Technology Matters*, 199.

8. Nye, *Technology Matters*, 199; the quoted passage is from Carl Mitchen, "Of Character and Technology," in *Technology and the Good Life*, eds. E. Higgs et al. (Chicago: University of Chicago Press, 2000), 144.

9. E. F. Schumacher, *Small Is Beautiful* (New York: Harper & Row, 1963), 62.

10. The notion that we are entombing ourselves in death cities, necropolises, is articulated first with direct reference to the plight of the city of Rome (and may be read as a possible end to the contemporary city) in Lewis Mumford's classic *The City in History* (New York: Harcourt, Brace, 1961), 205–42, 568–76. The conjunction of the controlling city and the dominating city is at play throughout Mumford's *Myth*

of the Machine: Pentagon of Power (New York: Harcourt, Brace, Jovanovich, 1964) and is made explicit on 24.

11. For the source of this definition of *kitsch,* see Roger Scruton, *Beauty* (Oxford: Oxford University Press, 2011), 158–62.

12. Jacques Ellul, *La Technique, ou l'enjeu du siècle* (Paris: Librairie Armand Colin, 1954); English trans. by John Wilkinson, *The Technological Society* (New York: Random House, 1964).

13. Jacques Ellul, *La Parole humiliée* (Paris: Seuil, 1981); English trans. by Joyce Main Hanks, *The Humiliation of the Word* (Grand Rapids, MI: Eerdmans, 1985). This book proposes that words and language, through diverse means, offer multiple meanings. Truth itself is multifarious. It involves the refined use of analogies, metaphors, and myths; the full articulation of temporal modalities; the elaboration of rhetoric; an aesthetics of storytelling; and the formulation of logic based on the either/or propositions of yes and no and being/not being. It also calls forth the test of riddles and paradoxes. The linkage of language and word to truth squares with the biblical language quoted earlier: "No eye has seen, nor ear heard, nor human heart conceived."

14. Pierre Teilhard de Chardin, *The Phenomenon of Man,* trans. Norman Denny (New York: Harper & Row, 1964 [1955]), especially 161–91, 312–24.

ACKNOWLEDGMENTS

Surfaces had its beginnings in two of my earlier books. In *Dust: A History of the Small and Invisible,* I take up humanity's recent entrance as an explorer, designer, and manufacturer of microcosms. In *On Foot: A History of Walking,* I study bipedalism and its role in defining humanity. I dwell particularly on the structures and machines that permit humans to arrange, order, and move efficiently across great swathes of the earth's surface.

The immediate source of this book was an article, "A Superficial Evocation of Our Times," that I wrote for *Historically Speaking.* My article on surfaces won the enthusiasm of Niels Hooper, history editor at the University of California Press. Niels brought deliberative, imaginative, and cheerful support to my preliminary prospectus. He proposed the word *encapsulation* to describe contemporary society's enfoldment in its own works and images. Along with his editorial assistant, Kim Hogeland, project editor Kate Hoffman, and keen copyeditor Laura Harger, Niels and the University of California team moved the manuscript from acceptance and refinement to production and publication.

My abiding indebtedness goes to professors A. W. Salomone, Eugen Weber, Stephen Tonsor, and the dean of the history of technology and the city, Lewis Mumford. It also extends to a range of contemporary scholars and scientists: Clive Gamble, David Kaplan, Martin Kemp, Carl Knappert, Alan Megill, David Nye, Henry Petroski, Roger Scruton, Dietrich Strout, and James Tracy. On October 15, 2011, the Minnesota Independent Scholars Forum generously listened to an outline of *Surfaces.*

During a single day of research in the Twin Cities, I conducted long personal interviews with Tim Farrell, Willie Hendrickson, and R. Lee Penn in July 2011. Bill Hoffman, another Twin Cities friend and scholar, expanded and corrected my understanding of stem cells. Daniel Leary directed me to the sidewalk art of Banksy.

At the nearby university here in Marshall, Minnesota, I took counsel from Jay Brown, Corey Butler, Ed Carberry, Tom Dilley, Dan Kaiser, Ken Murphy, and

Dave Pichaske. Librarian Connie Stensrud kept a plentiful stream of books flowing my way through the interlibrary "pipeloan." In off hours, Shawn Hedman found time to keep my fickle computers up and running. Friends and critics Julie Bach, Michael Hanson, and Scott Perrizo improved early drafts of the work.

Family and friends, too, came into play in a work whose writing spanned several years. Frank Ackley set me thinking about tires, while friend and physicist Basil Washo generously gave me an understanding of the science of surfaces. Friends Kevin Stroup, Jeffrey Russell, and Robert Jahn, and friends and former colleagues Dave Nass, his wife, Judy, Mike Kopp, and his wife, Vicky Brockman, all offered encouragement.

My daughters Felice and Beth and her husband Brent, and my sons, Anthony and Adam, and their spouses, Anne and Nelia, contributed in various ways to conceiving of and making surfaces. My parents and grandparents account for reach and tenacity. And for so many reasons, my thanks and love go to my wife, Cathy. Enfolding me in a good life, she is the surface of surfaces, the heart of hearts.

And for the record, all mentioned here are excused from all errors except being the object of my unmistakable gratitude. All who deserved mention here but were forgotten are owed a heartfelt apology.

FIGURE CREDITS

Frontispiece and figures 1–3, 9, 12–14, 17, and 25. Reproduced with the permission of Abigail Rorer, Petersham, Massachusetts. Figures 3, 9, and 17 are prints found on her website, www.theloneoakpress.com, which is also the home of Rorer's Lone Oak Press. The others are from the author's collection; all but figure 2 previously appeared in Joseph Amato, *Dust: A History of the Small and Invisible* (Berkeley: University of California Press, 2000).

Figures 4 and 5. Original pencil drawings by James Dahl, Marshall, Minnesota.

Figures 6, 7, and 11. Furnished by Wikimedia Commons. Figure 6 first appeared in H. G. Wells, *The Outline of History* (London: George Newnes, 1920). Figure 7 was first published in William Stukeley, *Itinerarium Curiosum,* 2nd ed. (London: Printed for the author, 1766).

Figures 8, 10, 15, 16, and 18–20. From *Dictionnaire encyclopédique Trousett* (Paris: Girard & Boitte, 1886–1991), furnished by oldbookillustrations.com and its webmaster, Hervé (Harvey) Livet.

Figures 21–24. Minnesota Historical Society Library.